KU-431-549

Thomas Heatherwick

Making

 Thames & Hudson

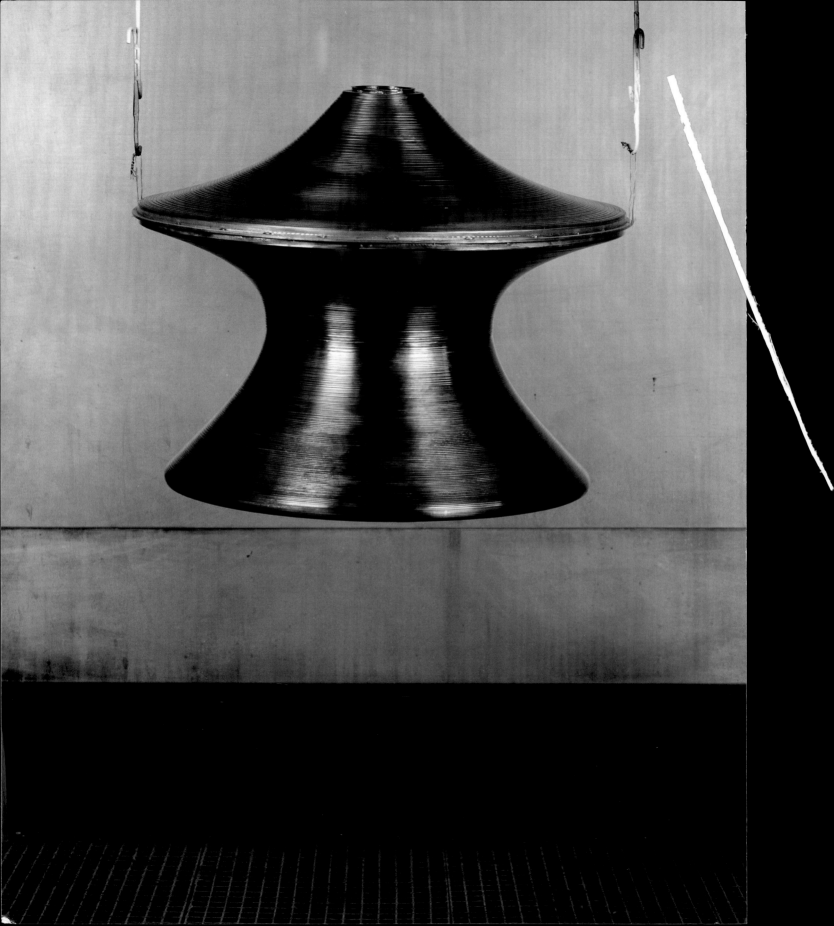

Contents

From I to We

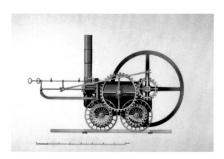

'Catch Me Who Can', Richard Trevithick, 1808

THIS BOOK ABOUT my studio's projects contains a selection of work carried out over more than two decades, presented in chronological order. The intention is not to persuade others to adopt any single approach to design or to promote any one philosophy but only to try to explain the thinking that went into each project and tell the story of how our ideas developed. Throughout the book, my voice may appear to fluctuate arbitrarily between 'I' and 'we' but the reason is that all except the earliest projects were undertaken by a group of people working with me to develop ideas. Thinking and experimenting together like this, we have found that we tend to guide ourselves towards ideas by finding a few key questions to ask ourselves. This is why every project in the book is introduced by one of these provocations. These descriptions may give the impression that ideas come easily, but almost every project, whether it is built or not, is an intense mixture of certainty and doubt, breakthroughs and dead ends, tension and hilarity, frustration and progress.

Elisabeth Tomalin, pencil on paper, 1989

I grew up in London and my early years were spent among people who pursued strong personal interests, exposing me to different influences and encouraging me to develop any natural aptitudes I might have. My grandfather, Miles Tomalin, was a writer and musician who wrote pacifist poems every year, which he sent as Christmas cards. He had been among those who had volunteered in the 1930s to go to Spain as part of the International Brigade, to fight the fascists in the Spanish Civil War. His study of the history of engineering convinced him that George Stephenson had been wrongly credited with the invention of the steam locomotive and led him to wage a personal campaign for Richard Trevithick to be rightfully recognized as its true innovator. My German-Jewish grandmother, Elisabeth Tomalin, had come to London after fleeing Dresden

Hammock making

Hedge laying

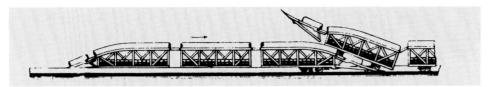

Stern's Improved Means for Allowing the Passing of one Vehicle by Another, 1904, 'Relates to systems of transport on single line or narrow routes whereby collisions may be avoided and travel carried on without interruption... It consists in passing one vehicle over the roof of the other, and of modifying the vehicle roofs and tyres to allow of such passage.'

An artistic way of hiding an unsightly view from a flat from 'How to Live in a Flat', William Heath Robinson, 1937

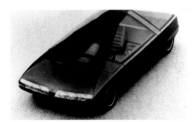

Citroën Karin concept car, 1980

Future Home 2000, Milton Keynes, 1981

from the Nazis, and worked with the architect Ernö Goldfinger before setting up and directing the textile design studio of Marks and Spencer. Later she became a pioneer of the practice of art therapy.

Stefany Tomalin, my mother, was a painter and jeweller before becoming an authority on beads and bead-threading. For twenty years, she had a shop selling necklaces and beads on London's Portobello Road. Together we went to exhibitions, model engineering shows and crafts fairs, spending time with people who were forging iron, blowing glass, machining metal, erecting timber building frames, knotting hammocks, laying hedges, making sheep fences and constructing dry stone walls. Hugh Heatherwick, my father, trained as a pianist and at the age of fifteen joined the band of the Royal Marines, where he was also a boxer. Later he developed an expertise in fostering the creativity of children, adults, organizations and communities. Interested in innovation and in the future of cities, he took me to see Milton Keynes' futuristic housing prototypes and the new forms and technologies on display at international car shows. During the past twenty years, he has played an important role in the studio and continues to help us to develop as an organization and evolve as a creative entity.

In childhood, I spent time drawing and making things as well as taking apart mechanical and electrical devices such as typewriters and cameras. I became curious about ideas, structures and problems being solved, and enjoyed my grandfather's books about great buildings and engineering, as well as the clever and comic inventions of Heath Robinson. After leaving school, I began a two-year diploma in general art and design, followed by an undergraduate degree in three-dimensional design at Manchester Polytechnic and then a two-year master's degree at the Royal College of Art in London. In these seven years, my training allowed me to move

freely between materials and processes that included working with plastics, glassblowing, welding, jewellery-making, ceramics, embroidery and timber joinery. Exploring different scales of problem-solving I was able to pursue my on-going interest in the design of buildings and the built environment.

At this time I became interested in the historical figure of the master builder, who had combined the roles and skills of the builder, craftsman, engineer and designer, which meant that the generation of ideas was connected to the process of turning them into reality. However, with the establishment of the Institute of Civil Engineers in 1818 and the Royal Institute of British Architects in 1834, engineering and architecture seemed to have evolved into elite professions with separate identities from the rest of the building trade. Meanwhile, the craftsman became the employee of a new figure called the general contractor, whose interests were predominantly financial. Now, not only was the designer of a building discouraged from having a creative connection to materials and practical making, but the craftsman lost his prestige, beginning the slow decline in skills and expertise within the building industry.

My experience of making my own design ideas convinced me that understanding materials, and gaining practical experience of using them, was essential to developing ideas and finding ways of making them happen. In the research for my degree course thesis, I interviewed architects, self-builders and contractors about their education and ways of working. At that time, young architects were given no practical experience of making, such as casting a form in concrete, making a timber joint or constructing a brick wall. Given that buildings are some of the largest objects made and experienced by humans, it was surprising to find that the designers of these objects were so far removed from the craftsmanship of making them. I felt that this helped

Using an ash tree that I had cut down to make furniture pieces, Manchester, 1990

Constructing hay stacks

Practical making skills

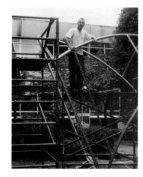

Constructing the Pavilion, Manchester, 1992

Making bread

Forging steel

Making the world's largest telescopic mirror

Motorway construction

to explain why much of the new architecture I saw around me felt sterile and lacking in three-dimensional sophistication.

Having used my thesis to explore this subject, it felt logical to me at that time to use the final year of my degree at Manchester Polytechnic to experiment with a different model of building procurement. I found myself designing and making a full-size building, the Pavilion (pages 32–37), something that had not been done at the college before.

Studying at the Royal College of Art gave me space to think about the way in which I might practise as a designer when I left the education system. Instead of rigidly dividing artistic thinking into separate crafts and professions such as sculpture, architecture, fashion, embroidery, metalwork and landscape, product and furniture design, I wanted to consider all design in three dimensions, not as multi-disciplinary design, but as a single discipline: three-dimensional design. Also, because each separate creative discipline seemed to be associated with a particular scale, there was an opportunity to take the aesthetic sensibilities of smaller scales of making, such as jewellery or bread-baking, and introduce these into the large-scale world of building design.

In 1994, I set up a studio in order to continue researching and experimenting with ideas and ways of making them happen. Since I had learned that I worked best in dialogue with others and wanted to do projects of a scale that a person could not do on their own, the studio was from the outset a collaborative venture. Since that time, it has been a mixture of people with backgrounds in engineering, architecture, product design, landscape architecture, project management, sculpture, photography, theatre design, craft and making. Today, Heatherwick Studio is based in London and works as a collection of overlapping teams, each formed around a project and led by an experienced studio member.

The studio's design process has always depended on its workshop, which allows it to test and realize ideas through the making of experimental pieces, prototypes, models and full-size parts of buildings. In order to make a project happen, we have sometimes needed to construct all or part of it ourselves, beginning with the Pavilion (pages 32–37) and continuing with projects such as Autumn Intrusion (pages 98–109), Bleigiessen (pages 250–259) and the Aberystwyth Artists' Studios (pages 354–365).

When developing ideas for a project, we work as closely as possible with the project's commissioner and our team of collaborators. It is unusual for me to come into the studio in the morning with a drawing of an idea and hand it to my colleagues. Instead, we iteratively pare a project back in successive rounds of discussions, through analysis, questioning, testing, experimentation and interrogation, looking for the logic that will lead to an idea. If a potential commissioner asks for 'just a sketch', we have to try to explain that this is not the way we work. Since the budget for every project is limited, the focus of our creative thinking is often on how to make best use of limited resources. With the UK Pavilion (pages 442–459), our project was allocated half the budget given to many other Western nations and our design solution was led by our decision to concentrate these resources on a small proportion of the space, rather than spreading it thinly across the entire site.

In recent years, the studio has become involved in the strategic thinking that is shaping the future of cities and towns. It seems that the people who write the briefs for new buildings and infrastructure have more power to make places unique and special than designers. The greatest need for innovation seems to be in finding new ways to apply artistic thinking to the problems of a city, rather than automatically emulating Bilbao, where an extraordinary art gallery transformed the fortunes of

Studio, Camden Town, 1999

Constructing Bleigiessen, London, 2001

Constructing Artists' Studios, Aberystwyth, 2008

Studio, King's Cross, 2008

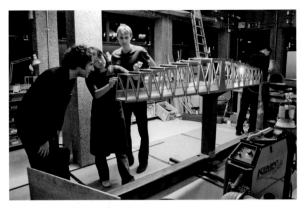

Studio workshop, King's Cross, 2009

Studio workshop, King's Cross, 2011

Studio, King's Cross, 2012

a city. For example, in designing a new bio-mass power station in Middlesbrough (pages 520–525), there was an opportunity for the area to develop a new identity by investing in necessary renewable energy infrastructure, which would at the same time be a park, cultural facility and educational resource. We are also increasingly working with communities and organizations that, having had little access to funding, are occupying buildings and spaces that fail to meet their present needs, making it progressively harder for them to grow, change or sustain their existence. And, as well as building new environments, we are being asked to explore the re-use of existing structures, giving new relevance to outdated environments, rather than demolishing them and building again. Even when thinking on the broadest, most strategic level, the preoccupation is with how to use materials and forms at a human scale, the scale at which people touch, experience and live in the world.

Making this book has been a bit like working on one of our projects, except that our projects are normally about three-dimensional form. This time, the task has been to find ways of crushing our own projects down into flat two-dimensional images and text, like putting flowers in a flower press, in order to squeeze them into a book. I hope that, as you turn the pages, these projects pop back up and come to life again as ideas in three dimensions.

Acknowledgments

FROM ITS BEGINNING, the studio has been a group endeavour with team members contributing phenomenal amounts of effort. The difficulty we faced was that there was no business model or precedent for the type of environment we needed to make. It was not a conventional architecture or product design practice or sculpture studio and I had not worked for somebody else before setting it up, so we improvised as we went along. There was great enthusiasm, conviction and determination but it was a demanding environment that required people to work out for themselves what needed doing and to then do it to a level of excellence that outweighed all our experience. Team members willingly gave their time before the studio was able to offer much more in return than an adventure and their contribution remains deeply appreciated.

Particular credit is due to Jonathan Thomas, who as a fellow student made it possible for me to build my first building and went on to help me set up the studio; Nader Mokhtari, who oversaw an important stage of the studio's growth; and Kieran Gaffney and Tom Chapman-Andrews, who took leading roles in its early development. Over time, the studio has been lucky enough to grow into an incredibly talented group of people who are both highly imaginative and very practical, but we are now part of a more evolved organization that is better able to support us all. The longest-serving team member is the designer Stuart Wood, who is a brilliant creative collaborator.

The studio has also been supported by the involvement of its associates, who as friends and mentors contribute expertise, experience and enthusiasm. The engineer Ron Packman has a unique place in the studio's narrative as a true collaborator in the endeavour of having ideas and the adventure of putting some of them into practice. More recently, the studio has also formed an association with the architect Fred Manson, who was instrumental in realizing London's Millennium Bridge, Tate Modern and Peckham Library projects and who spends a huge amount of time with us, provoking, questioning and encouraging. An on-going keeper of the studio's spirit is my partner Maisie Rowe, who helps to translate ideas into words on paper and transform a group of people into an organization.

Another important supporter has been Terence Conran, whom I met at the Royal College of Art. Our friendship began when he let me live in his house

in the country and build the Gazebo (pages 58–63) for my degree show and since then he has been both mentor and patron.

For their collaboration, support and friendship, the studio and I would also like to thank Colin Amery, George Amponsah, Ron Arad, Zeev Aram, Ken Arnold, Rachael Barraclough, Mem Baybars, Danny Boyle, Patricia Brown, Scott Buchanan, Andrew Cahn, Wilfred and Jeannette Cass, Jean and Philippe Cassegrain, Daniel Charny, Edmund Cheung, Victor Chu, Louise-Anne Comeau, Sebastian Conran, Vicky Conran, Andrew Crawford, Jolyon Culbertson, Ted Cullinan, Claire Cumberlidge, Alan Davidson, Lucas Dietrich, Tom Dixon, Clive Dutton, Ben Evans, Gerard Evenden, Marcus Fairs, Nabil and Eliane Fattal, Mark Fisher, Ruth Gee, Leigh Gibson, Cynthia Grant, Antony Gormley, Taher Gozel, Martin Green, Haunch of Venison, Peter Hendy, Alan Hewson, Steve Hilton, Brooke Hodge, Bingyi Huang, Father Christopher Jamison, Derek Johnson, Alan Jones, Mark Jones, Corinne Julius, Hanif Kara, Keith Kerr, Pearl Lam, Patrick Lee, Amanda Levete, James Lingwood, Stuart Lipton, Alan Lo, Kai-Yin Lo, Victor Lo, Christine Losecaat, Toby Maclean, Roger Madelin, Steven Mahoney, Pritpal Mann, Leila McAlister, John and Bob McClenaghan, John McDonald, James McElhinney, Munira Mirza, Jimmy Mistry, Paul Morrell, Michael Morris, Daniel Moylan, Peter Murray, Ravi Naidoo, David Nelson, Kenneth Ng, James Nutt, Kaoru Okamura, Malin Palm, Gavin Pond, Jane Priestman, Jason Prior, Jane Quinn, Alice Rawsthorn, Malcolm Reading, Vicky Richardson, Tony Rizzo, Peter Rogers, Najib Salha, Edwina Sassoon, Patrik Schumacher, Martha Schwartz, Joanna Scott, David Shapiro, John and Frances Sorrell, Steve Speller, Jeremy Strick, Sean Sutcliffe, Minesh Talati, Diane Tammes, Albert Taylor, Theo Theodorou, Abraham Thomas, Bill Tustin, Austin Williams, Michael Wolff, Jane Wood, Alan Yentob and Dai Zhikang.

This book is dedicated to the imaginative vision of clients, commissioners and authorities who demand that projects are special.

Projects

Throne

*Can the suspension system of
an old-fashioned pram lead to
the design of a chair?*

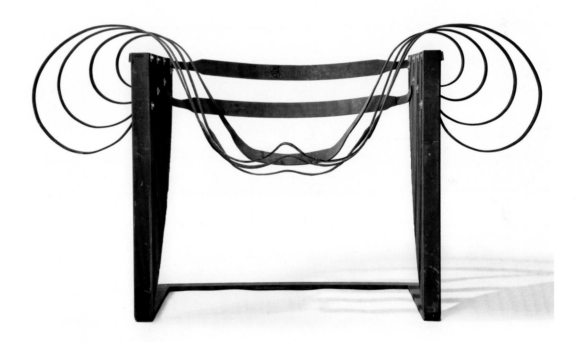

Chain Experiments

*What different forms can link together
and articulate to form a chain?*

SPOTTING ROLLS OF COPPER, aluminium and brass wire in the materials store at college, I began taking long pieces home at weekends and sitting for hours with pliers bending and cutting them, to experiment with repetition, geometry and interlinking elements. While some of the things I made came from looking for different ways to articulate the movement between two interconnected elements, with others I was just exploring the forms that wire would allow itself to be turned into.

Two of the tests were based on interlinked spirals. One was made with a two-dimensional element which, unlike a conventional chain, created more than one point of contact between each link. Another worked in a similar way but consisted of three-dimensional spirals with rounded forms that swivelled through each other.

Slipcast Tile

How much three-dimensionality can you give to a repeating ceramic tile?

Test Pieces

Where can ideas come from?

WHILE I WAS STUDYING, I developed a particular way of thinking through making. Instead of always starting with a drawing or a discussion, I used the making of test pieces in the workshop to find ideas. Adopting a spirit of purposeful aimlessness, I was trying to avoid needing an outcome. Although giving myself permission to experiment, I remained open and receptive to the possibilities that the materials in my hands were offering, ready to convert them into something useful.

For me, most of these experiments were mini-mission statements for architectural projects. Making them, I was wondering how each one might translate to the scale of a building or piece of furniture, or thinking about how a twist or joint or texture could become an element such as a roofing membrane or cladding system. I also found that working on this restricted scale to develop ideas for buildings forced me to maintain the clarity and simplicity of an idea.

What is shown in the following pages is a selection of these test pieces. One was an experiment with wood-turning on as large a scale as possible. Having got a green tree trunk from staff of the local council woodyard, I managed to fit this into the college lathe and, at great danger to myself and onlookers, found that I was able to carve into the huge piece of spinning wood and produce an enormous turned wooden object, which was also interesting when it was cut in half.

On a placement with the college's embroidery course, I experimented with the possibilities of creating three-dimensional form using fabrics, holding a piece of calico and wondering what kind of forms I would get if I repeatedly twisted it in different places. Another fabric experiment was to iron heavily starched calico into multiple pleats using an industrial iron. This made the fabric behave like structural origami and transformed it into a twisted geometrical form.

Sometimes I made test pieces to explore specific design ideas. Imagining forms for the roofs of buildings, I investigated tensile surfaces by dipping wire into a liquid plastic that hardened into three-dimensionally curving surfaces. In another test, I was wondering if there was a way to make a seat that could be a bed and explored the idea of surrounding a rolled-up single mattress with a frame that makes a back and arms, as well as acting as a clip to keep the mattress rolled up. Another time, I was looking at how the part of a chair you sit on could also be what the chair stands on.

Working with cardboard, I developed a folding mechanism that allowed the card to hinge so that the cuts in it moved past each other in an interesting way. The spiralling rope form came from combining rope, a flexible material, with a more rigid element, wire. I also used copper wire to explore the potential for making structural forms.

Experimenting with making loops in identical-length strips of oak wood veneer using an office stapler to secure the loops, I found that fitting the pieces together produced a form that opened out and leaned forward as the relative proportions of the loops changed. Again working with thin wood, I manipulated a single sheet of quite bendy plywood into a free-standing screen. And finally, as part of the geometrical carving experiments that developed into the Twisted Cabinet (pages 54–55), I produced two pieces using the offcuts that had been removed from the main element, before it developed its twisted curving surfaces.

Cabinet

*When a tutor sets a project to design
a piece of furniture using a single
sheet of MDF, what can you make?*

Vessels

*Can friction alone hold the
pieces of an object together?*

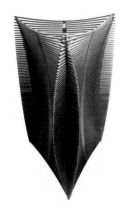

THE DESIGN FOR THIS OBJECT came from experimenting with a bandsaw to make lots of cuts in a piece of wood, in close proximity to each other, without cutting through the wood completely. I found myself transforming the wood into something with two textures, the comb-like quality of the cut area contrasting with the smooth section in between.

Once I had made three identical wooden pieces, I gradually slid them into each other and found that, as the cuts interleaved, they formed a subtle and beautiful corner detail. With so much surface area between the touching pieces, the elements gripped each other with enough friction to make it possible to gently bend their surfaces and hold them in a form that resembled a vessel. Later, I made a metal version using laser cutting, which at that time was a relatively new industrial technique.

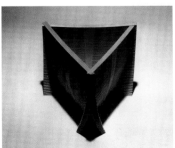

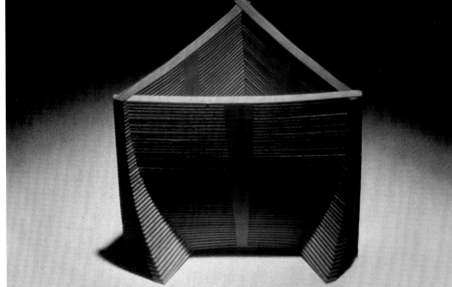

Clay Study for a Water Sculpture

With an idea in your head and a material that lets you make any shape you want, how much three-dimensional complexity can you give a form if you work at it for several weeks?

Clay Test Pieces

*With no predefined idea and
a material that lets you make
any shape you want, how much
three-dimensional complexity can
you give a form in a few seconds?*

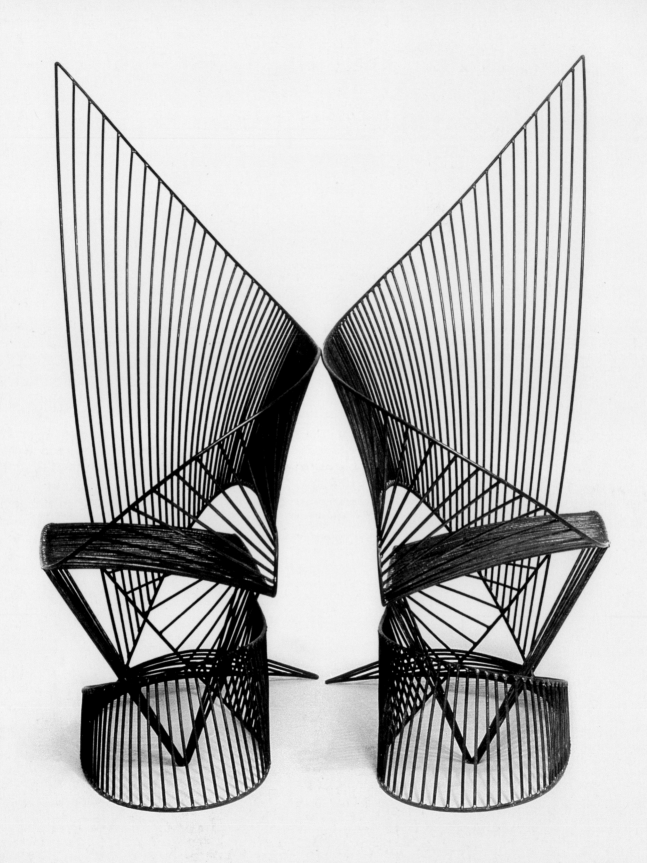

Pair of Seats

Symmetry or asymmetry?

WONDERING IF IT WAS POSSIBLE to form a seat and a back from a single ribbon-like strip, I had used Sellotape and copper wire to make a tiny model of a chair that had an enjoyable dynamic asymmetry. I then became interested to find that the addition of a second chair, a mirror image of the first, seemed to act as a stabilizing force to convert the unbalanced form of the single chair into a pleasingly symmetrical composition with an obvious aesthetic harmony.

Rather than using measurements or drawings to fabricate the two chairs, I worked by eye, cold-bending the steel bar using jigs and bending dogs. Each time I welded a piece to one chair, I would do the same to the other. Working with the lengths of metal, I found that trying to make them twist or spiral too quickly produced a confused and mangled mess, and that the only way to make a satisfying sinuous form was to allow the metal bars to curve in only one plane at a time.

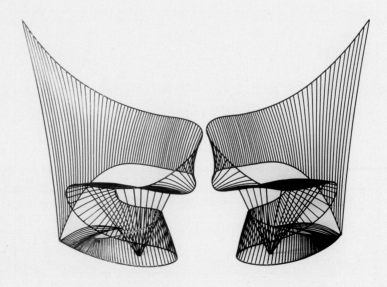

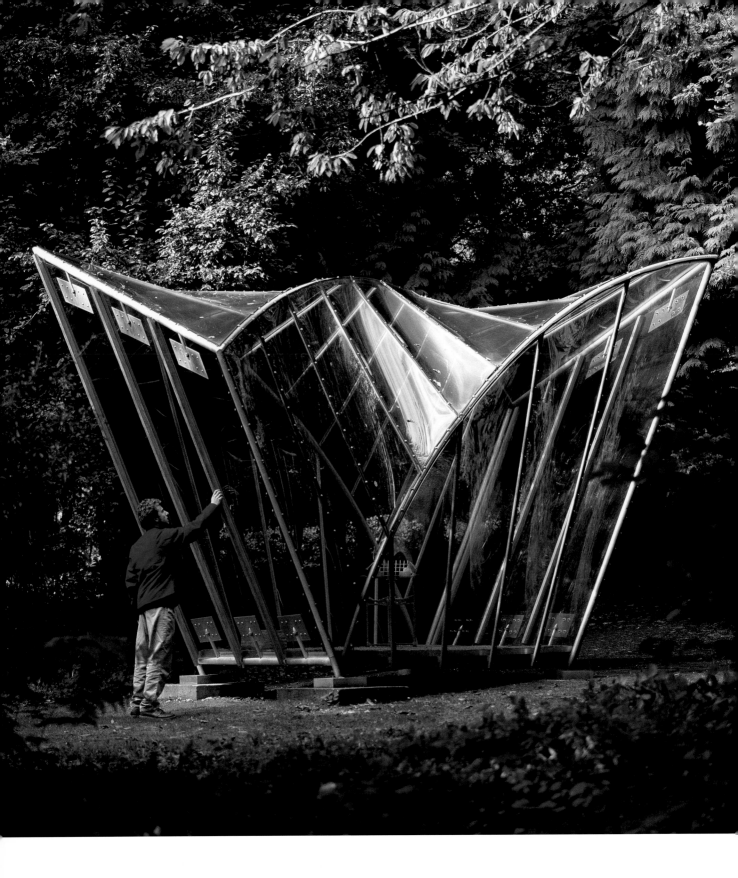

Pavilion

1992

*How can a student make
a real building?*

AT THE TIME WHEN I WAS STUDYING at Manchester Polytechnic, the world of designed products and furniture had recently come alive with new ideas. Many young students aspired to design chairs and lights like the famous practitioners whose work they saw in magazines and exhibitions. Although interesting things were happening in the context of small objects, I felt that this kind of energy and originality was not being applied in the design of new buildings.

Because I was interested in design at every scale, from the smallest objects to the largest, I had chosen to study design instead of architecture, but continued to have a particular focus on buildings. I wanted to know if the kinds of ideas, techniques, materials and craftsmanship that were usually applied on smaller scales could be made

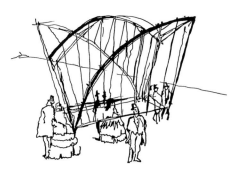

to work on a much larger scale. Since it was part of my degree course to research and write a dissertation, I took the opportunity to look at the apparent disconnection between the practice of architecture at that time and the practical craft of making. This led directly to my decision to use the final year of my course to try to design and make a full-sized piece of architecture.

I was interested by a category of building that seemed to have been overlooked. In Victorian times, there had been a craze for constructing fascinating, tiny buildings – pavilions, follies and gazebos – within the grounds of country estates. This scale of building appealed to me because it did not fit neatly into the conventional categorizations of architecture, sculpture or design. In the absence of a client, I took on the challenge of building at this scale by myself.

At that time, in the 1980s, there was a strong reaction in Britain against the postwar architecture of concrete city blocks, which resulted in demands for new architecture to be 'in keeping' with the country's heritage of buildings from the past. The pressure to make new buildings look similar to the older buildings that sat next to them seemed to be having a paralysing effect on design in the present. But I wondered if I could side-step this need to conform to an existing context by making my building both transportable and temporary.

As there were only nine months left of my course, I needed an idea for a building that could be designed, engineered and built in this time. The problem

with being my own client and having no site was that, as long as it was achievable, the concept could be anything. I explored many ideas but it was hard to find a reason to choose any one of them. The idea that stood out was a version of something ordinary, a derelict farm shed that I had once seen in Northumberland, in the north of England. My eyes had been trying to make sense of its pitched roof, which had subtly distorted because the ground it stood on had subsided.

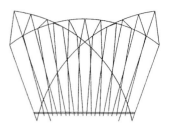

My final idea was an extrapolation of this: a normal building with a pitched roof that has been twisted down so much at its opposite corners that the roof starts to become the walls. At each end, there is a set of three 4-metre-high doors, which rotate to open, while leaning both sideways and outwards. I chose to make the walls, windows and roof using a restricted palette of materials, consisting of timber, aluminium and clear polycarbonate. I was excited about exploring the idea of producing twisted glazing, something I had never seen done.

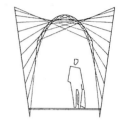

A young structural engineer, Aran Chadwick, who taught on the architecture course, took an interest in what I was trying to do. Computer-aided design was in the early stages of development and he had specialized software at his home, where we worked together in the evenings and every weekend, to model the building and make the detailed calculations that were needed.

As there was no ready-made architectural product available for constructing twisted glazing, I had to invent a new system for twisting, holding and waterproofing the structure's polycarbonate window panels. It took a combination of screw fixings, rubber sealing strips and 2 kilometres of Velcro to hold in place the twisted panels, with the enormous tension in them.

Having no money to buy materials, I was helped by a tutor who had recently set up a sponsorship department, and who worked with me to get thirteen sponsors to donate materials worth many thousands of pounds.

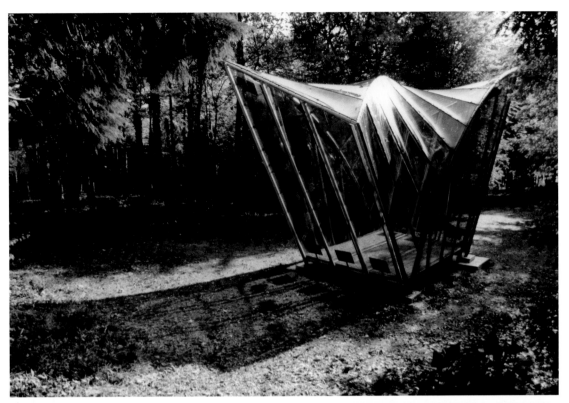

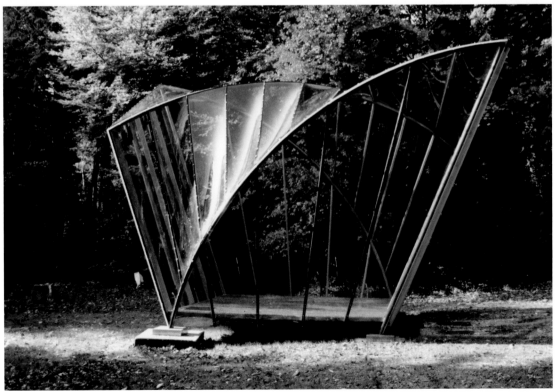

Building the pavilion was a collective effort. For three months, the course technician, a skilled machine engineer, worked alongside me machining the metalwork for the project. A student from the year below, Jonathan Thomas, also worked with me on the project for half the year, excited by the prospect of making a full-sized building. He was also good at motivating other students to help us. The only place we could construct the pavilion was outdoors in a courtyard in the college, where we had to work in full sight of everyone in the cafeteria, with the rain of Manchester pouring down on us. In the end, even the caretakers helped.

The pavilion was never meant to be a permanent structure. The aim of the project was simply to make any building at all; if it lasted a year, I was happy. After the degree show in Manchester, we took the pavilion to London and rebuilt it outside the Business Design Centre in Islington. It was on show for two weeks and was later bought by the Cass Sculpture Foundation in Sussex, where it is still on permanent display.

I later explored the possibility of translating the Pavilion's twisted roof form into a modular building system that used a series of left- and right-handed versions of the Pavilion, with vertical sides, pushed together in different configurations to create covered spaces with three-dimensional tessellating roofs.

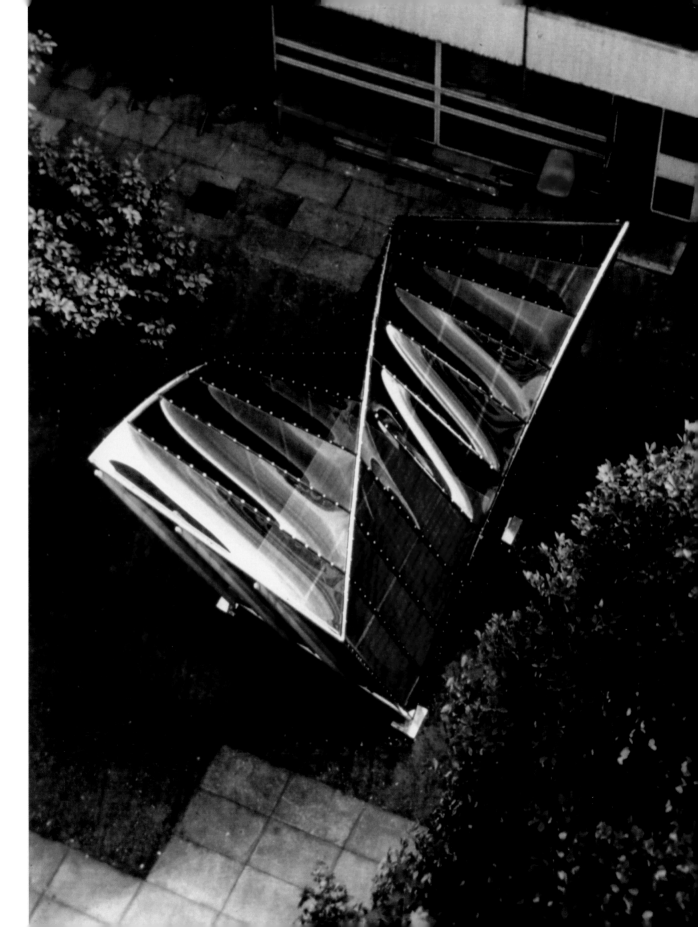

Transformable Seat

*Can a chair also be a stool
and a bench?*

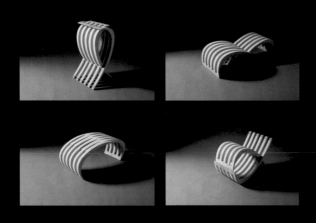

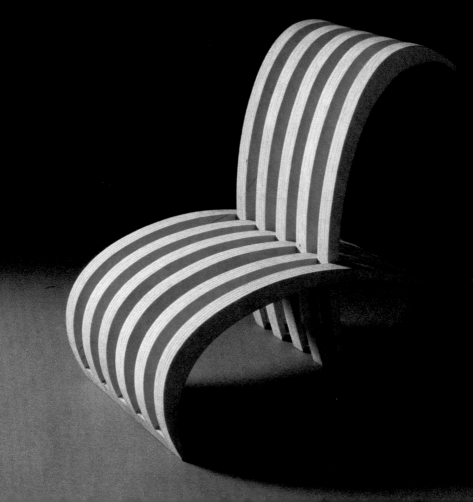

Sculpture Park Gates

1992

*Can an automated gate open and
shut in a more interesting way?*

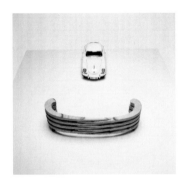

ASKED TO DESIGN AUTOMATED GATES for an outdoor sculpture gallery, I became interested in the choreography of their opening movement. Instead of a single surface that breaks into two flat halves along a vertical line, I looked for a different way in which the two sides of a gate could relate to each other.

The proposal was for a gate operated by a standard mechanized opening system, consisting of timber elements that interleaved with each other as they pivoted on their hinges, like interlocking fingers. Open, the gates look emphatically welcoming; closed, they splice securely together.

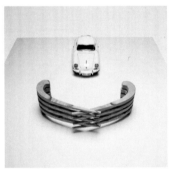

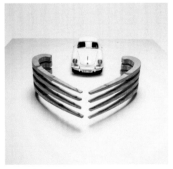

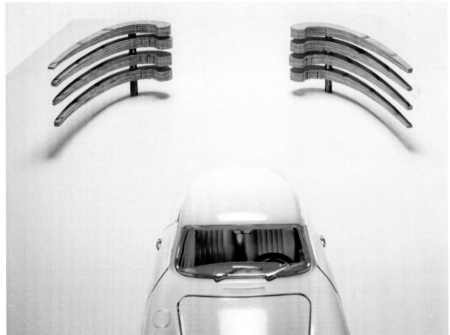

Upholstered Furniture

Can furniture upholstery have the qualities of an animal's skin?

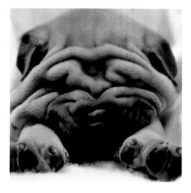

WHEN I WAS A STUDENT IN THE EARLY 1990S, I became interested in the use of upholstery in furniture. In existing upholstered furniture pieces, the familiar formula seemed to be that designers thought of shapes and then other people made soft versions of them. Since a craftsman could make almost any form you drew by carving it in foam and then cutting and sewing fabric as necessary to fit over it, there was little meaningful relationship between a design and its fabrication.

It appeared to me that it might be possible to allow an upholstered shape to emerge through the process of experimenting with upholstery materials instead of drawing it in advance. Rather than imposing my will on the materials, could the materials impose their will on the design?

The Chinese Shar-pei is a breed of dog that has so much more skin than it needs, relative to the quantity of muscle and bone that it has, that its coat forms velvety creases, furrows and wrinkles like living upholstery. Thinking of this, we developed the idea of constructing furniture by manipulating a flat, foldable skin of laminated fabric and upholstery materials.

With a fellow student, I created small maquettes of the concept, going on later to make full-sized test pieces in the studio, using large, laminated sheets of fabrics and foams. Through this experimentation, we found that, as it rippled and rucked up, the manipulated material produced incidental forms similar to those found in nature, which at that time seemed to be a fresh visual language for upholstery.

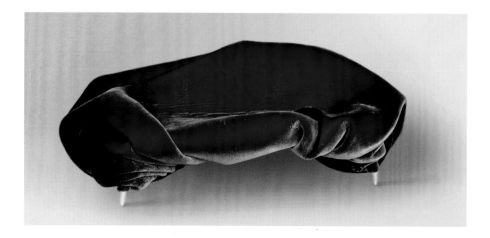

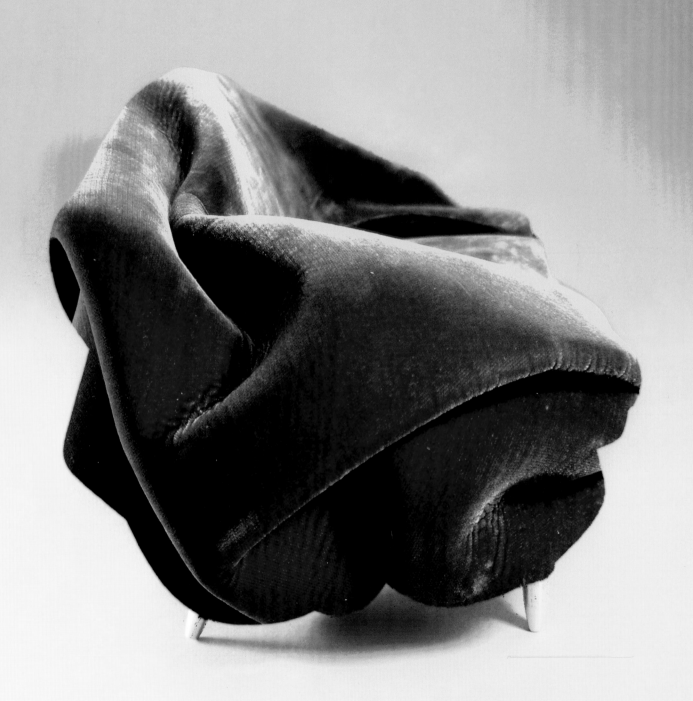

Three-Dimensional Picture Frame

Can you display favourite objects without needing a large, expensive piece of furniture?

AS STUDENTS, WE WERE GIVEN a brief to design a display cabinet. Feeling that people's sensibilities had changed and that the format of the display cabinet was old-fashioned and more suited to showing family silver, I looked for a different way to show three-dimensional objects. Having always admired the simple and economical snap-together picture frames known as clip-frames, I wondered if I could adapt one of these to display three-dimensional objects.

The idea was for a mutant clip-frame in which the transparent front protrudes forward to become a box, forming a protected space in which images and objects can be displayed together. Being both smaller and much cheaper than a grand display cabinet, it seemed that this new product could be used to display everything from memorabilia, heirlooms and souvenirs to promotional material.

Working with a plastics company, I manufactured some prototypes and then collaborated with a group of business students from Imperial College London to assess the frame's marketability. Having concluded that the product did indeed have commercial potential, I had the frames made up in three sizes, packaged the product as '3D Frame' and put it on sale in an art shop on the Charing Cross Road, alongside its brothers and sisters in the clip-frame department.

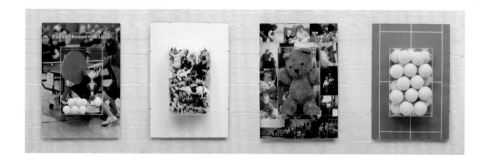

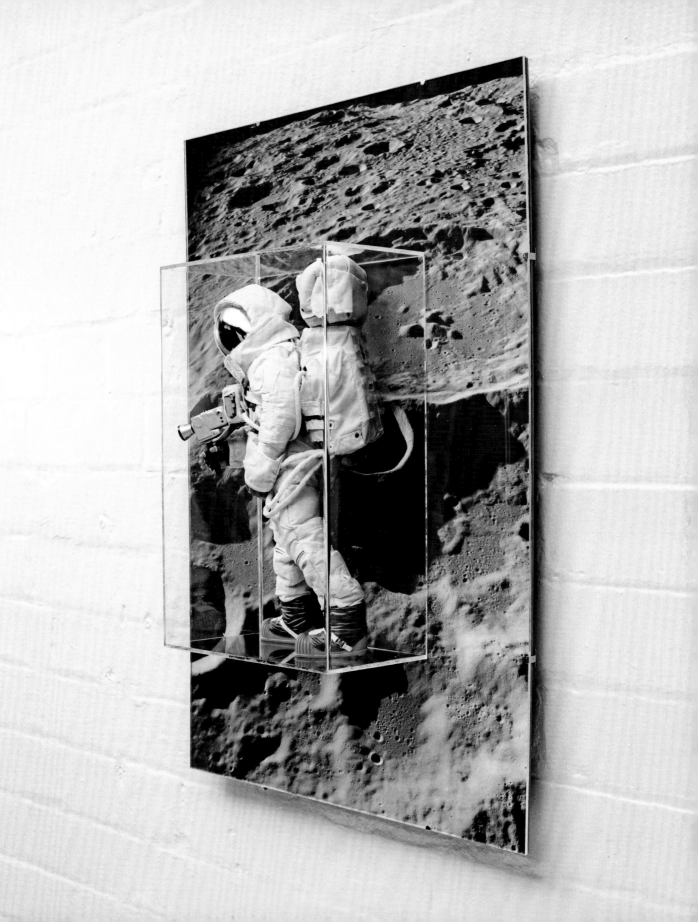

City Gateway

*Can a monument be made
from the ground?*

CONCERNED THAT THE ASSOCIATION with ugly 1960s social housing blocks had given concrete a bad image, the British Cement Association held a competition, asking students to propose new ways of using concrete. Picking a notional site, I imagined a major road that needed both a pedestrian route underneath it and a landmark to signify that this highway was the gateway into an area.

The proposal was to manipulate the land on either side of the road by first cutting into the ground, in order to excavate the ramp that leads down to the foot tunnel, and then lifting the pieces of ground and peeling them back to create a pair of arching forms, rising 80 metres into the air on either side of the road. As the elements curl back, they reveal their undersides to be raw and highly textured, a surface we had never seen before in cast concrete.

The project was a first attempt to explore both how large structures might be integrated into a landscape, rather than stuck on top of it, and the architectural use of giant texture.

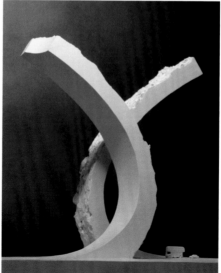

Pocket Knife

*Can something dangerous
also be a piece of jewellery?*

WHEN I WAS AT THE ROYAL COLLEGE OF ART, a whisky manufacturer asked us to design a gift that could be given out with their bottles.

Remembering a small collection of pocket knives owned by my grandfather, I decided to try to design a new one that did not damage the fingernails as it was being opened and that revealed more of the dangerous bit of a folding knife, without it being dangerous.

The final idea was to mutate a conventional pocket knife, making it easier to open but still protecting you from the sharp part when closed by making the body of the penknife dance around its blade.

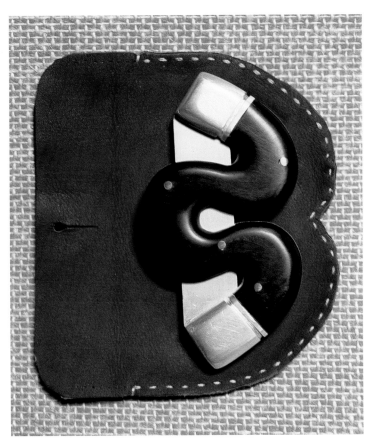

Interlocking Book

Can you do joinery with books?

WHILE CUTTING AND SHAPING pieces of wood for other projects, I was interested in the idea that single sheets of paper are thin and delicate whereas hundreds of sheets put together and bound into books turn into dense blocks. Was it possible to treat these solid lumps of paper in the same way as planks of wood?

Using woodworking tools, I found that I could make a simple joint and connect two books by cutting channels in both books and slotting them together. Joined together, they lock into each other to form a self-supporting structural composition. When they are pulled apart, the small missing section on each page gives the text an unusual composition. This idea is a good way of expressing the connection between two books with related subject matter, such as two-way language dictionaries or a novel in two parts.

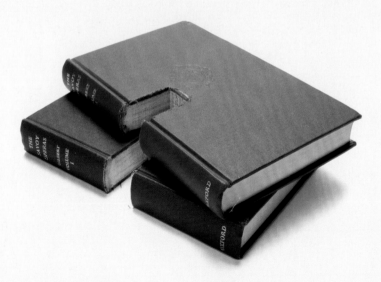

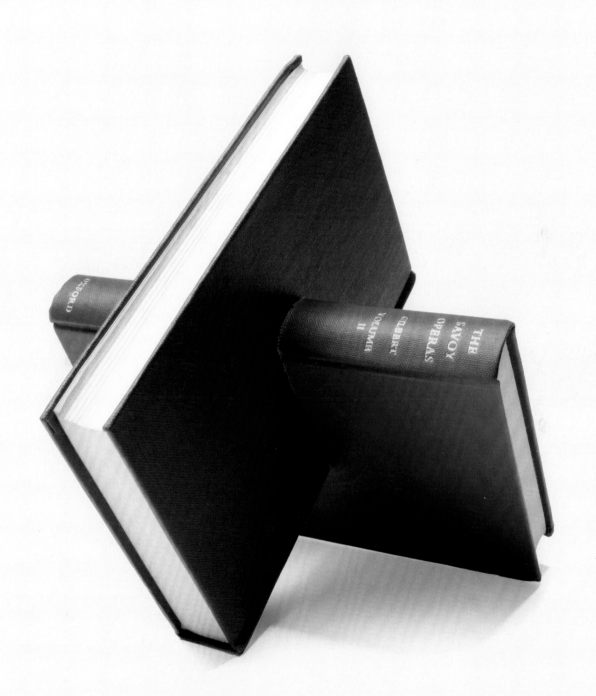

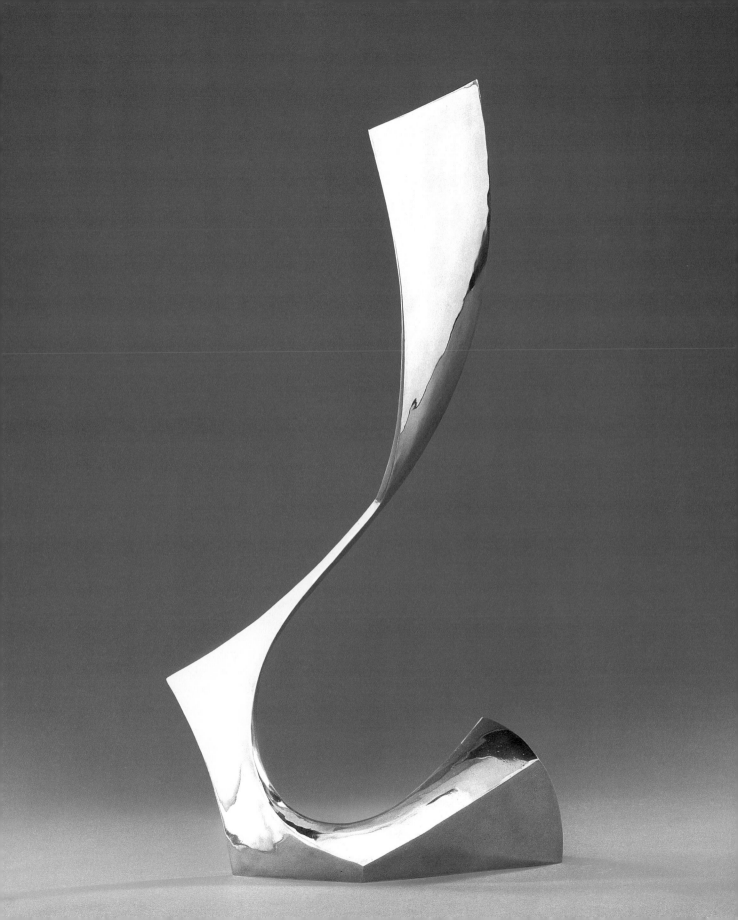

Arts & Business Award

How can you increase the impact of thirteen small objects?

WHEN I WAS A STUDENT, I won a competition to design thirteen awards, which would be presented at the National Theatre in London to businesses that had sponsored the arts in an innovative way. Small awards would make little visual impact in an auditorium of this size, whereas a single large object would stand out better. And if this single object were able to break down into thirteen individual awards, the winners would feel they were part of something beyond their individual achievement.

The idea was to make a grand chalice of polished metal, 1 metre across, formed from thirteen identical abstract objects, which interlocked like an Islamic pattern based on repeated tessellating geometry. During the ceremony, the cup would gradually be dismantled as the thirteen award-winners each received a segment. I liked the idea that the chalice would exist again only if the winners got together for a reunion.

One of the awards was given to Diana, Princess of Wales. It had been announced that morning that this would be her last official public appearance because, the week before, a photographer had got into her gym and taken an intrusive and embarrassing picture of her lifting weights, which had been published around the world. I said, 'Princess Diana, I am supposed to present you with this award, but it's a bit heavy.' Despite the strain she was under, she laughed and said 'Don't worry – I do weights!'

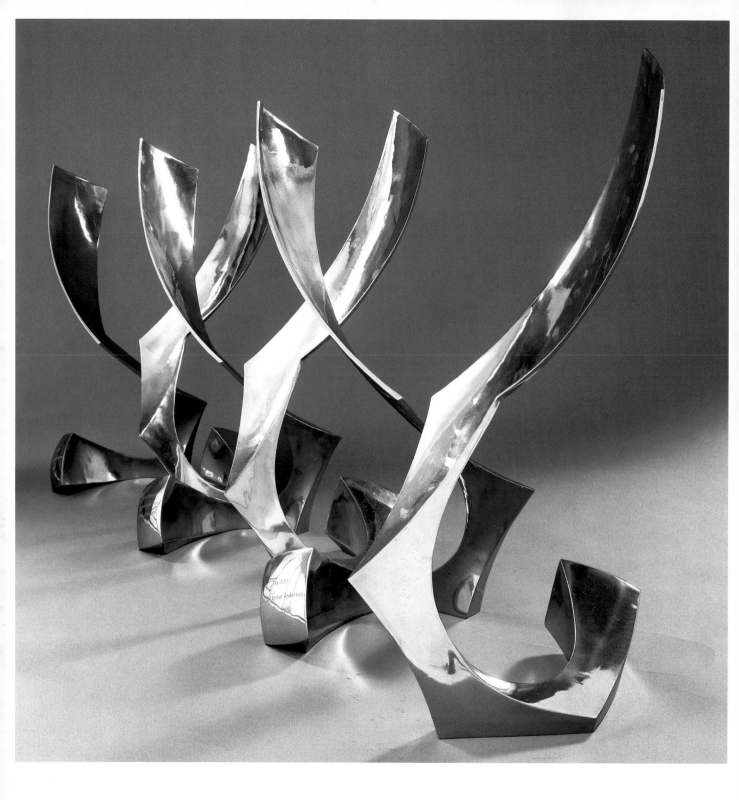

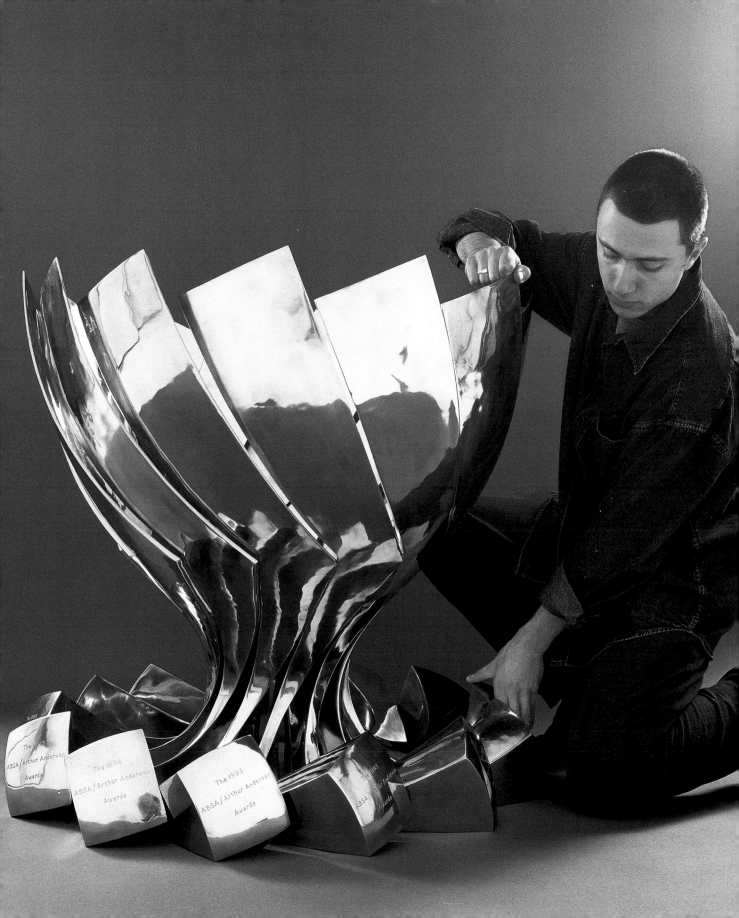

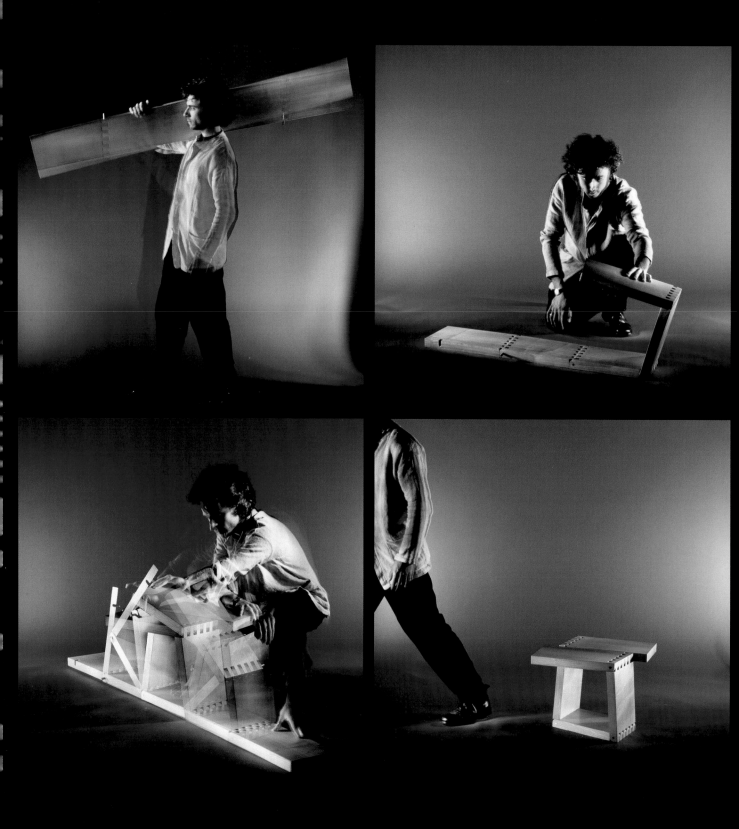

Plank

*Can a plank of wood also be
a piece of furniture?*

WHEN I WAS A STUDENT at the Royal College of Art, we were asked to design and make a coffee table, using the leftover pieces of wood in the materials store. Even though I don't drink coffee I began thinking about taking a single plank from the storeroom and seeing if it was possible to make it into a whole piece of furniture.

Experimenting with folding long pieces of paper that had the proportion of a plank, I found that if I folded the paper several times, at a slight angle to the direction of the plank rather than straight across it, the strip would make a spiral. Instead of colliding, the two ends would go past each other, making a form with a curious rotational symmetry.

The outcome of this process was an ordinary plank with a secret. It can lean against a wall or lie flat in a pile of other planks, like a piece of wood at a timber merchant. At any moment it can be folded up to make a side table or a seat and then fold out again, returning to its raw state as a plank.

The complexity was in how to make the plank hinge. It had to fold, be strong as a piece of furniture and have joints that were almost invisible when the plank was folded out flat. It took many experiments and a surprising degree of precision craftsmanship to solve this. Having made two of these myself, I was later approached by a specialist manufacturer with a proposal to produce it in limited quantities.

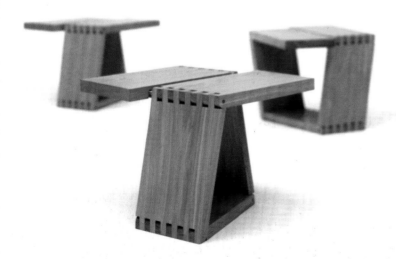

Twisted Cabinet

How can a test piece lead to the design of a piece of furniture?

THE PROJECT BEGAN AS AN EXPLORATION of geometrical form. As a student, I was experimenting with a machine tool called a bobbin sander, which consists of a spinning abrasive cylinder, mounted vertically on a work table. I liked this machine because it did not allow you to shape things into flat planes, but forced you to carve different kinds of surfaces.

While the objects I was carving originated from a rigorous geometry of straight lines, they produced forms with twisting surfaces. I made versions that twisted in opposite directions and put them next to each other and found that, if the pieces were hinged along their straight edges, they could combine to make a screen – but that if I combined four of these elements, I could make a cabinet with schizophrenic doors. When they are opened halfway, the bottoms of the doors look as if they are nearly open, while the tops still look almost closed.

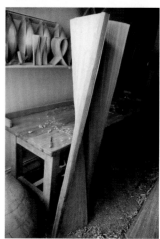

After setting up the studio, my first project was to handmake a large version of the cabinet from heavy pieces of oak, for an exhibition. To have it ready in time, I was obliged to carve for sixteen hours a day, seven days a week, for four months. The finished cabinet was the height of a person and needed four people to lift it. It was strapped to the roof rack of my car (ready to travel to the exhibition), when I found a man in a suit, standing in the street, examining it. He turned out to be the local undertaker and he insisted that I had a successful career ahead of me as a coffin-maker.

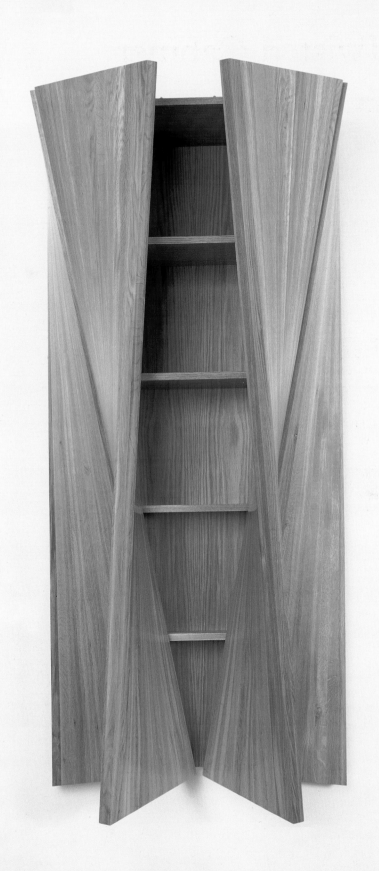

Bench

*How can a seat encourage
better posture?*

WHILE TAKING LESSONS in the Alexander Technique, a discipline based on understanding habits of body movement and posture, I became increasingly aware of the way that when people sit in chairs, they tend to slump against the backrest. I started to think about whether it would be possible to design a comfortable outdoor seat without a backrest.

The idea is a tapered slab that comes out of the ground with its top edge folded to form a seat. It allows you to sit with your back straight and relaxed, because the seat is set higher than a normal chair. Also, its surface slopes forwards rather than backwards and its curved shape supports the base of your spine. The forward tilt not only makes the seat easier to get up from but also sheds rainwater, so puddles do not form on it.

To make the bench, I worked with craftsmen who were skilled in the traditional craft of making terrazzo, the concrete material that consists of marble chips set in cement and polished. I carved the pattern for the seat out of wood and car body filler, and this was used to make moulds to cast the final concrete pieces.

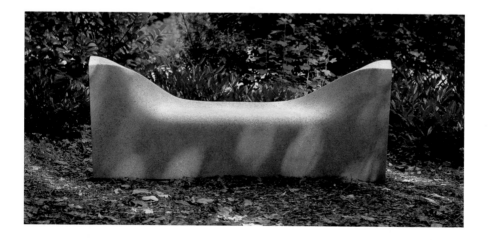

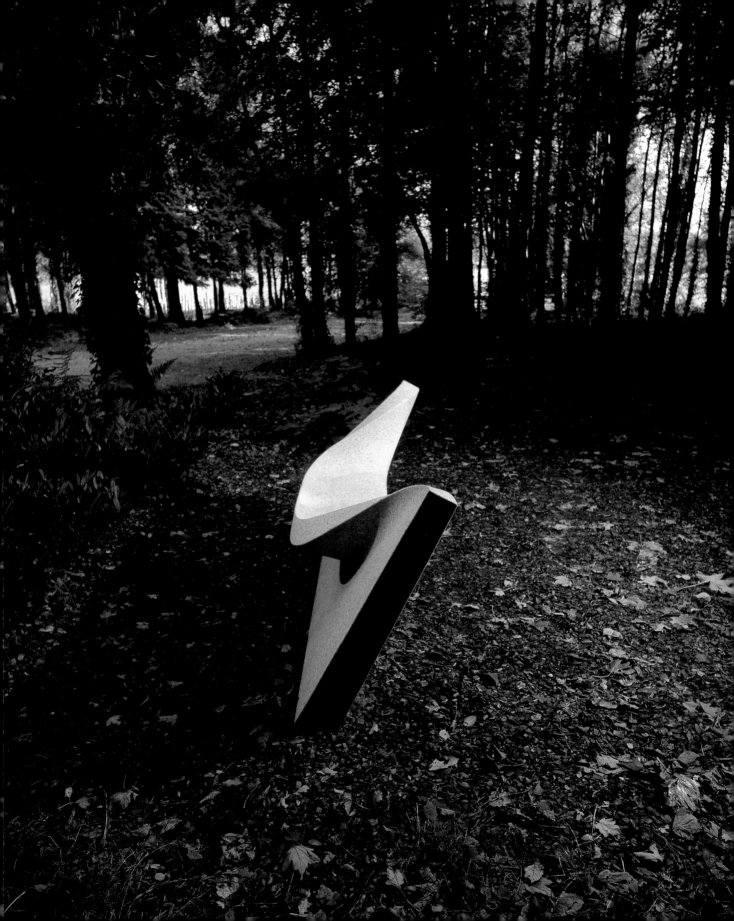

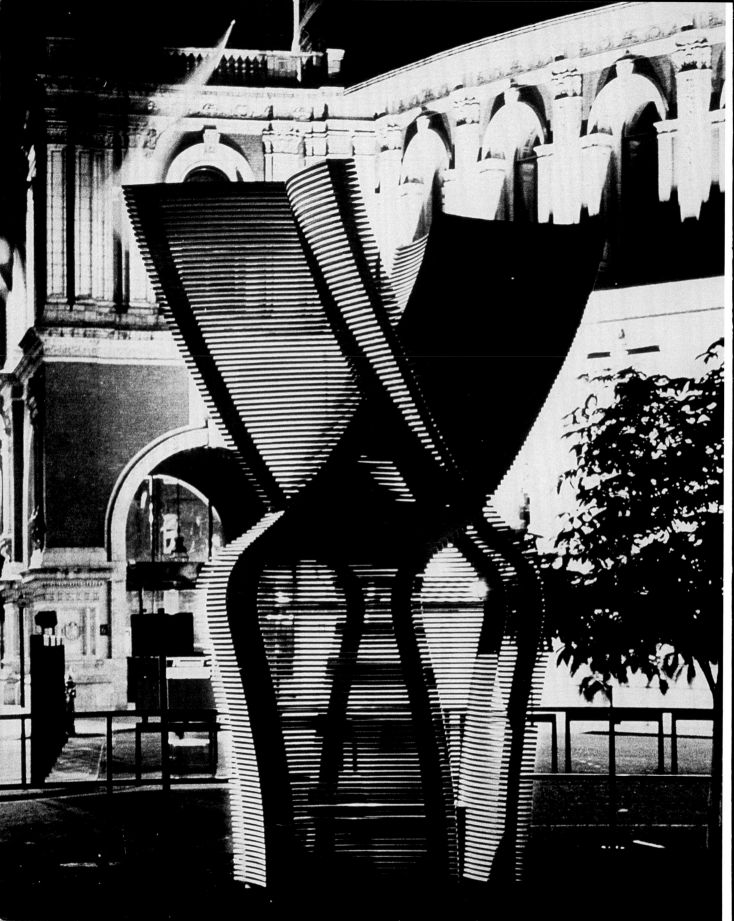

Gazebo

Can you make a building using only two components?

WHEN I BEGAN MY POSTGRADUATE COURSE at the Royal College of Art in London, I wanted to continue researching and experimenting with ways of making buildings. During the summer break, I was commissioned to make a piece of furniture, a 4.5-metre timber bench, which was the test piece for Extrusions (pages 504–513). At one point, there had been hundreds of pieces of plywood piled up, ready to be glued together. Playing with these stacks, I found that if I distorted them, tilting them towards each other until they were almost toppling over, but then interleaved them as if shuffling playing cards, the stacks could support each other structurally. It seemed possible that this idea might work on an architectural scale.

The gazebo consists of two stacks of birch plywood L-shapes, 6 metres high, which curve outwards and then in towards each other. As they meet, they mesh together for support, passing through each other and continuing upwards. The exact form of the curve, which follows the shape of a person's back, was an experiment in finding the most comfortable shape possible to lean against as you sit inside the structure.

The building was an experiment in setting a rule and letting that make the design. It is made from one main component, an elongated element with a gentle curve. Six hundred of these identical elements are stacked up, each layer separated by a circular disc spacer, to form the interlocking stacks. These two components form sophisticated details by themselves as the two stacks slide into and past each other. The ceiling has a visual richness and intricacy, formed by nothing more than the merging of the piles.

By alternating the elements with spacers and leaving gaps within the layers, I could halve the quantity of plywood I needed and therefore halve the cost. The gaps formed by the spacers gave extra interest to the structure by allowing the piles to slip through each other while remaining intact. The final pieces were hand-cut from fifty 8 x 4-foot (244 x 122 cm) sheets of marine ply, using an efficient cutting pattern for the sheets of plywood that produced virtually no waste.

It was possible to build this project only because I met Sir Terence Conran. He visited the Royal College and I showed him a model of the idea. Understanding that there was not enough space at the Royal College to build anything of this size, he generously invited me to live at his house in Berkshire and construct it at his furniture workshops, with the help of Dominic Raffler, a student from the year below.

The finished piece has an unusual optical quality. From close up, where you can only see through the slats at your eye level, the building appears to be a solid object, but it becomes progressively more transparent as you move further away and the slats become parallel relative to your line of vision. From a distance, the interplay of lines produces an unexpected moiré effect. Altering your point of view by bending your knees causes the appearance of animated phantom curves within the structure.

For the graduation show, the project was brought to London and assembled outside the college in Kensington. At night, its partial transparency allowed the brightly illuminated Royal Albert Hall to be seen through it. After this, Terence Conran gave the gazebo a permanent home in Berkshire.

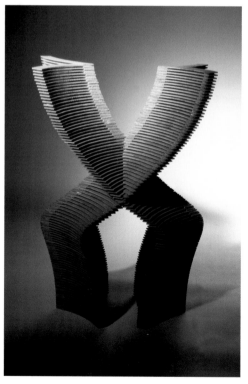

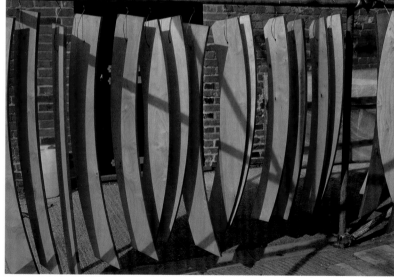

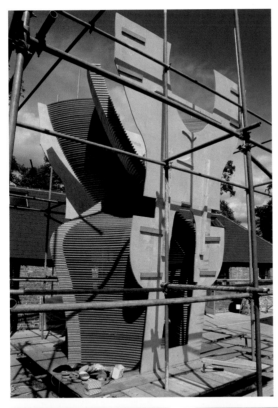

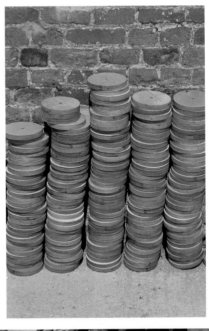

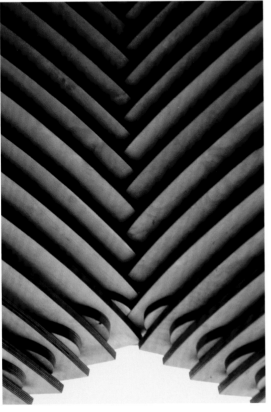

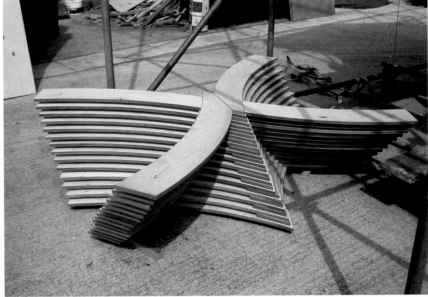

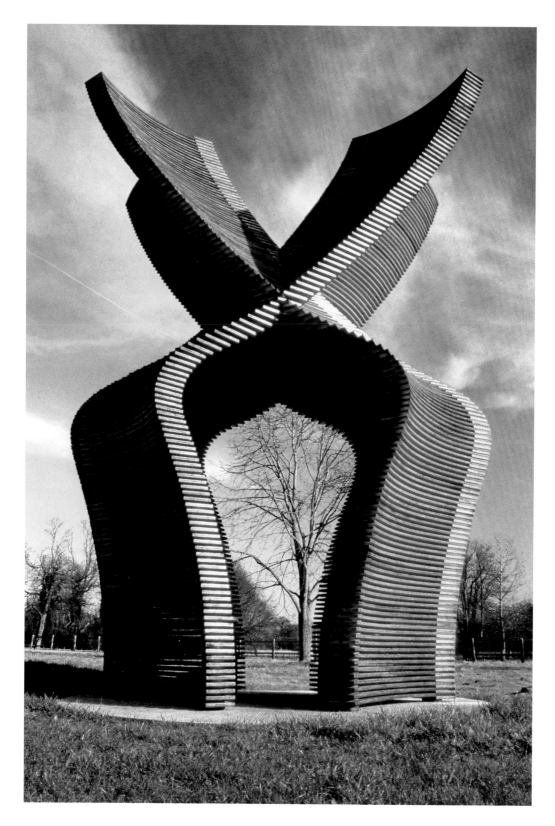

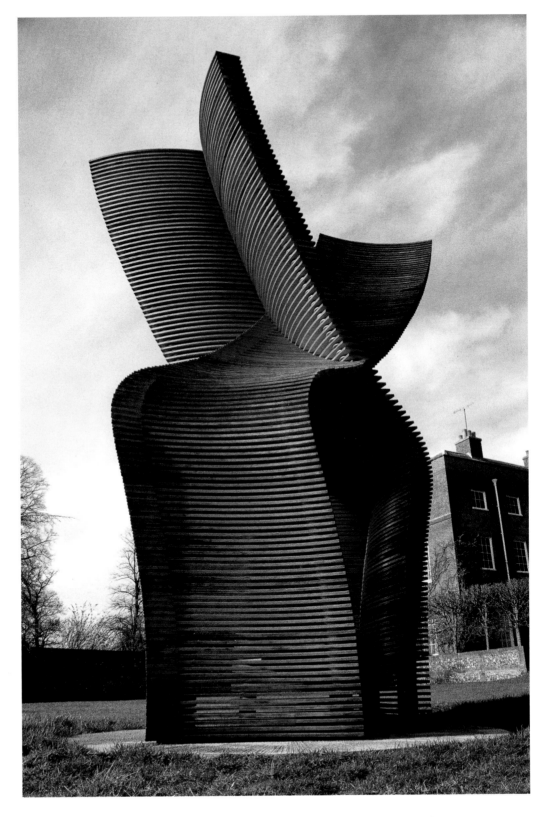

Business Card

Can you make someone eat your business card?

WITH MY MASTER'S COURSE coming to an end and the degree show approaching, I wanted to find a memorable way to give people my contact details, while also making a connection with the pieces I was showing. As it was a hot summer and my work would be exhibited outdoors, it occurred to me to create a business card that was also a refreshment.

Because I missed those bad jokes that you used to find on British ice lolly sticks I decided to design and manufacture an ice cream and put my name and telephone number on the stick. My first idea, a form that appeared to have been crushed, like a piece of clay, in the recipient's hand, looked unappetizing, so I rationalized it into a twisted shape that fitted the licking area of the end of a tongue.

To make six hundred lollies, I made a set of twelve wooden formers, from which I made trays of plastic moulds using the college's vacuum-forming machine. A south London ice cream-making company gave me access to their factory by night for a month, and allowed me to use their ingredients and machinery. From a factory-full of flavours, I chose vanilla cream for the lollies, with their tips dipped in chocolate.

For the sticks, I bought wooden tongue depressors from a medical supplier and used my cooker to heat a branding tool that had been acid-etched for me to burn my details on to them. Every morning, throughout the two weeks of the show, I took outside a second-hand freezer that I had bought. If

people wanted my business card, they had to eat the ice cream to find out my name, telephone and fax number.

Windsor Great Hall

How do you design a new piece of heritage?

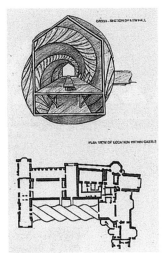

WHEN THE GREAT HALL at Windsor Castle, the British Queen's weekend home, was destroyed by fire in 1992, there was a debate about whether to rebuild the hall or replace it with something that reflected the present time. A competition was held for ideas and, working with a fellow student from the Royal College of Art, I produced quick drawings for an idea that used both the existing materiality of the monumental castle – a palette of historic materials such as carved wood, stone and stained glass – and the same high level of craftsmanship that had been used to build the previous hall.

An elongated space like this hall gives your eye the pleasure of appreciating the pattern and perspective that comes from the repetition of details growing smaller as they recede into the distance. Our proposal involved taking that splendid space and twisting it through 360 degrees from one end of the hall to the other, while leaving the floor a flat surface suspended within its length. We imagined that the new space, constructed with exceptional craftsmanship using traditional materials, would offer the most remarkable view as it spiralled away from you.

In creating this hall, our Royal Family would be expressing confidence in contemporary ideas while retaining the richness of historic materiality and craftsmanship in its realization.

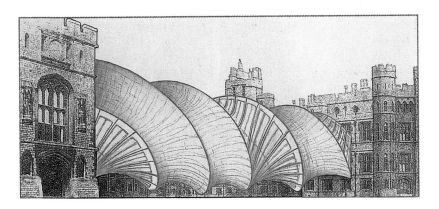

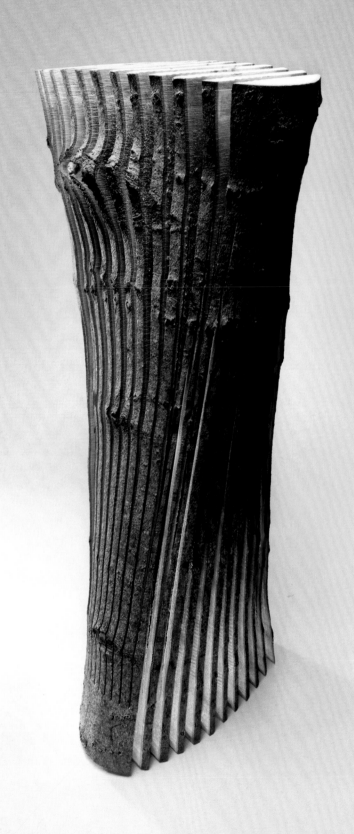

Log

1994

Can you expand a tree trunk?

THIS TEST-PIECE CAME FROM SEEING tree trunks in Sweden that had been felled and split into planks. To allow moisture to escape from the green wood, the logs had been put back together with small pieces of wood inserted between each plank to let air circulate between each one. These reassembled logs were no longer round in section but stretched into ovals. It occurred to me that you might be able to stretch a log like this in more than one direction while still holding it all together.

Using a bandsaw, I repeatedly sliced a log lengthwise, stopping before each piece was completely severed, and then, having turned the log through 90 degrees, sliced it from the other end so that these cuts went through the log in a perpendicular plane.

As the slices were fanned out using spacers, first one way and then the other, it made a geometrically interesting object that remained a single piece of wood, with the expanded texture of its bark continuing across the splayed edges of the slices.

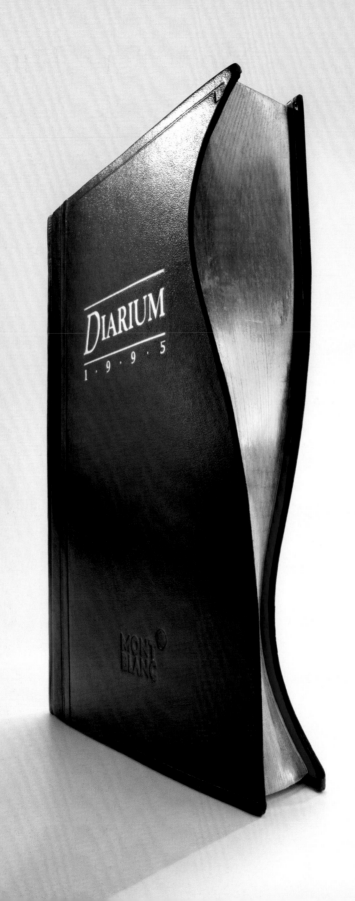

Montblanc Diary

*Can each day's page in a diary
be a different shape?*

A LUXURY GOODS COMPANY asked the studio to design a limited edition diary. Influenced by the technique of cutting finger-holds into the edges of dictionaries and encyclopaedias to identify their alphabetical sections, we decided to treat the book as if it was a block of wood and to sculpt undulating curves into its long edge. In the manner of traditional bookbinding, this carved surface was gilded with gold leaf. Breaching the conventional rectangular extents of the book by carving it in this way made it sensuous to handle and gave a unique shape to the page for each day of the year.

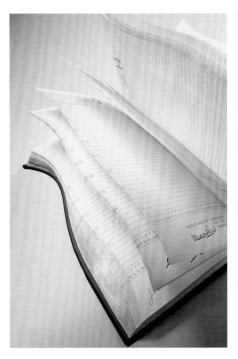

Sleeping Policeman

How can you make a sleeping policeman work harder?

OBSERVING THAT BRITAIN'S STREETS were filling with miscellaneous items of street furniture and infrastructure, such as barriers, traffic monitoring cameras, bollards and electricity boxes, we wondered if there was a way to reduce the number of these objects by combining their functions.

Our idea was to take a sleeping policeman, the sausage-like lump across a road designed to slow cars down, and twist it up and over the pavement. As well as controlling the speed of the traffic, it would make a pair of cantilevering benches. It could be made from terrazzo, a polished concrete containing pieces of marble.

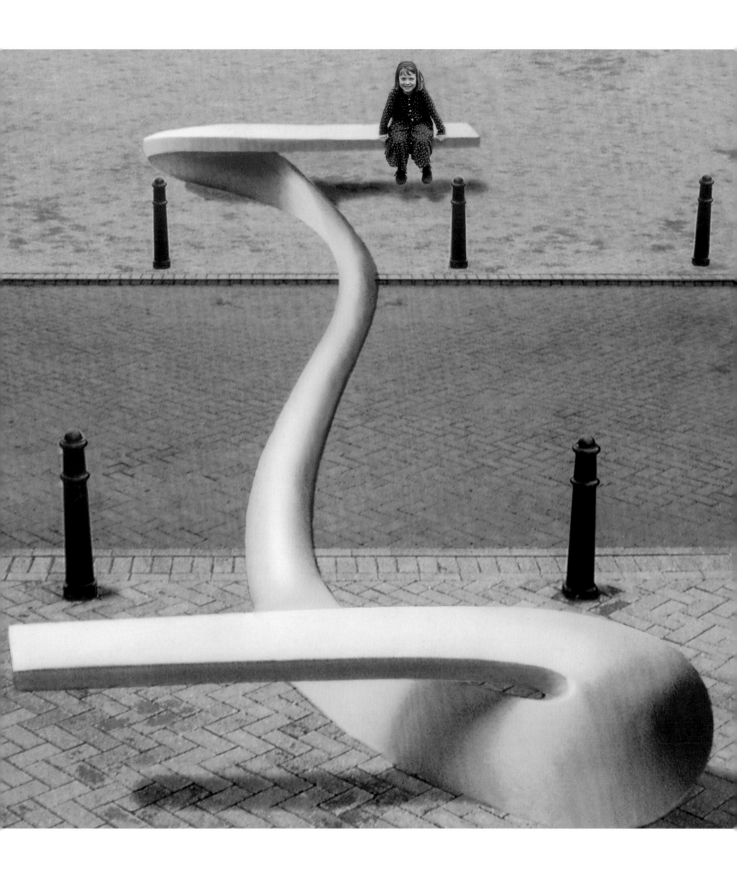

Christmas Cards

*How can you send appreciation
by post?*

TO SHOW OUR GRATITUDE to people who had supported us or worked with us, the studio began sending out special cards at Christmas. Each year, we looked for ways of turning inexpensive materials into postable objects.

Our earliest cards were little more than decorative test pieces. The first one came from experimenting with the studio's new rotary trimmer, a piece of office equipment for cutting paper, which, when used to slice card very finely, produced tiny, twisted slivers. Another card was an object made by taking a stack of birch plywood strips and weaving them through each other. As we carried on looking for ways to send love, we became interested in the process by which they were sent, the rituals of posting and receiving a card, and found that the subject of our Christmas cards became Christmas cards themselves.

For seventeen years, we produced the cards in our workshop, setting up mini-production lines that allowed us to repeat the making processes several hundred times, using tools, jigs, devices and systems that we invented and constructed. When we had 350 cards to make and each one needed 52 holes in it,

we had to construct a jig with which we could drill 15,600 holes (or bond 6,300 stamps to each other or stick 7,500 small envelopes together). We would suddenly find ourselves becoming experts in stamp adhesive, manila stationery paper and casting from a postbox. Each year, the staff of the Special Handstamp Centre, a department in the vast Royal Mail sorting office at Mount Pleasant in north London, helped us get the cards through the postal system.

Film Festival Ticket Office

Can straight pieces of wood make a curved building?

THIS IDEA FOR A SMALL BUILDING from which to sell tickets for a film festival developed out of research and experimentation with small temporary buildings, such as kiosks, pavilions and gazebos.

Following tests with interleaving piles of wooden pieces, we developed a 10-metre structure that consists of four V-shaped stacks of wood which curve upwards, crossing through each other and converging at the top into two V-shaped peaks. The planks form buttresses and walls, which in turn become the structure and the roof.

A supplier of sustainable timber offered to source some of the fragrant wood from a cedar of Lebanon tree that had blown over in a gale. Using identical straight lengths of wood meant there would be little waste and the timber would be easy to reuse after the project was dismantled.

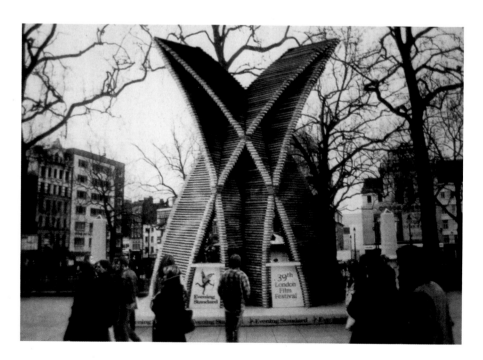

London Underground Station

*How can a tubular space
be less tubular?*

IN THE 1990S, the proposed extension to the Jubilee line of the London Underground system went ahead and the studio was invited to develop ideas for the design of the new platforms at Waterloo Station.

 With the intention of giving a more detailed layer of form to the smooth, tubular tunnel walls, we generated an idea for a repeating glass tile module, manufactured in the same way as glass bricks, which was based on a single, rotationally symmetrical form that tessellated in three dimensions. Used to line the rounded walls of the platform, these 400-millimetre-square tiles would create a blue, translucent surface that wiggled and curved, with forms that were comfortable to lean or sit against.

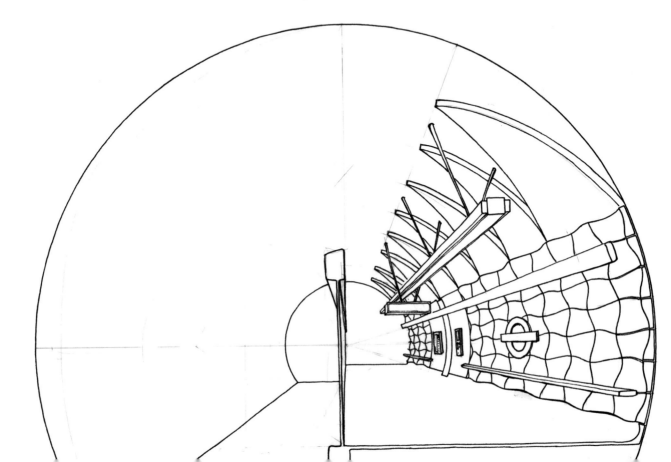

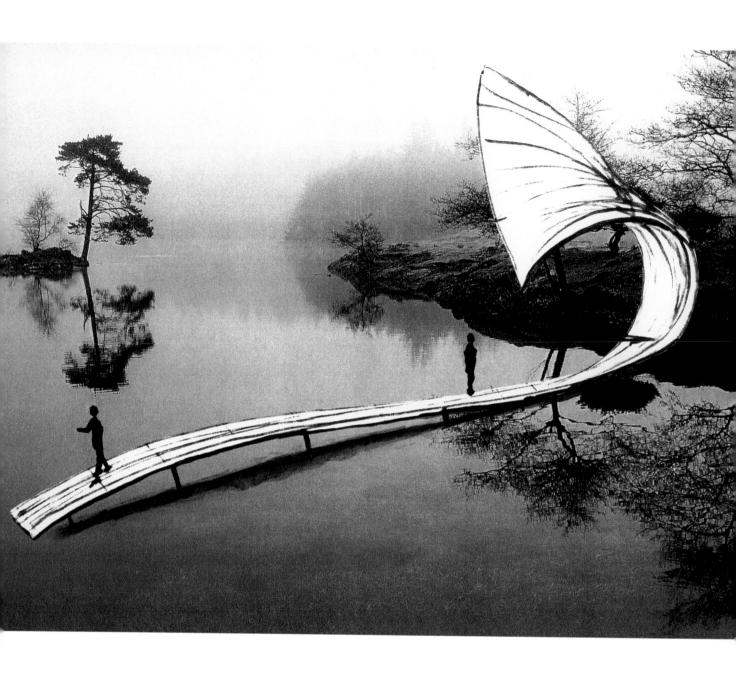

Kielder Boathouse

Can a floor become a roof?

INVITED BY AN ART CONSULTANT to propose a project for the area around Kielder Water, the vast manmade lake in Northumberland, the studio suggested a boathouse with a jetty for a boat to pull up against and a roof to protect people from rain while waiting for the local ferry service.

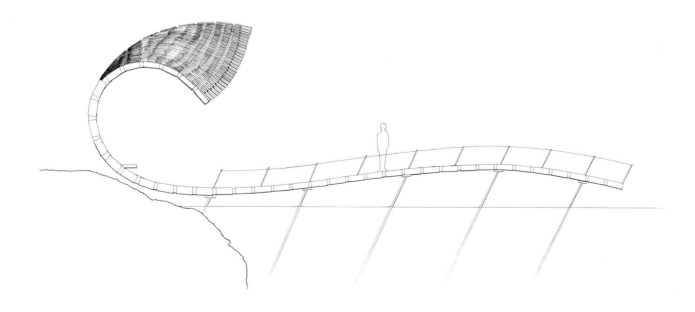

Instead of creating a conventional jetty with a separate covered structure, we made the end of the jetty become the canopy, curling itself round and over to form a shelter, forming a connection between functional elements that are normally separate. The boathouse was to be constructed entirely from glass: thousands of identical glass sheets bonded together using high-performance, transparent, ultraviolet adhesive.

We imagined this as a crystalline form suspended above the water, reflected in it and illuminated at night. Although the technology that would make this project possible was still in development, it came out of the studio's interest in the structural use of glass and was the beginning of the idea for a glass bridge (pages 280–285).

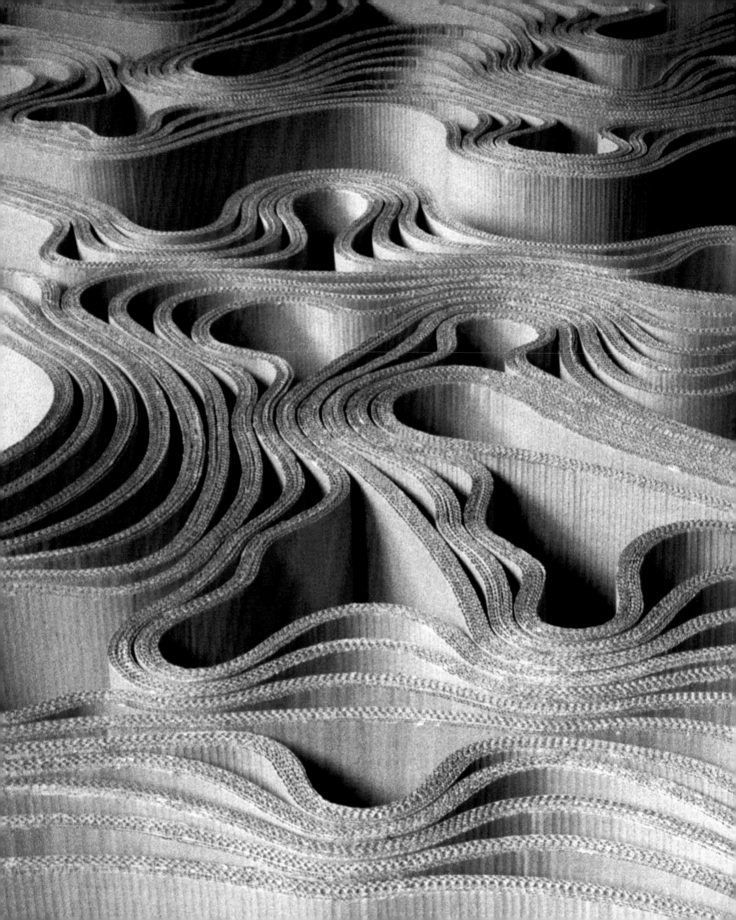

Conran Shop Window Display

Can the design of a shop window display evolve like a doodle?

FOR THE WINDOWS OF THE CONRAN SHOP in London, the studio was asked to produce a display of four hundred pieces of kitchen equipment, a collection of disparate objects – spoons, cloths, bins, kettles, brooms – all different sizes and made of all kinds of materials. We wanted to get away from the conventional format of using a separately designed set of shelves to exhibit the objects.

PASS-THE-PARCEL

Experimenting with drawing, I drew one of the objects and wrapped a line around it. I kept going and added in another object and put another line around that. Disturbed by the accumulation of objects, each new line reacted to the previous lines. By obeying a small artistic rule, a design evolved. The rule gave you some control but as you carried on adding more and more disturbances, you did not know exactly what the whole thing was eventually going to look like.

It reminded me of visiting furniture factories in Sweden, which were set in the forests that supplied them with timber, and hearing that they often found bullets embedded in the grain of this wood. At some point in the trees' lives, bullets had got lodged deep in their trunks but the wood had carried on growing around them, accommodating the bullets like an infection that disturbs a tree's growth rings. I liked the idea of inserting imperfections into something that would otherwise be perfect.

Working on the floor of the studio, we grew each piece by incorporating the objects layer by layer, wrapping them in the cheap, corrugated cardboard that comes in rolls and is used for packaging. There was no final design. We designed the pieces as we made them, deciding where to put a saucepan or a toaster and then reacting to what happened next. All we could do was to try to steer the design as we allowed the series of forms to make themselves, gradually incorporating twelve kilometres of cardboard.

The finished pieces were in place for ten weeks and resembled slices through a vast pass-the-parcel game package.

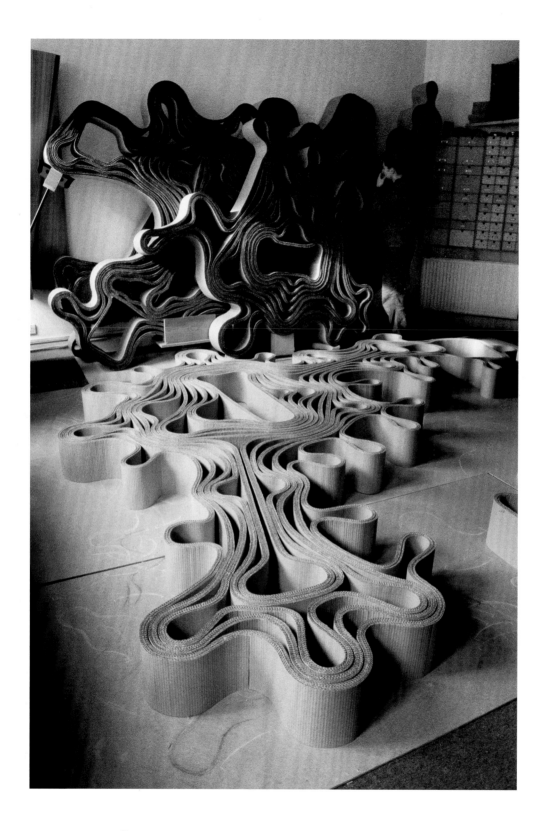

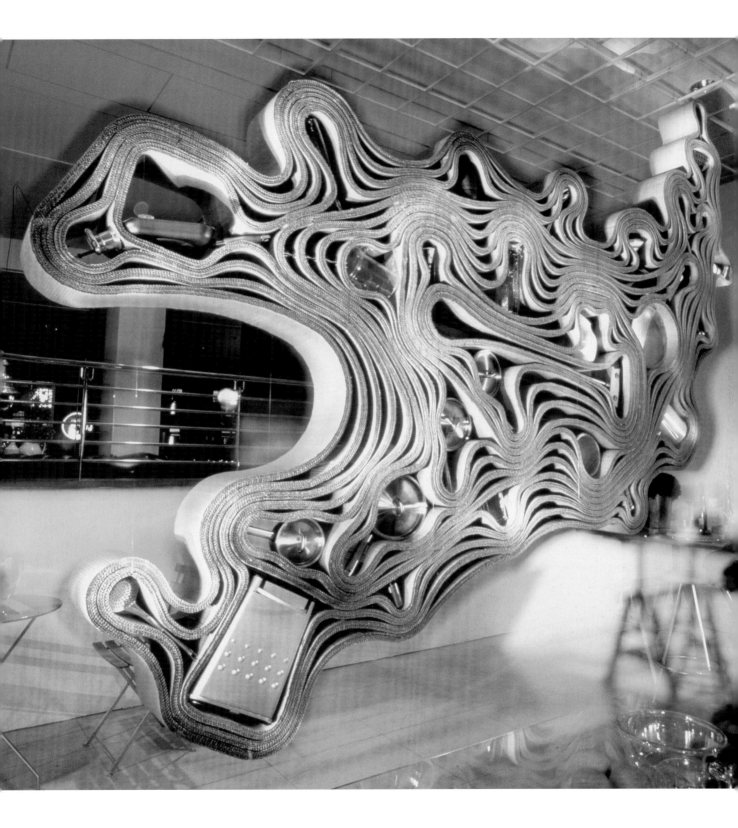

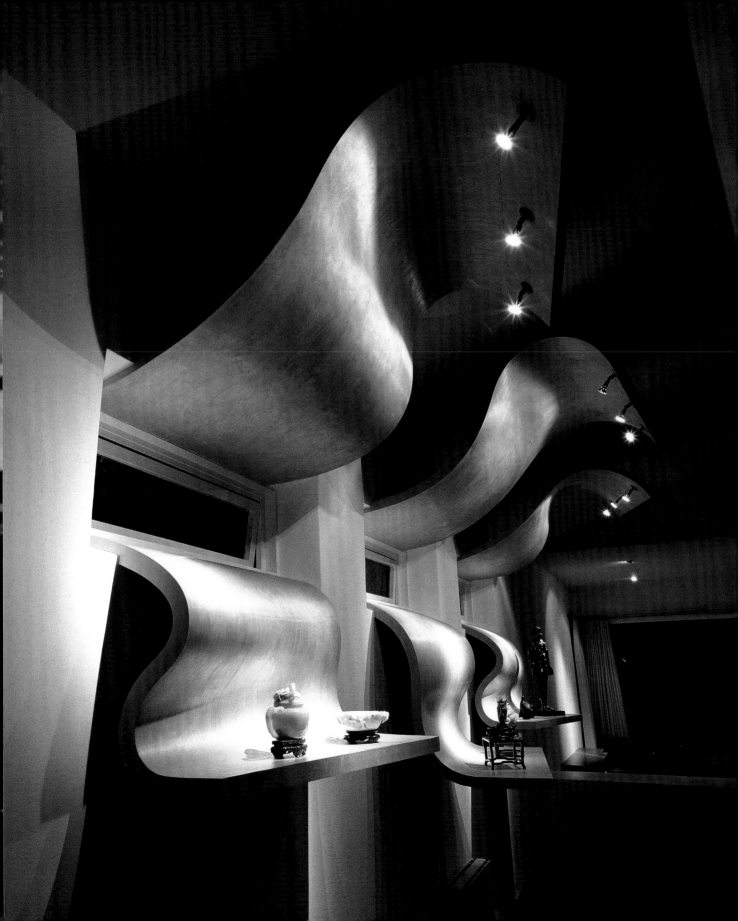

Shelving for a Jade Collection

1995

Can a windowsill be more useful?

THE STUDIO WAS COMMISSIONED BY A FAMILY in north London to design display shelves for their collection of carved jade objects. Because the wall on which they wanted to display the collection was dominated by three narrow, horizontal windows that looked like letterboxes, we felt that any new piece of furniture needed to relate to these windows.

Our solution was to treat the windows as if they were eyes and grow the display units out of each one like eyelids. The bottom eyelids pulled out to make surfaces on which to display the objects and the top eyelids stretched up to the ceiling to cast light downwards on to the collection, the intention being to symbolically draw in the light from outside.

The finished pieces were fabricated in the studio's workshop, combining a steel structure with a twisting birch veneer surface.

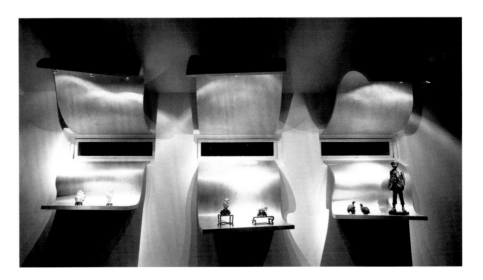

Office Interior

How can separate spaces on two floors of a building become a single working environment?

THE STUDIO WAS ASKED TO REMODEL an outdated office interior for a computer software company based in a former banana warehouse in central London. The challenge was that the workspace was split over two levels. As well as giving the company's environment a stronger identity, we needed to find a way of allowing more connection between team members working on different floors.

Because we wanted the two levels to be seen and experienced as one, we proposed opening up the ceiling above the entrance, between the two floors, peeling half of it up and curving the other half down. Punching boxes through both floors to make spaces for new toilet, kitchen and storage facilities, the design created a visual connection between the floors, a new staircase and a double-height entrance area.

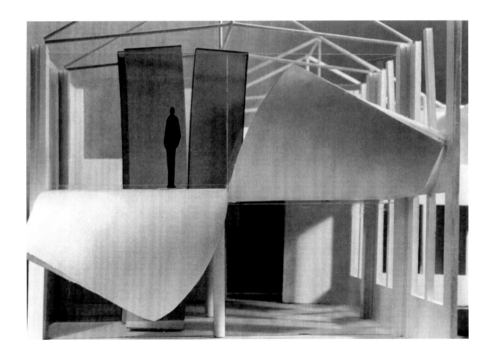

Laing Square

*How can a piece of old road
become a city square?*

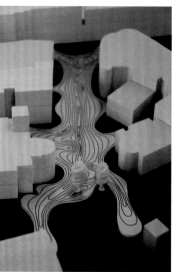

THE STUDIO WON A COMPETITION to design a new square in the centre of Newcastle upon Tyne, outside the main art gallery. The site was an old piece of road, a remnant of tarmac that formed part of an important pedestrian route into the city centre, with an ugly steel staircase coming into the space from the east.

Rather than a civic square that had been intentionally defined and enclosed by buildings, this was a ragged space with side streets coming into it between buildings of many types and ages. Since we could not make this a square by moving or redesigning the surrounding buildings, all we could work with was paving, street furniture and trees. But once you started repaving, where would you stop? The space was like a spider with legs that stretched up side streets. Because it had no defined edges, we could have ended up repaving half of Newcastle.

Our strategy was to use the surface as a device to unify the space and acknowledge its lack of containment by allowing the surface to go where it was not supposed to. Creating this surface as an object in the centre of the space drew attention away from the disjointed form of the surrounding buildings. The other strategic decision was to dispel the impression of a road and a hard-surfaced urban context by introducing trees. We felt that without this element of nature, it would be impossible to call this a public square, which is by definition a breathing space and place of relaxation.

Initially we aimed to create a fluid surface that seemed to have been poured into the space and allowed to run up side streets and across the adjacent main road. For this, we developed a concrete that had fibre-optic data cables cast into it, which lit up at night to create linear constellations within the surface. The proposal was achievable but expensive.

Looking for a different kind of paving idea we reconceived the surface as an ill-fitting carpet, dropped into the space. This carpet is not neatly tailored to the shape of the space but infringes on side streets and occasionally folds up against a building. The surface is sculpted to create changes in level that reinforce

the sense that it is an object that you are walking across. Working with researchers at Sheffield Hallam University, we developed a new paving material, a white resin tile, incorporating recycled glass from bottles that had contained French perfume or Harvey's Bristol Cream, which gave the paving a subtle blue colour.

Benches were formed by cutting open the surface, peeling back and twisting the pieces to expose glass-covered spaces below the ground containing coloured light installations. Here we collaborated with expert makers of terrazzo, a highly polished coloured concrete, who manufactured the benches using steel armatures with twisted brass edge details that we fabricated in our workshop. The bollards, which puncture the surface, use similar materials. We replaced the narrow steel staircase with a generous timber one, formed from a single helix of laminated wood, which was made on site by a company of traditional Tyneside boatbuilders.

Because we considered the trees to be the most sculptural element of the project, they needed to be mature and characterful, as we could not wait twenty years for them to develop. They also had to be too large to vandalize. We selected seven trees from nurseries in the Netherlands and Germany, which were successfully transplanted. One was the largest and most mature tree ever transplanted into this country.

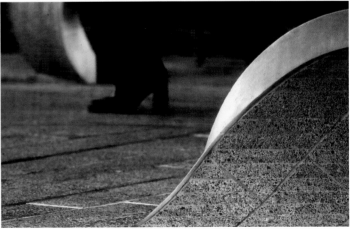

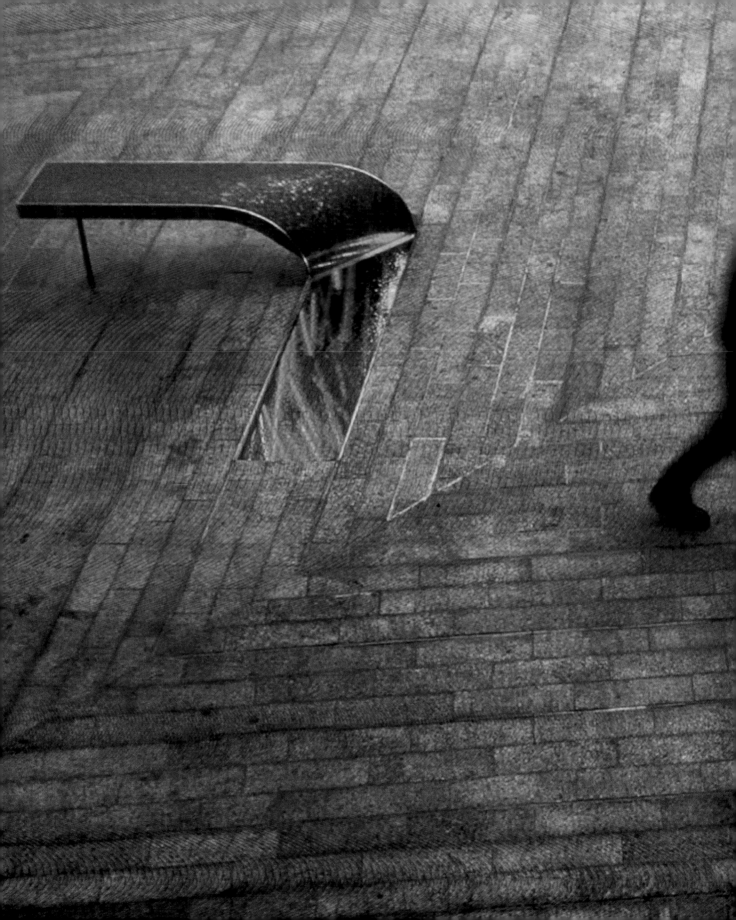

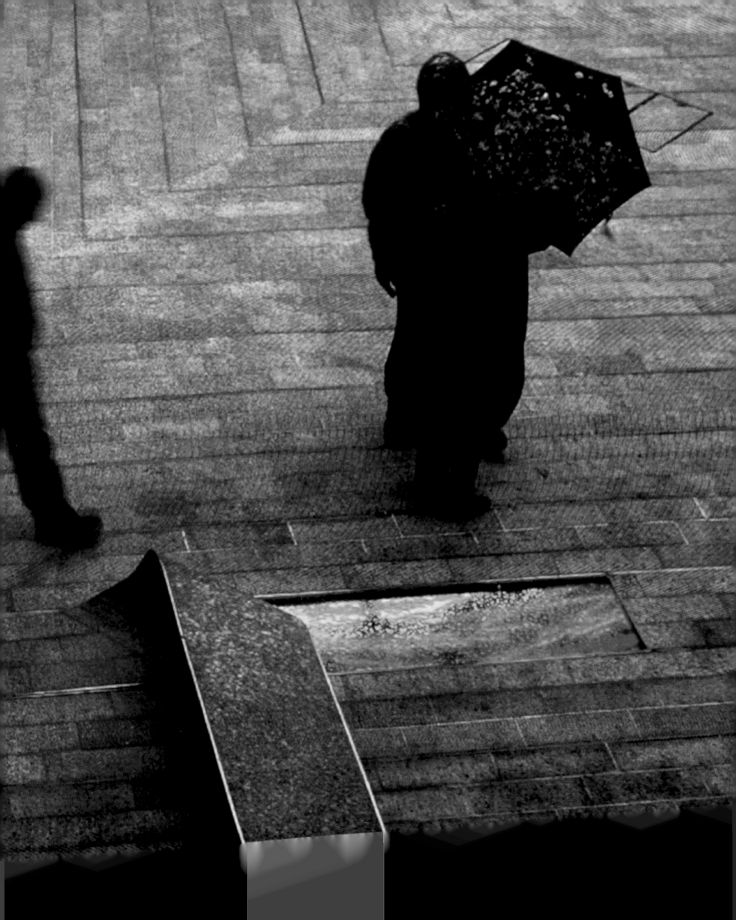

Complete Christmas Tree

What does a whole Christmas tree look like?

FINLAND WAS DONATING A FORTY-YEAR-OLD, 20-metre tree to stand outside the Design Museum in London at Christmas, and we were invited to design decorations for it. Because the project involved cutting down and killing a tree, we wanted to treat it with respect. Instead of covering it with Christmas kitsch, we looked for a way of celebrating the tree itself.

Rather than chopping it off at the ground, we decided to excavate it and bring the whole tree to London, with its entire root system intact. Like decorating the tree with candles, we would then decorate this forty-year-old tree with forty one-year-old trees in gilded pots. These could later be replanted, replacing an older tree, which would die, with forty young ones.

As conventional digging machinery would have damaged the roots, we worked with the Finnish fire brigade to wash the tree out of the ground. A deep trench, 20 metres in diameter, was dug around the tree. Then the firemen connected their hoses to a nearby river and, with 100,000 gallons of water, carefully washed the soil away from the bottom of the tree, having first anchored it in place with a crane to prevent it from toppling over. The roots were more extensive and delicate than people had thought: a vast, lace-like network of filigree elements, fine hairs designed to suck up moisture and nutrients from the ground.

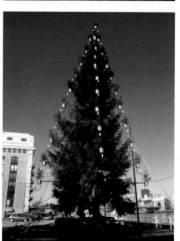

The tree was transported by lorry, its roots delicately packaged into bundles that looked like dreadlocks. Forty plant pots were gilded with gold leaf and attached with steel arms to the main tree trunk, each fitted with a light source to illuminate it and the whole tree. The roots spilled out over the plinth and on to the riverside walkway. Their bark was beautifully patterned and had the quality of snakeskin.

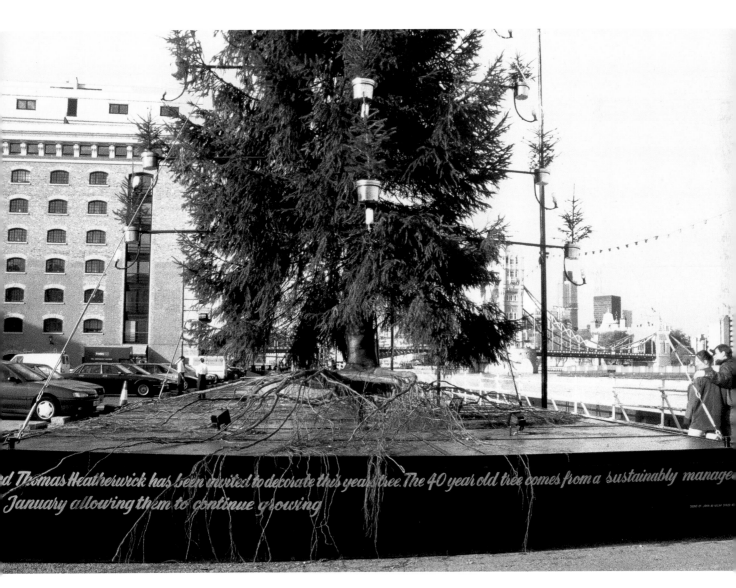

...d Thomas Heatherwick has been invited to decorate this year's tree. The 40 year old tree comes from a sustainably manage...
January allowing them to continue growing

93

Hate Seat

*How can a strip of folded
paper lead to the design of
a functional object?*

THE ORGANIZERS OF AN EXHIBITION at Belsay Hall in Northumberland invited
the studio to design a piece of furniture. We experimented with paper folding,
wondering whether a single folded strip could become a functional object.

The idea was for a piece of furniture formed from a single strip of wood
that made the seat, legs and back of a bench, by folding its ends down, along,
around and up. If we angled the fold lines slightly off the perpendicular, the strip
formed a subtle spiral that intersected itself as it folded.

Like the classic love seat, the bench is rotationally symmetrical, but instead
of gazing into each other's eyes, the couple sit with their backs to each other,
although, in the event of a reconciliation, they can sit in the middle side by side.

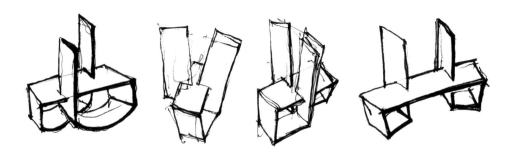

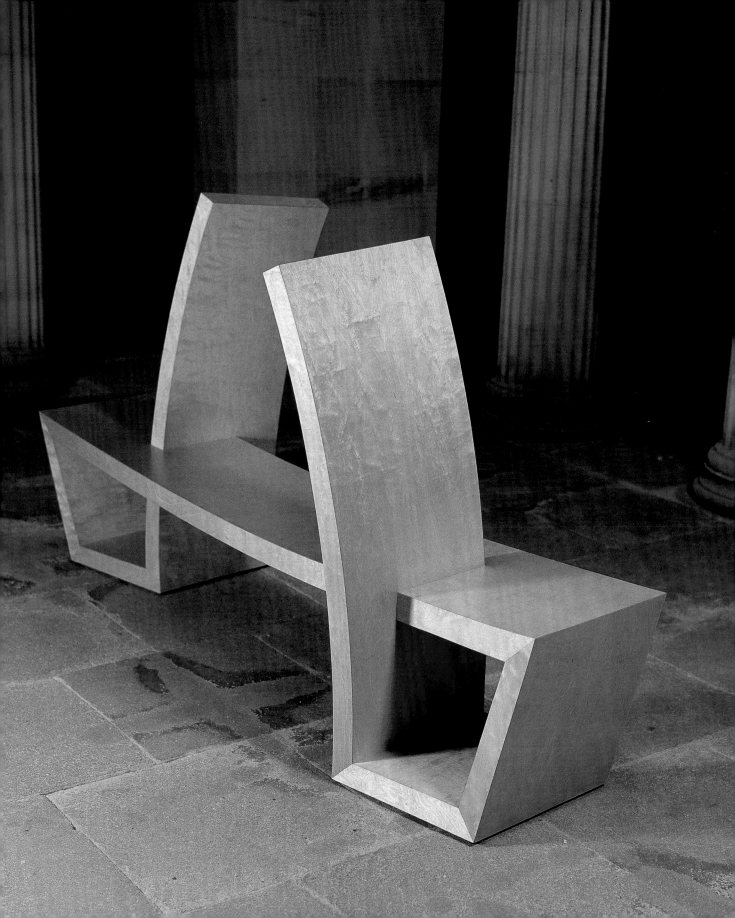

Millennium Bridge

*Can the character of a bridge change
as you cross it?*

TO CELEBRATE THE MILLENNIUM, a decision was taken to build a new foot-bridge over the River Thames in London and the studio entered the anonymous competition that was held to find a design.

Seeking not only to create a route but also to make public spaces over the river, we came up with a proposal based on the difference in the character of the two banks at either end of the bridge. The northern end of our bridge would emerge from a narrow slot between the buildings below St Paul's Cathedral and land on the south side of the river in a wide open space, next to the former Bankside Power Station, which was in the process of becoming the Tate Modern art gallery. The bridge could, we thought, reflect the vastly differing qualities of these environments, one corporate and one artistic, by transforming itself as it crossed the river.

Researching the dynamic forms made within moving liquids, we developed a bridge that, like water thrown from a bucket, left the north bank in a shape that was tight and directional and then became wider and more generous as it travelled towards the south bank, breaking down into eddies and undulations that created significant public spaces and contained stopping points and performance areas, as well as a direct route for people in a hurry.

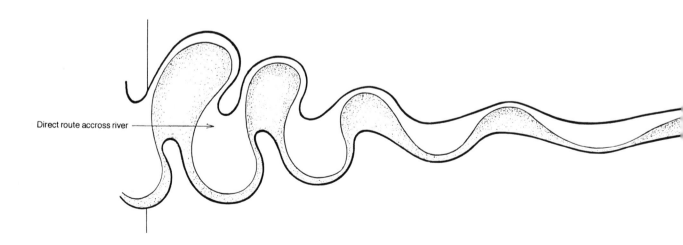

Direct route accross river →

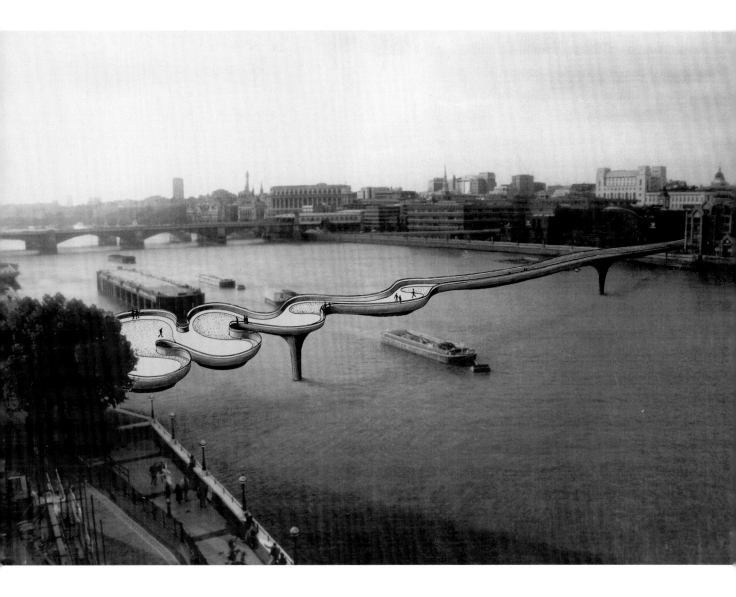

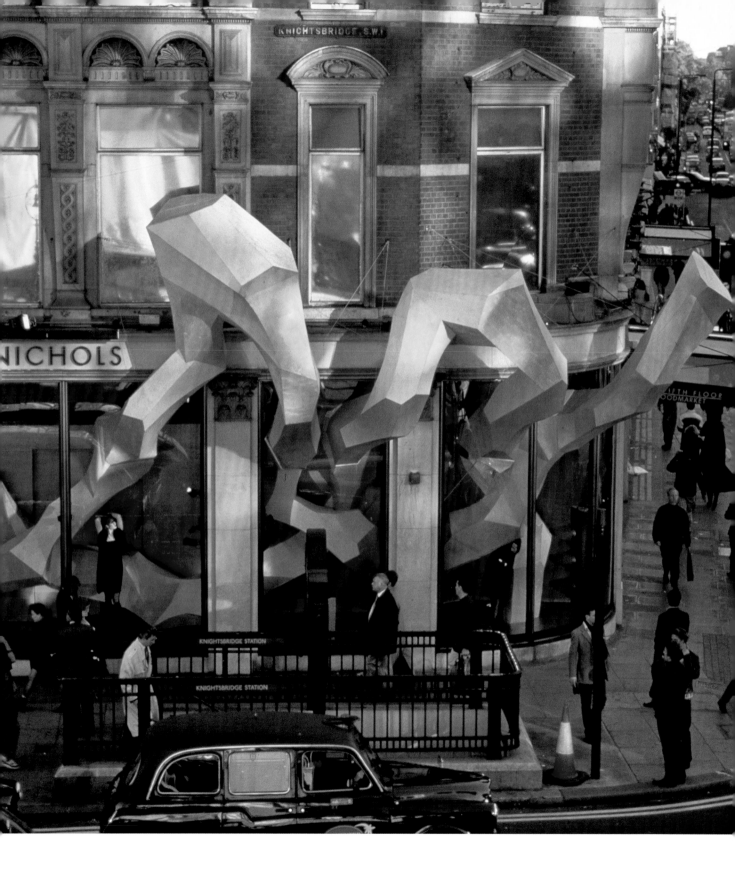

Autumn Intrusion

*How can a shop window display
relate to the architecture of its shop?*

HARVEY NICHOLS IS A DEPARTMENT STORE in London famous for its special window displays. The studio was asked to design the windows that would celebrate Autumn 1997 Fashion Week. As we started to think about the project, it seemed to us that in the world of fashion retail, you could choose almost any theme for the windows – Mickey Mouse or giant Airfix kits – as long as it attracted attention. But we had never seen a window display that made a connection with the architecture of the building.

We felt that there was seldom a logical link between the design of a shop and the architecture of the building that sits on top of it. London is full of ornate Victorian buildings that appear to have had their ground floors pulled out from underneath them and replaced with a modernist slice of retail. Harvey Nichols, though, is unusual because it has stone columns that come all the way down between its windows and attach it to the pavement. It is a detached, free-standing building, rather than part of a street of shops, and occupies an important corner.

We wanted to create a design that was specific to the architecture of the Harvey Nichols building, something that could not be done with any other shop. Instead of treating its twelve windows as twelve separate display cabinets, we began looking for a single idea that could bring them together.

Although glass is associated with the idea of transparency, the contents of shop windows are often veiled or even obscured by the light that reflects off these large panes. Rather than putting objects in the boxes behind the glass and allowing the glass in these windows to be their jailer, we began to think about finding a way to escape the confines of the shop window. We started to imagine that there was no glass and that our installation was allowed to burst out into

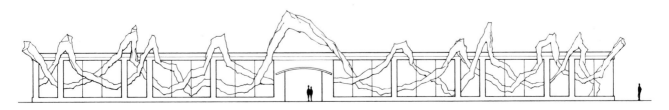

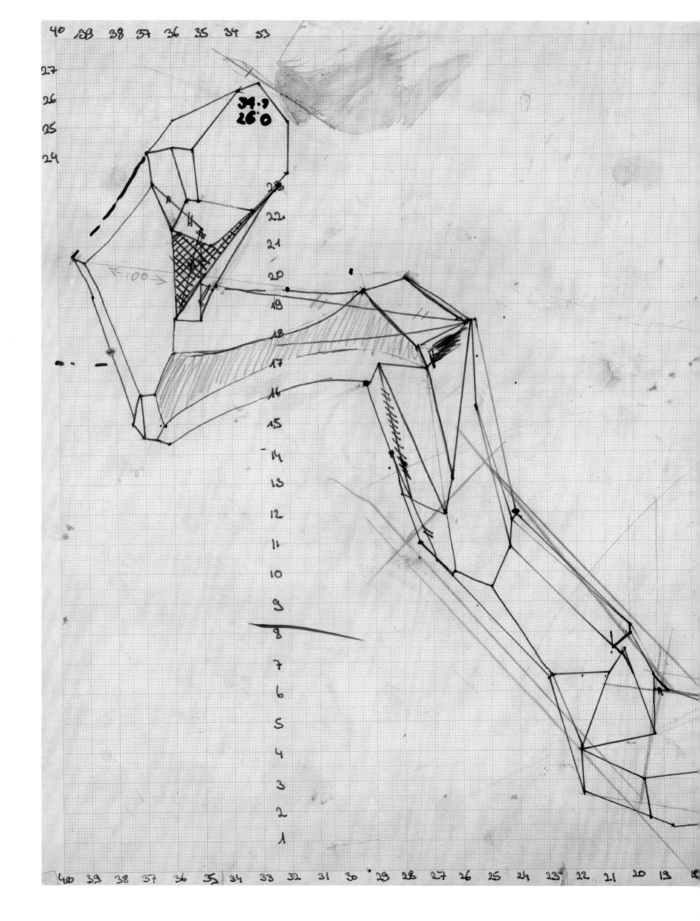

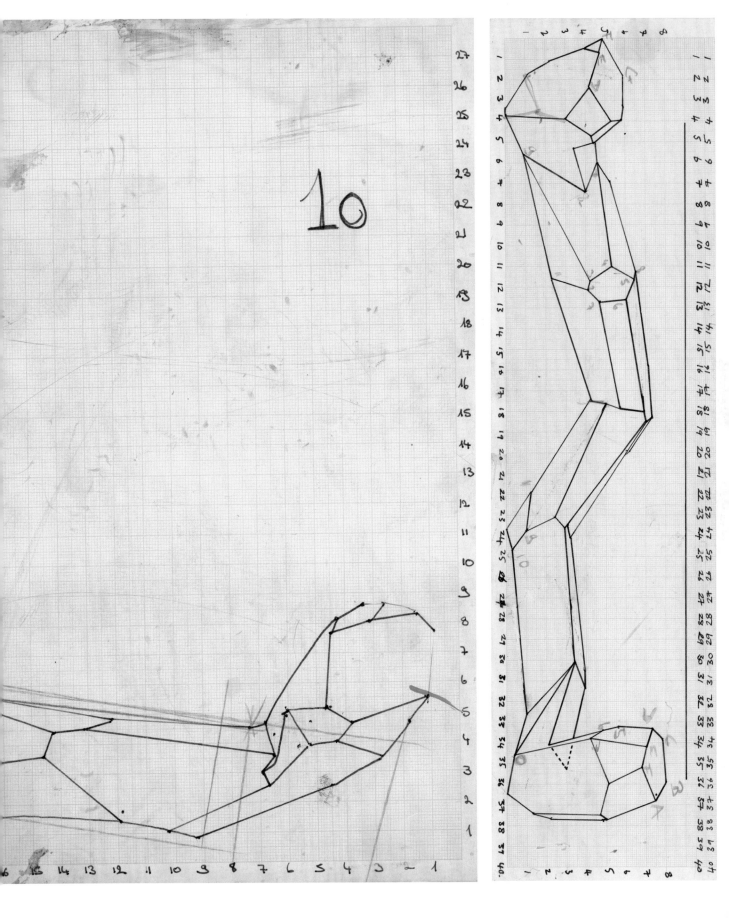

the street and steal space from the pavement, as well as making a connection with the façade of the building and drawing attention from around the corners.

The idea that we developed was to stitch all twelve window spaces and the façade into a single composition using an element that wove in and out of the stone pillars, extending beyond the boundaries of the shop, rising up the front of the building and protruding beyond its corners. Rather than the flowing, passive language of a snake or ribbon form, we wanted this element to feel muscular and unpredictable, a dynamic, wriggling and struggling form that is deliberately awkward and stubborn, consciously changing and contorting as it goes where it wants to go.

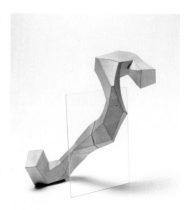

The only way to design such a dynamic form was for me to carve it in polystyrene, using a sharp kitchen knife. The process was too intuitive for me to be able to instruct somebody else and the piece evolved as I carved and experimented. Unless the knife was razor sharp, the polystyrene pieces would rip into bobbles.

We had six months and six people to build this huge object. It had to be strong enough to withstand the particularly strong winds in this part of the city but light enough for us to build and suspend it. We could have made it from fibreglass and painted it, but we didn't want it to give the impression of a painted simulation of something else; it needed materiality and craftsmanship. Instead, we created a special composite material consisting of an expanded polystyrene core and a veneer of aeroply, the extremely thin birch plywood that was originally developed for constructing aeroplane wings. Like the cross-section of a bone, this combination had great structural efficiency: tensile and compressive strength on its outer surfaces and a lightweight, aerated structure in the middle. The aeroply also had warmth and silkiness.

I carved two identical models of the project at 1:20 scale: one stayed in the studio and the other went to a warehouse in east London, where our team was building the project. Today, we might use three-dimensional digital technology to scale up this form, but this was not available to us then, so we had to divide the sculptural form into sections and scale up each complicated shape by hand.

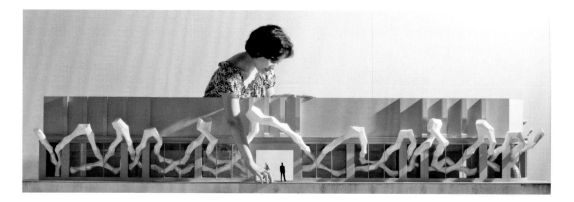

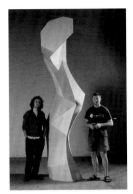

We placed the miniature pieces on graph paper and made plan and elevation drawings for each one, which we scaled up on to a giant grid marked on the floor and walls of the workshop. Once we understood the geometry of each piece, we bonded and carved vast blocks of polystyrene with hot wires until we had the right form. Each piece was then veneered with aeroply, which was a highly skilled job to do cleanly on such a scale and required a craftsmanship that was closer to cabinet making than set building. One by one, as they were completed, the pieces were stored in the neighbouring building, which happened to be London's last surviving lighthouse. Finally, working with a rigging company over a series of ten nights, the pieces were put in place, where they remained for two months.

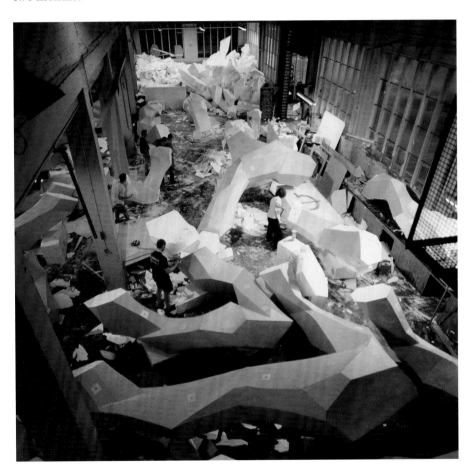

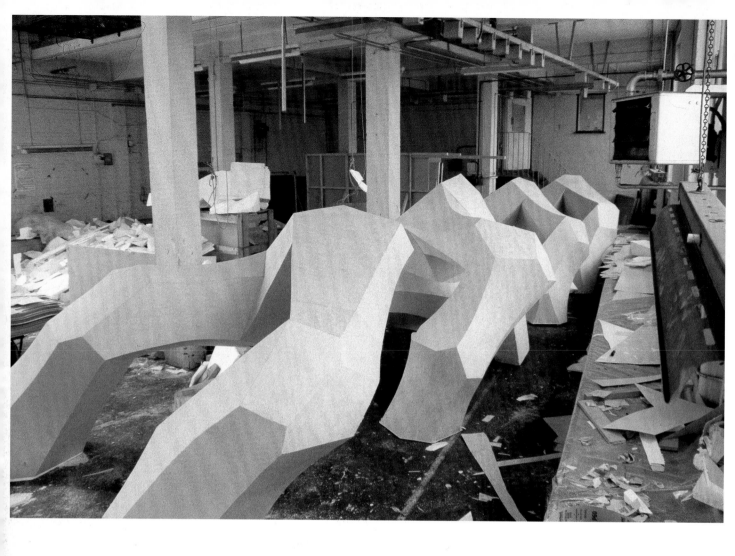

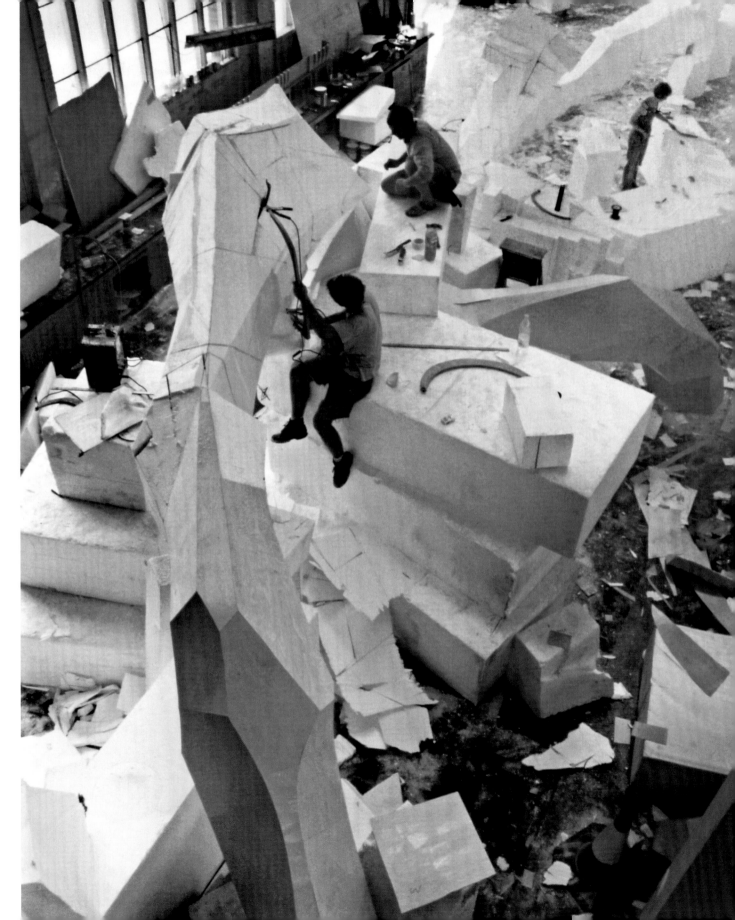

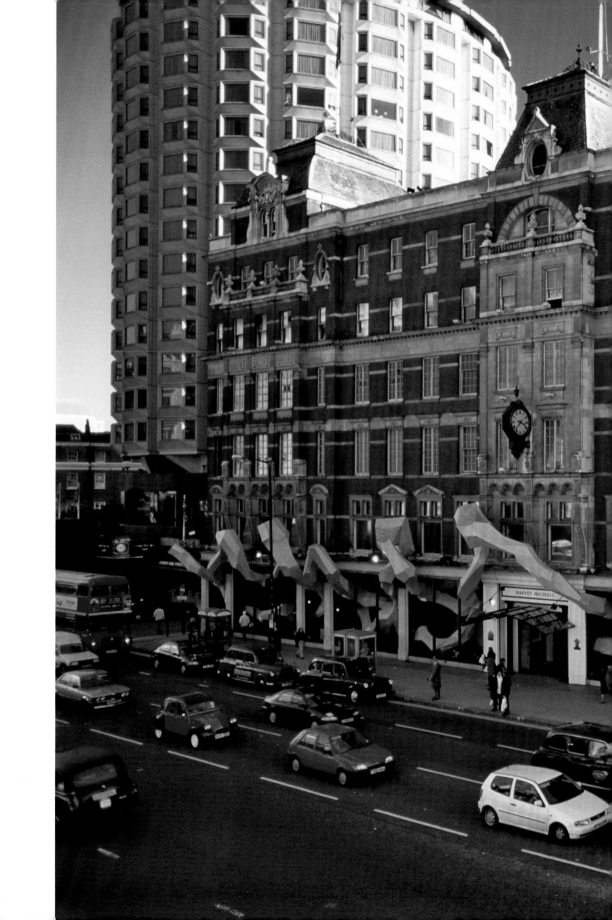

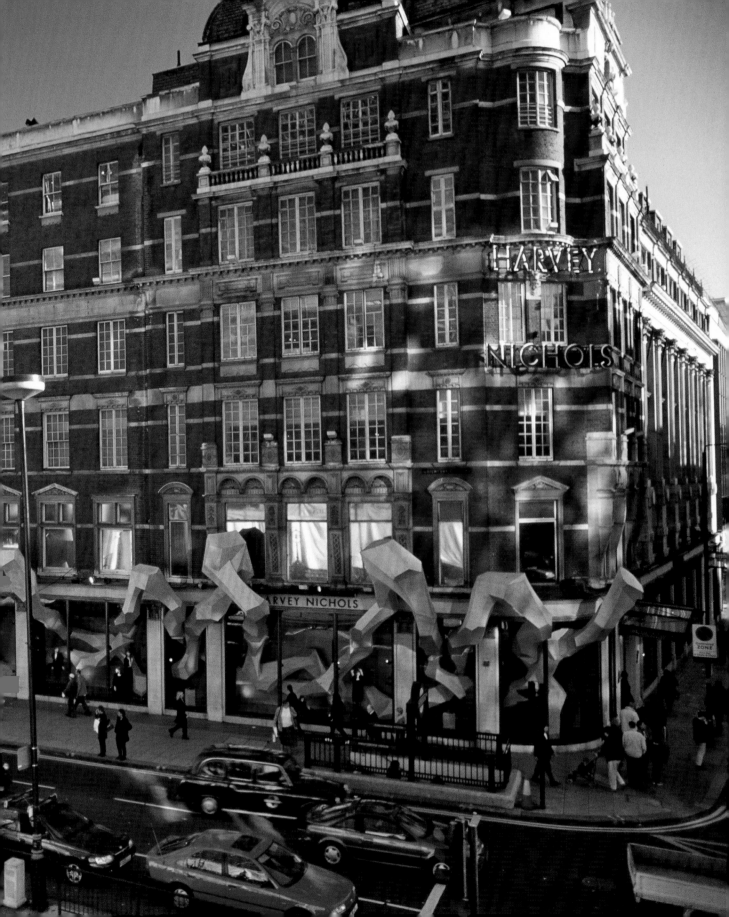

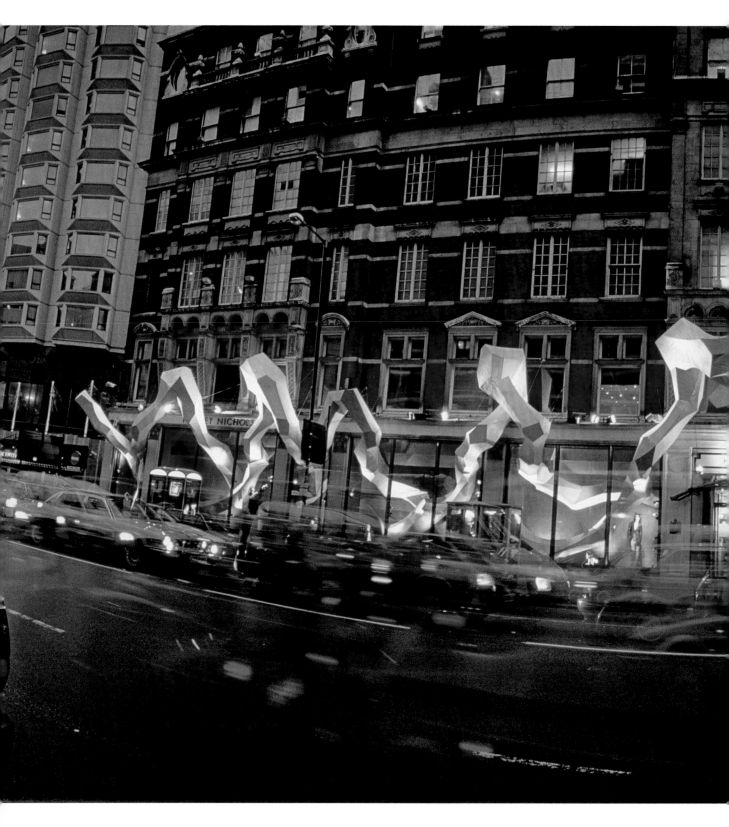

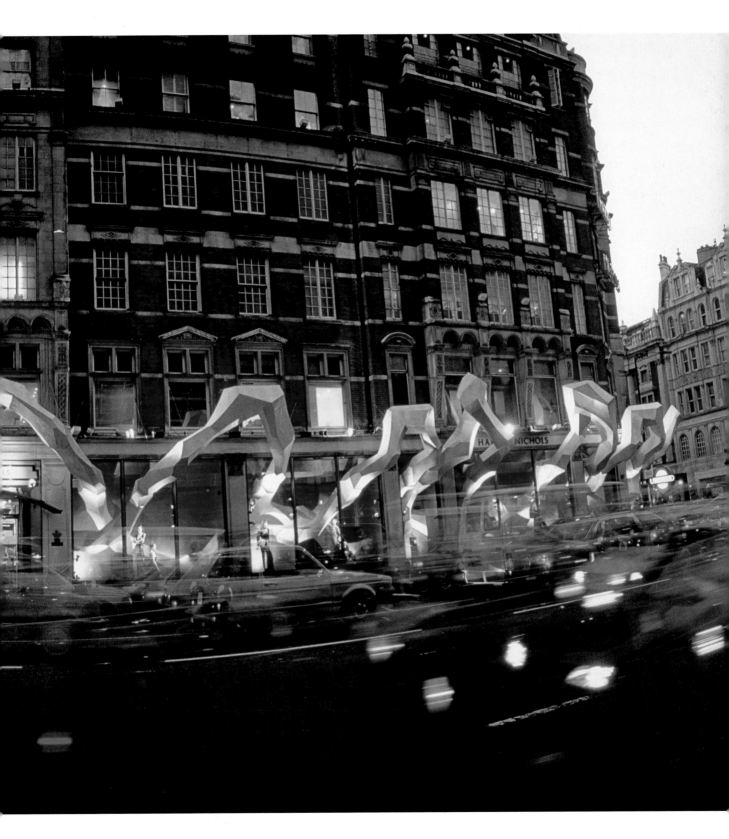

Garden Railings for a London House

1997

Can you make a connection between a garden and the railings that enclose it?

AS PART OF THE REFURBISHMENT of a house in west London, the studio was asked to design railings for its front garden, to replace ironwork that had been removed during the Second World War. Our feeling was that any new railings needed to relate to the existing character of the building, which was a classic Victorian London terrace house, and to the heritage of architectural metalwork in the local area. Our proposal was to fabricate a set of traditional black-painted, spear-topped railings and prise them apart to insert plants in terracotta pots, which would be held between the vertical elements. The hostility of the spears, with their language of war, was cancelled out by the peaceful calming quality of the plants.

Christmas Card

How much work can you get the Post Office to do for 21 pence?

IN MY FIRST SATURDAY JOB, which was in the packing depart-
ment of a mail order cycling equipment supplier, I was once sent
to the nearby post office to buy £2,000 worth of postage stamps.
The sheets of tiny rectangles with perforated edges and Queen's
heads on them looked charming and precious and it seemed
funny that a sheet of two hundred £5 stamps, worth £1,000,
was the same size, had the same high print quality and carried
an equal number of Queen's heads as the sheet of two hundred
halfpenny stamps, worth just £1.

Years later, I wondered how the Post Office would react
if we used as many stamps as possible on our Christmas cards
to make up the value of a second-class stamp, which at that time
was 21 pence.

Our idea was to create Christmas imagery by arranging
twenty-one one-penny stamps in the shape of a Christmas tree, stuck down on
to a piece of card, with the address written at the bottom, as if it was the pot
of the tree. As the Post Office has to postmark every stamp with the date and
place of posting so that nobody can use it again, the postal workers were forced to
decorate our Christmas trees with circular postmarks that looked like Christmas
tree baubles. If halfpenny stamps had not already disappeared from circulation,
we could have made our trees from twice as many stamps.

Hugh Heatherwick
Flat 35, Bridge Wharf
230 Old Ford Road
London E2 9PR

Image Bank Award

How can the awards in a set relate to each other?

COMMISSIONED BY AN IMAGE ARCHIVE COMPANY to produce seven awards to be given out to its staff, we gave ourselves the task of creating seven objects that had value individually and a collective presence when brought together. To form a symbolic bond between all the winners, the awards that we designed fitted inside each other, like a set of Russian dolls, each part of the same family but at the same time different.

The pieces were made from a single substantial piece of polished stainless steel plate, 70 mm thick, cut to shape with high-pressure jets of water mixed with abrasive powder. We collaborated with a company that normally machines armour plating for the British Ministry of Defence. This was the thickest metal they were able to cut and we asked them to make their machine work especially fast, to make the blade of water waver, giving the cut edges an artistic quality, like draped fabric curtains. Because the sliced sides have such a highly textured matt finish, the front faces look particularly shiny and precious.

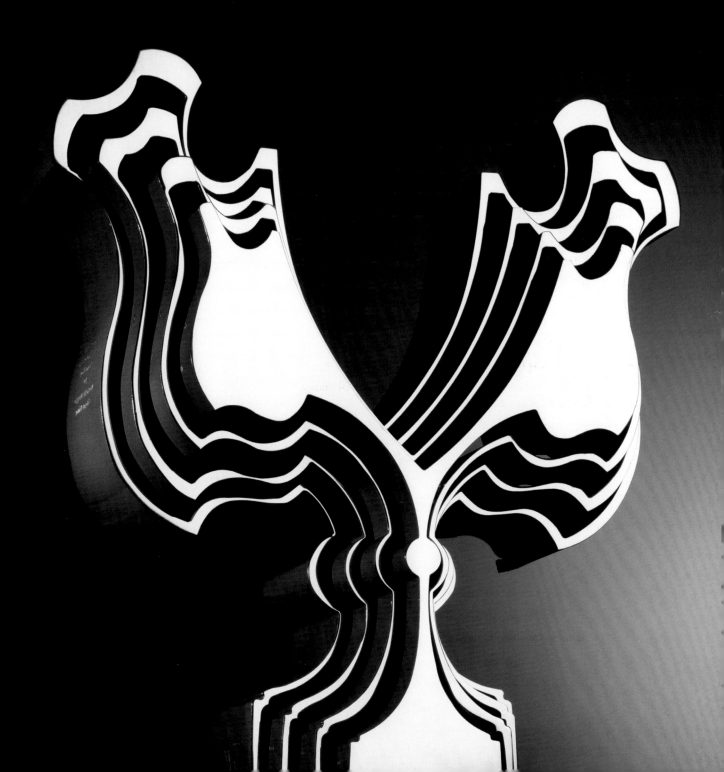

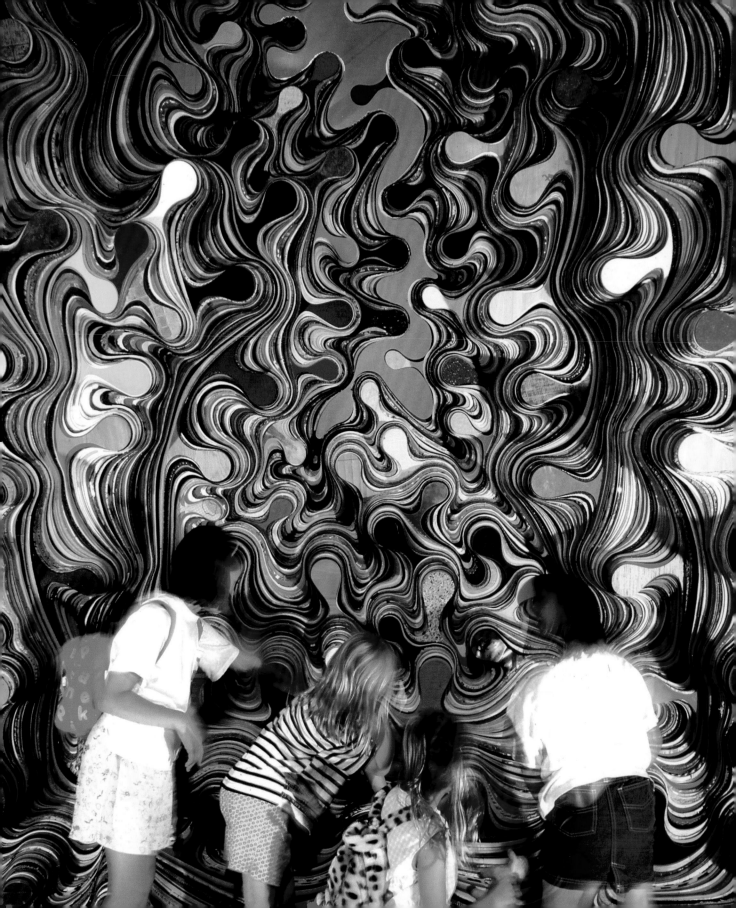

Materials House

*How do you engineer a structure
using 213 materials without giving
any one greater importance?*

THE SCIENCE MUSEUM IN LONDON commissioned the studio to produce an exhibit called the Materials House for a new gallery about materials. The brief was to design a structure that would show everything that anything can be made of.

At first, we wondered what to make this house out of. The implication was that we would choose one main material to build the house and stick all the other materials on to it. But we did not want to give one material a more important role than any of the others.

Studying design at Manchester Polytechnic, I was able to go into the college's material stores and see piles of copper sheeting, racks of different kinds of glass with exotic finishes and different textures, bundles and reels of nickel-plated wire and stacks of wooden planks. In some ways it was depressing to go into the stores, because these materials were already gorgeous. They seemed to be defying you to do something with them that made them more beautiful than they already were.

When the Science Museum sent us the box full of the materials that we were to use, it was disappointing. They resembled manufacturers' free samples, each one the size of a small tile, and seemed inconsequential, even pathetic. With materials capable of such phenomenal things as conducting electricity or protecting spacecraft, the challenge was to find a way to do justice to their capabilities.

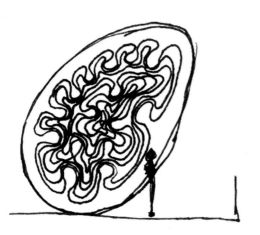

We asked ourselves if, instead of showing tiny pieces of each material, we could have a sheet of each material as tall as the gallery. If we fused sheets of this size together, we could make the world's biggest sandwich of materials and carve away at it to reveal the surfaces of the materials, like creating our own geological strata.

The form of the sandwich is a simple rectangle, the height of the gallery, 6 metres high and 3 metres wide. It contains 213 materials, each carved to reveal its surface. Every layer is different: the first one is simple and quiet, but the following layers mutate and mutate until the final one is completely contorted.

To make sense of the project and to be able to build it, we needed a single massive drawing representing all the layers at the

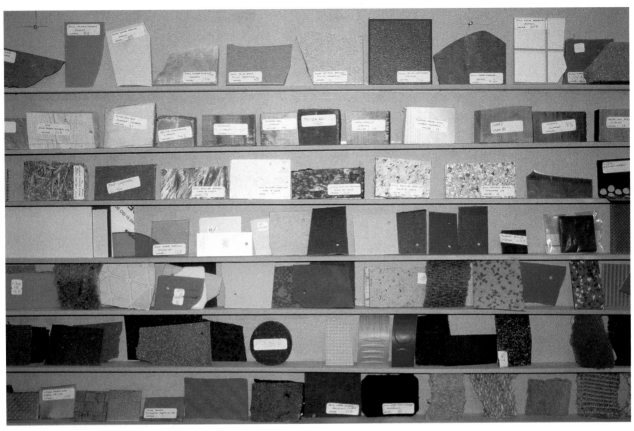

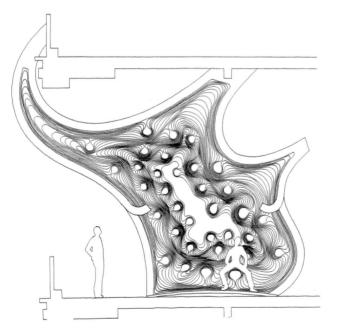

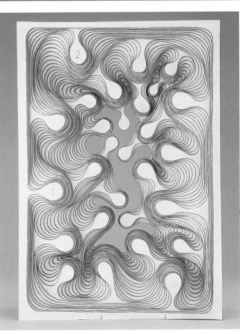

same time. We assumed that a computer might be able to help us with the design but we found that the lines generated by a computer had no spirit. In the end, to get the quality of curves that we wanted, a very patient designer in the studio spent three months hand-drawing each one of the thousands of metres of lines into a computer.

The project was logistically challenging. As each layer was made from at least ten pieces, the project consisted of more than 2,500 unique elements. We had layers of different types of plastic, textiles, wood, stone, papers, rubber, glass, copper, gold leaf, materials made by recycling other materials and materials used in the aerospace industry. They were sourced from different suppliers and many were donated, requiring lengthy correspondence. Every layer was a different shape and thickness and cut by different companies. On top of that, many of the materials did not come in sheet form, so we had to convert them into flat layers before they could be cut to shape. There was a huge amount of project information to manage and many opportunities for things to go wrong.

The Welding Institute advised us on the project, pointing out that we needed to be careful about the order of the layers. Because certain materials generate an electrical charge when they sit next to each other, we were at risk of creating a giant battery.

The piece was assembled layer by layer on the floor of the Science Museum, lying on its front, a process that took many weeks. Then the 4-tonne piece was hoisted up, allowing us to see it for the first time, while a member of the team played a sailors' shanty on the accordion: 'Heave ho and up she rises!' The Materials House is about as visually rich as it is possible to be. You look at it and your eye is full.

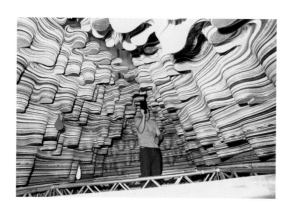

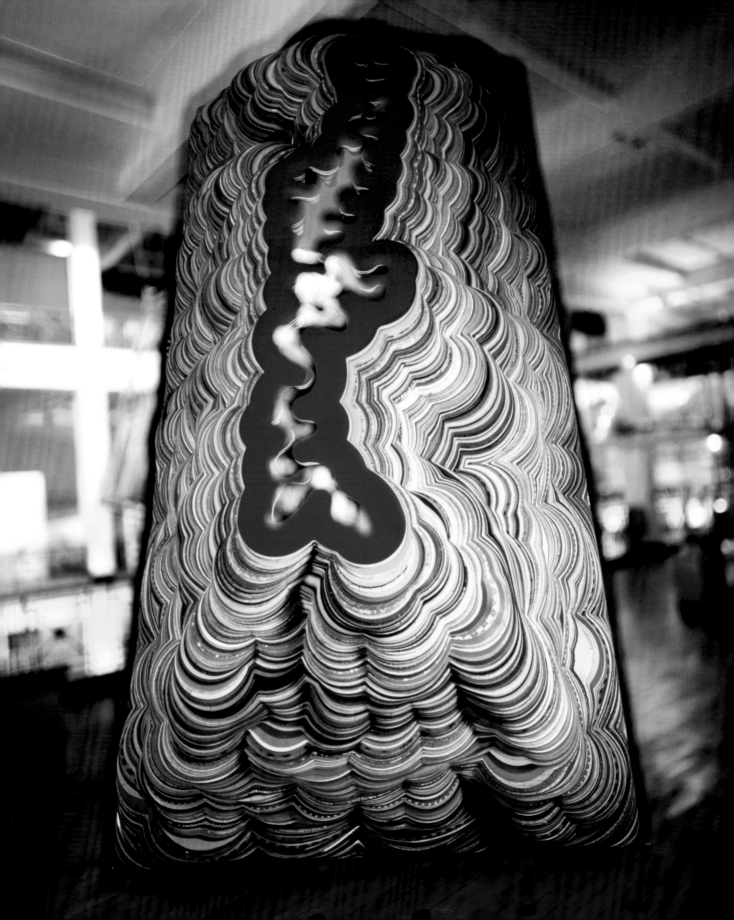

Installation

*How much three-dimensional form
can you give to flat boards?*

THE STUDIO WAS ASKED TO DESIGN an installation that would be in place for
one night at a party to celebrate the work of D&AD, an organization that
champions the creative industries. They wanted to show text and pictures that
would be displayed on computer monitors but felt that, to encourage people to
look at the screens, they needed to do more than put computers on tables.

Using the largest available wooden sheets, 3 metres high and 50 milli-
metres thick, we constructed a series of small buildings to house the screens by
cutting hundreds of concentric, radiating circular shapes, which turned the flat
sheets into vast contoured forms when they were telescoped outwards. By leaning
them against each other, we transformed these manipulated sheets into structures
that you could enter, with surfaces suspended inside for the computers to sit on.

Having pre-cut hundreds of metres of curving lines into the heavy boards
with jigsaws, we loaded the flat pieces on to a lorry. Once at the venue, they were
pulled out into shape to make the three-dimensional sculptural objects.

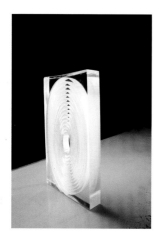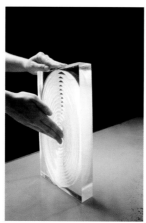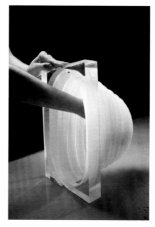

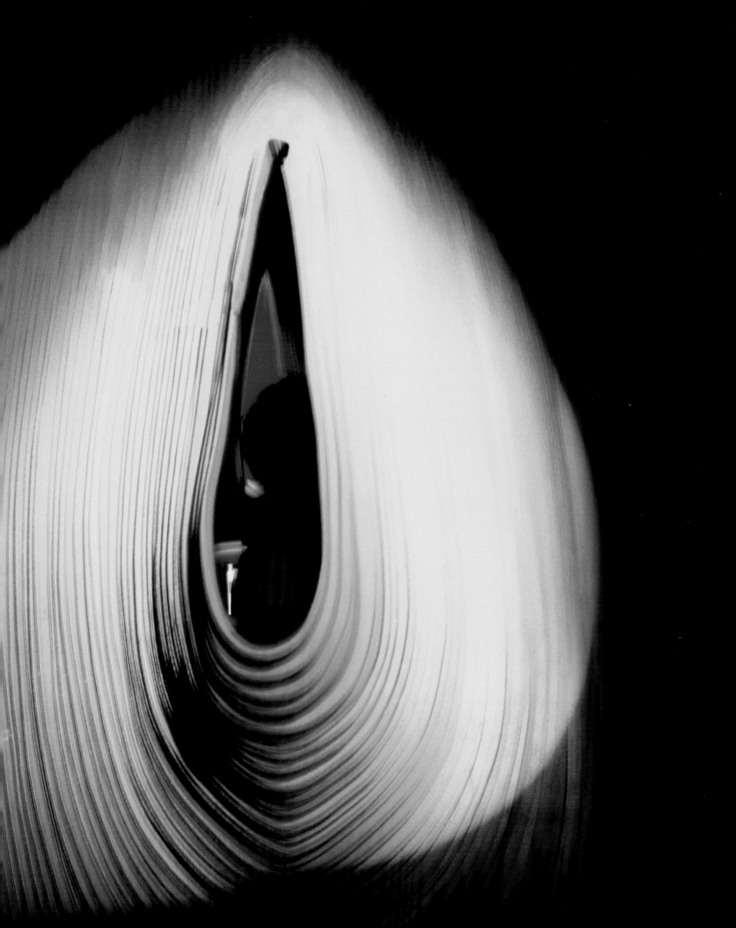

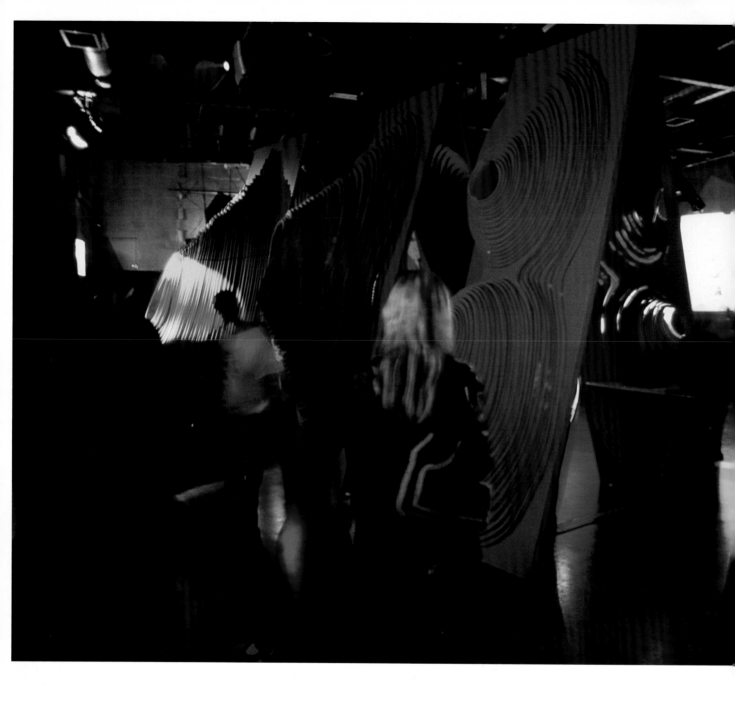

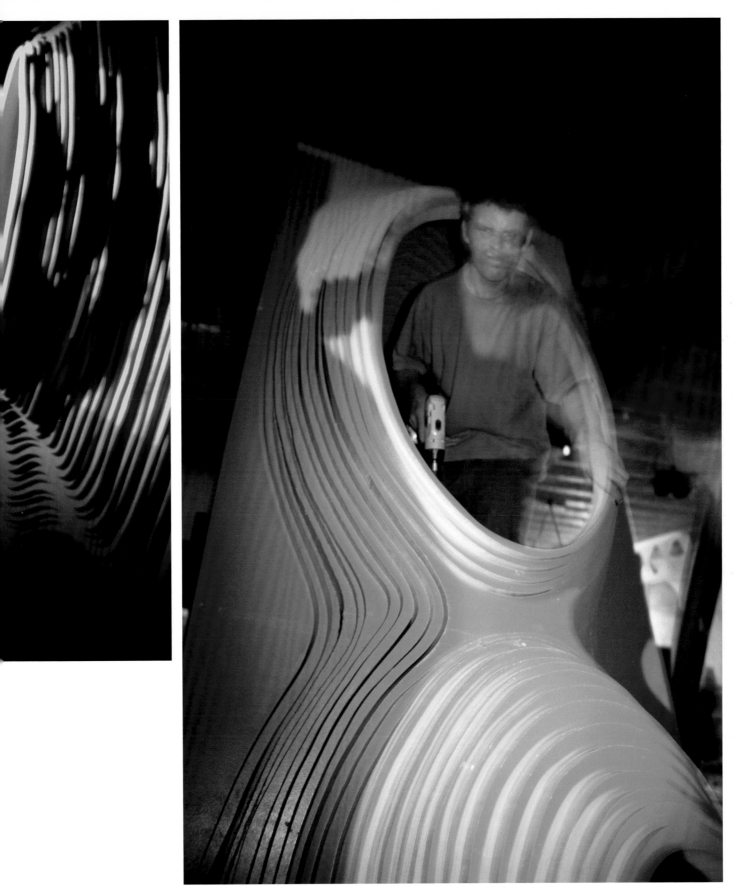

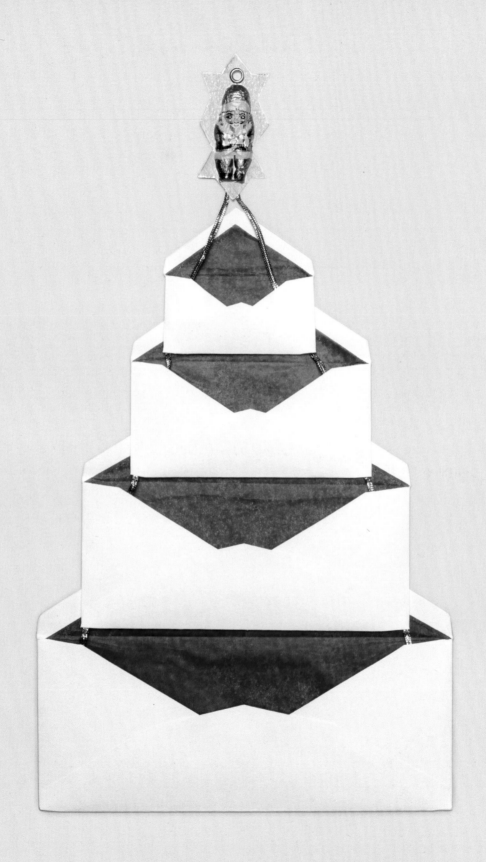

Christmas Card

*Can a Christmas card be
bigger than its envelope?*

THE IDEA FOR THIS CARD came from feeling sorry for the envelope that normally gets thrown away as soon as someone has taken the Christmas card out of it. We wondered if the envelope could avoid its usual fate by being the card itself.

You receive what looks like an ordinary white, sealed envelope, lined with green tissue. When you open it, you find a second smaller envelope inside. Inside that is a third envelope, which is even smaller, and inside that a fourth one, a miniature envelope that contains a tiny chocolate Father Christmas. The telescoping, green, tissue-lined envelopes are connected to each other with pieces of ribbon, so that when you hang them up, they dangle one below the other and form a surprisingly large Christmas tree.

Blackburn Emergency Platform

Can a wall shelter you from the rain?

THE STUDIO BECAME INVOLVED in a project to improve a railway station in the north of England. Three elements – a windbreak, a rain canopy and an artwork – were being separately commissioned for the station's emergency platform, where trains stop when the other platforms are in use. Our challenge was to fuse the three elements into a single proposal.

The rain canopy would stop rain running down the ramp into the tunnel that connected the emergency platform with the rest of the station; the windbreak was to shelter the station from the wind sweeping across the main platforms. We felt that if we solved these functional requirements in a distinctive way, there would be no need for any additional artwork.

Our idea was to take the windbreak, which was a 140-metre-long wall along the length of the platform, and twist the entire structure above the entrance to the ramp through 180 degrees, to become a canopy. As the vertical element twists, it forms a horizontal surface that shelters the ramp.

In collaboration with engineers, we developed a structural solution based on aeroplane wing technology, which used a catenary structure of internal steel tension cables within a metal-clad form.

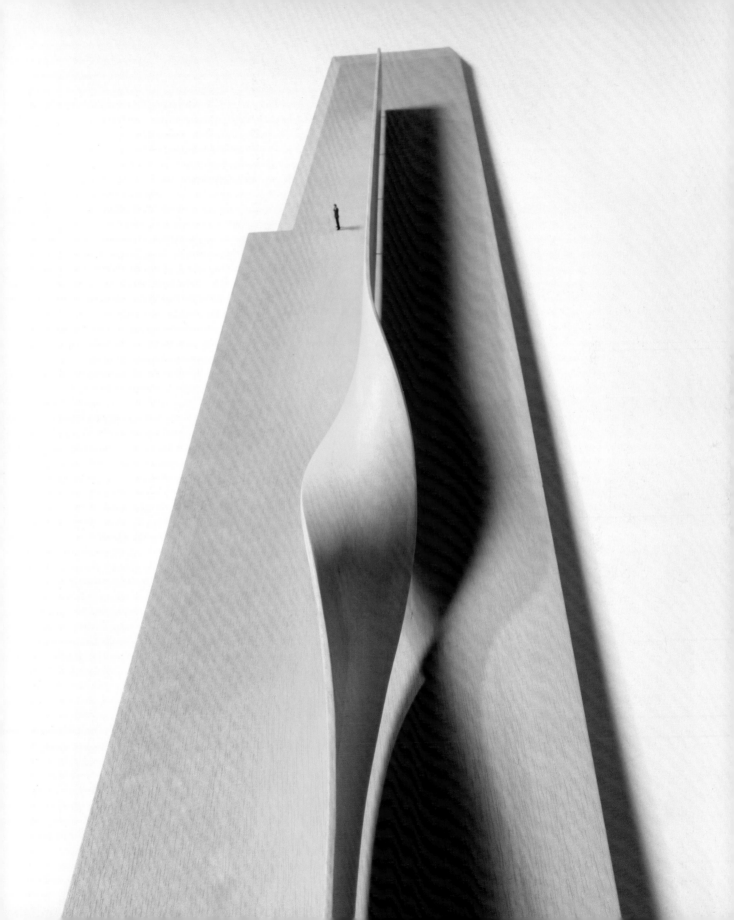

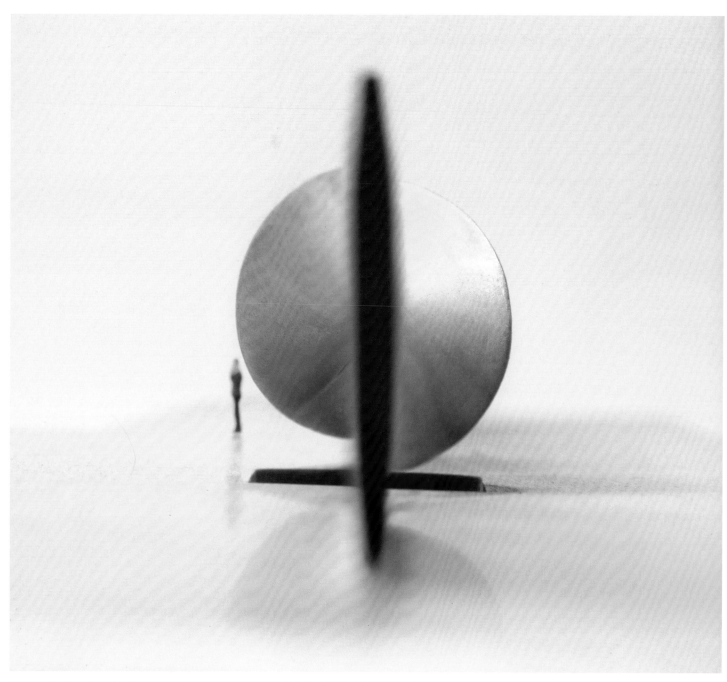

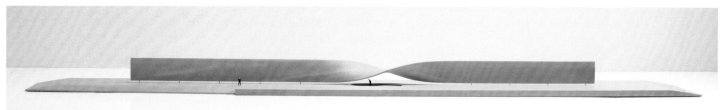

130

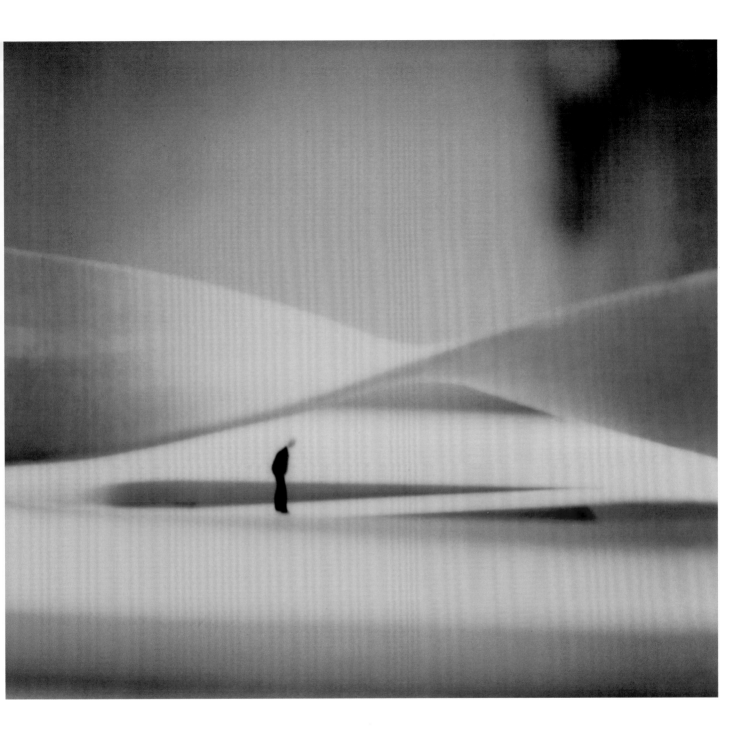

Millennium Dome: National Identity Zone

How do you organize a circular space in a non-circular way, without denying its circularity?

THE STUDIO WAS INVITED TO PROPOSE a design for an exhibition to go inside a circular building within the circular Millennium Dome. The difficulty was that the round geometry of the space made it hard to find a way to break down its formality. The lack of internal corners or spatial differentiation made a homogeneous space in which everything was equal, apart from one disproportionately important place, which was the centre. But if you put something there, everything else became subordinate to that, and the interior easily became too symmetrical and over-ordered.

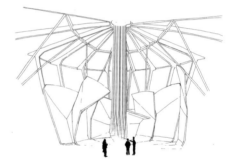

The round building had been designed in sixteen sections, delineated by structural steelwork in the walls and roof. Our proposal was to provide the space with a wooden floor and divide it up, like a cake, into the same sixteen sections and fold up these sections of the floor into dynamic forms to create a landscape of exhibition panels. Though asymmetrical and irregular, the outcome still respected the circularity of the building.

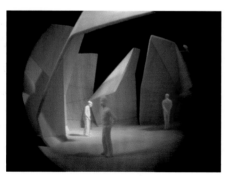
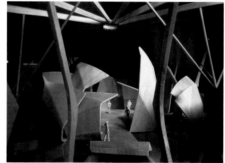

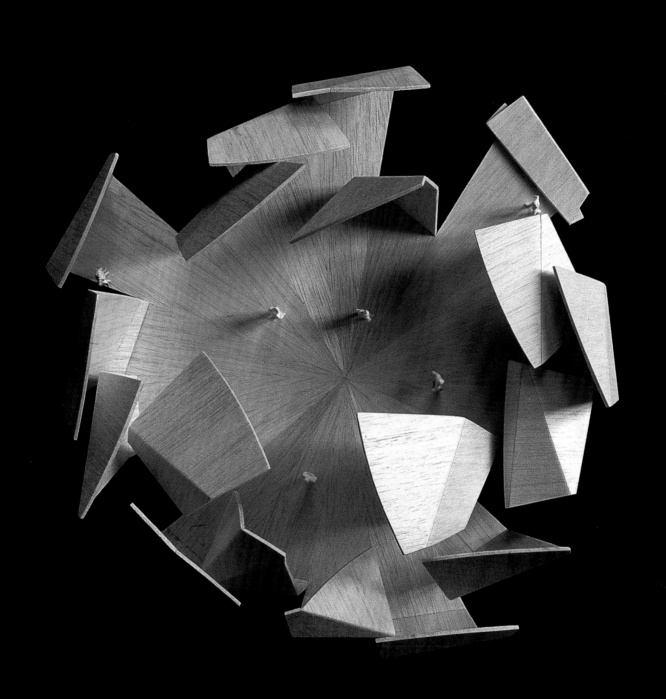

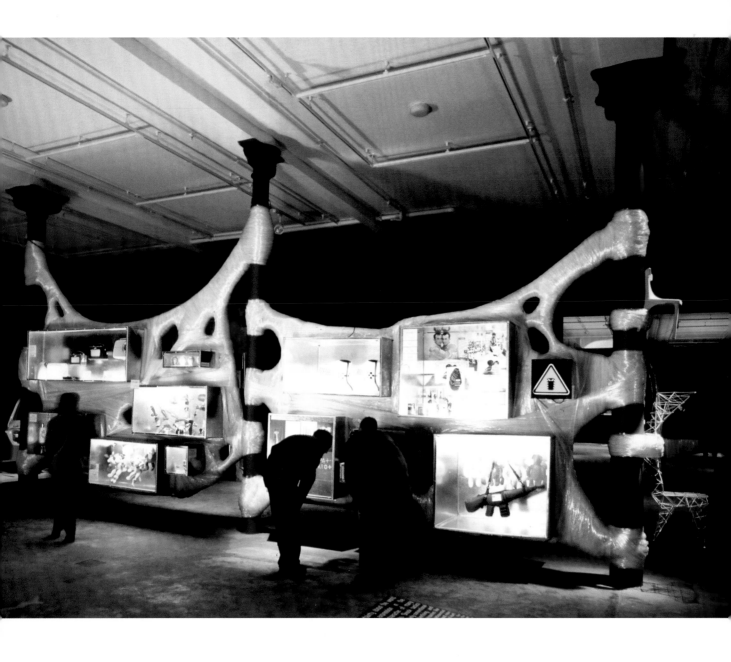

Identity Crisis

How far can you stretch a budget by using a material that is virtually free?

AS PART OF THE GLASGOW 1999 Festival of Architecture and Design, we were asked to design an exhibition of three hundred objects at the Lighthouse, a former industrial building designed by Charles Rennie Mackintosh. The curators' idea was to explore the new strand of irony, provocation and ambivalence that had appeared in contemporary product design.

Exhibitions that travel to a series of venues must fit into many different kinds of spaces, which makes it difficult to relate the design to its setting. But because this exhibition was not going anywhere else, we could look for ideas specific to this space, which was raw, high-ceilinged and distinguished by its large number of cast-iron columns. We could have treated the columns as obstacles and built the exhibition around them, but we became interested in finding a way to make them useful and decided to borrow their structure. We began developing the idea of suspending the objects between the columns, as if a spider had spun its silk around and between all the pillars, trapping the exhibits in its web like flies.

Because the budget was extremely low, the tensile material that would act as giant spider silk had to be very cheap. We explored all sorts of ropes, strings and elastics but nothing was cheaper or silkier than a material we found in our kitchen drawer. We began experimenting with the industrial version of cling film, the thin plastic used to wrap food to keep it fresh. On the roll it looked like a yellowy-green lump of translucent plastic, but unrolled, pulled out and subjected to tension, the material came to life. It looked surprisingly precious, glossy and silky, like the hair of a new Barbie doll. Layered and wound tightly over itself, this ludicrously cheap material could share the structural work with the iron columns.

The objects were put inside inexpensive cases made from folded galvanized steel by a factory that produced air-conditioning ducts. We then lashed them to the iron pillars with 100 kilometres of cling film, leaving nothing sitting on the ground. This space of concrete, brick and cast iron was taken over by a

strangely delicate installation. Lit only by lights set inside the boxes, it became ethereal, as if spun by an alien life form.

Normally, exhibition displays are made in workshops beforehand and installed by a small team, but the nature of our design meant that we needed to use a large team and build on site. Instead of using costly materials and having little money left for labour, we employed cheap materials and concentrated our spending on the labour and skill to transform them. The construction team developed a level of craftsmanship with cling film that almost became a new folk craft. They learned different winding patterns and how to wind with just the right amount of tension as they worked to form the silken tensile structures. As they were being unrolled, the hundred kilometres of cling film made an extraordinary screeching sound.

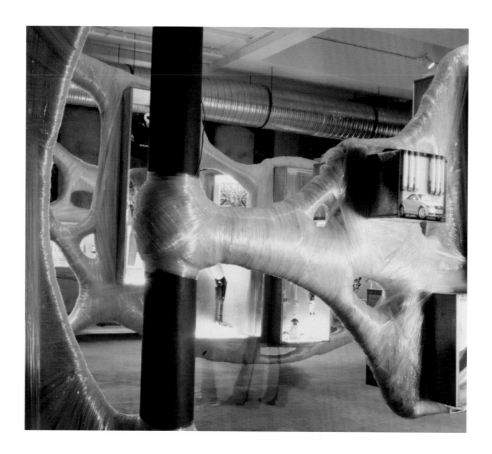

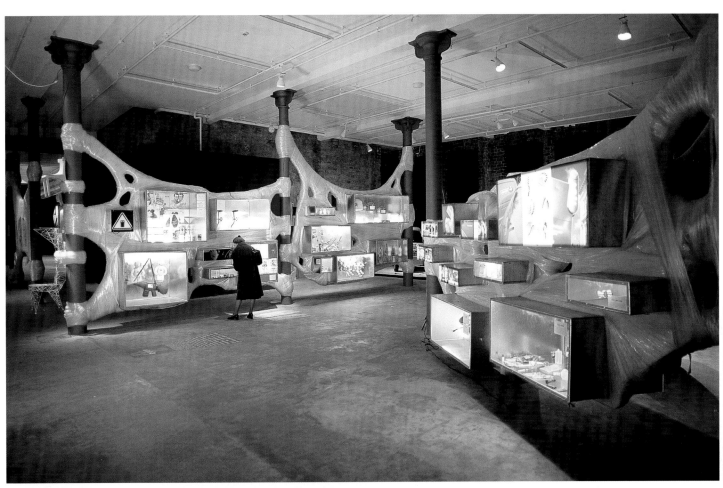

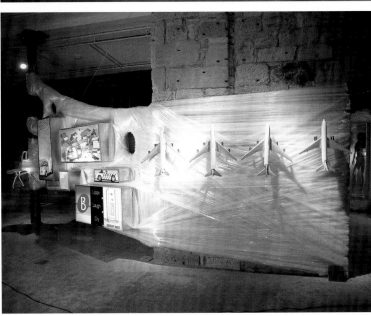

Twin Roundabouts

1999

Roadwork or artwork?

THE STUDIO WON A COMPETITION to design an artwork to be installed on the A13, the main road that goes out of London to the east, passing through Barking and Dagenham. The work was to be sited on a new roundabout, with the A13 passing above but, having seen sculptures stuck on the suburban roundabouts of many towns in many countries, we were wary of the disconnection that can occur between a roundabout and an artwork when the roundabout is treated as an empty plinth for the artwork.

Instead of making an individualized, isolated artefact, we chose to think of it as a special piece of road-building, an integral part of the road improvement scheme. To avoid making a distinction between the craft of road-building and the making of artworks, we wanted it to be made by the highway contractor, using the language and materials of highway design: tarmac, kerb and paving slabs. We also looked at integrating into the scheme a second new roundabout on the other side of the A13, so that the two roundabouts would create a gateway for the road passing between them.

Thinking about the millions of cars that would circle the roundabouts over the years, gradually wearing away the ground and carving out pinnacles of tarmac, like rock formations eroded by the sea, we imagined our roundabout structures taking similar carved-out forms.

With its height equal to its radius, the geometrical form of each roundabout structure is pure. The structures are made from concrete sprayed over tensile stainless steel mesh cones supported on steel posts. Inside each one is a large space that no one will ever go inside, like a sealed pyramid. In construction, with their mesh partially sprayed with concrete, these interior spaces provided an unusual optical experience. Where the concrete faded out, solidity gave way to transparency in a way that was unlike the sudden transition between walls and windows that we are used to. This led to the design of windows for the pavilion that the studio built for the World Expo in Shanghai (pages 442–459).

139

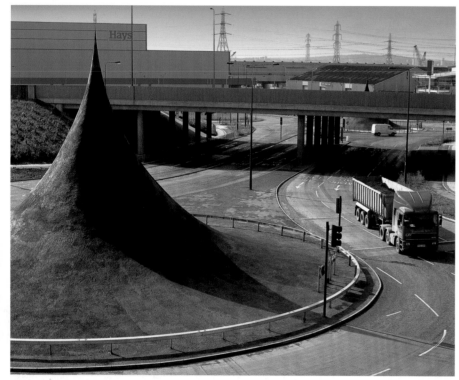

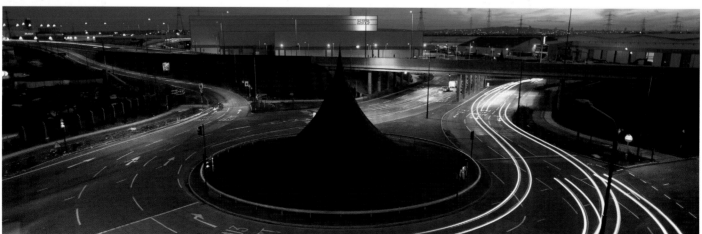

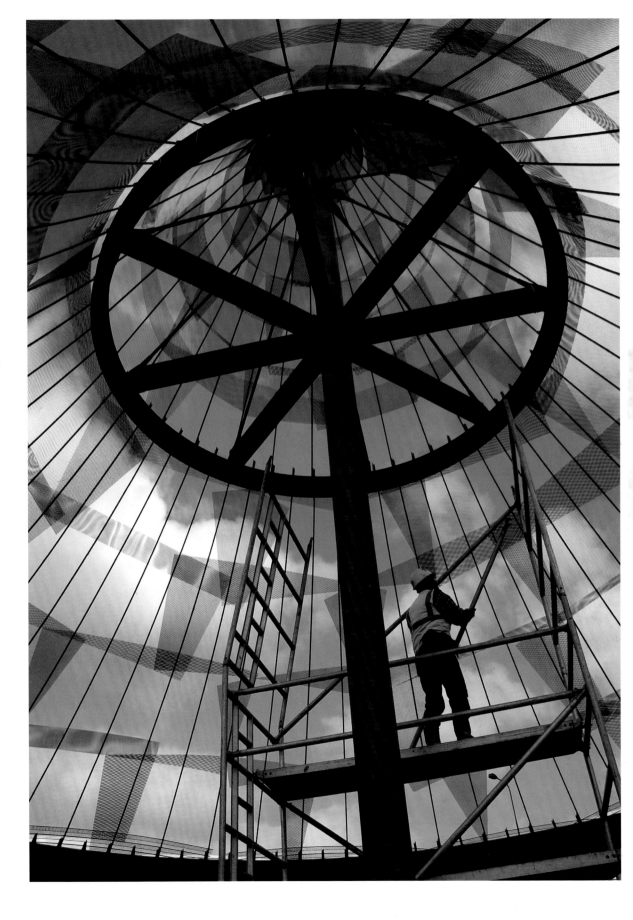

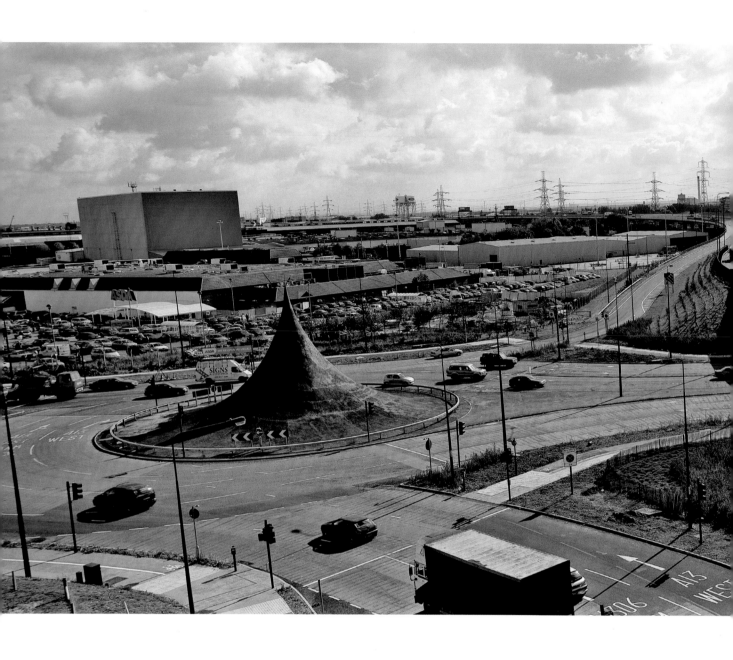

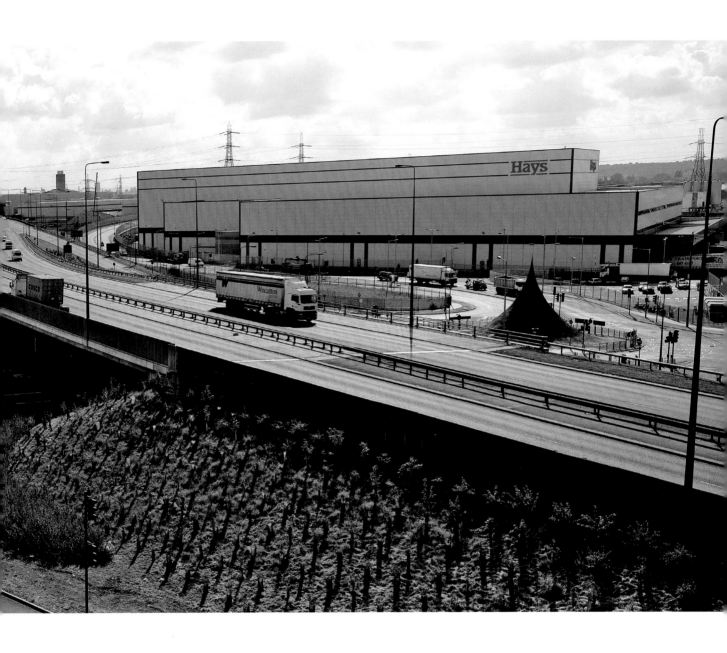

Hairy Building

When asked to put a sculpture next to an ugly building, how do you respond?

WITH THEIR SEVERE SILHOUETTES and ageing concrete, the buildings constructed at Notting Hill Gate in west London in the 1960s were considered by many local people to be cold and alienating. A group formed to look at ways to improve the area and invited the studio to propose a work of art, to be placed on or near a prominent building with shops on the ground floor and offices above.

We felt that the real problem was the poor quality of the buildings and the unpleasant spaces around them and that sticking unrelated pieces of art next to bad buildings would only accentuate how awful they were. To us, the only way to improve the public environment was to treat whole buildings. The question we wrestled with was how to transform a tired-looking rectilinear shape, without pretending that the underlying four-storey building was not there.

The legacy of the postwar building boom was an architecture of soulless boxes – the ubiquitous building objects of my childhood – and architectural fashion at that time appeared to have polarized into either jettisoning all ornamentation or retreating into a pastiche of historical building styles. The studio wanted to sidestep this aversion to ornamentation and had been exploring alternatives that relied on craftsmanship and materials and experimenting with texture on an architectural scale.

Our approach to this project was to engineer the greatest possible contrast with the rigid, hard-surfaced texture of the existing brick and concrete building. Our idea was to embed thousands of protruding hair-like elements in the façade, which would sway in the wind like a field of tall grass. In the same way that hair does not grow from mouths and eyeballs, the hair on this building grows only from its blank façade panels and not from the windows and doors. We liked the idea of thousands of hair-like elements growing from the building, shivering and trembling as a bus swept past.

Though highly textured, the surface remains a direct manifestation of the building underneath, just as the tips of someone's hair are an approximate projection of the form of their scalp. The idea was influenced by the Play-Doh barber shop toy, a hollow plastic man that 'grows' hair when you wind a handle by

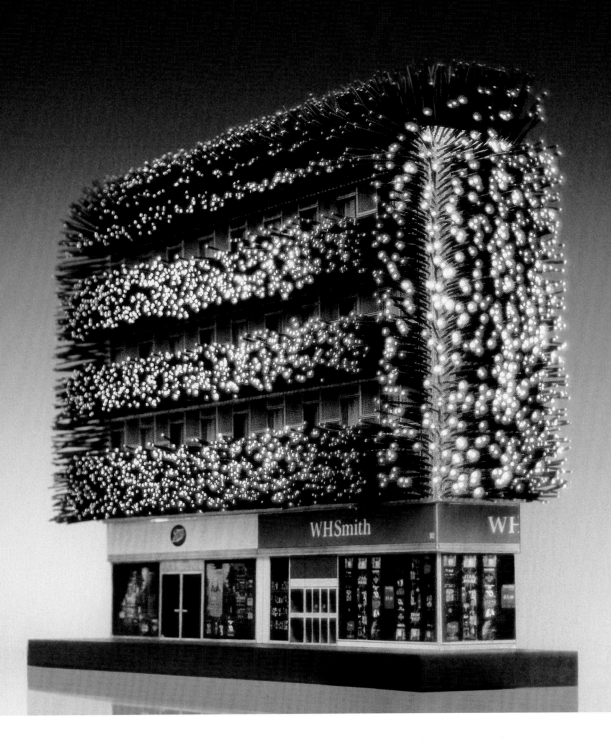

extruding coloured putty out of holes in his bald plastic head. The form of his new hair is the shape of his head, projected outwards. On a square building, the protruding hairs would soften its sharp corners and at night, tiny light sources at their tips would create a shimmering ghost of the façade beneath.

To realize the project, we worked with engineers to formulate a framework of prefabricated steel panels that could be brought to the site by lorry, lifted up and attached to the existing building. Six thousand hairs, made of fibreglass tubes with a fibre-optic core, could then be connected to the pre-prepared fixings.

The scheme did not go forward, but in later projects the studio got the chance to put into practice these ideas about texture in relation to buildings.

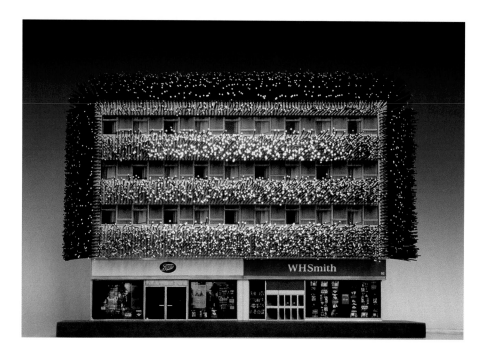

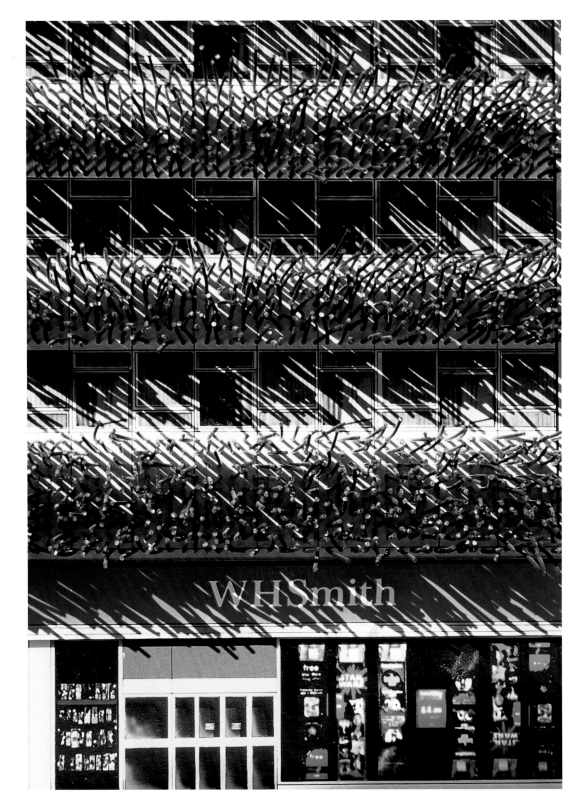

Electric Cinema Façade

Does a window have to be flat?

AS PART OF THE RESTORATION of a historic cinema in Portobello Road in London, the studio was asked to design the façade of the new building that was being constructed next door to act as the cinema's bar, café and meeting place.

Our proposal, developed in collaboration with a glass artist who specializes in making glass baths, was for a transparent curtain walling system consisting of shaped glass panels. These square tiles, 1 metre across, share an identical, three-dimensional form; when rotated relative to each other and repeated in sets of four, they tessellate to create a larger undulating surface that ripples across the building.

The panels are formed with a process known as heat slumping, which involves heating flat glass sheets in a kiln until they deform against a mould. They are then bonded to a structure of vertical glass blades to produce a glass façade with no metal fixings.

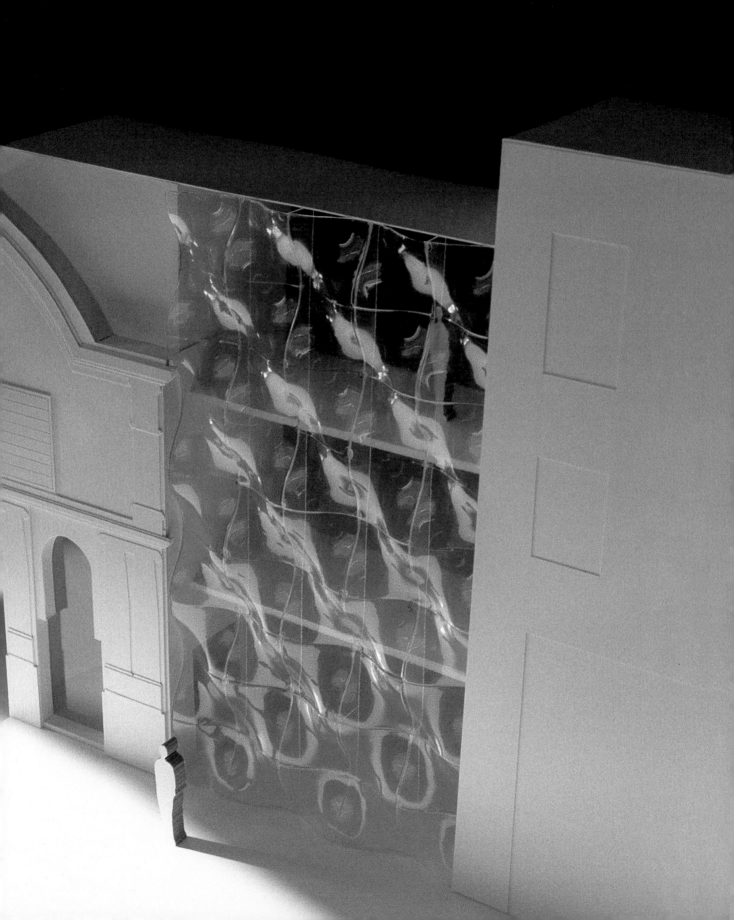

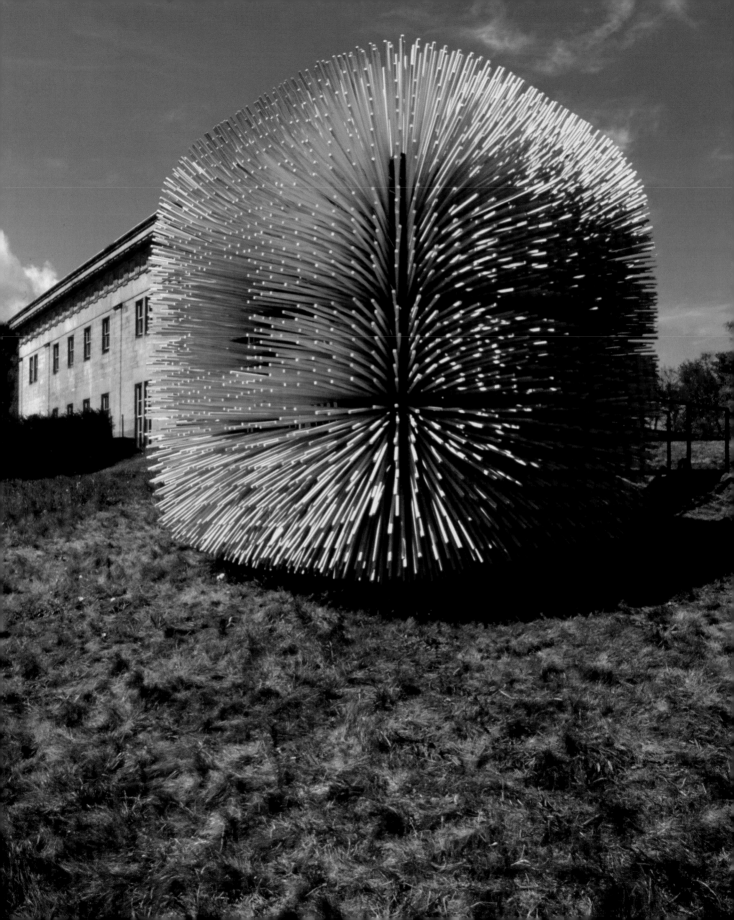

Belsay Sitooterie

*Can a building stand on
the architectural equivalent
of matchsticks?*

ENGLISH HERITAGE APPROACHED THE STUDIO to build a pavilion at Belsay Hall in Northumberland, one of twelve temporary 'sitooteries', a Scottish term for a garden structure in which to 'sit oot'. Folly, gazebo and sitooterie form a category of buildings that fascinated well-to-do Victorians, who had these special structures built in the grounds of their country homes. It was a surprising commission to come from an organization better known for conserving old buildings than creating new ones.

Although the budget for each sitooterie was small, it was an opportunity for the studio to try out an unbuilt idea for a hairy building (pages 144–147), as well as exploring a different way of making a building structure. An individual bristle of a scrubbing brush has little strength, but a whole brush is remarkably strong when you push down on it. Could we make a building stand on the architectural equivalent of bristles, a multiplication of single, delicate structural elements?

New buildings are generally smooth boxes, but this project experimented with the silhouette of a building against the sky. How far was it possible to splice building and sky together and blur the edges of a building? It was an exploration of texture on an architectural scale – taking a box, applying a texture to it and magnifying that texture to a point where it changes your perception of the form. We also felt that large building objects tended to be flat and textureless, their interest spread thinly over their form; yet smaller objects, like jewellery or clothing, often exhibit a rich concentration of detail. Could we apply this level of intricacy on an architectural scale?

The building is a cube with hairs embedded in every surface, like hundreds of thin legs, holding it raised above the ground. Individually, each leg is delicate and easily snapped in two, but together the legs combine to carry the weight of the structure.

The Sitooterie consists of a steel and plywood box, 2.4 metres square, perforated with 5,100 holes, with 1-metre long, ash wood staves fixed into each one. The staves project perpendicularly from every face of the central box, but

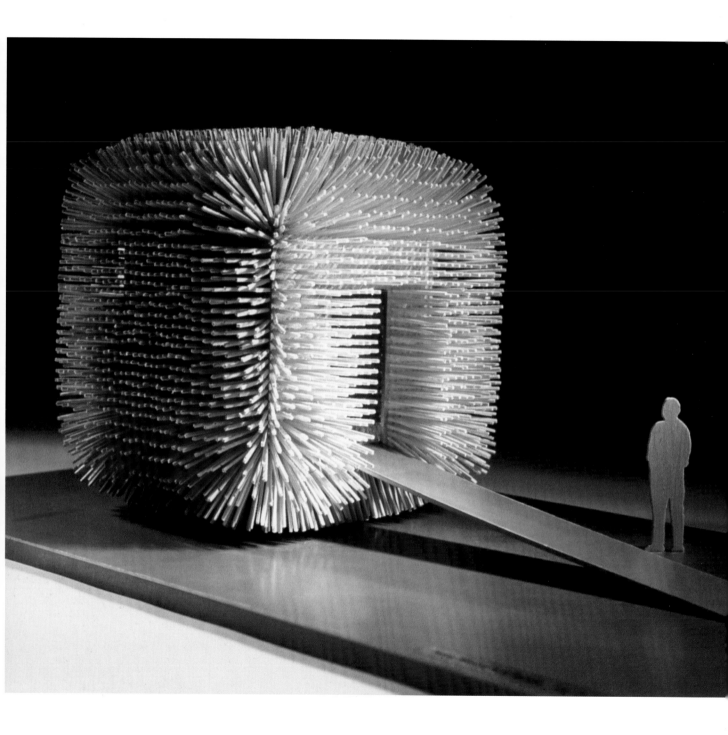

radiate around the corners. The rounded ends of the staves protrude slightly into the box, giving the interior a dotted texture, like tactile paving. Some are allowed to protrude further into the space to support seating.

The Sitooterie was in place throughout the summer, when Belsay Hall received record numbers of visitors, and was dismantled in the autumn.

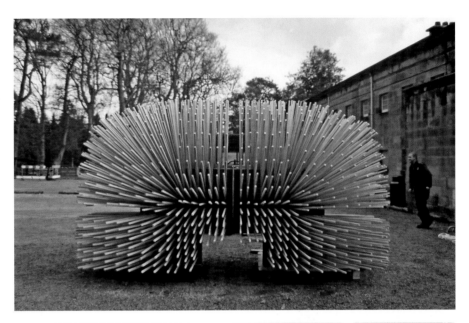

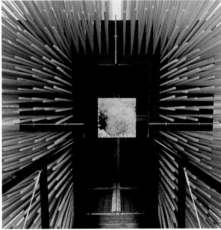

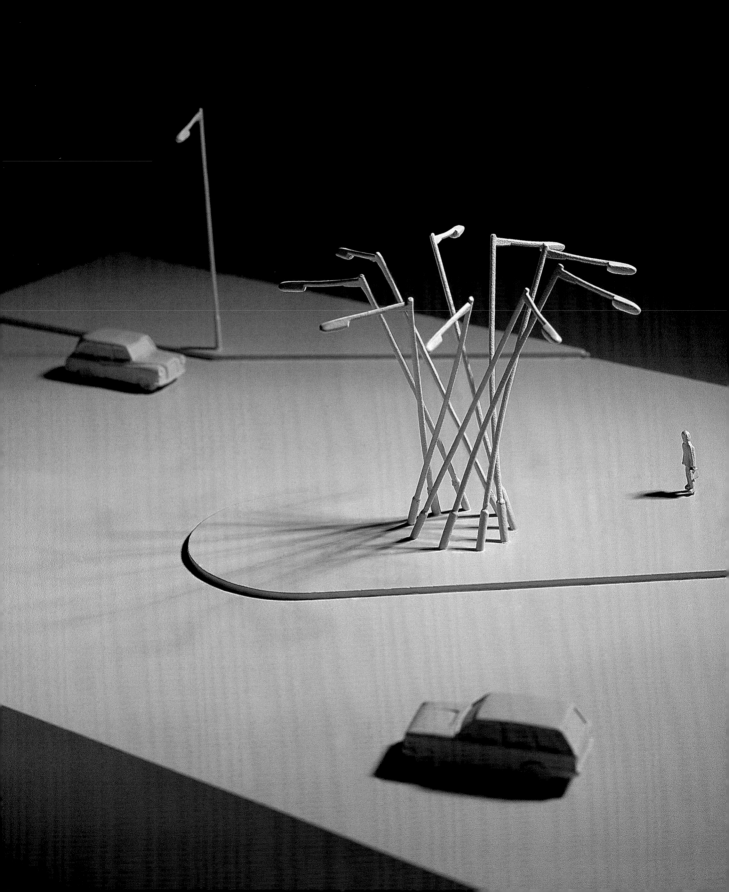

Street Chandelier

*Can conventional street furniture
be used to furnish a street in an
unconventional way?*

A BOROUGH COUNCIL IN SOUTH LONDON wanted to demarcate its boundary with neighbouring boroughs by installing gateway structures on two of the main roads into the borough. As London's streets are already littered with objects such as safety barriers, bollards, lamp columns, traffic notices, signposts and utility boxes, we began thinking about how we might use the street furniture that existed already, instead of adding to the clutter. The proposal we developed was to use ordinary street lamp columns – the biggest item that local authorities customarily install – to celebrate the gateway.

On the first site, a road junction with a central traffic island, we planned to set up a circle of leaning lampposts that had the combined effect of a giant decorative lighting feature, a grand version of the chandeliers that had become fashionable in domestic interiors. This chandelier would be made not from crystal but from ordinary street lighting components.

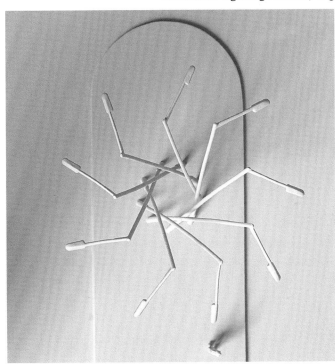

The second gateway, which was for a straight section of busy road, was to consist of a line of normal street lights on each side of the road, with the lamps on one side of the road leaning one way and those on the other side leaning the other way, so that they formed a dynamic relationship across the road without building over it, in a way that suggested a gateway.

The two compositions are very affordable to build because they use ordinary grey lamp columns that can be erected by the normal contractors, the only difference being in the angle and geometry of their placement.

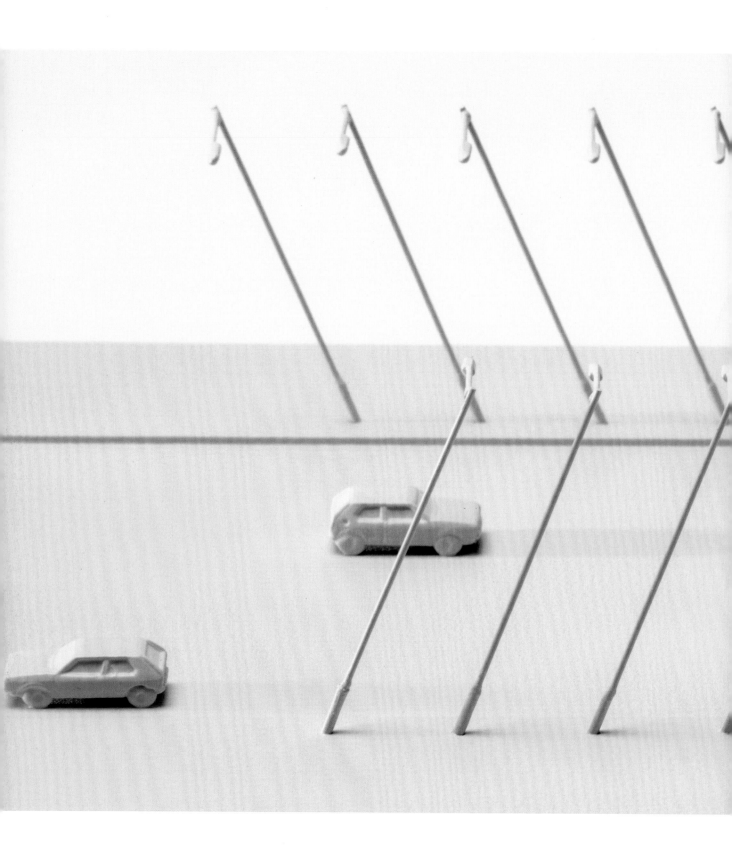



Barking Square

Can fragmentation create cohesion?

COLLABORATING WITH A TEAM of architects and landscape architects, the studio was shortlisted in a competition to design new buildings next to Barking Town Hall in east London, a space that, like much of the borough, was in need of regeneration. The brief was for a new public square with a library, as well as retail and residential buildings in the surrounding area. We felt that the best way for this project to act as a catalyst for the future regeneration of the borough was to bring together the disparate requirements of the brief into a single design idea that would lend the area a more cohesive identity.

Influenced by an event in the town's history – an explosion at an engineering works in Barking Creek in 1899 – our proposal explored the notion of a single large building, containing all the scheme's functional requirements, that had been detonated in front of the town hall, dispersing pieces of the building throughout the town. The largest sections constitute libraries, shops and apartment blocks and the smaller fragments, displaced as far as the creek, form bus stops and seating pieces. Where the pieces have been broken away from each other, the façades are jagged and crystalline, a surface created with faceted glass. Where buildings carry the skin of the original notional entity, their curved surfaces consist of a combination of green patinated copper, small windows and embedded planting. As separated pieces of something that was once whole, the buildings are a family with a shared story, rather than an assortment of disparate elements.

Shopping Centre

How do you treat the façades of a building when it does not need any windows?

THIS PROJECT WAS A PROPOSAL for the skin of a new shopping development in the north of England. As the building did not need windows apart from those at street level, we suggested that, to prevent it from having blank elevations, its surface should be given an emphatically three-dimensional treatment.

We designed a large, undulating tile module, which would give the building a repeating sculptural surface that created variations of light and shade and texture. Each 3.5 square metre tile could be made from glass, concrete or resin and would be based on a single, tessellated form.

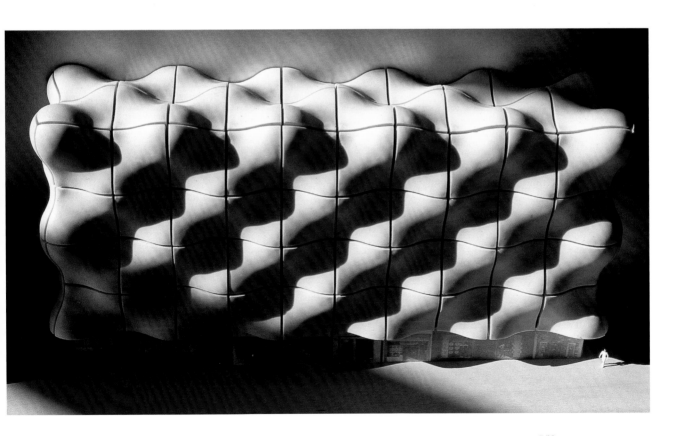

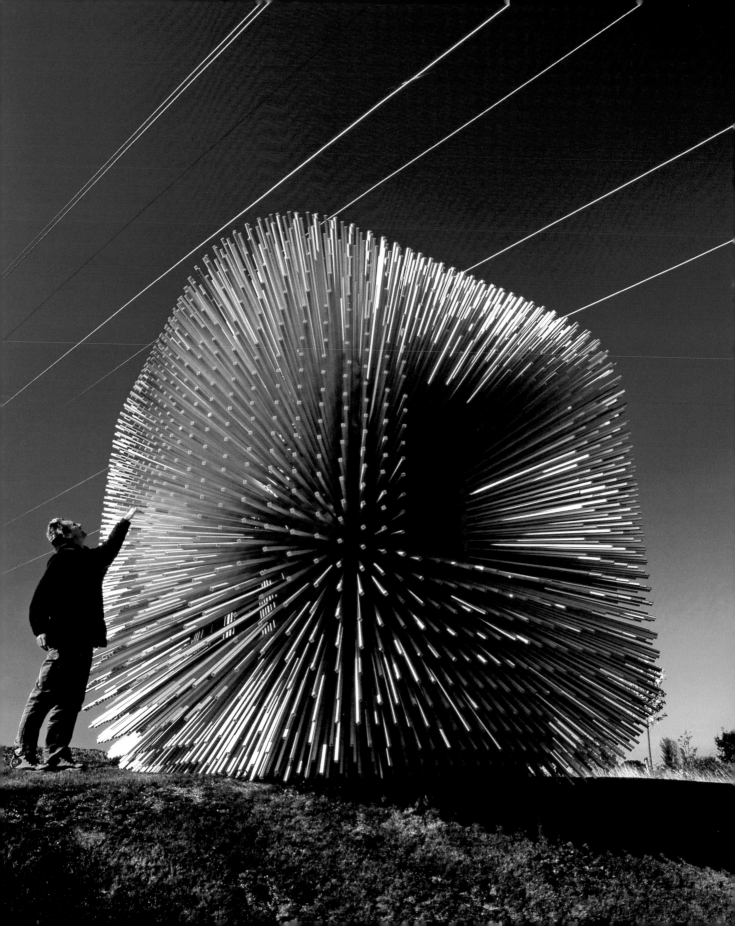

Barnards Farm Sitooterie

2000

How can a small building have four thousand windows?

THE TEMPORARY SITOOTERIE AT BELSAY HALL (pages 150–153) led to a commission for a permanent version, built with a new specification, for a public sculpture garden in Essex. To make this sitooterie into a permanent structure, we used anodized aluminium plate for the main box, instead of plywood, and hollow, square-section, aluminium tubes for the staves, instead of ash wood. The choice of aluminium tubes transformed the project from the original experiment with structure and visual texture into a building that also possessed an optical quality, with its four thousand staves that protrude from the central cube acting as four thousand windows. Each one is individually glazed with a tiny orange, transparent window that keeps out rain but allows warm-coloured light to pass through to the internal space.

The permanent sitooterie also has a different geometry from the first one: its staves point to an imaginary point at the centre of the cube, instead of projecting outwards perpendicular to the surfaces of the box. This means that every hole in the box is drilled at its own unique angle, giving it a distinctive geometry and creating beautiful patterns on the walls, floor and ceiling, from the rows of angled, circular holes. Another effect is that if you stand inside the completed building with your head in the absolute centre, all the windows point in your direction and the daylight suddenly hits you at this optical sweet spot.

The central cube was not constructed by a conventional building contractor, but by an engineering company that specializes in milling aluminium for the aerospace industry, so the structure was made to tolerances normally reserved for small machine components, not buildings. Inside the sitooterie, this level of precision feels extraordinary. No mechanical fixings and no welding went into the construction, but instead the pieces were bonded together with adhesive. As in the Belsay structure, some staves extend inwards from the cube to form furniture and are machined to support seats made from thick aluminium plate, the same machined plate also being used for the door and window shutters.

161

By night, a single powerful light bulb, hanging at the exact centre of the space, throws light out through the thousands of glazed hollow aluminium staves. At the opening event, after it grew dark, a member of the studio went inside the sitooterie with her baby daughter and started walking around the central light, lifting the baby up and down. From outside, their figures appeared silhouetted in the dots of light at the end of the staves. Shrinking and growing as they moved nearer or further from the light bulb, the figures turned the sitooterie into a live, low-tech, computer-like display screen.

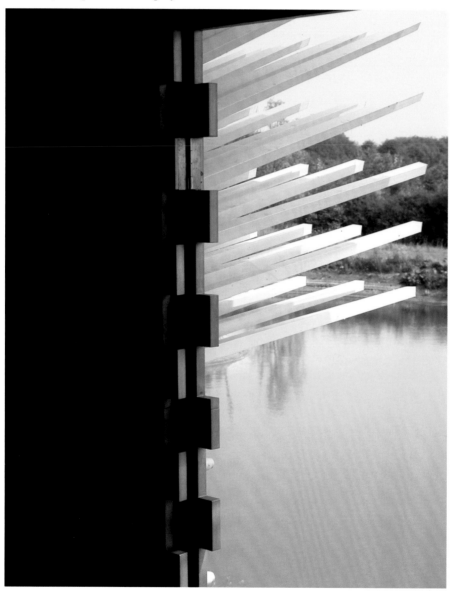

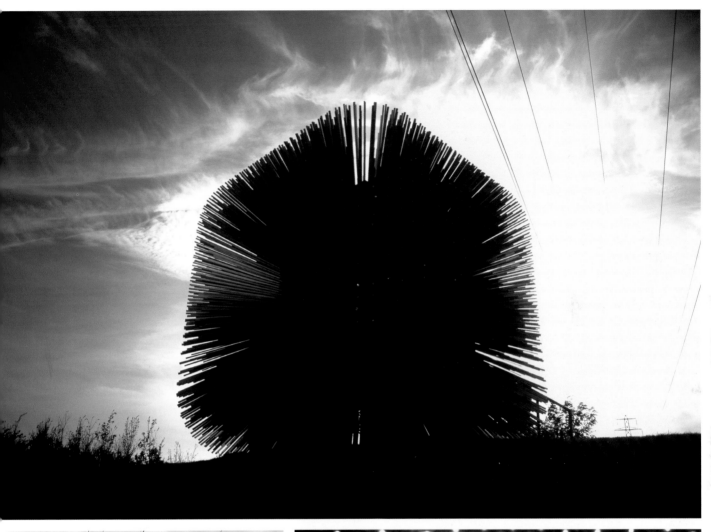

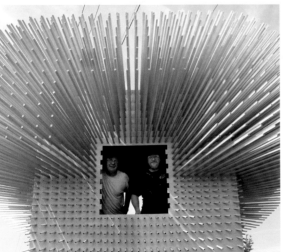

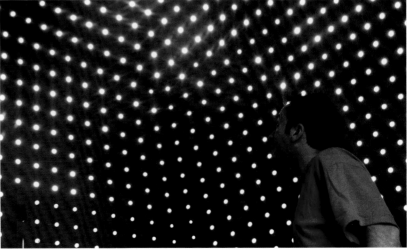

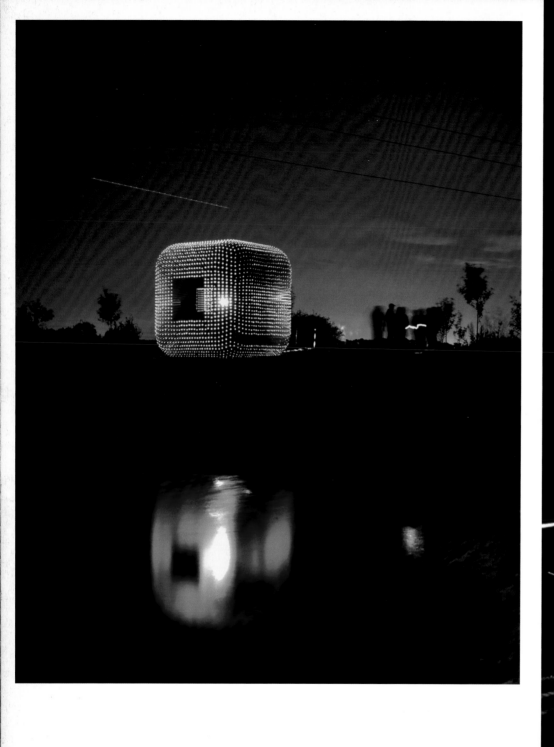

Double Clothing

*How much neck can a polo
neck have?*

GETTING A SORE THROAT FROM TALKING so much, I often wore jumpers with long, rolled-over necks, called polo necks. Wondering if there was any limit to how much fabric you could roll over, I imagined that if a polo neck went berserk and continued growing, you could end up with an entire garment that rolled back over itself.

Working with a dressmaker in the studio, we discovered that we could make various double-layered garments with curious geometries, which opened out to be conjoined-twin clothing objects. Jumpers could be connected by the neck, the sleeves or the bottom hem, trousers could be joined by their bottoms and fingerless gloves could be made by merging together the fingertips.

We made a set of prototype garments from delicate fabrics, including skirts, dresses, tops, trousers and gloves, which were unusual objects to put on and whose folded necklines, sleeve ends or trouser bottoms gave them a softer appearance.

Zip Bag

Can you make objects out of long pieces of zipper?

DISCOVERING THAT IT WAS possible to buy, on a roll, a single 200-metre length of zip, I began researching ways to use it, not just as an opening device in a garment but as a main material in its own right.

Experimenting with sewing together spirals of zip ribbon by stitching the coil of the zip on to itself, we made three-dimensional objects that could vanish into a pile of zip when they were unzipped and re-form when zipped back up. We made many different kinds of bags and vessels and even a dress out of very long lengths, but it seemed that the bag, made with a single length of zip, was the best use of this idea.

After approaching the French luxury goods company Longchamp, we collaborated on a new version of the design that incorporated strips of fabric between the toothed edges of the zip so that the bag could open up and double its size. Our structural engineer had the task of carrying out surprisingly complex calculations to find a geometry for the bag that would allow it to do this without twisting. Having originated as a student experiment in 1993, the resulting product was manufactured and put on sale worldwide in 2004 and became a bestseller for Longchamp.

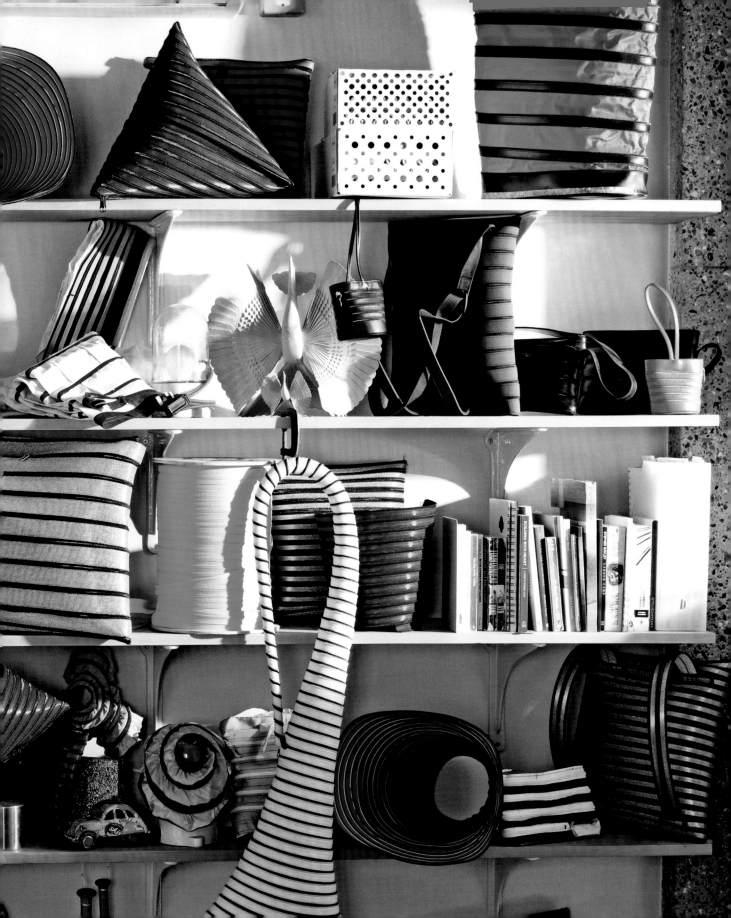

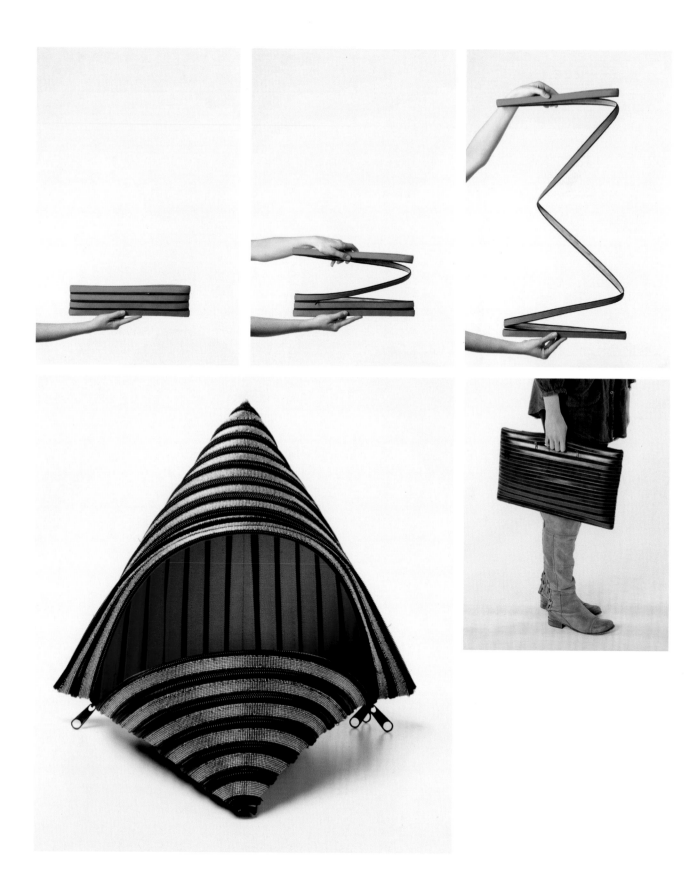

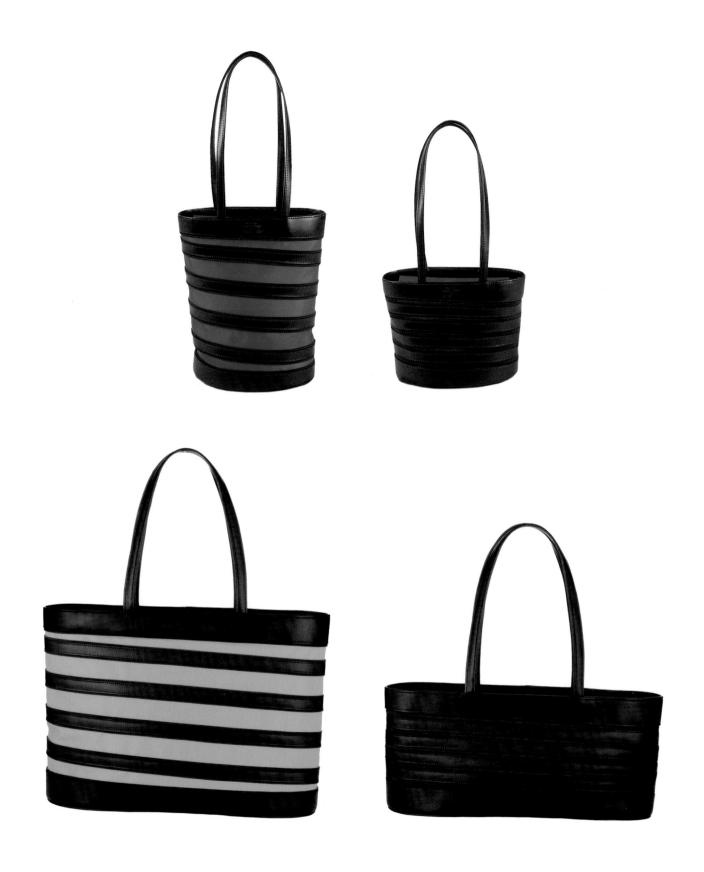

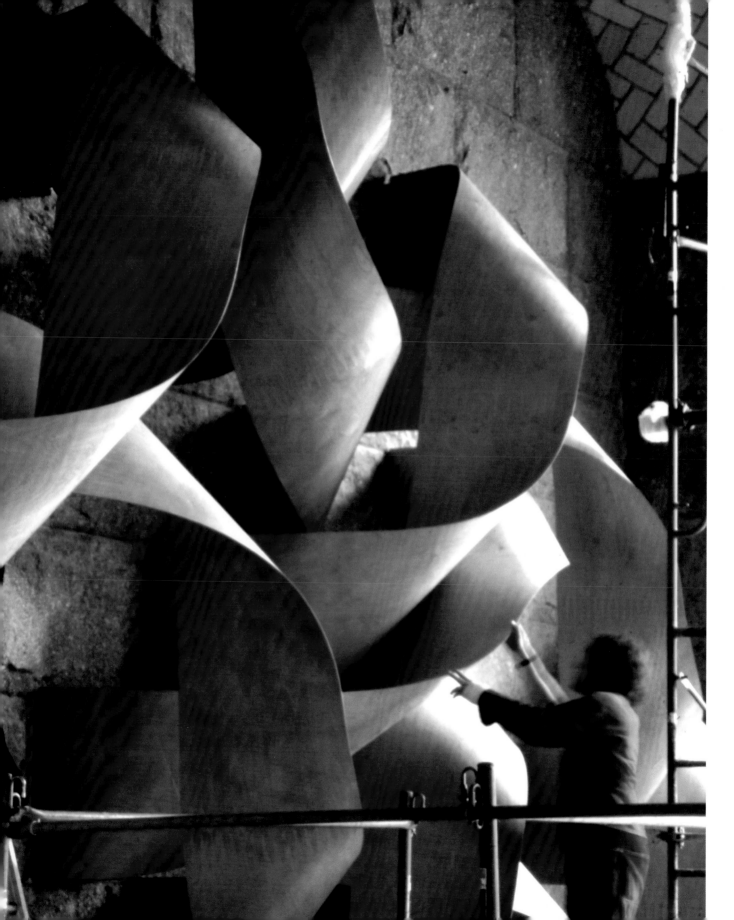

Guastavino's

Can you flat-pack a ten-metre-high sculpture?

THE BRITISH DESIGNER AND ENTREPRENEUR Terence Conran was opening a new restaurant under the arches of the Queensboro Bridge in New York, in a spectacular space with granite walls and a high, vaulted ceiling lined with white ceramic tiles. The studio was asked to design a sculpture for the wall that would face diners as they entered the restaurant.

Because the project did not have a high budget, it was clear that it would not be possible to do much construction in New York. Instead, we had to make something in London that could be packed flat in a box, like a shelving unit, shipped across the Atlantic and assembled on site.

At first we found it hard to justify putting anything on the wall. There was no problem to solve. We could make anything we wanted. Rather than hanging something on the front of the wall, we wanted to anchor an idea into the wall in a more fundamental way. The wall was constructed from giant raw granite blocks, with spaces in between them, filled with grout. We began to think about squeezing material out of these gaps between the blocks. Something squeezed out of a slot of this shape would take the form of a ribbon and, if that ribbon was springy enough to hold its shape, we could make it twist and leap from slot to slot, across the wall.

The final idea for the sculpture was to stitch the wall together with ribbons of plywood. Each ribbon extrudes from the spaces between the stones, twists over and then tucks back into the wall. Like a tapestry kit, in which a fabric mesh is a guide to placing the stitches, the wall is a matrix, a grid composed of all the gaps between the blocks. The wooden ribbons are restrained at each end, where they emerge from the wall, and are held under their own tension by gravity.

To do this, the plywood had to be 7 metres long and thin enough to push into the gaps between the blocks, as well as light, strong and particularly resilient along its length, in order to hold its shape and not hang down limply. Existing plywood products did not meet these requirements, nor did they feel precious enough. For this reason we decided to make our own laminated wood for the pieces.

In standard, commercially sold plywood, the direction of the wood grain changes in alternate layers to make the material equally strong in all directions,

but for our plywood we organized the layers so that more of the grain ran the length of the material. This made it springier along its length than across its width. Even different adhesives affected this characteristic of the plywood. To stop the wood tearing as it twisted, we worked with our structural engineer to develop a way of strengthening each piece by laminating strips of thin stainless steel foil into its edges. We also created a special fixing to mechanically anchor the pieces between the stone blocks.

After much prototyping and testing, we glued together the final plywood pieces in our studio in London and loaded them into a slim container and shipped them to America. Once they had arrived, we followed them to New York, where we transformed these flat elements into dramatic three-dimensional forms.

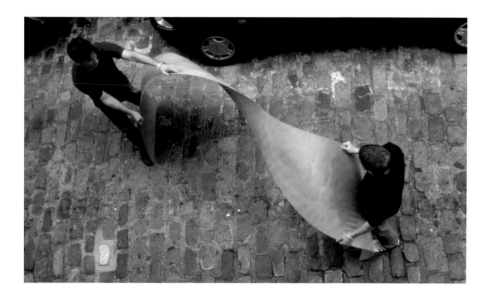

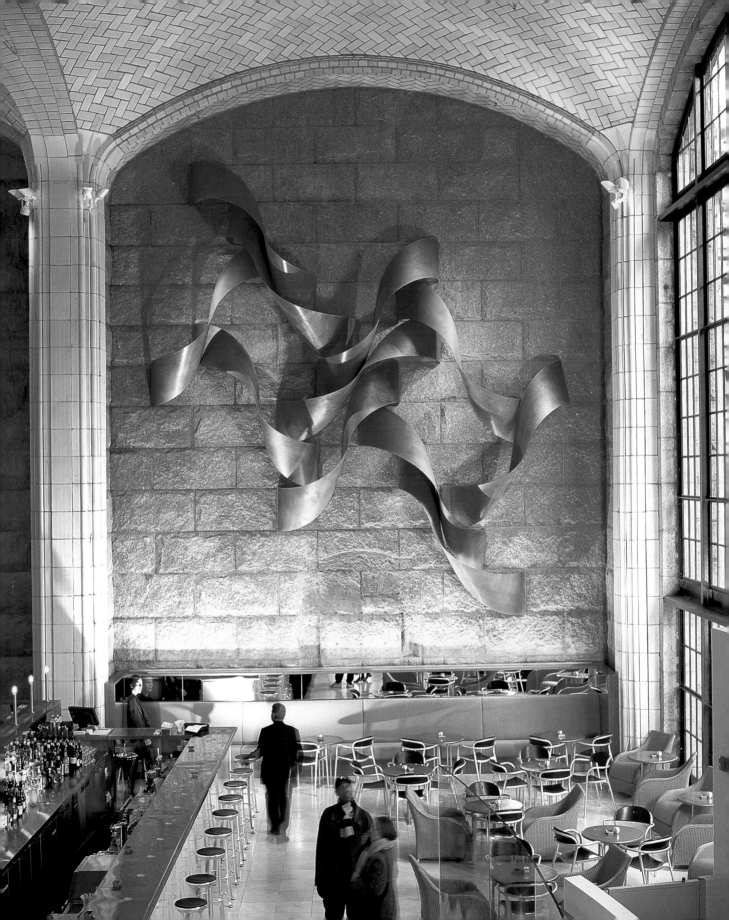

Shop Design

Can a single idea meet the multiple requirements of a shop interior?

THE STUDIO WAS ASKED by a bag and clothing label to design a new shop within an ornate Edwardian building in central London. The project required shelves for displaying bags, rails for hanging clothes and lighting, and we saw a chance to combine these into a single system using fibrous plaster extruded cornice, the decorative detail found in many old European buildings.

Our proposal was to use this traditional craft technique to create an interior by continuing the fibrous plaster cornice down to the floor and around the walls of the spaces. Within the ornate profile of the walls, a completely flexible system of retail display elements is unobtrusively incorporated, including horizontal tracks for light fittings and slots at different levels for shelves or clothes rails to slide into.

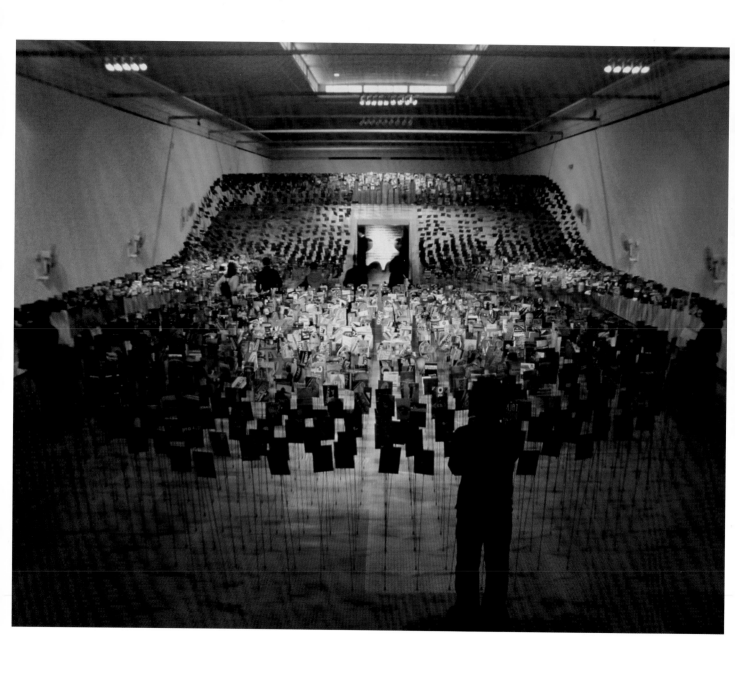

Brand.new Exhibition

How do you make an exhibition about something intangible?

THE VICTORIA & ALBERT MUSEUM in London invited the studio to work with its curators to design an exhibition about branding, the process by which consumer products acquire mythical status and the consumer culture associated with their names, logos and slogans. It was the museum's first major exhibition about this contemporary aspect of design.

As each supermarket and high street is already an exhibition of brands, the risk was that an exhibition on this theme could become clichéd, commercialized or banal. Our approach was to express the curatorial content as a series of immersive installations. Rather than a design led by exhibits and text-based panels, we proposed a sequence of dramatic environments. Each room had its own distinct character and identity and was experienced in isolation, with no visual link to the others.

Exhibitions usually begin with a panel of introductory text, but most people already know what brands are, so we decided to make the entire first hall act as the introduction to the exhibition. In the hyper-real, well-lit world of shopping and advertisements, branding is a phenomenon associated with the glamorous, glossy and new. Our approach was to look beyond this at the worlds of religion, weaponry, mortuary equipment and even whole countries. We commissioned Bettina von Kameke, an intrepid and artistic photographer, to travel to many countries, taking pictures of brands wherever they appeared: a logo printed on a piece of discarded packaging at a waste dump or tattooed on to a bit of pink, goose-bumpy skin. Four thousand of these images were attached with crocodile clips to the tips of upright wires set into the entire floor of the first room, engulfing the visitor in a field of brands. Fans around the room blew air across this field, making it ripple and sway like a field of wheat in the wind. Every brand was equal; a company that makes fishing hooks, a fascist political party or Coca-Cola – the biggest brand in the world – all presented at exactly the same size, rubbing up against each other, with no further information. The field rose up to form a brand-covered hill that you entered through an opening in the surface, forming an exhibition space underneath itself, containing detailed content about some of the brands. The materials were low-cost and basic: cheap plywood peg board,

normally used to make workshop tool storage, fixed together to make a sheet as large as the hall, with the swaying steel rods bolted through the holes.

In the highest space in the sequence we needed to find a way to present film, so we kept this room completely dark and filled it with huge, glowing, Sputnik-like objects. The centre of each one was a television screen showing a film of people talking about what brands mean to them, held within an array of radiating metal spokes, with light boxes on the end of each one displaying illuminated images of the brands that they surround themselves with in their lives.

During its three-month run, more than 100,000 people visited the exhibition.

Paternoster Vents

*How can energy infrastructure be
integrated into a public space?*

AT PATERNOSTER SQUARE, next to St Paul's Cathedral in London, a new office
development was being built. Below one of its public spaces was an underground
electricity substation, which needed a system for cooling its transformers,
a substantial structure consisting of two main elements: air inlet vents that enable
cool air to be drawn down from above and air outlet vents that let warmed air
escape upwards through a cooling tower. Our task was to design and configure
this cooling system.

The commissioner had been exploring options that involved creating
a single structure that housed both inlet vents and outlet vents. It made a large
bulky object that dominated the public square around it, reduc-
ing it to little more than a corridor. As this was a sensitive
location, close to St Paul's, we decided to make it our priority to
shrink the visible mass of the vent structure to a minimum.

Since the substation itself is below ground, we worked
with the project's engineers to find out if more of its cooling
equipment could also be located underground. We learned that
the ducts that brought cool air in to the substation did not in fact
need to be accommodated within the tower structure, but could
instead take the form of steel grilles set flush into the pavement,
which would allow us to drastically reduce the size of the tower
element. We also discovered that the warm air outlet vent could
be divided in two, enabling us to break down the mass of the
structure even more. Instead of a single, squat, fat object that
would force you to walk around it, there could be two slim objects
with a pathway between them. These moves opened up the space, transforming
it by creating a composition of two objects that had a chemistry between them.
It also made room around them for a viable public space.

The final form for this project came from experiments I had done as
a student in Manchester, when I had explored the possibilities of making struc-
tures with textiles. Experimenting with folding heavily starched canvas into
multiple pleats using an industrial iron had made the fabric behave like structural
origami, twisting to make a strangely gorgeous geometrical form. Later, I found

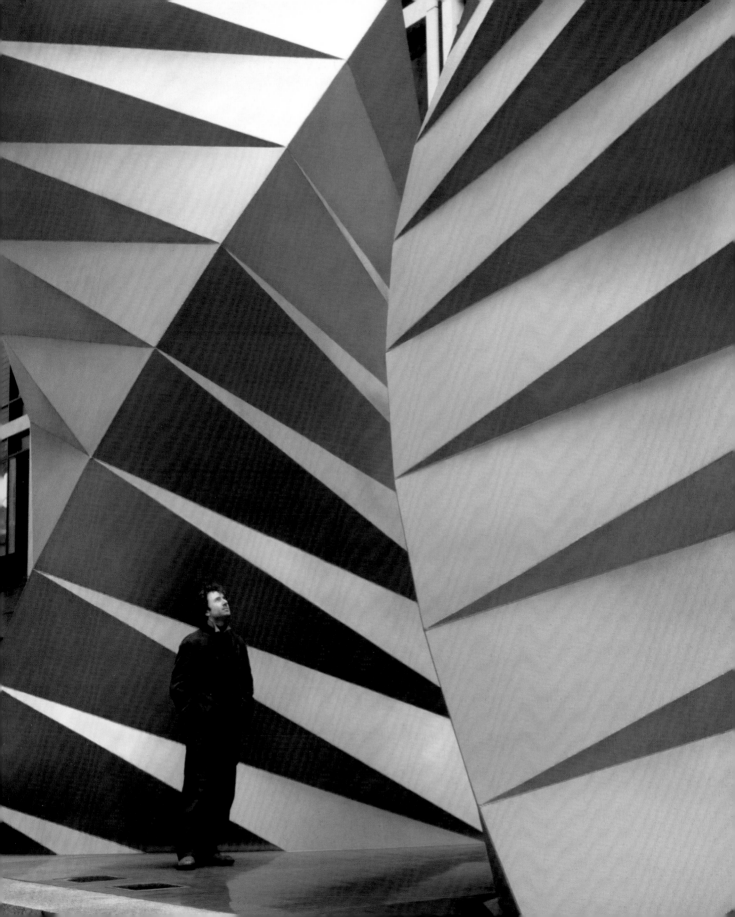

that I could reproduce this form by folding a single piece of A4-size paper into identical isosceles triangles.

There was a moment when we looked at one of these folded shapes lying on a shelf in the studio and realized that it might give us the form for the two warm air outlet vents. The final towers are two of these forms, scaled up to a height of 11 metres, with exactly the proportions that came from folding a sheet of A4 paper. We tried using sheets of paper of various proportions, but the form looked best when it was made from an A4 sheet.

Rather than an identical pair, the towers are mirror images, each made from sixty-three identical isosceles triangles, cut from 8-millimetre-thick stainless steel plate, welded together. The steel is glass-bead-blasted, a long-lasting finish more commonly used for small components than for building-scale structures. Unlike a blasted finish using sand, which can feel rough to touch, firing tiny glass beads at sheet steel gives it a soft, silky look as if it has been finely pummelled by millions of tiny, rounded hammers. Because the metal triangles are set at angles to each other, the light reflecting differently from the angled facets gives the impression that they are made from different materials, like a harlequin's costume.

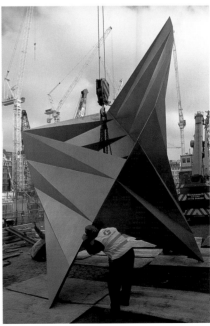

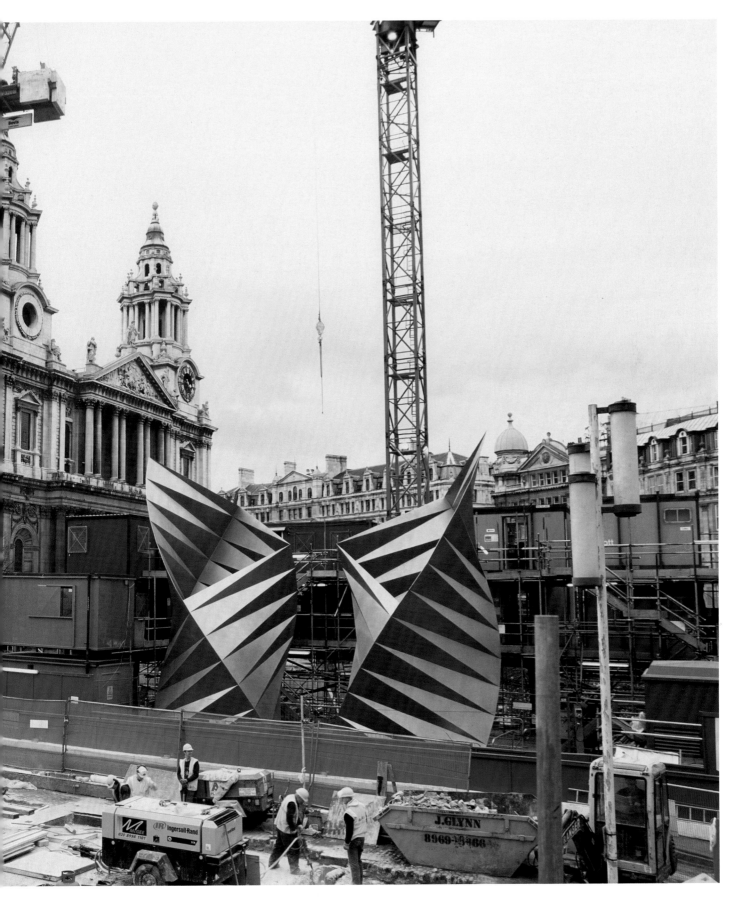

Masts

How can you minimize the visual impact of a mobile phone mast?

WORKING IN PARTNERSHIP with a telecommunications provider, Milton Keynes Council invited the studio to enter a competition to design mobile phone masts for two of the city's roundabouts. Because Britain at this time was equipping itself with new mobile telephone infrastructure, there was an increasingly vocal backlash against phone masts, which were seen as ugly structures that polluted the countryside, although at the same time people wanted to be able to use their mobile telephones everywhere.

Conventional mobile phone masts are about 12 metres high, with vertical steel columns and Meccano-like triangulations of steel struts. Taking account of the general public aversion to masts, we came to the conclusion that there was no point in just trying to make them look more attractive, but that instead we needed to try to reduce their visual impact. The important consideration was the size and concentration of the mast's structural members, which go together to make the silhouette of the mast.

Our proposal was, in effect, to vaporize the usual chunky metal structure of a mast by constructing it from smaller metal triangles and replacing the typical 80-millimetre-thick vertical columns with columns that were only 6 millimetres thick, creating a fine mesh of triangles. The outcome was a miniaturized structural system, like the inside of a bone that derives its strength from vast quantities of tiny filaments connected together. From a distance, this delicate triangulation would dissolve into a cloud of fine metal, making the transmission equipment and antenna almost appear to float.

Working with structural engineers to develop the idea, we found that, as the lower sections of the structure carry more load than the top, the triangulation could be denser at the bottom and looser and looser as it went up the structure, causing the mast to gradually vanish into the air.

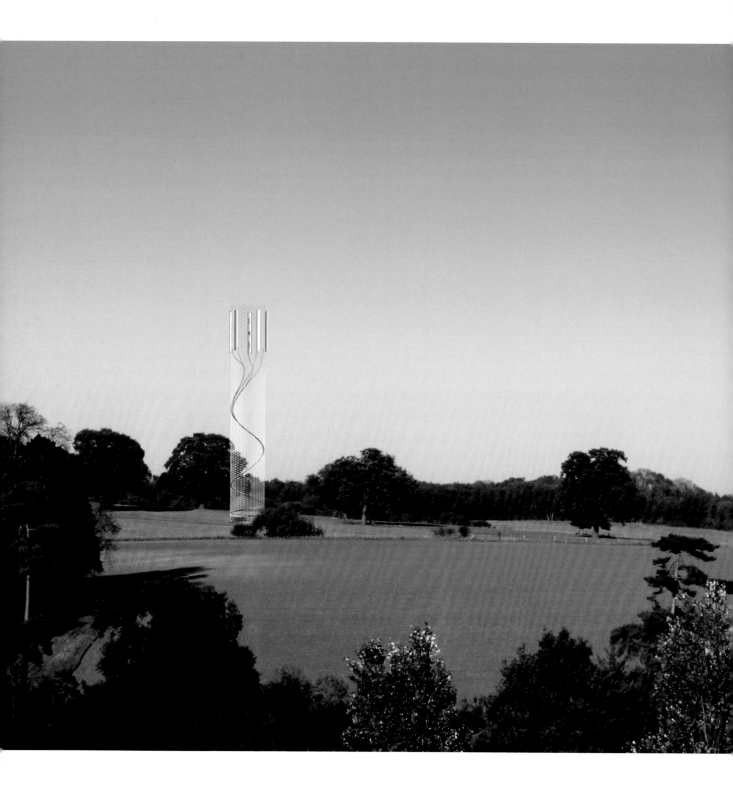

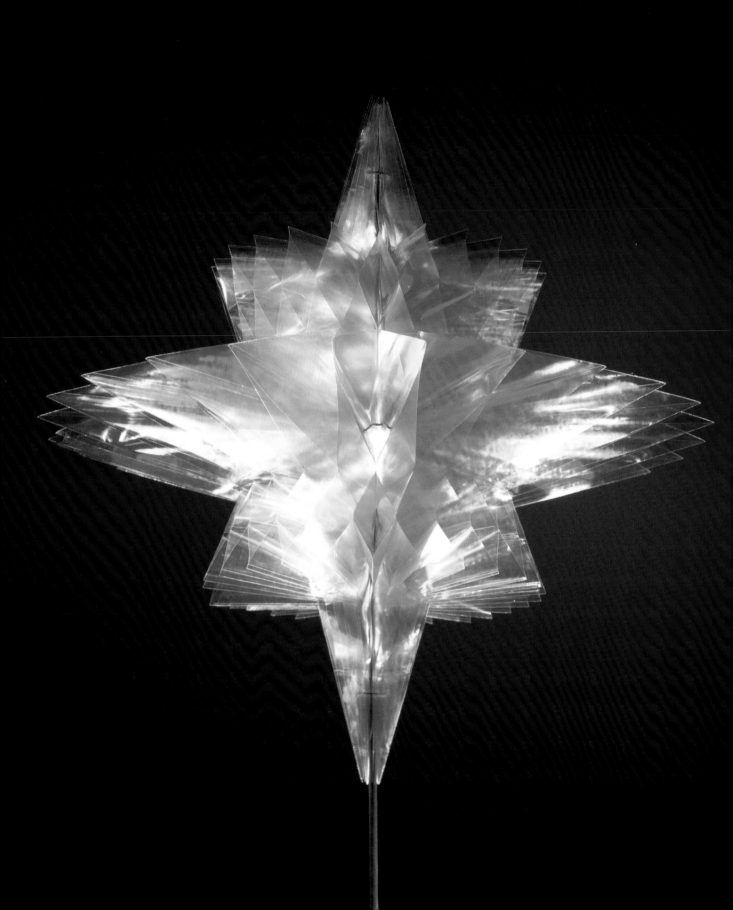

Boots Christmas Decoration

How can a Christmas decoration stand out in a shop filled with thousands of multicoloured products?

THE STUDIO WAS ASKED TO DESIGN Christmas decorations for Boots the Chemist, a well-known chain of British pharmacies, to be used in their two thousand shops.

The company tended to use decorations of a similar scale to the products on display but, because the typical Christmas bauble is about the same size as a shampoo bottle, the effect was to camouflage the decorations and add to the shops' visual clutter. For a decoration to stand out, we felt that it needed to be the biggest thing in the shop, but it still needed to be possible to transport it easily to all the shops.

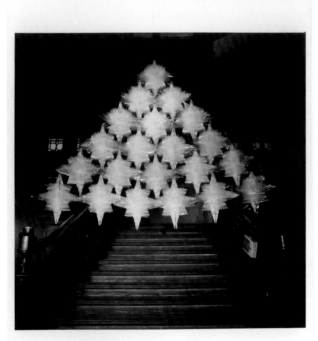

The final decoration was a single element, almost a metre high, which was repeated throughout each shop. It was a simple form, made from iridescent acetate, using the craft technique of a traditional paper Christmas decoration. It was a folded object, which was easy to transport and opened out in the shop into a three-dimensional decorative form.

The project was popular and we were invited to use the decorations to create an installation on the stairs of the St Pancras Chambers building in London.

Yorkshire Sound Barrier

What is the large-scale equivalent of an egg box?

THE STUDIO ENTERED a competition to design a 2-kilometre-long sound barrier for a motorway in the north of England, to dampen the impact of traffic noise on a nearby residential area. Knowing that music recording studios sometimes had egg boxes glued to their walls to dampen the sound, we decided to replicate the geometry and acoustic performance of this surface on an architectural scale, using the iconic orange plastic traffic cone. We proposed a 4-metre-high wall, 2 kilometres long, consisting of 32,000 cones mounted on a simple steel frame. The barrier would be economical to build because its main ingredient was a cheap, ready-made component.

Hereford Community Building

Can a building express on the outside what goes on inside?

A COMMUNITY GROUP INVITED the studio to design a structure to replace a 1970s church building in a deprived neighbourhood of Hereford in the west of England. The building was already being used by local people as a community centre, combining worship with craft, dance, music and children's activities, but all these functions were limited by the poor quality of the building.

The community group spotted the potential to grow a different kind of place with purpose-built facilities and together we evolved the brief from a broad statement of aspirations into a vision for a multi-functional building. It would support five distinct activities, described as 'domains' – worship, music and movement, performance, craft, early years – and also include a communal area, residential space and car parking.

For the building to feel accessible to people, the focus of our thinking was on how to make the building communicate itself. We needed to find ways for the functions of the domains to express themselves on the outside of the building, as well as being intuitively legible as you walked through the door. While a conventional lobby filled with signs and notices relies on you to have the confidence and patience to explore a building and seek out its different activities, we wanted to make this building self-explanatory by surrounding you with its functions as soon you entered it.

We were also interested in the relationship between the building and its immediate surroundings. Instead of dropping a single, big, punctuating block on to the site, we wanted to knit this building into its context. We could achieve this by creating routes through the building, rather than making you walk around it, giving you a reason to wander through the middle on your way to somewhere else, and offering opportunities to interact with the activities inside. We felt, too, that if we blurred the entrance of the building by getting away from the idea of a rigidly demarcated threshold or intimidating front door, you could find that you were halfway into the building before you realized it. And if the activities caught your attention, your curiosity would pull you the rest of the way in.

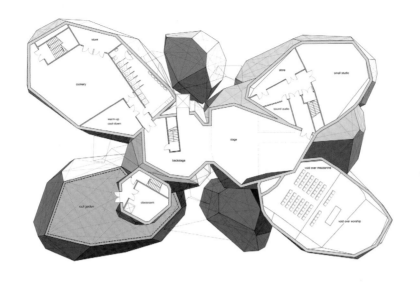

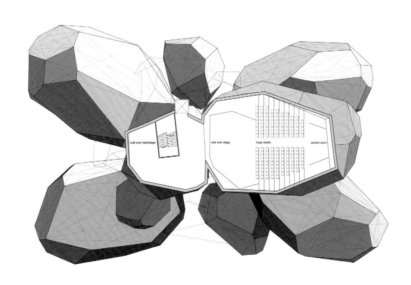

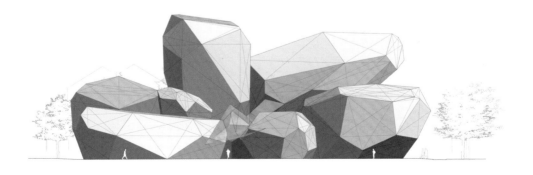

As this was a project with a highly evolved and unusual functionality, we spent a lot of time wrestling with how to programme the building, using diagrams to explore the relationships between the different domains. The only approach that seemed to work was to see the building as a collection of separate objects, like the individual cloves of a garlic bulb, that have reached an agreement to cooperate with each other. To work as a building, they needed to meet in a way that allowed them to be both together and separate, so our idea was to make a space that connected them, like cartilage or glue, and formed a central gathering space, common to them all.

Rather than thinking of the domains as boxes, we conceived of them as objects that had pushed against each other's surfaces. Making them faceted turned them into buildable forms that could acknowledge the ground and become practical roofs and floor plates. Functionally, these spaces could work well, one making an apartment for a caretaker and an angled one naturally forming a stage with raked seating. However, when we contemplated these domain objects as segments arranged radially around a central space, we could see that there was no chemistry between the domains. With too much mass around the edge, the composition lacked dynamism and looked defensive.

It was at that point that the studio's engineer suddenly picked up one of the pieces and dropped it on top of the others, covering the space in the middle. Suddenly the pieces depended on each other; if you took one of them away, the whole thing would collapse. The big glass roof open to the sky was discarded and instead exciting cracks and gaps appeared between the domains.

The final design for the building expresses the domains as a family of crystalline objects, grouped around a communal space, which is partially covered by two of the domains that sit on top of the others. Within this six-storey building, with its floor space of 3,000 square metres, the covered communal space occupies the cleavage between all the domains and is fundamental to the building's functions. Conceived as the 'domain of refreshment', this collective space is a café by day and a pub by night. It is not shaped like a neat circle or square, but deliberately has crevices and nooks that can be used in different ways. Because the goal was to make the building clearly legible without signage, every domain intrudes into the communal space, drawing you halfway into a domain before you even decide to go inside it. Domains are linked at first-floor level by a weaving route that emerges into the communal space as balconies and bridges and the entire central space is fused together with glass. It allows you to look through the building and out of the other side, always facing into the light rather than into a dark place.

The domains have a steel frame, finished internally in timber and externally with terne-coated steel. The window pattern comes from the building's faceted geometry, which continues into the crystalline glazing pattern of the communal space. For the worship domain, we developed special architectural glass panels, reminiscent of traditional stained glass, which generate powerful effects of light and colour.

Turning Trees

*What could be more sculptural
than a tree?*

THE STUDIO WAS ASKED to develop an idea for an artwork to sit in the public space in front of a new office tower in Tokyo, Japan. As there was already a plan to plant mature trees into the space, we wondered if the trees themselves could become sculptures, instead of making a separate piece of public art. We recalled a British television programme called *Take Hart*, screened in the 1970s, in which sculptures that had been created during the programme were displayed on revolving tables to show their full beauty from every side.

Our proposal was to transplant large trees into the space and make them rotate within the pavement, so that they silently and almost imperceptibly turned on the spot like slow-motion ballerinas. The trees would be carefully selected for the sculptural quality of their branch structure, like the exquisite asymmetrical specimens in Japanese gardens.

Our idea was that the project would at first be barely noticeable. You could walk past it many times before noticing anything strange. But, after sitting for a time on one of the benches that encircle the trees, you might find yourself facing in a different direction, or suddenly notice the trees' shifting shadows. The only things that turn are the tree, the tree grille that surrounds it and the circular seat. The detailing of these and the stone paving in which they are set are of the highest quality, appropriate to the landscape design of a prestigious urban site.

With the help of a tree specialist, we developed a method of planting our trees into substantial circular containers that would hold all the soil, moisture and nutrients needed to sustain them. Below ground, these containers are set within devices similar to the turntables used to turn train engines and military tanks. It seemed that the trees would benefit from being rotated because they would be more evenly exposed to the sunlight, just as houseplants on a windowsill grow better if they are regularly turned around.

To communicate the idea, we made a wind-up musical box with miniature trees that rotated gently to the tinkling tune of *Für Elise* when the lid was opened.

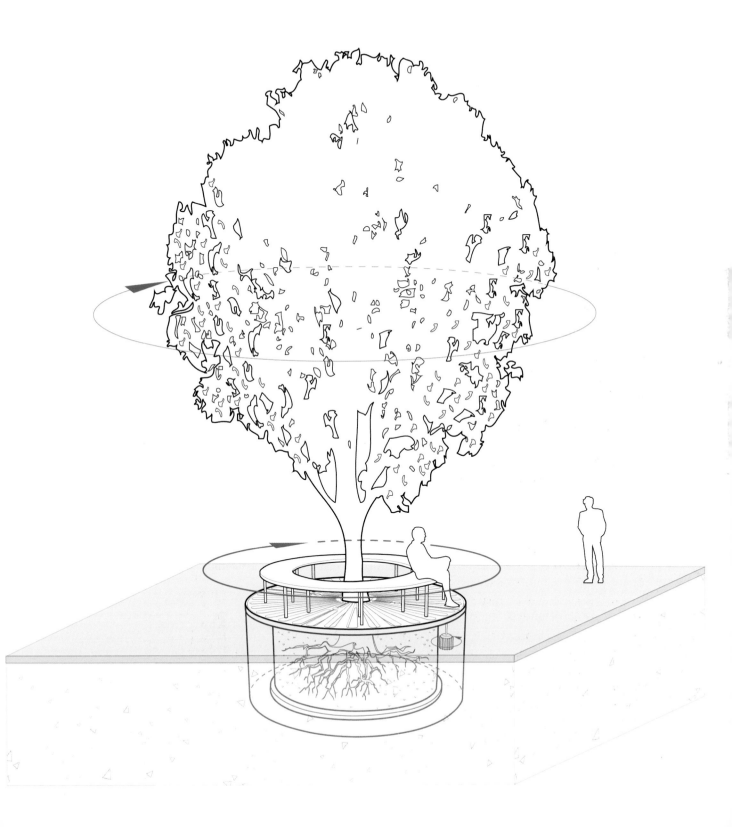

Temple

*Can the complex programmatic
needs of a spiritual building be
brought together with a single idea?*

EARLY IN THE STUDIO'S DEVELOPMENT, we were approached to design a Buddhist temple on the outskirts of Kagoshima, a city on the southernmost tip of Japan. The client was a priest of the Buddhist Shingon-shu sect. The temple site was on a mountainside looking over the city towards Mount Sakurajima, an active volcano famous in Japan. Kagoshima is also famous as the place where the forces of Saigo Takamori, the last samurai, were defeated by the imperial army in 1877. Saigo and twenty thousand soldiers and warriors died in these hills outside the town and the new temple was to be dedicated to him as it is thought that he perished on this site.

As well as a place of worship, the temple was to serve as a depository for cremated remains. In this still traditional region of southern Japan, honouring the dead remains an important aspect of family life. Unlike in Great Britain, almost every grave in their cemeteries has fresh flowers on it. There is also a tradition of storing the cremated remains of family members in specially dedicated buildings. Ceramic urns containing ashes are placed in individual family altars, which are stacked up to form rows of tall cabinets. Visitors bring a ladder, with which to climb up to their altar to pay their respects. It is common for people to buy space for their family and make monthly financial contributions for its upkeep. This temple was intended to hold the cremated remains of 2,400 people, and this part of the temple would fund its construction. The priest's project managers were alarmingly modern in their thinking, suggesting an automated retrieval system, rather than the traditional rows of altars. You would enter the repository, swipe your identity card and the urn would be delivered to you automatically, like a vending machine. We suggested that it might be more dignified for an urn to be brought out by a young monk.

Visiting Japan was a powerful experience. In Kyoto we were taken to the old Buddhist temples and became anxious that the priest was hoping for something similar and had mistakenly thought us the right people to do this. However, they made it clear that they wanted us to understand the old temples but not to copy them.

Our starting point was to decide which part of the site to build on and how to configure the arrival sequence so that you felt as if you were leaving the rest of

the world behind. It was important that you shouldn't be able to see the temple straight away. Putting it as far back on the site as possible, we could build a sense of anticipation and make the temple feel like a discovery.

In programming the building, we had to reconcile requirements for the placement of ceremonial elements. The large effigy of Buddha can face south or east, while the altars must face south. Using coloured wooden blocks, we developed a model of how this building might work but still needed an idea of what the temple might look like. We wanted a way to hold the building together, unifying all its separate functions.

Experimenting with shaping and sculpting forms in clay, based on the block model, we kept producing awkward, ugly shapes that didn't make any sense. The clay was allowing us too much control of the form. We suddenly found ourselves wondering if fabric, with its ability to fall into naturally sophisticated shapes, might give us the combination of cohesion and complexity that we were looking for.

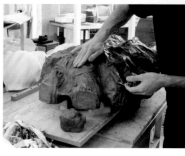

In historical portraits, there may be a superb rendering of someone's head, but I am often captivated by the part of the painting that depicts clothing or textiles in rich drapes and folds. We had never seen a building that took its form from the way fabric moves and falls. Thinking of the stiff silk robes worn by our Buddhist priest, we were trying to achieve the kind of folds of fabric you see in Old Master paintings. We tried different fabrics, including a very expensive silk, and finally found a thin, rubberized foam material similar to that used to make wetsuits. The material could fold and crease and undulate and make fantastic forms by itself but it could also rationally define spaces, such as escape stairs, monks' cells or teaching rooms. Rather than actively defining how it folded, we allowed the single sheet of fabric to manipulate itself into a temple. After he had seen the design, the priest pointed out that our building made him think of the soft cushion on which the Buddha sits.

It had only recently become possible to scan a three-dimensional object to capture its exact form and turn it into data for use in a computer. The Royal National Throat, Nose and Ear Hospital, close to our studio in King's Cross, had bought a scanning machine that was used to assess the swellings on children's faces before and after operations and they allowed us to use this to scan our models. The form was reproduced exactly, even the drawing pins that fixed the fabric in place, which we didn't want to try to hide or smooth away.

We used multiple layers of steps to translate this complex, three-dimensional surface into a buildable form, building the temple up in horizontal layers that were

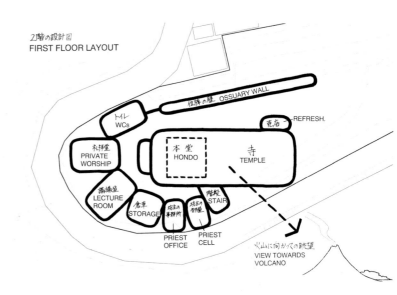

2階の設計図
FIRST FLOOR LAYOUT

位牌の壁 OSSUARY WALL

トイレ WCs

売店 REFRESH.

礼拝堂 PRIVATE WORSHIP

本堂 HONDO

寺 TEMPLE

講義室 LECTURE ROOM

倉庫 STORAGE

坊主の事務所 PRIEST OFFICE

坊主の部屋 PRIEST CELL

階段 STAIR

火山に向かっての眺望 VIEW TOWARDS VOLCANO

each the height of a step in a staircase. Constructed from plywood secured to a steel armature and coated with a waterproof membrane, the thick wooden layers also formed the interior of the temple. Extending the layers out of the walls, we could form staircases and furniture. We could also insert layers of glazing to give it windows.

To show what the temple would look like, at a time when the use of computer-rendered visualizations was not yet widespread, we commissioned an architectural illustrator to make watercolour paintings of the proposed building.

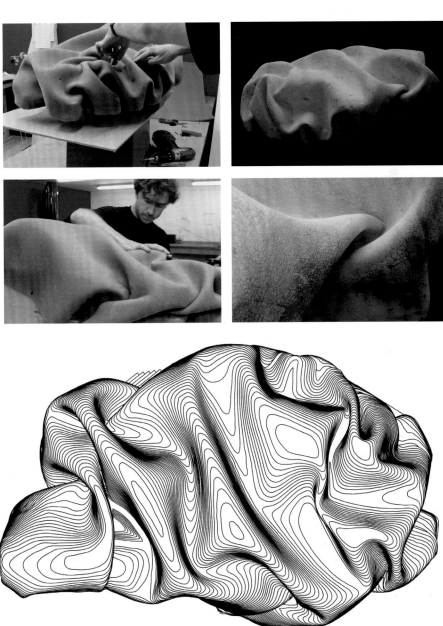

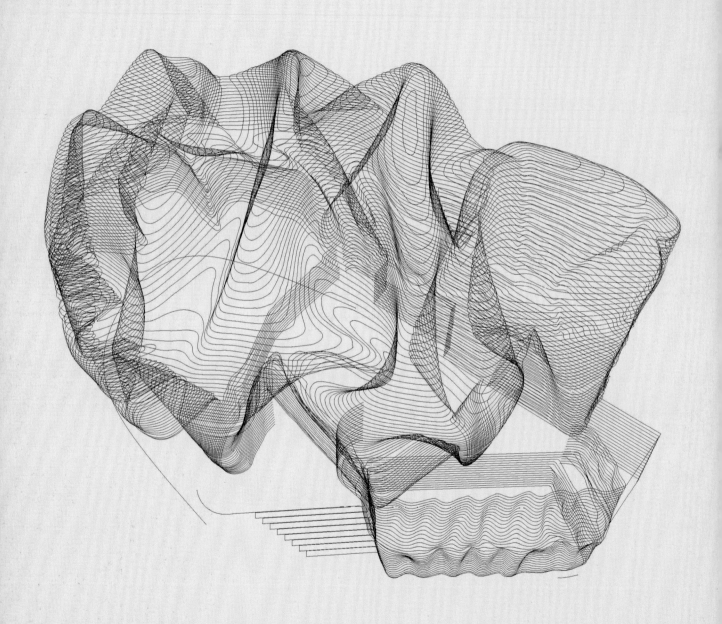

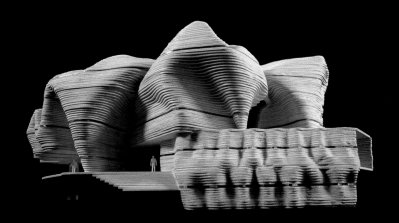

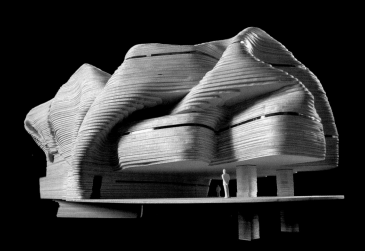

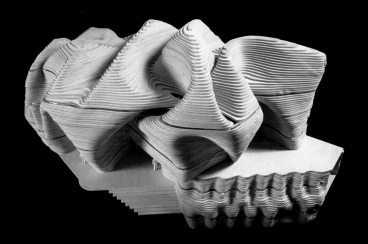

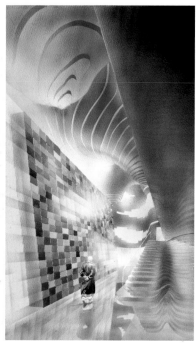

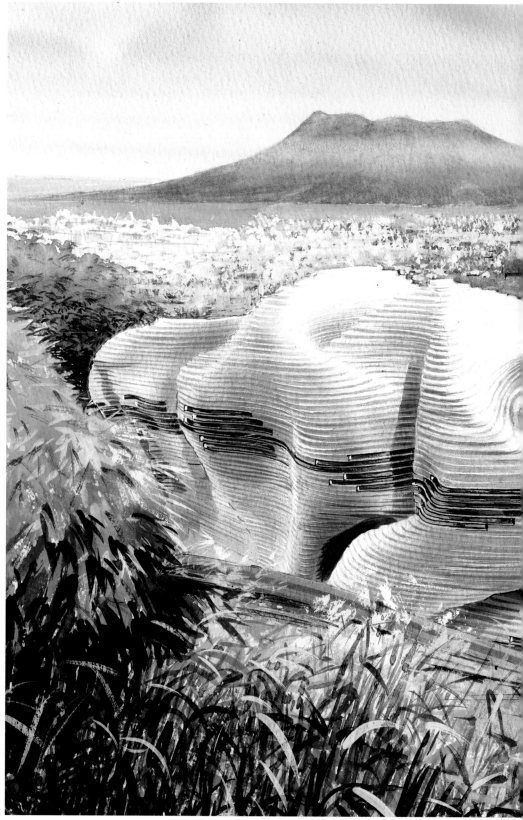

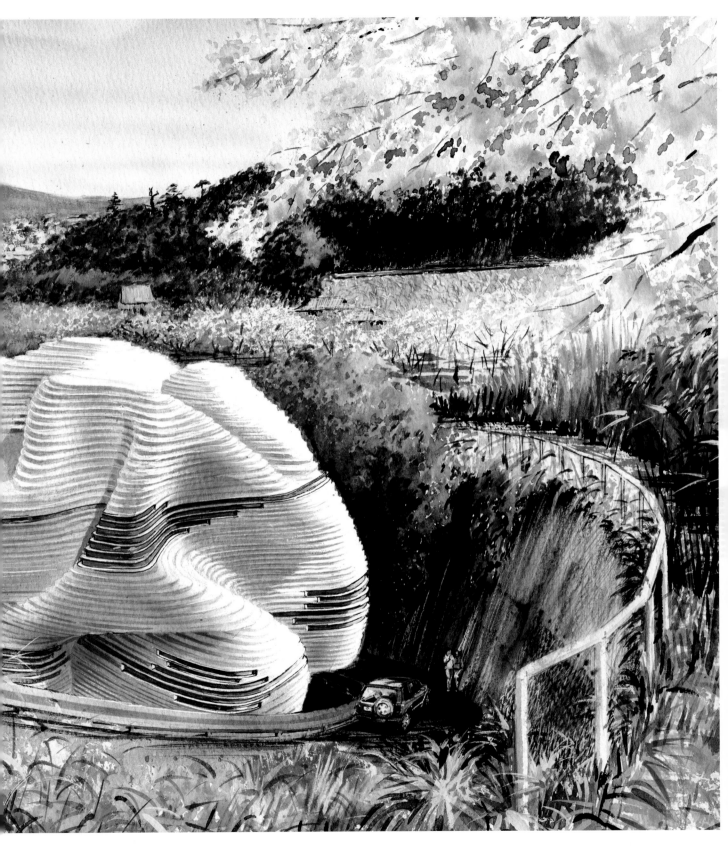

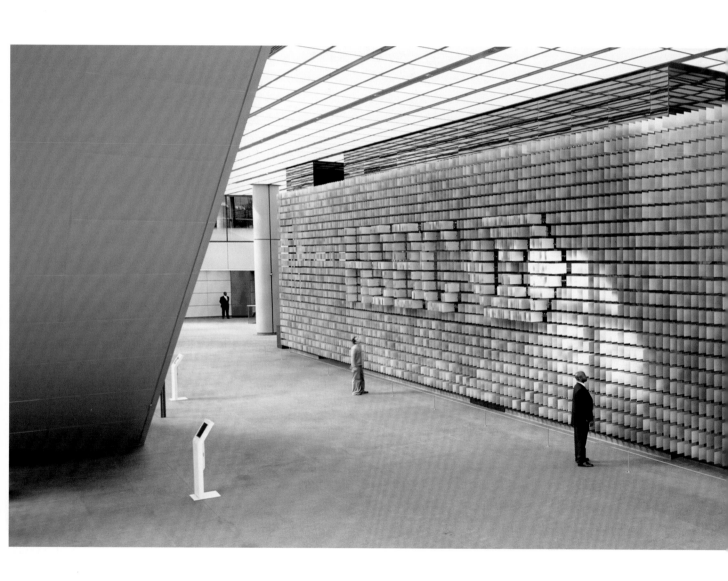

HSBC History Wall

*How can you communicate the
history of an institution?*

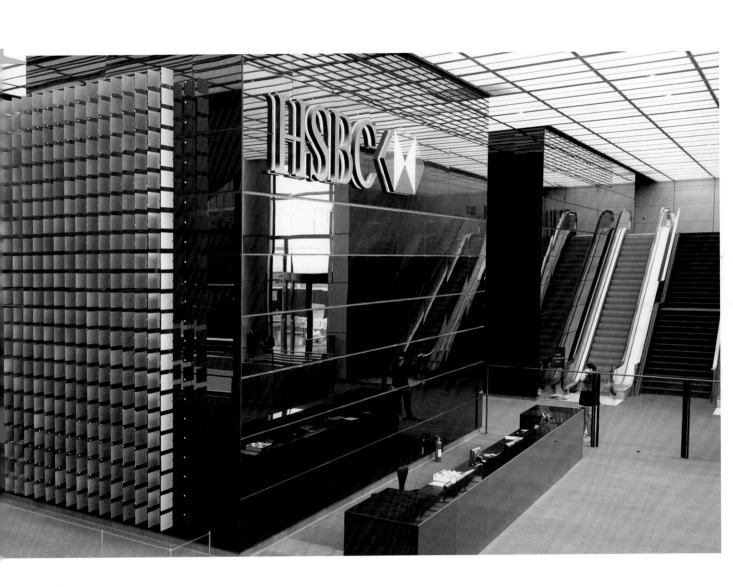

FOLLOWING THE BRITISH HANDOVER of Hong Kong to China in 1997, one of the world's largest banks was moving its headquarters from Hong Kong to London. The studio won the project to design the entrance installation for the foyer of its new building, a tower in Canary Wharf designed by Foster + Partners. The installation was to tell the history of the bank and commemorate the move to its new home, and it would go on a wall, made primarily of black glass, that was 40 metres long and 6 metres high.

Feeling that the project could easily become a dull, museum-like history exhibit and that a sculpture stuck on to the wall would have no connection with the architecture of the building, we looked for a solution that could be specific both to the space and to the institution.

Our idea was to make a giant field of images from the bank's archives, covering its entire history from 1865 to the present day, by attaching four thousand metre-long stainless steel rods to the glass wall and suspending an image from the tip of each one. Within the field, the name of the bank would be picked out so that the installation could also act as signage for the new building. You could take in the installation at a glance or spend weeks going through all the images and reading every caption.

A team from the studio spent six months selecting and scanning images in the bank's archive. Over its lifetime, the bank had accumulated a vast collection of huge, leather-bound ledgers, antiquated vellum documents and old photographs. These artefacts had originated in the humid offices of the tropical banks, long subsumed within this bank, and the smell of their leathery mustiness was unforgettable.

Each image was printed and mounted on a metal plate engraved with its own caption. These plates were then mounted on the steel rods and attached to the glass wall. It seemed impressive that, using a high-performance adhesive in order not to drill into the glass, you could bond such a long metal rod on to this wall with an attachment point no larger than the surface of a two pence piece.

With the four thousand images all facing one direction and the plain metal backing plates all facing the other, this vertical field produces a number of optical effects. If you look along the wall in one direction, the images create a patchwork of colour and the history of the bank shouts at you at high volume. Look back the other way and your eye is met with a sea of calm, engraved metal plates, although when the sun shines on them, they become washed by subtle hues, as they pick up the colours reflected from the images facing them. It is also interesting to stand by the elevators and look out through the glass from behind the installation, as if you were looking out through a scalp at its hair follicles.

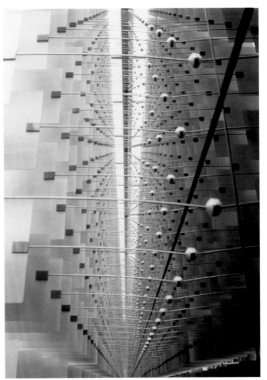
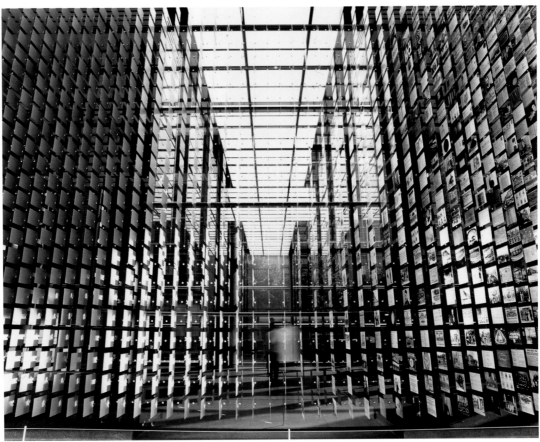

Conran Foundation Collection

How many ideas can you buy for £30,000?

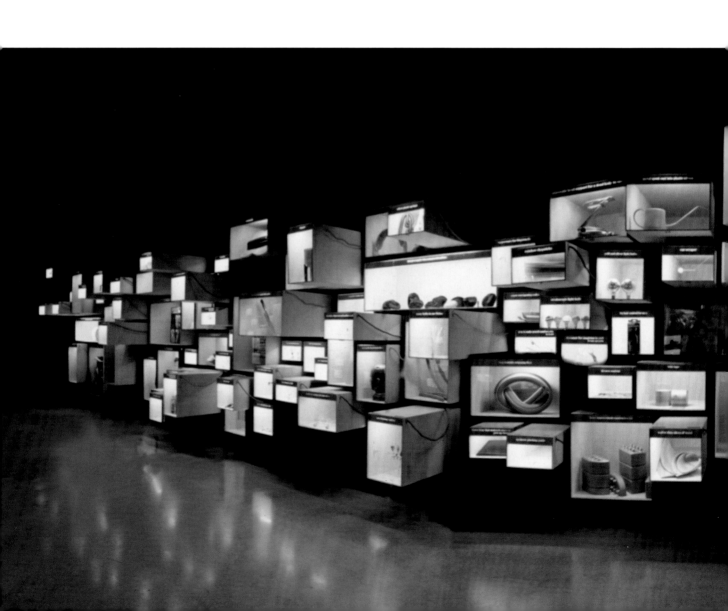

Slicing, grating, pouring, brushing, baking, drinking, feeding, planting, freshening, cleaning, exfoliating, grooming, combing, funnelling, gouging, freezing, drying, organizing, space-saving, separating, bonding, tying, wrapping, binding, holding, clamping, turning, driving, spreading, writing, painting, daubing, papering, castrating, harvesting, attacking, trapping, killing, shooting, learning, teaching, drilling, running, jumping, throwing, catching, reminding, remembering, counting, measuring, testing, checking, locking, folding, erasing, playing, loving, marrying, praying, deceiving, protecting, concealing, spying, sacrificing, worshipping, embalming, enforcing and comforting.

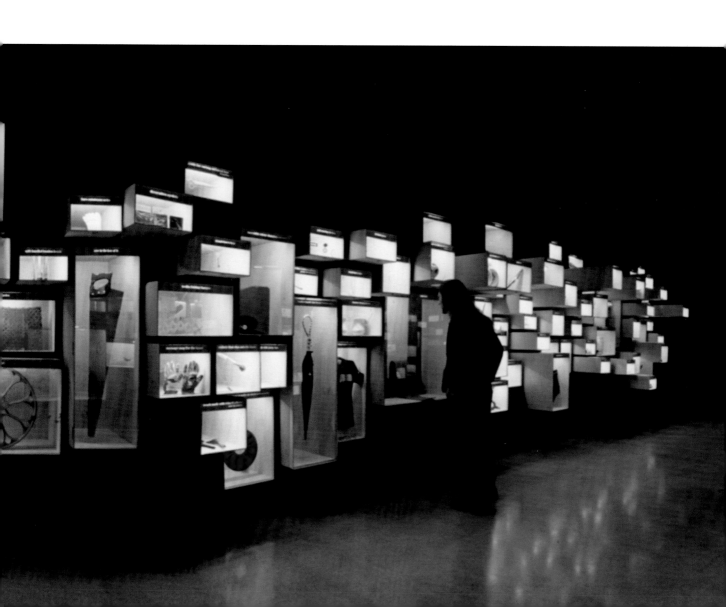

EVERY YEAR FROM 1993 TO 2004, Terence Conran, the founder of London's Design Museum, invited a different person to spend £30,000 on a selection of designed objects, which was made into a small exhibition at the museum and then archived. The studio was invited to curate the eleventh and final collection.

bread roll
restaurant, Bolona, Italy free

At that time, museums of design seemed to have a preoccupation with familiar pieces of expensive furniture and domestic objects and to neglect designed objects from other areas of human life. Curious about different kinds of ingenuity and innovation and objects from areas rarely

glue for making caucasian-style creases in japanese eyelids
deparment store, Tokyo, Japan £4.30

represented in such museums, we took the invitation as an opportunity to collate an exhibition about ideas, by looking for examples of problem-solving in other worlds, such as food, farming, medicine, science, religious worship or paint-balling.

In the studio's experience, it was immensely difficult to get any new idea manufactured and into the shops. To us, the fact that somebody managed to do this seemed worthy of celebration in a museum of design, whether or not the item could be considered beautiful, stylish or tasteful enough.

In the story of every silent object, a clever idea is only the beginning. After that, a manufacturer must be convinced to produce it, a wholesaler persuaded to stock it and a retailer given the confidence to put it on to their shelves. Everything depends on being able to manufacture the product at a low enough cost for everyone

fifteen meters of sausage skin in a roll
made by Devro, Glasgow, UK

udder bucket
agriculture suplier, UK £6.90

to make a profit, without pushing the selling price up too far or compromising quality. As well as navigating the patent process and complying with safety legislation, the product needs to be easy to package, distribute and display, while its name, brand identity, style, colours and materials have to appeal to current tastes. A person who comes up with an original concept, method or object has to be phenomenally determined and creative to see it through. We wanted this exhibition to celebrate the inventive thoughts that have managed to get through this obstacle course of a process.

Instead of reinforcing the idea that £30,000 doesn't go very far in the world of design by choosing a small number of high-cost objects, we set ourselves the task of squeezing the maximum value out of the budget, by focusing on ideas instead of design objects. The challenge was to collect a thousand ideas, spending an average of £30 on each object and turning

untomatoey coloured ketchup
made by Heinz UK £1.30

222

fruit that has been grown inside the bottle
duty free, Heathrow, UK £80

decorative thread packaging
market, Berlin, Germany £1.00

this collection into a major exhibition that would occupy the museum's main gallery, instead of a small part of its top floor. It meant collecting five objects every working day for a year, obsessively filling every spare moment in scouring shops, warehouses and mail-order businesses and interrogating everybody we met, in case a conversation about someone's obscure hobby or secret specialism might yield up another suitable object. The evolving collection became a snapshot of things that you could buy in the world at that time. Mostly, we gathered objects in person – from China, Japan, Poland, Italy, Nepal, Hong Kong, Turkey, Germany, the USA, Australia and Mexico, as well as the UK.

Whereas a major show in the museum might normally contain up to two hundred artefacts, this show would have five times that number to source and display. As the collection grew larger and sub-collections began to emerge within it, there was an urge to count, categorize and seek order in the mayhem, but with limited time available, we stuck to the simple curatorial principle of displaying the thousand objects in a thousand boxes, in the order in which we found them. We wrote a brief caption for each object, trying to explain what it was and why we had chosen it, in no more than ten words, trusting viewers to make up the rest of the story for themselves.

Some of the objects we collected happened to be very beautiful and appealing. Others might be regarded as superficial, even repellent, flawed or undesirable. In themselves they could be unfashionable, imperfectly resolved or compromised by the inevitable difficulties of getting them into production but our aim was to celebrate innovation and human ingenuity, not to debate whether a particular problem was worth solving or even if the solution was the best possible one.

Many of the objects told a story about an aspect of human life. There was the innovative combined sick-bag and photo-processing envelope found on an airline, which, if you had not vomited into it, you could use to send your holiday films off for processing. In Kathmandu, we found kite string impregnated with glass to enable you to cut the strings of your opponent's kite in their fiercely contested traditional kite battles. Then there was the glue that Japanese girls use to create Caucasian-style creases in their naturally smooth eyelids, which spoke of a bizarre form of interracial envy; the mirrors with little lacy covers that you could put over

buried ceramic signage for underground cables
building site, London free

nappy-like bag for pizza boxes
made by Naelor, UK free

223

**brush with handle made entirely
from bristle**
brush shop, Beijing, China £9.17

donor kebab meat catcher
cookware shop, UK £34.71

the glass to improve the feng shui of your room; the Chinese children's crotchless trousers, a response to deal with the country's lack of nappies; and the budgie feeder with built-in mirror that allowed lonely birds to dine in the company of their own reflections. We also included the two versions of prosthetic dog testicles: one is for surgically placing inside the empty scrotum of a neutered dog and the other, a jewellery version, for hanging around the human neck, to enable the owner to sympathize with their castrated pet.

We uncovered a world of innovation in objects that had been grown. In Japan, we found square bamboo produced by forcing the stalks to grow through wooden formers, increasing the numbers of ways that this light, strong wood can be used in furniture making, and square watermelons, grown in clear Perspex boxes, which stacked more effectively for transport and display. Next to the Great Wall of China, we found souvenir pumpkins for sale, with text that had been carved into their rinds, which had healed and scarred into engraved lettering as they grew. And in Beijing we found apples with albino writing marked within the coloration of their peel, made possible by a sticker that blocked the light, like a stencil. In Shanghai people had worked out how to grow a good health message inside the shell of a pearl oyster by embedding a small, plastic, letter-shaped form inside the shell, which the oyster then coated with nacre.

As the collection developed, it would suddenly go off in a new direction. At one time we had a rush of objects from the trade in supplying mortuary and embalming equipment, which yielded the spiky pieces of injection-moulded plastic that are placed under the eyelids of a dead body to hold them closed while it is in an open casket and the stand that allows the angle of the cadaver's head to be adjusted. In the farming industry, we found a device that places elastic bands around the testicles of a young

jar with a handle
supermarket, Datong, China 31p

**how does this designer of replica
female genitalia define their edge?**
sex shop, Berlin, Germany £32.94

bull, cutting off the circulation so that they drop off after a while; a bucket for feeding milk to calves, which looks like a mutated builder's bucket with three nipple-like teats coming out of it; and a spiked nose ring to discourage nanny goats from drinking their own milk. From the world of espionage came the glasses that allow you to look behind you to check if you are being followed and a bottle of water designed

224

for concealing secrets in your fridge. From the first aid industry we found training devices such as the rubbery birthing mannequin with no legs and the gory, three-dimensional wound-recognition kit.

good health message grown into pearl oyster's shell
pearl shop, Shanghai, China £21.10

cups for keeping the eyes of dead body closed
mortuary supplier, US £8.51

For some reason, perhaps because of the primal curiosity we have about mutated life forms, we were drawn to objects that embodied unusual kinds of repetition. As well as double-ended pens, double-headed brushes and a double tap, there were the scissors for cutting up bait worms that were like normal scissors, but with multiple blades. The double umbrella for a couple was one of the most appealing objects in the exhibition. Beverage-making seemed to be an area in which repetition had been employed in interesting ways, with a double coffee pot that is turned upside-down when the coffee is brewed and the teapot with two spouts, one pouring tea and the other dispensing hot water.

coiled candle with holder that limits burning time
candle shop Stockholm, Sweden £10

Our quest brought us into contact with the inventors of some of the objects,

bare-minimum socks
craft shop, Tokyo, Japan £4.74

such as Shaun Mooney, the designer of a plastic bag specifically for carrying pizza boxes flat, which looked like a nappy for a four-legged baby, with four holes for the corners of the pizza box to stick out of, and a young man called Adam Stuart, who, aged sixteen, had invented and marketed a very simple device for helping people to improve their golf swing.

We could only hint at the stories behind the objects and, without the resources to find out the designers of everything in the show, the emphasis was on the things themselves. We included the body bag with a window in it, to enable someone to look at a body without opening the bag and allowing the terrible smell to escape. Somebody else had had the astonishing idea of car hubcaps that carry on spinning once the car has come to stop, so that at traffic lights it looks as though

welding masks with character
welding supplier, UK, from £69.99

the wheels are still going round, and another had come up with under-car lighting that illuminates the road beneath the vehicle with bright blue light. Then there was the white plastic stick that is sold with a helium balloon to make it easier to hold on to and the tiny plastic table that stops a pizza box lid sticking to the pizza.

injection-moulded wafer
supermarket, London 72p

Some objects spoke of a deeply felt tradition, such as the colourful Chinese cardboard replicas of clothes, shoes and consumer goods, which are burnt as a way of despatching them to the deceased,

high-heeled shoes with steel toe caps
office supply catalogue, UK £49.99

the beautiful Indian wedding garlands made of paper banknotes and the thin plastic trousers sold to shorts-wearing visitors to the Vatican to cover their legs. There was also a kit used in the eastern European tradition of bleigiessen, in which pieces of lead are melted in a sauce-pan or spoon over a flame and poured into cold water to form complex shapes that are then interpreted for signs of what the coming year will bring; and the sinister Turkish wedding ring that is a complex, three-dimensional puzzle, which comes apart if it is taken off during an extramarital liaison. The mosque alarm clock, featuring the muezzin's call to prayer, gave the exhibition a haunting sound-track.

We were astonished by how much human ingenuity had been applied to hygiene. As well as a wealth of products designed to allow a woman to pee standing up, there were tiny, triangular sanitary towels to wear with G-strings and black towels to match black knickers. Ecological feminine hygiene products were represented by the washable, reusable sanitary towel and the Mooncup, a small silicon vessel that is worn internally to collect the menstrual flow. The collected blood can then be used to fertilize your roses. Dental hygiene

anti-flyposting paint
local authority, UK £10

glove hanger
sports shop, London £2.49

was another area that had received a disproportionate amount of original thought, with flossing devices that meant you no longer had to wrap dental floss around your fingers, cutting off the circulation and turning them blue, and an assortment of tongue scrapers. Meanwhile, a Berlin sex shop turned out to be a hotbed of innovation, yielding the penis expander, the vibrating vagina with a puzzling hair-do and the puncture repair kit for an inflatable sex doll, for which the inventor's 'eureka' moment was particularly difficult to imagine.

Some objects we chose for being aesthetically innovative forms, such as the plaited cigar, the plaited bread and the plaited Jewish Havdalah candle. There was also a paintbrush

syringe for injecting jam into doughnuts
cookware shop, UK £428.88

drip-catching bottle
airport, Fiesso, Italy £30

detects if parcels have been turned upside-down in the post
made by LPS Industries, US free

made from the entire wing of a bird, an instrument made from a complete shell and the glycerine enema from Shanghai, which was an uncannily pure form, like a translucent tear drop. Placed in a museum of design and lit well, items of sanitary ware took on a graphic visual appeal, such as the horseshoe-shaped toilet seats used in junior schools, with a section taken out of the front to avoid dribbles, and the hairdresser's sink shaped to fit your neck. The doner kebab catcher, a frying pan with a piece missing so that it fits around the doner meat, also took on a strange beauty.

receipt in shape of service provided
taxi, London free

Food was an area of prolific innovation that was not usually represented in a museum of design preoccupied with furniture, lighting and domestic tableware. Among the first objects we chose was the round tea bag, which acknowledged that a mug bottom was not square, and the Pop-Tart, because it was an inventive new way to use a toaster to make a hot cake. We liked the ketchup produced in colours other than red and the pickle lifter, a small plastic device inside a jar of gherkins that enables you to bring the last pickles up through the vinegar to the surface. It seemed brilliant to spot that problem, come up with that solution and manage to get it produced, even if realistically it is probably not going to make people buy more pickles. We also included the stuffed-crust pizza, the industrial breadbutterer and the machine that puts jam into doughnuts. Sausage skins turned out to be extraordinary objects packaged into short, concertina-ed lengths that pull out to a crumpled, papery length of nearly 5 metres. And we could not believe that someone had thought of calling a product 'I Can't Believe It's Not Butter'.

crotchless trousers for toddlers without nappies
supermarket, Shanghai, China £1.75

It was exciting to see the bigger objects in a museum of design, such as the dustbins with no base that builders

kettle for separate spouts for tea and water
cookware shop, Istanbul, Turkey £5.37

connect together to form waste chutes, the large sheathing device that allows market traders to put tight netting over Christmas trees and the machine that uses a piece of orange-lit flapping cloth to simulate flames. Our largest object was the circular hay bale, but it was the machine that made it that was the real invention, permitting bales of hay to be produced not in rectangular blocks but in gigantic rolls and changing forever the rural landscapes of Europe and North America.

streamer for magicians to pull from mouth
craft shop, Tokyo, Japan £6.46

cast polymer cogs
industrial rubber supplie, Istanbul, Turkey £55.20

In some cases, the idea was in the packaging. We found dusters sold in cardboard sleeves printed with figures that seemed to have hair on their heads and chests thanks to the way in which the duster stuck out. What was appealing was that there were two versions of the packaging, male and female, which showed that someone had made the decision to give men AND women hairy, feather-duster chests.

In the area of protective clothing some surprisingly humorous inventions emerged, such as the construction helmet in the shape of a hardened Stetson, presumably for use by cowboy builders, and fully functioning welding masks shaped as the

glycerine enema
pharmacy, Beijing, China 75p

faces of cartoon characters. There was a fantastically shiny silver fireman's suit from Turkey and a phenomenally shaggy hunting suit that provided all-over, three-dimensional camouflage. We also included fishermen's waders that covered the whole body.

crayon strapped to rams' crotches to mark impregnated ewes
agricultural supplier, UK £25.15

228

pickle lifter from a jar of pickles
supermarket, London free

Within the thousand, one object was a fake. I had heard as a child about a chemical used in German swimming pools that makes the water change colour if people urinate in it. We spent months trying to find it, only to discover that the product was an urban myth. Doing our bit to promote this myth, we mocked up a bottle containing a blue chemical called Blurinate, which we put in the show and nobody questioned.

The exhibition was one of the largest shows staged at the Design Museum and attracted high visitor numbers. Having been displayed for six weeks, the objects are now archived.

stick-on stencil for apples that forms writing on the growing skin
supermarket, Datong, China 49p

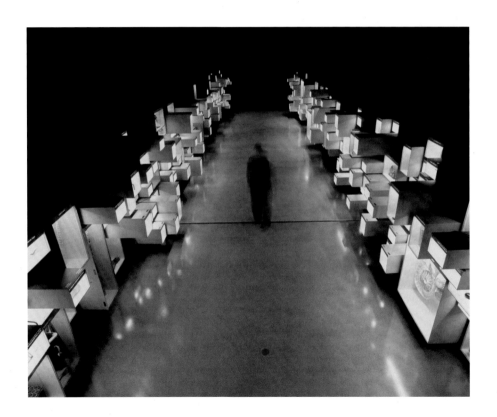

Christmas Card

Can you steal the picture from a postage stamp and use it as the festive image on your Christmas card?

THINKING ABOUT THE DESIGN of that year's Christmas card, we wondered what was the absolute minimum that we could send through the British postal service. Whatever it was, we could not get away without paying the postal charge and the way to do that was with a stamp.

The finished card was nothing more than a single stamp and its postmark, floating within a piece of clear resin. On the back of each stamp, in tiny writing, we put the person's name and address and a Merry Christmas message.

For our previous cards, we had always chosen ordinary stamps depicting the Queen's head but this year we used the cheesy, special edition Christmas stamp showing a smiling Father Christmas, because it was slightly bigger, giving us more space for the details on the back.

Manufacturing the cards in our workshop, with the friendly advice and cooperation of Post Office staff, we found a way of making the postmark float in the resin and calculated the exact size that the block would need to be, to not exceed the weight limit for normal first-class post. We posted them off as they were, with no envelope.

Brian Ham
Director Enterprise & Environment
Civic Centre
Newcastle Upon Tyne
NE1 8QN

Merry Christmas from
Thomas Heatherwick Studio

B of the Bang

*What shape should a monument
make against the sky?*

IN 2002, THE COMMONWEALTH GAMES were staged in the city of Manchester in northwest England. The studio won the competition to design a commemorative sculpture to be placed outside the games' main stadium, which was to become the home ground of Manchester City Football Club. The project was part of a strategy to regenerate this rundown area of the city.

The initial concern was how to site a sculptural object within a landscape of low-quality housing, industrial buildings and large empty spaces with roads passing through them. Other than the stadium, which sat in an open space, the closest building was Europe's biggest supermarket. Most of the time there were few people around and the area was occupied by passing cars, buses and lorries.

Since the site was so flat and open, we felt that whatever we built should be on a similar scale to the stadium. To establish a relationship with people inside the passing vehicles, we needed to pull the sculpture away from the stadium towards the road and, to engage with the intermittent match crowds, we decided to make it form a gateway that straddled the path into the stadium, rather than being a conventional statue on a plinth.

We wondered how to represent or connect with the Commonwealth Games that had taken place there. The monuments we had seen commemorating international sporting events all seemed to be celebrating international cooperation and harmony. While this spoke of sport as an arena in which nations compete in peace, the athletes' determination and ability to channel intense energy for fractions of a second seemed anything but peaceful.

Whether an athlete is a pole-vaulter about to jump in an Olympic final or a sprinter aiming to run faster than any other human being, he or she has to be utterly determined to win during those fleeting instants. This explosion of passion and energy seemed

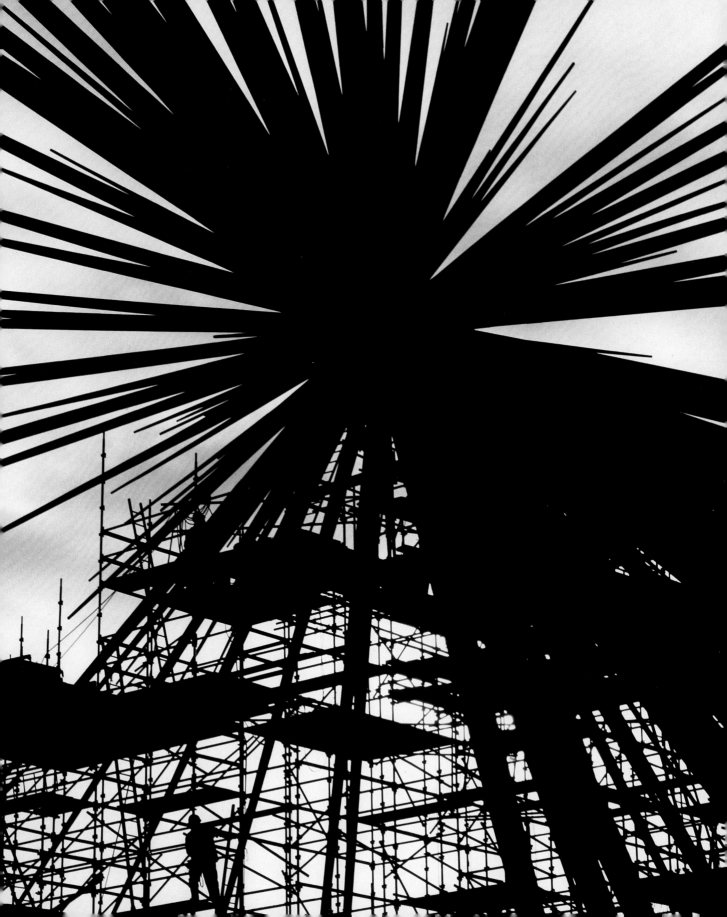

worthy of a monument and we decided that our sculpture should be as dynamic-looking as possible.

We began to think about the silhouette that a large sculpture creates against the sky and how we might use this silhouette to express extreme dynamism. Instead of a singular smooth entity, we chose to splice the object and the sky together. By giving it texture on such a gigantic scale, we formed a shape with a vast perimeter, creating fingers that stretched out into the sky and in turn allowed fingers of sky to extend back into the form.

We turned to the technology used to make the steel lampposts that are seen in their thousands along British motorways. We took these long, tapering tubes and pointed them outwards from an exact point in space above the ground. Although the arrangement of the spikes initially appears random, the structure has a sub-geometry, which, like the organization of the florets in a head of broccoli, subdivides them into smaller conical groupings. As you walk around the structure, looking into its core, you find yourself in the beam of a floret, as if a firework is exploding towards you. There are twenty-four of these groups, each consisting of three, five or seven spikes. Fabricated by rolling flat metal sheet into tapered cones, the columns we used varied in length from 5 to 35 metres.

The entire structure was made from weathering steel or COR-TEN, which develops a protective rust-like coating that stops the metal corroding without the need for paint. A model of the sculpture underwent wind tunnel tests to assess its performance under wind-loading. To support a structure 56 metres tall (almost eighteen storeys) and inclined by 30 degrees, concrete foundation piles had to be sunk 20 metres (six storeys) into the ground.

The core, where these elements met in the middle, held this 180-tonne sculpture together. In the 1980s and early 1990s there had been an architectural fashion for structures made from steel tubes, in which the nodes where tubes joined became an important detail. The centre of our structure was an exceedingly complex node, where 180 tubes, of all different sizes, came together with an irregular geometry.

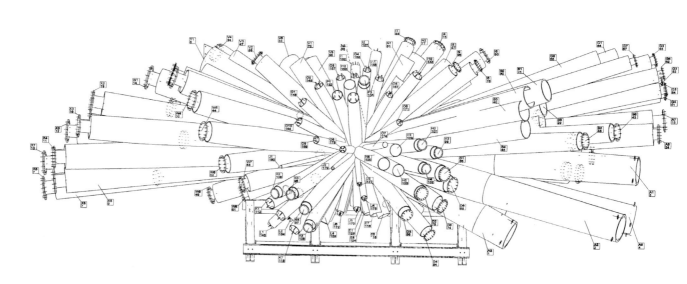

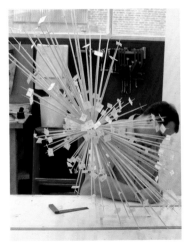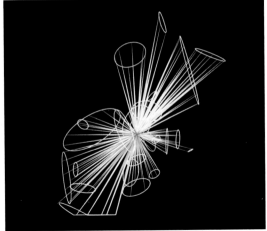

The construction of this core became an extraordinary work of craftsmanship. The welding was built up in stages, until the core eventually contained II tonnes of welding material alone. As the tubes were at narrow angles to each other, the welders had to get themselves into deep crevices like cavers. It was so awkward that we required the services of both left- and right-handed welders, since many welds could be reached only by one or the other.

We named the project B of the Bang, a phrase used by the British runner Linford Christie when explaining that fellow athlete Kriss Akabusi had trained him to leave the starting blocks on the 'B' of the bang from the starter's pistol and not to wait for the 'G'.

It was devastating when the project developed a technical problem and was taken down in 2009, four years after its completion, by Manchester City Council.

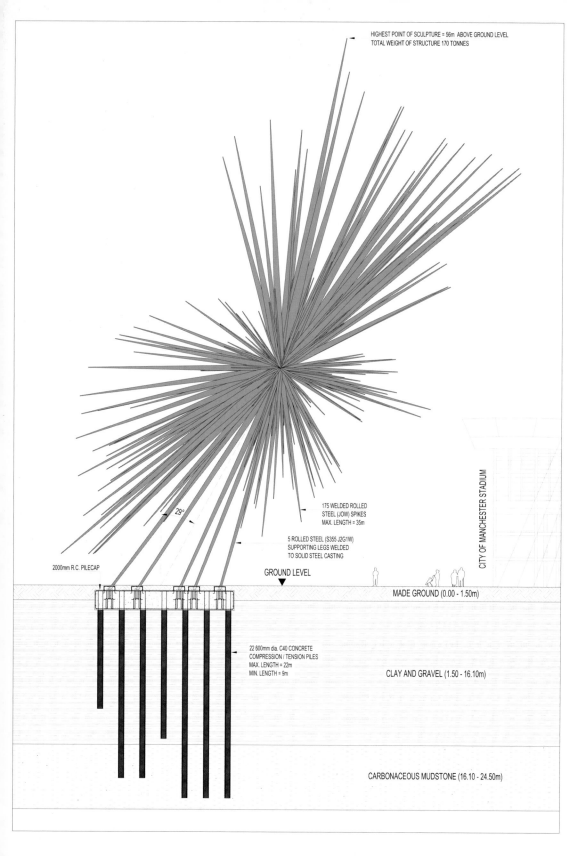

HIGHEST POINT OF SCULPTURE = 56m ABOVE GROUND LEVEL
TOTAL WEIGHT OF STRUCTURE 170 TONNES

175 WELDED ROLLED
STEEL (JOW) SPIKES
MAX. LENGTH = 35m

5 ROLLED STEEL (S355 J2G1W)
SUPPORTING LEGS WELDED
TO SOLID STEEL CASTING

29°

CITY OF MANCHESTER STADIUM

2000mm R.C. PILECAP

GROUND LEVEL ▼

MADE GROUND (0.00 - 1.50m)

22 600mm dia. C40 CONCRETE
COMPRESSION / TENSION PILES
MAX. LENGTH = 22m
MIN. LENGTH = 9m

CLAY AND GRAVEL (1.50 - 16.10m)

CARBONACEOUS MUDSTONE (16.10 - 24.50m)

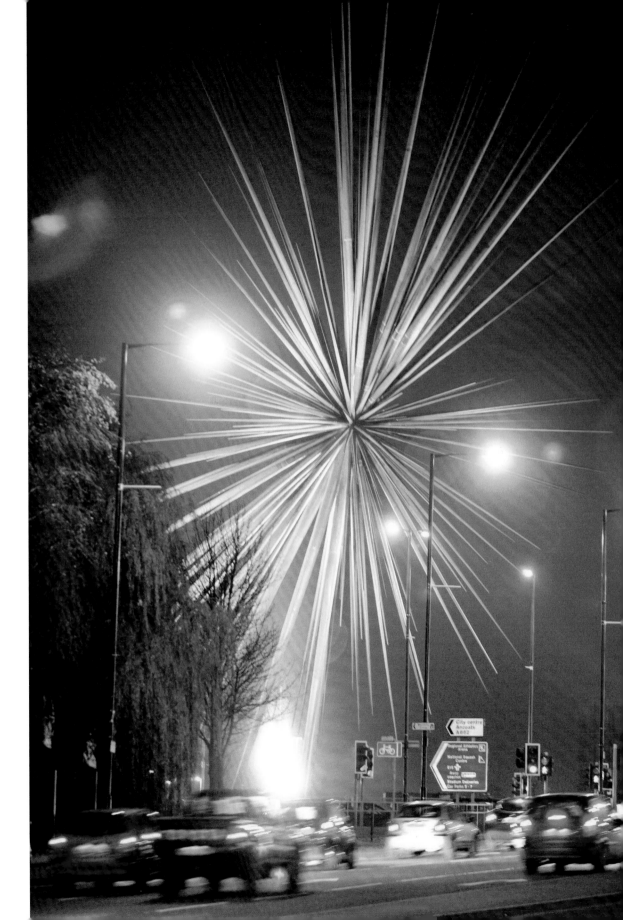

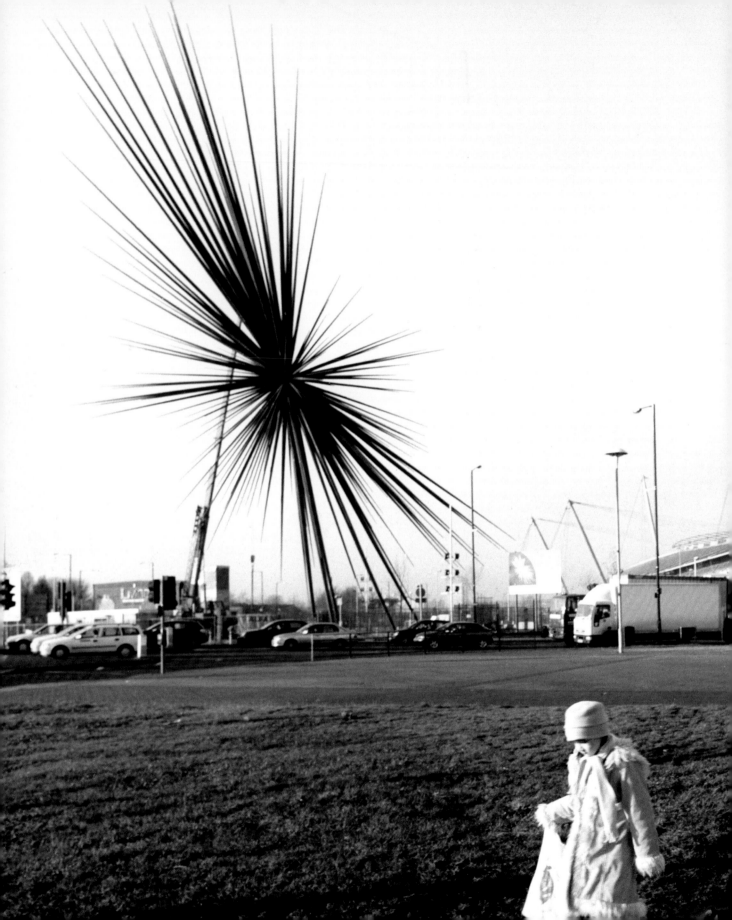

Paper House

How can you make a newspaper stand quicker to set up?

THE DEPUTY LEADER of the Royal Borough of Kensington and Chelsea in west London approached the studio with the idea of replacing some of the borough's existing newspaper kiosks. Watching traditional newspaper sellers at work, we saw that setting up a stall in the morning, often in the freezing cold or pouring rain, could take more than an hour. It was strenuous work, shifting heavy piles of newspapers and magazines, to rebuild the display taken down the night before. By night, when a kiosk is closed, it becomes a dead, uninteresting object. It needs shutters to protect it from vandalism and theft but these flat surfaces force the kiosk into the shape of a box and perversely seem to invite people to put graffiti or stickers on them. Also, kiosks tend to be made from fibreglass and plastic; cheap, lifeless materials that get grimy, scratched and faded with age.

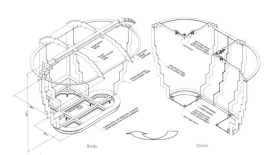

Body Doors

We set ourselves the task of designing a newspaper kiosk that could be set up in ten minutes instead of an hour. Even when closed, we wanted the kiosk to be a positive presence on the street and we looked for a way to make it secure without using conventional flat shutters or hinged panels.

The shape of our kiosk comes from the stepped tiers of shelving inside that hold the magazines. The steps on the outside of the building are the height of the magazine shelves inside. Instead of an obvious door or shutter, the curved walls at each end of the kiosk rotate open, sliding round each other, with the magazines in place. The magazines can be left on the shelves overnight and the vendor can simply roll open the doors in the morning. At the uppermost tier of the kiosk, a window brings in daylight and at night, when lit, the little building feels like a nightlight for the street. The kiosk's rounded plan comes from its opening mechanism and the point at which the structure connects with the pavement is recessed so that any urban grime has less impact.

Two of these kiosks were installed in the Royal Borough, but newspaper vending in London is a dying trade, with vendors increasingly reliant on selling sweets, drinks and cigarettes.

Eden Project Exhibition Buildings

How can you put one building next to another one but not see them both at the same time?

THE EDEN PROJECT IN CORNWALL, England, transformed a vast hole in the ground, once an open clay mine, into an educational visitor attraction by creating exotic gardens in vast, climate-controlled glasshouses known as biomes. The studio was commissioned to design new spaces on the site that could be used for temporary exhibitions.

Arriving at the Eden Project, you get your first spectacular view when you look down over the precipice on the south edge of the pit at the glasshouses, the heroes of the site, which are built into the opposite side of the pit. However, with huge numbers of visitors to cater for, many temporary structures have been added to the site and the space in front of the biomes has become littered with yurts, tents, stages and kiosks. Being reluctant to add to this clutter or to compromise the visual impact of the biomes, we decided to design something that could not be seen when you first looked at the biomes. To do this, we would need to build into the slope opposite the biomes, below this first viewing point, so that when you first looked into the pit you would look over the tops of the new structures without realizing they were there.

Our proposal was to prise the contours of the ground apart and wedge the giant slabs of land open by inserting simple, rectangular buildings. This would create two kinds of space, both different from the biomes. The enclosed buildings provided controllable indoor space, suitable for exhibitions, while the sheltering eaves of the lifted slabs of land made cave-like spaces that could

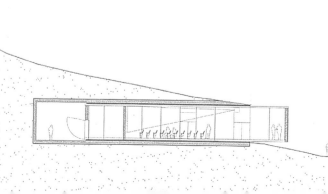

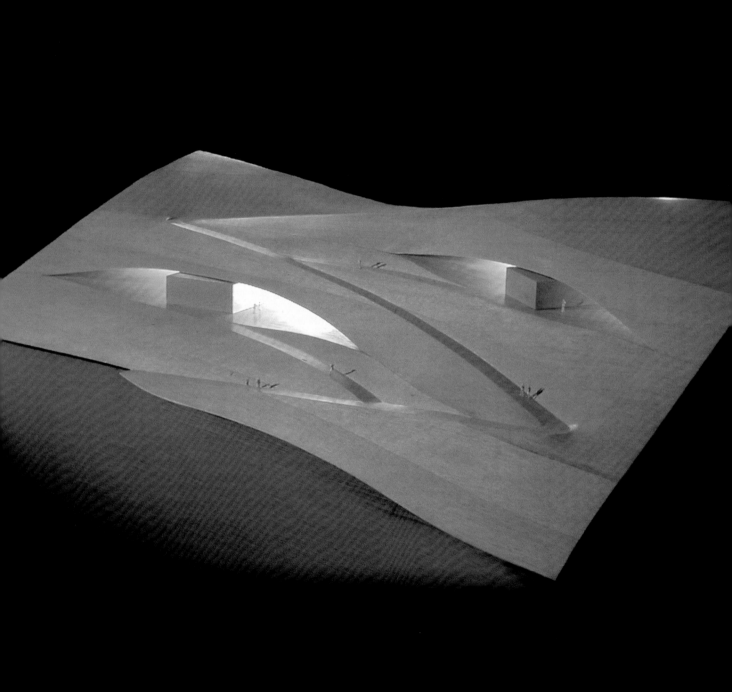

act as semi-outdoor rest areas for visitors walking up the steep pathways out of the pit.

These small buildings, inserted into the landscape between the site's zigzag paths, posed no visual challenge to the biomes, since the two structures could not obscure each other or even be photographed together.

A woodcarver who had been involved in the renovation of St Paul's Cathedral in London helped us to make the wooden model of the proposal that we presented to the Eden Project team.

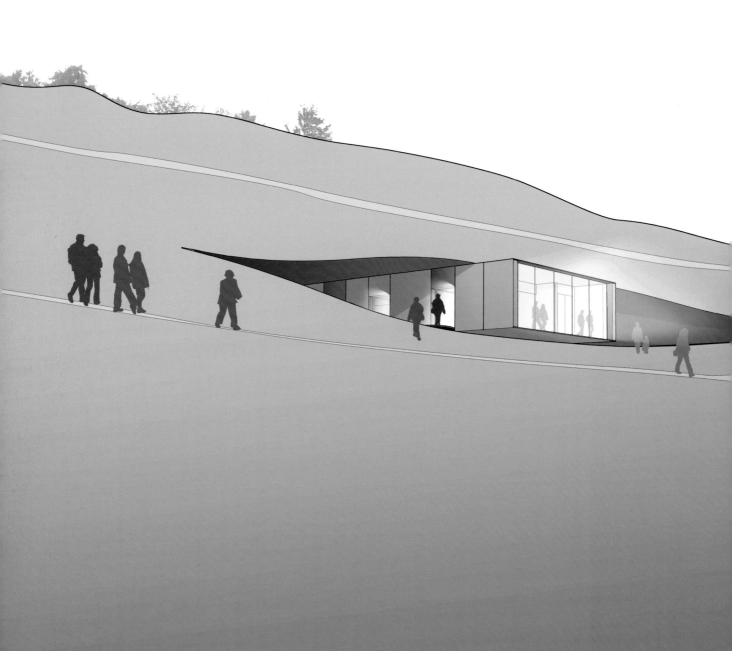

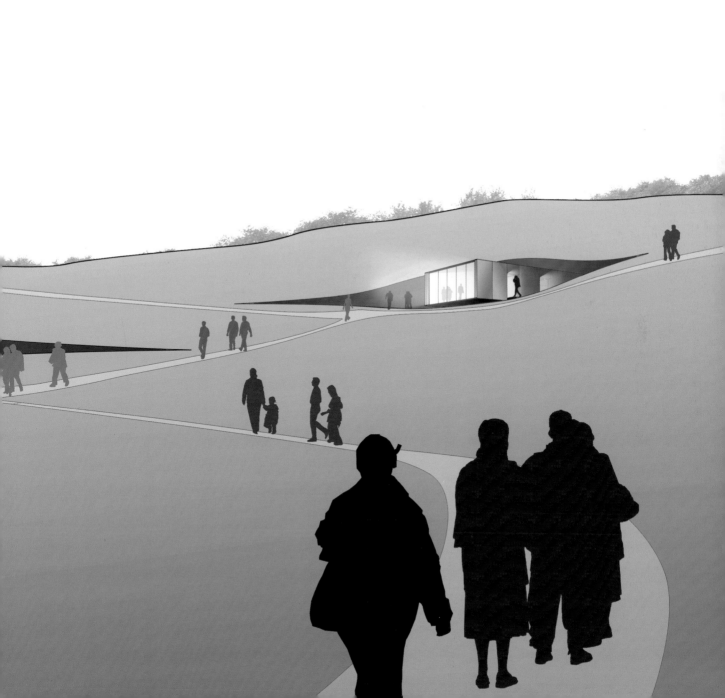

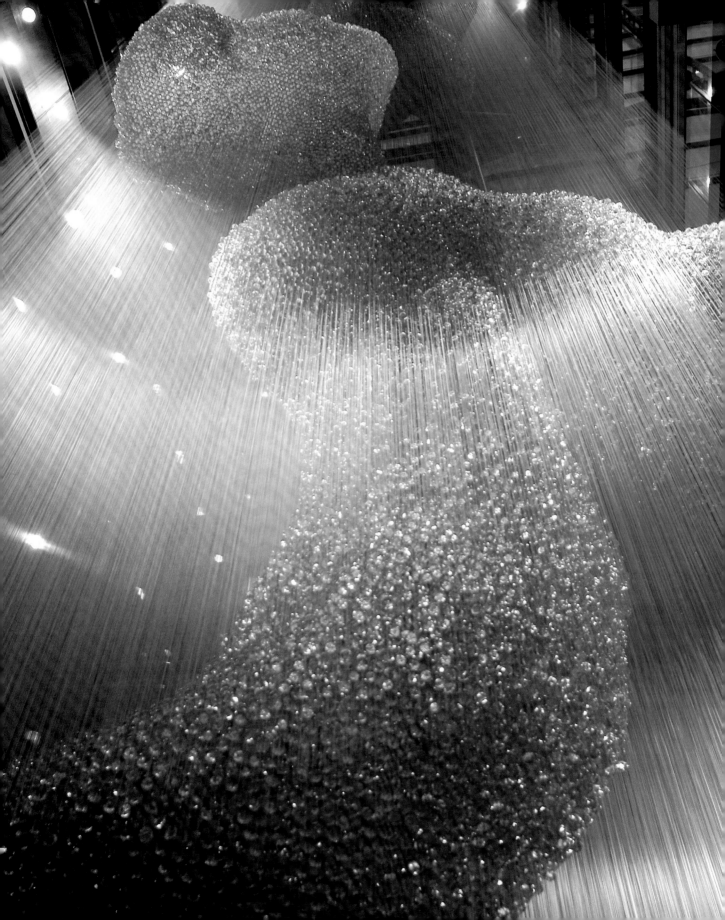

Bleigiessen

Can a giant sculpture fit through a letterbox?

THE WELLCOME TRUST, the charitable organization known for funding bio-medical research, commissioned the studio to design a sculpture to go above a pool of water in the seven-storey atrium of their new headquarters building in London.

Even though this new building had been designed to accommodate a large object, the only way to bring anything inside was through a smallish, domestic-sized front door. We found that we were uncomfortable with the idea of making a huge object out of door-sized pieces and bolting them back together once they were inside the building, with connection lines that would always be there to tell you how it had been made.

This was a large sculpture in a prominent location for a well-established organization, which might well be in place for a hundred years. It would not be enough to make an extraordinary shape; the project had to have depth and complexity and meaning. How could we find a shape sophisticated enough to justify a long-lasting presence in the building?

The tall, shaft-like proportions of the 30-metre-high space reminded us of a gigantic gravity chamber and this, combined with the pool of water at the bottom, gave us the idea of experimenting with falling liquids. As water falls, it does not form simple teardrops but tumbles and contorts into surprising sculptural forms. It seemed that a form with a complexity determined by natural forces might be appropriate for this project, rather than a form sculpted by hand in clay, for example.

To harness this idea, we experimented with a number of approaches, including photographing falling liquids and pouring hot wax into the snow that had fallen in London that week. We found that the best way of capturing the form of falling liquid was to pour molten metal into

cold water. This produced extraordinary unique and tiny objects in a fraction of a second, the metal squealing explosively as it made contact with the water.

While the process itself was quick, it took a long time to analyse each test piece to see if, enlarged to 30 metres, its proportions and detail would fit the building. We had little control over the process and had to make more than four hundred pieces before we got one, 50 millimetres high, that fitted the proportions of the building. The form of the giant sculpture that would be there for a hundred years had been created in a hundredth of a second. But in the absence of any drawing or sculpting, who was its designer? Was it us, or were we just curating or choosing?

The piece we finally chose was not the most obviously beautiful object produced in the course of our experiments but it was the one that had the best sculptural personality and changing diet of detail throughout its length. It was a shape that your brain could never have thought up and your hands would never have formed from clay.

The piece was three-dimensionally scanned, so that we could enlarge the form to 30 metres, scaling up its every idiosyncrasy and contortion. But, given the modest size of the doors, how could we bring such a large and complex object into the building? If we could not bring the sculpture in through the door, why not bring it in through the letterbox?

I remembered that many years ago my mother, who is an authority on beads and threading, had been commissioned to make a large bead curtain with coloured beads arranged on hanging strands to produce an abstract image. Thinking of this, it occurred to us that we could make this piece out of bead-like elements. Within this 30-metre-high form, each bead would be a three-dimensional pixel (or, to be precise, a voxel) that would fit easily through a letterbox. By suspending thousands of wires from the top of the atrium, we could make a grid in three-dimensional space, within which we could make an object, defining its volume by locating beads at different points on these wires. But if beads were the main ingredient, what would make them special?

We commissioned two British glass artists, who work under the name of Flux Glass, to make us samples of handmade beads the size of golf balls, in different colours, but we were reluctant to choose any one colour. They then showed us a prototype of a glass sphere with an unusual iridescent quality, made from bonding colour-changing dichroic film between two glass

hemispheres. These acted as lenses, which magnified the colour changes within the sphere depending on the angle of the light and the position of the viewer. Unlike a clear glass bead, this had warmth and life and its coloration changed constantly.

252

Our next challenge was to find the most effective way to arrange beads on wires so that they would form a dense enough skin for an object. When the beads were arranged in a grid pattern, the effect was stripy and full of gaps. Researching how to organize spheres in space, we found a body of scientific literature on the subject, including studies of the most efficient way to pack oranges.

At this point we had a sculptural form and a way of constructing it, but it was almost impossible to produce an accurate representation of what the finished piece would look like. On the computer, the thousands of fine vertical wires turned the screen black, and the most powerful machine in the studio crashed when it attempted to render the 150,000 colour-changing beads.

The final piece was made from just under a million metres of stainless steel wire and 15 tonnes of glass beads. The colour-changing beads were made in two stages. A spectacle lenses factory in Poland manufactured 300,000 half-spheres of glass, while a company that usually makes bottles for perfume and cosmetics bonded them together in London, inserting a layer of dichroic film between each pair.

To put the sculpture together, the beads were hung on the wires suspended from a specially made frame, which cantilevered out from the building's uppermost floor plate. On every wire there were 600 points at which a bead could be placed to create the form, so there were 16,000,000 potential locations for beads. With each of the 27,000 wires programmed differently – some wires holding one bead but others having dozens – this project became all about data management and a system of manufacturing that resembled a factory production line. A team of thirty people assembled the piece on the seventh floor of the empty new building. They worked in three shifts, twenty-four hours a day, for four months. There was a data sheet for each set of ten wires, listing the coordinates for every bead that was positioned by hand and crimped in place on the wire. We made plywood tables 35 metres long to use as jigs, with egg-cup-like indentations for the beads. These tables acted as tracks for specially made trolleys that rolled up and down them carrying the beads and data for each set. Everything had to be done extremely slowly and carefully. It was a huge problem if the wires tangled as we hung them in the atrium; this happened frequently and there was no solution other than to cut them down and start again.

It was not until we were halfway through installation that we began to see our object emerge. The wires accumulated into a shimmering cloud and with every set of wires that was carefully unrolled down into the space, the floating object became more and more apparent. The beads define the surface of the sculpture – the form is hollow – and while the shapes were still emerging, before the form was complete, you could look into the hollow pieces as they appeared. The holes were unintentionally so sensual and sculptural that we were faced with a dilemma as to whether

to stop there and leave the form unfinished, but we took photographs and decided to let this be the project's secret.

When my German-born grandmother saw what we were working on, she immediately said: 'This is Bleigiessen.' Bleigiessen means 'lead pouring' in German, and is an east European tradition. On New Year's Eve, people melt pieces of lead in saucepans on their cookers. Then they pour the melted lead into water and interpret the unusual shapes it makes to predict their fortune for the coming year. Without realizing it, we were making an object that symbolized the future of an organization in its new building, using an old custom about telling the future.

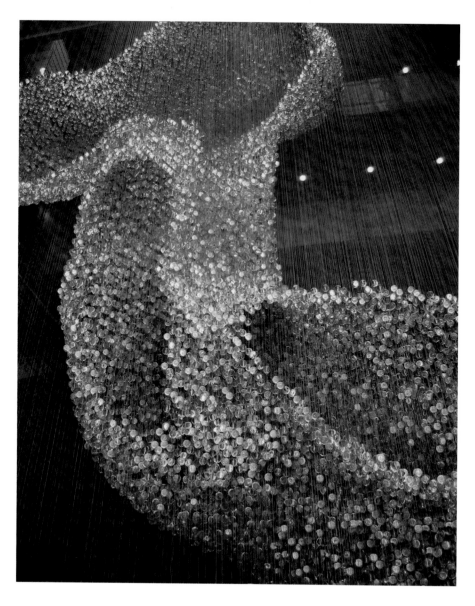

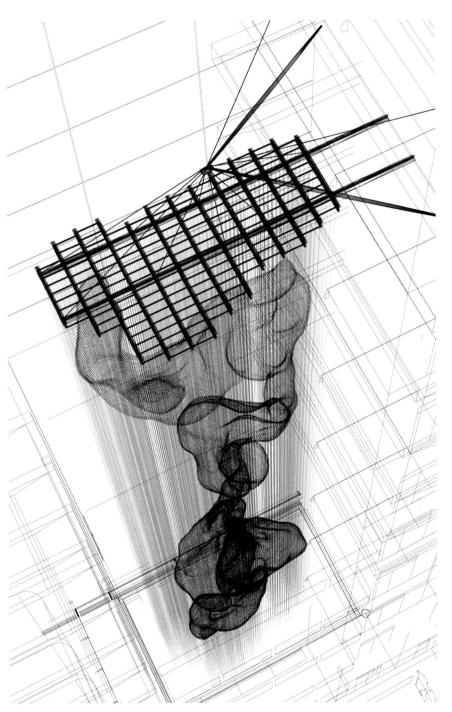

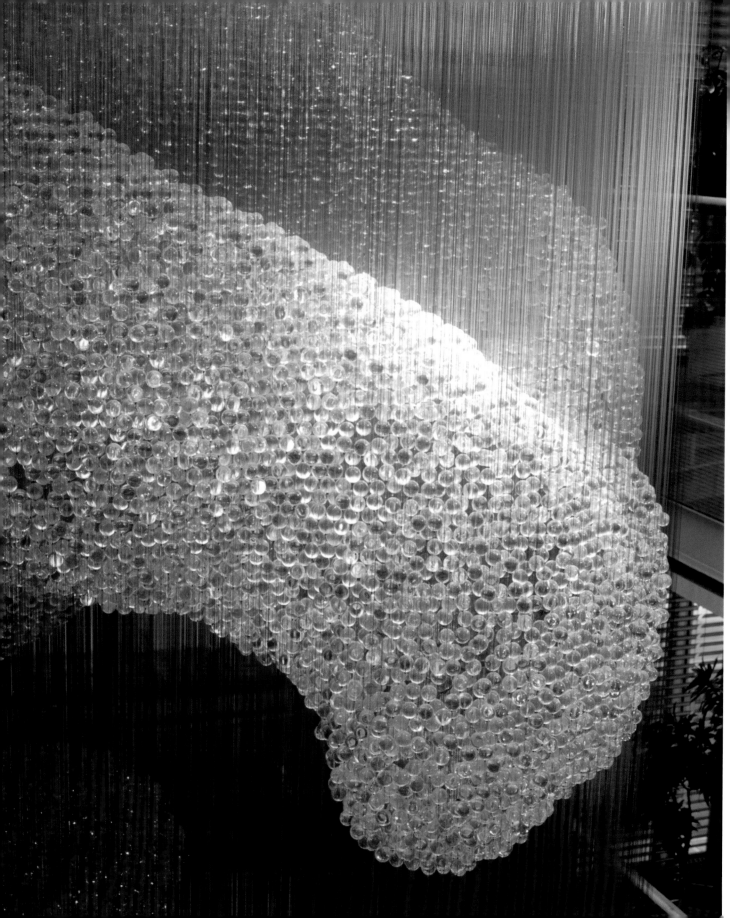

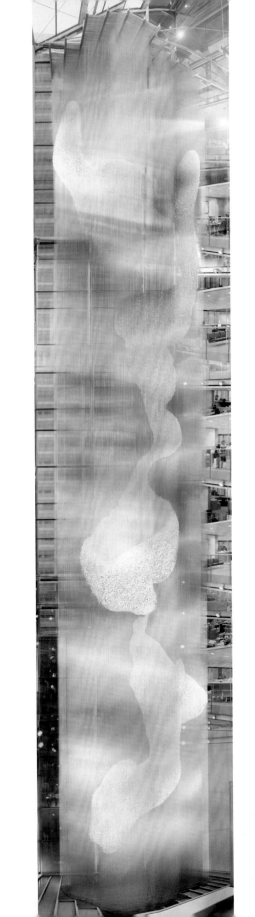

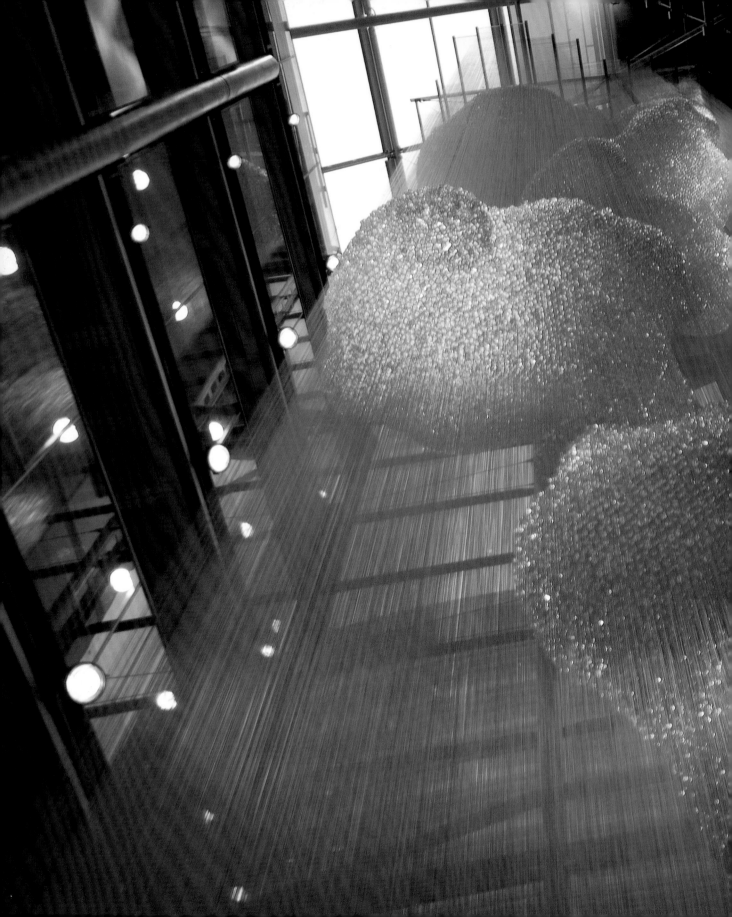

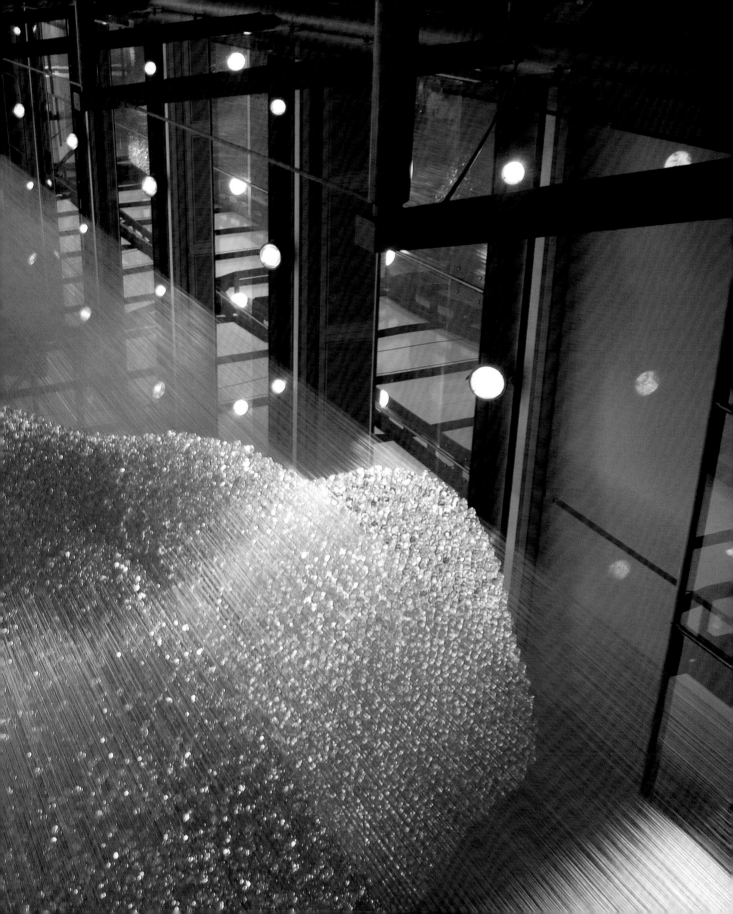

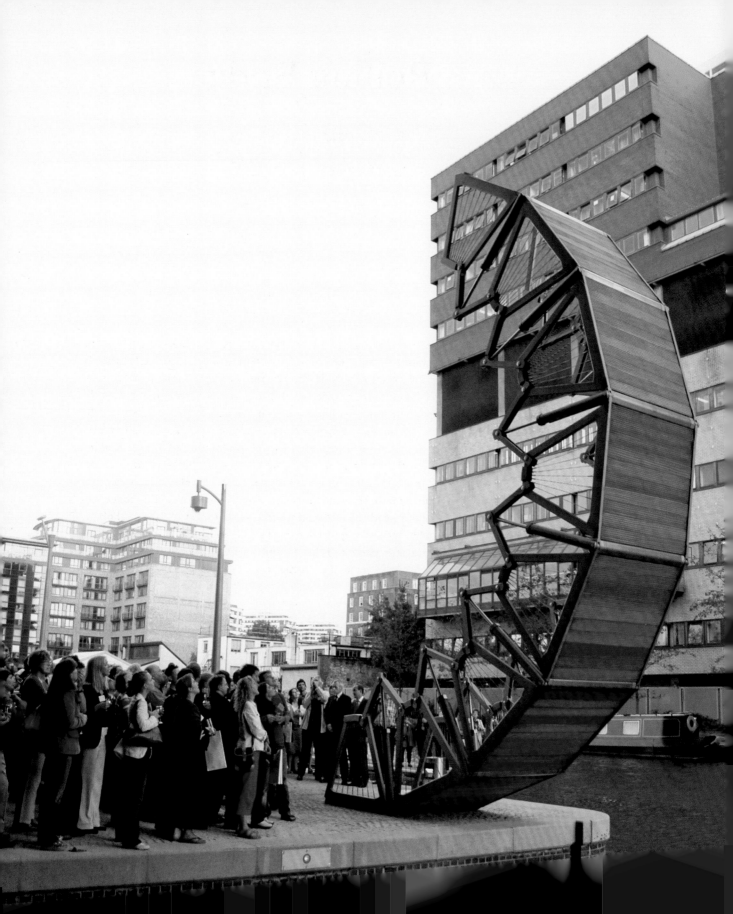

Rolling Bridge

2002

*Can an opening bridge
open without breaking?*

AS PART OF THE REDEVELOPMENT of Paddington Basin in London into a landscaped enclave of housing, shops and offices, the property development company Chelsfield decided to commission three new pedestrian bridges. The studio was invited to design one of them. The brief was for a pedestrian bridge to span an inlet off the main canal basin. It had to be possible to open the bridge to let boats through.

From the Industrial Revolution to the present day, Britain has acquired a wonderful heritage of opening bridge structures, from Tower Bridge with its decks that flap up like pinball flippers, to the opening bridges of Newcastle, which swing round or tilt over. People seem to love the spectacle of these pieces

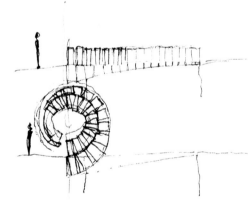

of civil engineering, even though the motion of a big, clunking element moving out of the way on a giant hinge is often crude. To us, it seemed that opening bridges tended to 'break' as they opened to let boats through. We couldn't get the image out of our heads of a newspaper picture that showed a football player who had been going for a tackle when another player accidentally stamped on his knee as he reached for the ball; his leg badly broken, bent at the wrong angle like a snapped-open half of Tower Bridge.

Rather than considering how to make a bridge 'open', which suggested that it needed to break, we began to think about how to make a bridge 'get out of the way', and looked for a softer, less crude mechanism. Could we make a bridge that got out of the way by transforming itself by mutating rather than fracturing?

We began thinking about the animatronic creatures made for films such as *Jurassic Park*, in particular the dinosaur called Apatosaurus, which had a tail longer than our bridge. Using steel mechanisms covered in silicon rubber to simulate the animal's flesh, the animators had given their dinosaur a bendy tail that moved fluidly. We wondered if we could do the same with a bridge, imagining a simple form bending in a smooth, animal-like way, its mechanism sheathed in silicon, but then we realized that this confused the idea. It would be perceived as a 'rubber bridge', even though the rubber had nothing to do with the way it opened. The silicon material would also be both expensive and heavy.

261

The final idea was for a bridge that rolls up until the two ends join together to make a circle. It is a simple, self-contained object, fixed to one bank, with no ramps or platforms on the other side, so that when it rolls up on to one bank, it leaves nothing on the other side, where the end was resting. To allow the emphasis to be on the theatrical effect of watching it open, rather than on what it looked like, we chose architectural materials that allowed the bridge to blend into its environment, a deliberately uncontroversial palette of familiar architectural elements: grey-painted mild steel, stainless steel cables, timber decking and aluminium treads.

The deck of the bridge, which people walk on, is made in eight sections. There are seven pairs of hydraulic rams set within the balustrades, which correspond with the joints between each deck section. Most of the time, the bridge is down and the hydraulic rams just look like the posts that hold up the handrail. But these rams are powerful extending mechanisms and, as they lengthen, they push upwards on the handrail, causing it to fold. Folding of the handrail folds the deck sections in on themselves and makes the bridge roll up. The fourteen rams

PIN BUSHING - MAX. BEARING STRESS = 270 N/mm² Ult.

PIN BUSHING - MAX. BEARING STRESS = 350 N/mm² Ult.

FABRICATED HANDRAIL SECTIONS FROM 20thk PLT (GR. S355).

PIN BUSHING - MAX. BEARING STRESS = 250 N/mm² Ult.

PINNED CONNECTION.

HYDRAULIC RAM TO SUB CONTRACTORS DETAILS

PINNED CONNECTION

TIMBER DECK SCREWED TO FRAME. 60 x 60 x 4 RHS.

100 x 60 x 4.0 RHS WITH 33 DIA x 2.6 CHS INSERTS TO SUB-CONTRACTORS DETAILS.

100 x 50 x 6.3 RHS TYPICALLY. SEE ELEVATION FOR VARIATIONS.

150 x 50 x 6.3 RHS BOTTOM BOOM (TYPICALLY).

are powered by one mechanism, a single, large ram, which is set in an underground box next to the bridge.

Most of the time, it is an unremarkable footbridge across the water, but when it rolls up until the two ends kiss, it mutates into a free-standing sculptural object that looks nothing like a bridge. We imagined that the bridge would be noisy as it opened but, because it is powered by hydraulic fluid, the mechanism is so quiet it is almost spooky.

The project was built in Littlehampton on the south coast of England and the studio worked closely with the fabricator to develop the details of the design, as well as with the hydraulic power experts who helped to engineer the mechanism.

Although the Rolling Bridge rarely needs to open for a boat to pass through, it is operated regularly for visitors and tourists.

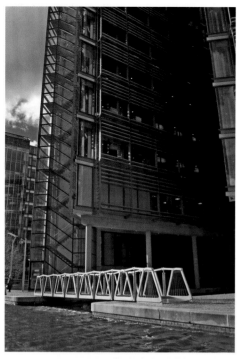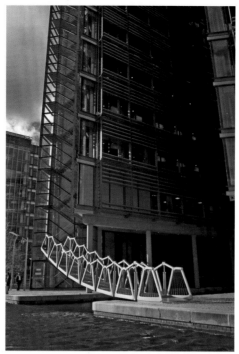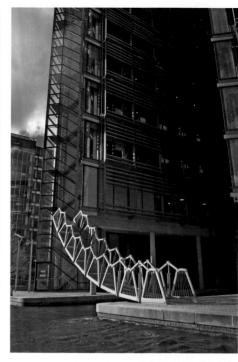
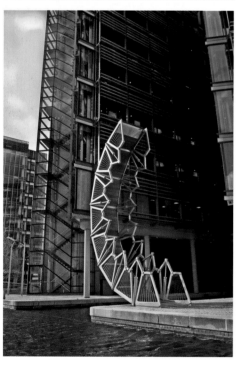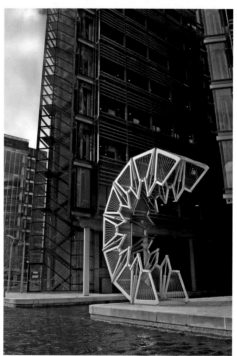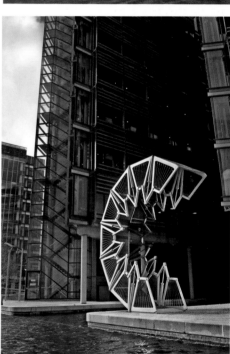

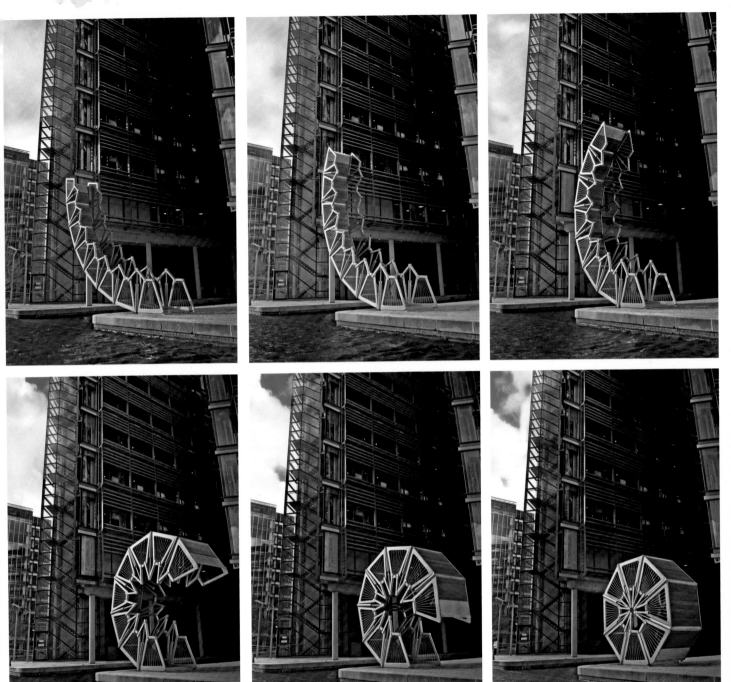

BMW Pavilion

*Is it possible to design a building
in less than a minute?*

BMW WAS LAUNCHING A NEW CAR and the studio was invited to design
a pavilion to promote it. Instead of the usual television and billboard campaign, the
strategy was to create a temporary pavilion in which to exhibit the car in a promi-
nent location in London and, without carrying any branding on the outside, let the
manufacturer become known as the company behind this special project.

The first decision was not the design of the pavilion but its placement, and
finding a suitable place was surprisingly difficult. Most of London's public spaces
are either obstructed by benches or railings or have a sculpture, a column or
fountains in the middle. Others are already well known for temporary installa-
tions or loaded with associations. It showed the value of flexible unprogrammed
space in the city – and how little there is of it in London.

Our choice of location was the space around the well-known landmark
Marble Arch. As a site, it was unique in London: a large, open public space,
a highly visible hub and meeting point of four major routes through the city.
It also had greater relevance to cars than a space in a park or next to the river and
although its identity is world-famous, it was an underexploited location that
offered few people an excuse to actually go there.

Asking ourselves what kind of object could sit next to this classical
structure, we decided on making a confident contrast. Our idea was to take a sheet
of material the size of the open space and wrap up the car to form an enclosure.
We imagined it to be an entire building, taller than Marble Arch, made out
of a single sheet of architectural wrapping paper. It was a development of the stu-
dio's interest in translating spontaneity into building structures and came from
experimenting with crushing sheets of paper with our hands. It interested us that,
instead of designing a building in a normal way, painstakingly working through
every detail, we adopted the role of a midwife, helping a material to take on a useful
form while it underwent a spontaneous and uncontrolled transformation.

To develop the design into a final form, we had to invent a special kind
of thin paper laminated with aluminium foil, which was able to hold the crinkles.
We carried out hundreds of tests, looking for a piece that made an extraordinary
internal space as well as a sophisticated external form. Although the act of crush-
ing this paper was a spontaneous gesture, it had to be done carefully because

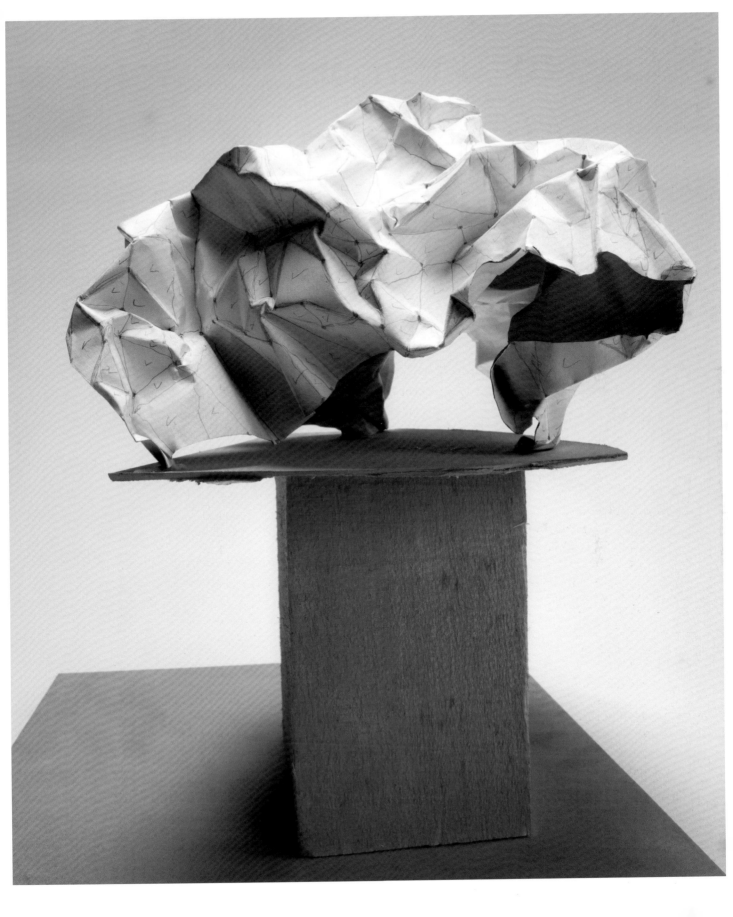

if the paper was fiddled with or over-manipulated, it lost any special quality and began to look bullied. In our search for the form, we covered every surface of our workshop with test pieces of carefully laminated, crumpled paper. We came in one morning to find that the studio's cleaner had thrown away every single carefully crumpled test piece.

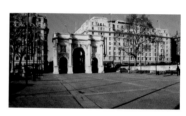

We finally found a piece that seemed to meet the project's architectural needs and used a 3D scanning arm to turn all the folded corners and edges into exactly replicated data points. We then translated the digital information from this delicate object into a proposal for a welded structure made from 900 uniquely shaped pieces of laser-cut steel. If the pieces were laid out flat, they would form a sheet of steel the shape and size of the open space at Marble Arch.

The client was enthusiastic and Westminster City Council wanted the project to go forward. We fabricated test pieces and negotiated costings and a programme for delivering the project but an unexpected slump in the sales of luxury cars prevented the project from going ahead.

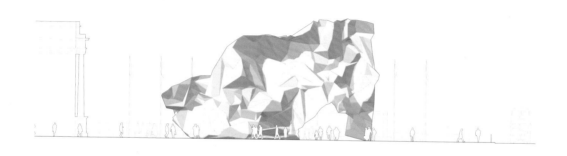

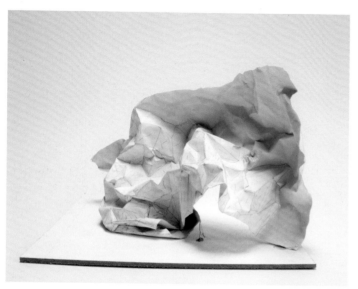

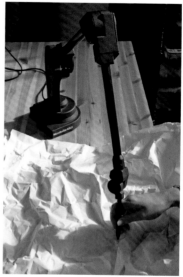

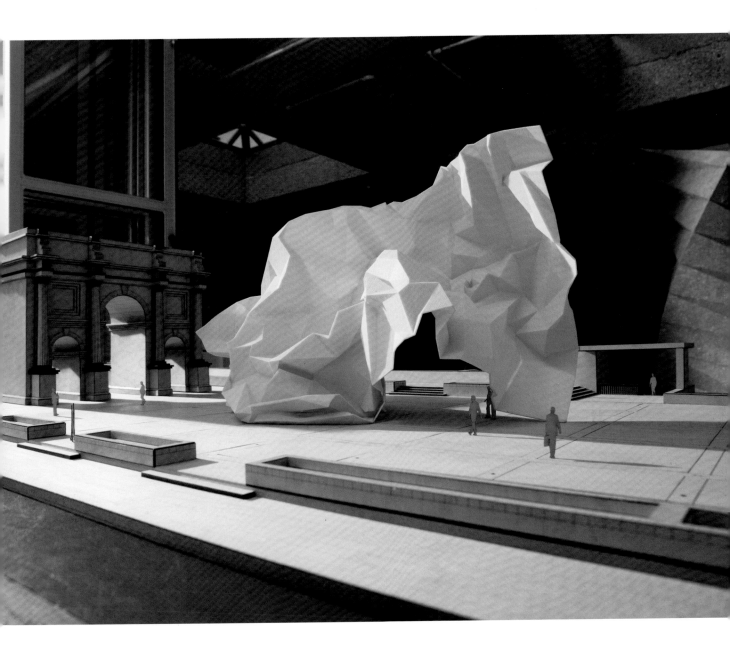

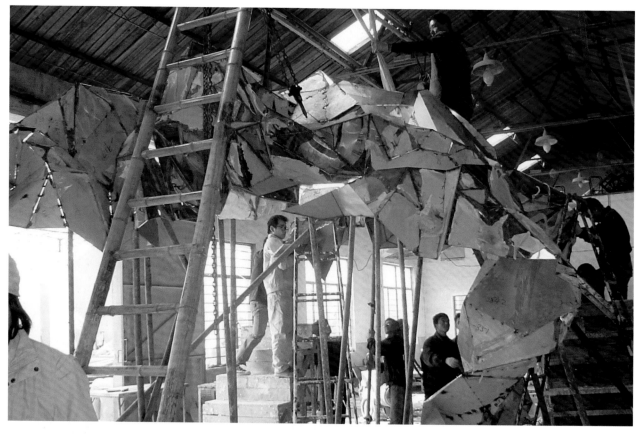

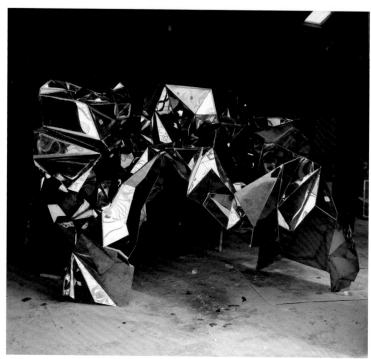

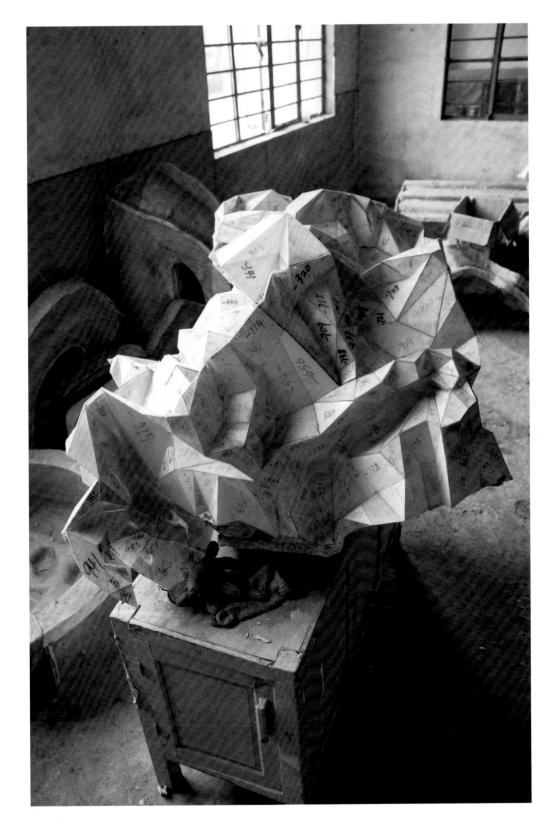

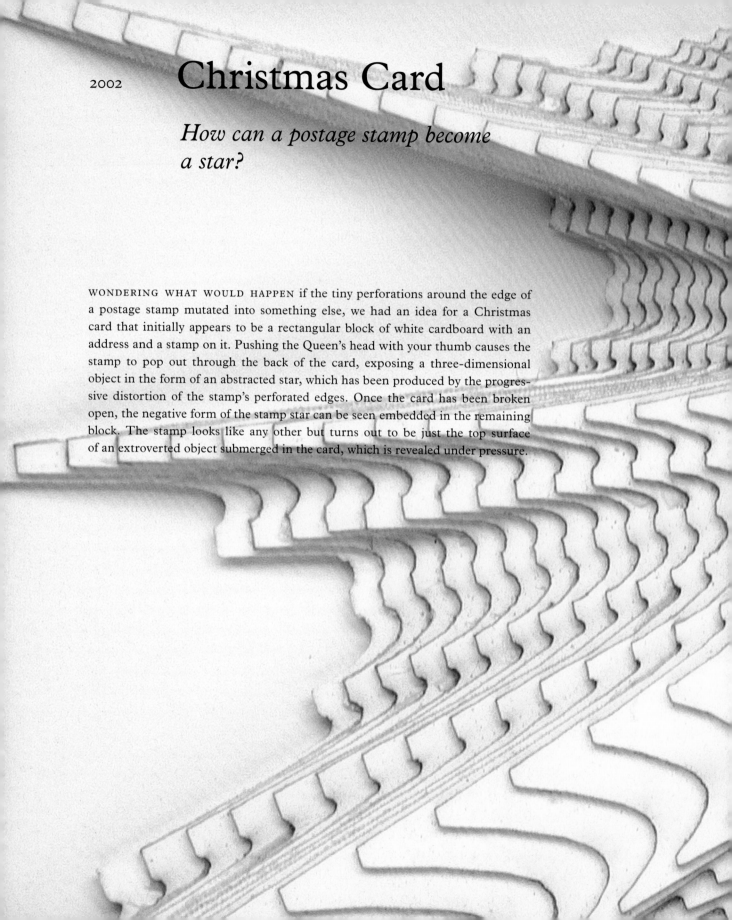

Christmas Card

How can a postage stamp become a star?

WONDERING WHAT WOULD HAPPEN if the tiny perforations around the edge of a postage stamp mutated into something else, we had an idea for a Christmas card that initially appears to be a rectangular block of white cardboard with an address and a stamp on it. Pushing the Queen's head with your thumb causes the stamp to pop out through the back of the card, exposing a three-dimensional object in the form of an abstracted star, which has been produced by the progressive distortion of the stamp's perforated edges. Once the card has been broken open, the negative form of the stamp star can be seen embedded in the remaining block. The stamp looks like any other but turns out to be just the top surface of an extroverted object submerged in the card, which is revealed under pressure.

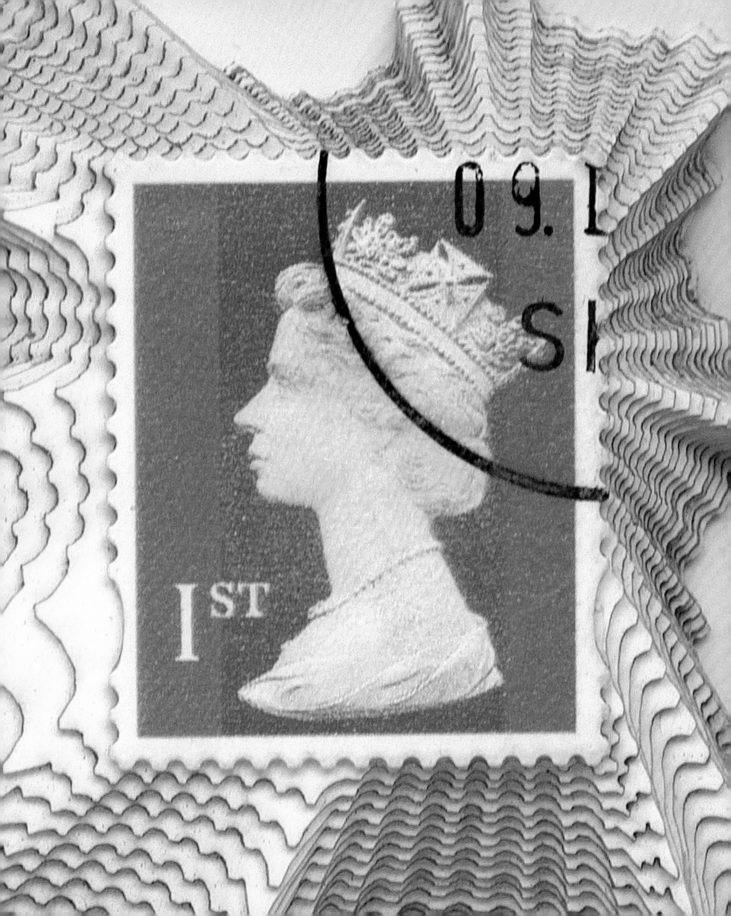

press
firmly
helpline:020 7833 8800

FRITH KERR AND AMELIA NOBLE
STUDIO 53
PENNYBANK CHAMBERS
33–35 ST JOHN'S SQUARE

LONDON EC1M 4DS

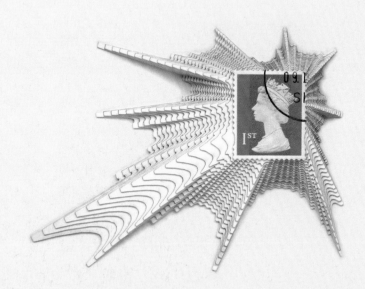

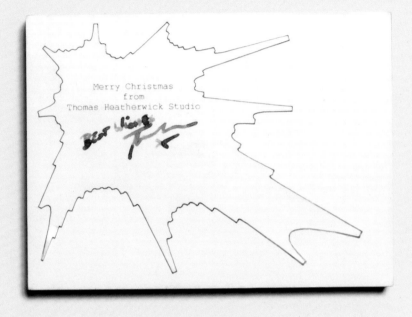

Merry Christmas
from
Thomas Heatherwick Studio

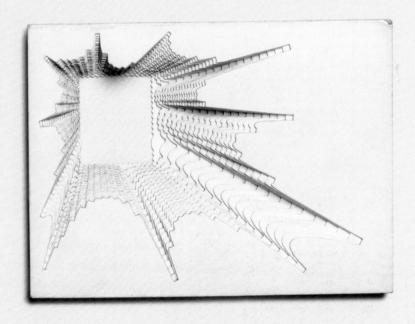

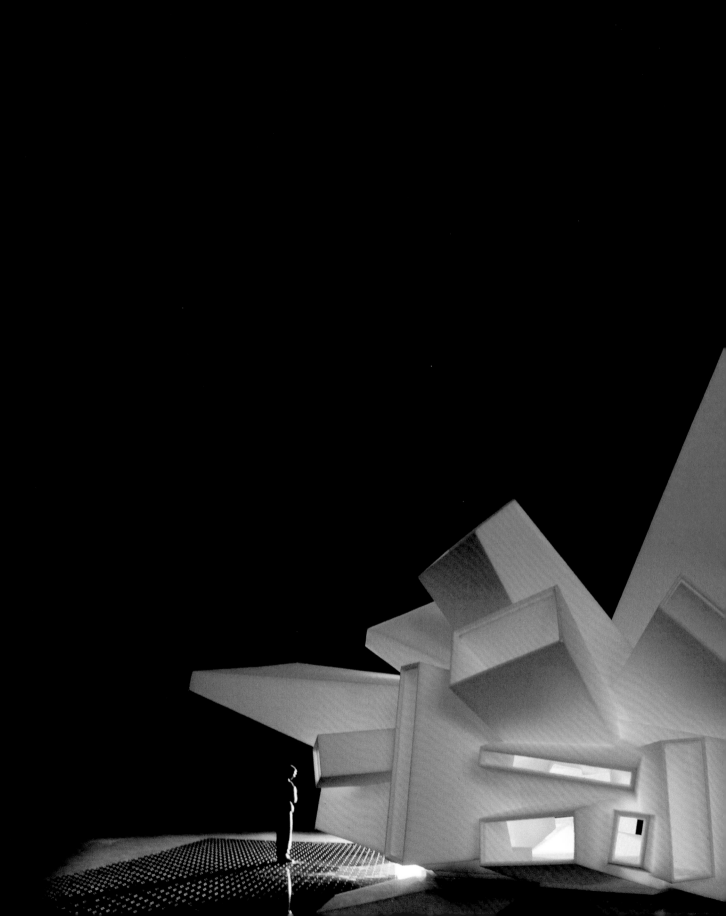

Milton Keynes Information Centre

How can a building communicate what is happening in a town?

THE CITY AUTHORITY of Milton Keynes in England asked the studio to design an information building. Inside, it would be a meeting space and information centre; on the outside it would contain a cash machine and a postbox, tell the story of the town's history, promote current events and let people know about proposed developments in the town and receive their responses. The aspiration was to inform and enthuse the town's inhabitants, as well as to reconnect with its history of radical design.

At the time, the studio was working on the sculpture called B of the Bang (pages 232–243). We had been imagining what it might be like to stand within its central core, which was big enough for people to stand inside, and wondered if this structure could be like B of the Bang's core. Just as the form of the Manchester sculpture consisted of steel cones emanating from a central core, so too this project was a collection of intersecting square tubes projecting from a central point, trimmed away where they intersected to create an internal space. Each protrusion contains a particular function, ranging from an apparently mundane cashpoint and postbox to aspirational models and drawings of the future town and solar panels to help power the building.

Most buildings are multi-functional but for this one, the functions become the building, each one distinctly and separately embodied within the form of the structure, making this a cluster of intersecting ideas. Every box is like a tannoy speaker or megaphone, projecting a message and transforming the structure into a modern-day town crier. Milton Keynes is famously composed of boxes, and this seemed to be a dynamic way of reconnecting with that.

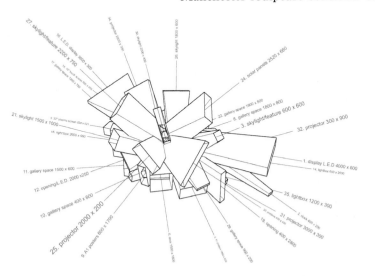

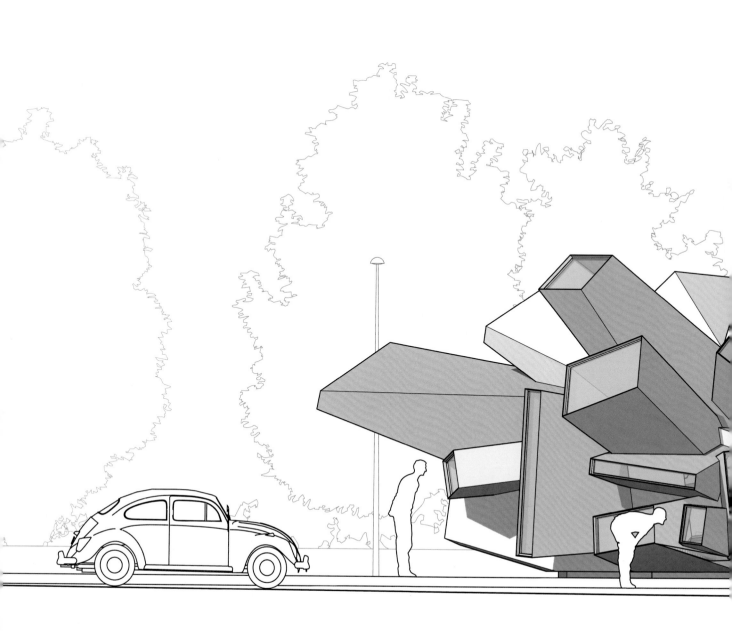

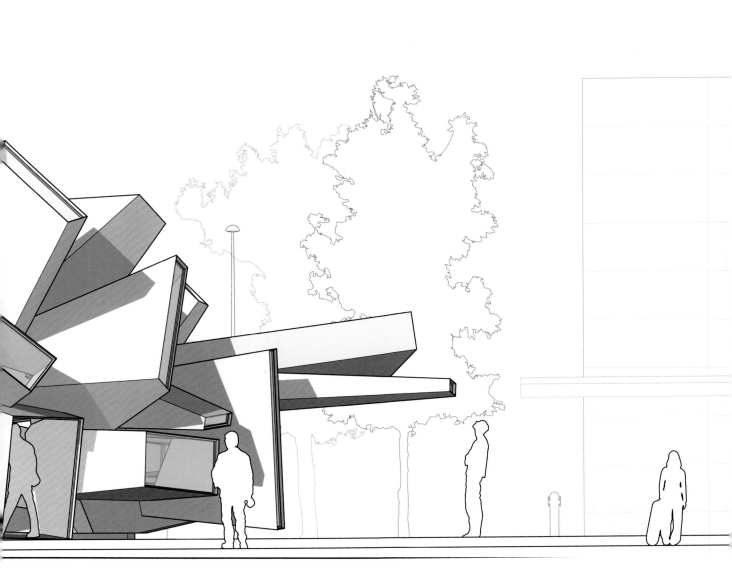

Glass Bridge

*Is it possible to make
a bridge out of glass?*

DURING THE 1990S, glass was increasingly used as a structural material in architecture. Structures appeared that were described as glass walkways or glass staircases or glass roofs. Although they contained glass used in a structural way, they relied on metal bars, bolts or tension cables to do much of the work. At a smaller scale, in contrast to the architectural trend for minimalistic glass structures, artists and craftspeople seemed more prepared to take pleasure in this extraordinary material and use it more expressively.

The idea that the studio conceived in 1995 was to build a bridge across water that both celebrates the optical qualities of glass and uses it as its structural material, without resorting to steel fixings, cables or structures to support the span, in the same way that a medieval bridge builder might have used rock. The potential for lighting an object like this at night seemed fantastic. Although architectural structures are normally lit by shining lights at the outside of them, to illuminate an all-glass bridge you would need only to put lights in each end for the light to be transmitted inside the glass and make the bridge glow from within.

BASIC GEOMETRY ISOMETRIC VIEW

The initial design used pieces of glass layered together in the direction of the bridge. Instead of specially shaped pieces of cast glass, which would have been expensive to produce, it employed identically shaped sheets of standardized float glass. Because we were also interested in making a form that altered the typical symmetry common in bridge design, it had a tilted, longitudinal geometry, which gave it directionality. Crossing the bridge from one end, the deck and its balustrade are coming towards you, while in the other direction, they appear to be flowing along with you. As this approach was dependent on adhesives that were not sufficiently tried and tested, we looked for a different way to make a glass bridge.

The new structural idea came out of analysing the Millennium Bridge over the River Thames in London. This entire structure is extremely slim because the cables that support the deck are held in high tension. The extraordinary tension in this bridge gave us the idea of using the opposite principle: could we use extraordinary compression? Instead of making two river banks pull on the ends of the cables, could you make two river banks squeeze together so hard that they create enough friction to hold hundreds of pieces of glass between them?

FRONT ELEVATION 1:2

When you are moving books around on shelves, you find you can lift a whole shelf-full at once by squeezing the stack of books from both sides between your hands. Instead of books, could we use pieces of glass? And instead of using the strength of your arms, could we apply a vast mechanical force?

Our design proposal is to take 1,200 pieces of glass, weighing 140 tonnes, and arrange them perpendicular to the direction of a bridge to form a beam by squeezing them tightly together. With their stone arches made of wedge-shaped elements, traditional stone bridges relied on gravity for their compressive force.

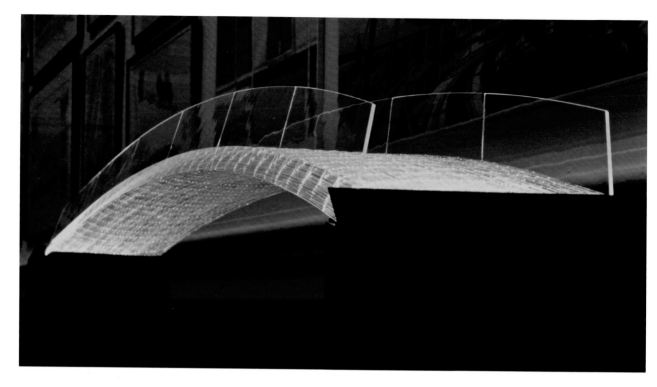

Instead this structure would squeeze the pieces horizontally with 1,100 tonnes of
lateral pressure. When we were considering how such pressure could be exerted,
we imagined that it would require a powered mechanism or motorized hydraulic
system, which would be costly and need constant maintenance. Our engineers
developed a method that employed only weights and levers, using gravity to power
a cam to transmit the pressure from 800 tonnes of weight suspended in shafts
adjacent to the bridge. One mechanism would be sufficient, but placing a second
mechanism at the other end of the bridge would create a failsafe system that
allowed you to lock down one side and carry out maintenance work on it while

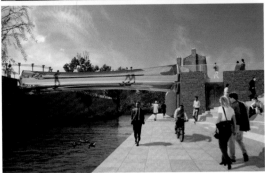

the other one continued to apply enough pressure to hold the bridge in place.

The bridge is made from 1,200 layers of glass, each layer given a U-shaped profile to make the balustrade, handrail and bridge deck as a single form. The profiles of the pieces alter progressively across the span, in order to use the glass efficiently and to give the bridge its distinctive form that changes along its length. We used glass with an especially low iron content, to avoid the green tint that gives normal glass its dark edges. To prevent the deck from being slippery to walk on, the finish is raw and crystalline. Being pre-chipped, it makes the bridge less tempting to vandalize and absorbs inevitable minor surface damage, in the same way that the carpets in cinemas are sometimes designed with a pattern that looks as if they already have popcorn all over them.

The feasibility of the glass bridge concept has been tested in collaboration with leading engineering experts in bridge design and glass technology using a series of scale models and prototypes. At Imperial College London, full-size test rigs were constructed in a large underground facility for the testing of industrial prototypes. One test proved the strength of the compressed glass beam, allowing a person to stand on it, suspended in mid-air. The glass performed so well when its compressive strength was being measured that it broke the laboratory's testing machinery. We also measured the potential slipperiness of the bridge deck, how it might respond to cracking, how it would be built and maintained and the costs of construction.

The project is a romantic, powerful idea that has evolved with sponsorship, the prize money from a glass award and our own investment in research and development. It now needs a patron to give it a river to cross.

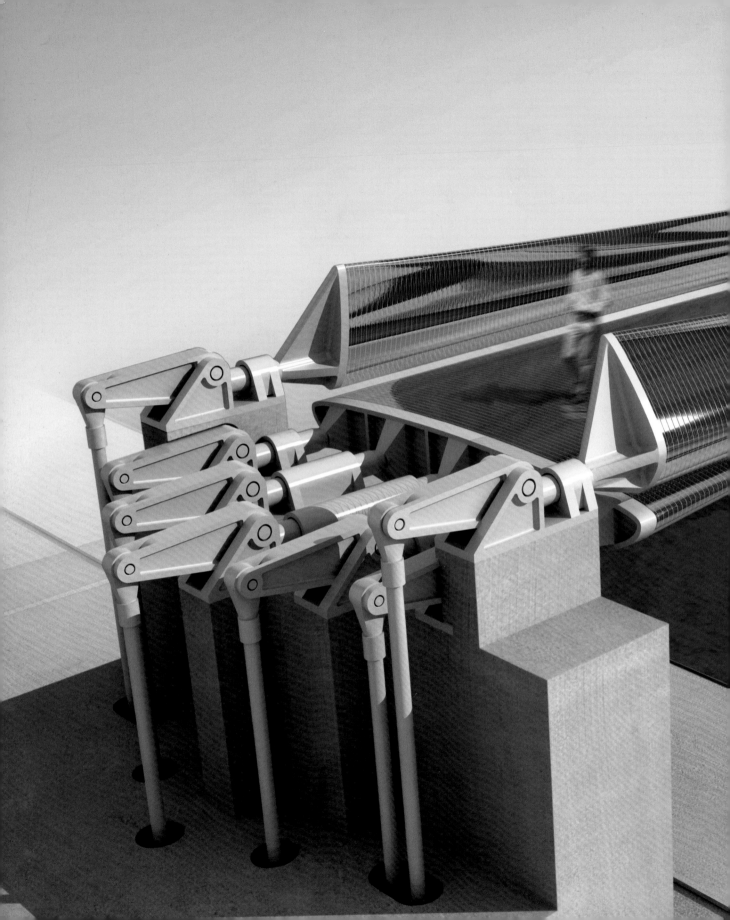

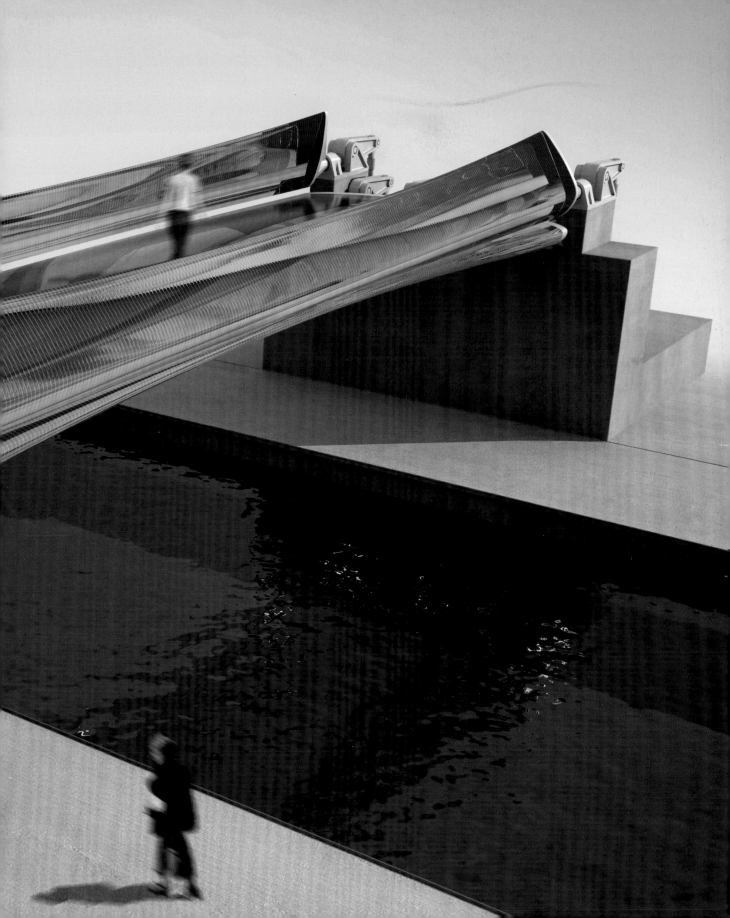

Piano Factory Apartments

How do you build a new building on top of an old one?

THE STUDIO WORKED with a property developer to design a residential extension on top of a former piano factory building in north London. Instead of building upwards in the style of the existing architecture, we treated the building as a plinth for something new to sit on. We evolved a proposal for a series of apartments that pointed in multiple directions, emanating from a central core and framing many views. The form was an independent object, like a wasps' nest that had grown on the building.

We also developed a scheme that was less tall based on progressively bending three additional floors to lean out over the car park and make large south-facing terraces.

Kagoshima Carpet

*Can a construction drawing
become a carpet?*

AS PART OF THE CELEBRATIONS of its fortieth year, the Aram Gallery in London
invited the studio to design a limited edition carpet. Basing the design on the plan
of our Kagoshima temple in Japan (pages 208–215), we made a carpet that was the
same shape as the building and which exactly reproduced the lines of the black-
and-white drawing with tufts of wool.

Grange-over-Sands Café and Bridge

How can an electron microscope help to design a building?

GRANGE-OVER-SANDS IN CUMBRIA, northern England, is a small coastal town set in a beautiful and distinctive landscape, with a shoreline consisting of vast expanses of sand, where the incoming tide is notoriously dangerous. The brief for the competition we entered, in collaboration with a landscape architect, specified both a new bridge over the railway lines, connecting the town to the seafront promenade, and a new pavilion containing a café and flexible space for exhibitions and events, on the site of the old lido.

Because the tides pose a risk to people venturing out on to the sand, we felt that a new bridge should not only get people over the railway lines could but also give them a way to admire the landscape safely. Our proposal was to lengthen the footbridge into a significant cantilever that extends 60 metres out over the sands after crossing the railway. Starting at 4 metres, the width of the deck gradually tapers to 1 metre, so that the tip resembles the prow of a ship. The bridge would be constructed in a shipyard from welded steel plate, finished with a marine-grade paint system and brought to site in sections and assembled.

For the design of the café, we began by working out the optimum functional arrangement of spaces within the building and searched for a form that would be particular to this site. Taking sand from the shoreline and magnifying it under the electron microscope of a university near our studio in London gave us the idea of generating the form for our building from a single grain of real sand. The actual grain that we chose was broken into halves, which sat well with our proposal to put the café in one side of a building and flexible event spaces in the other, with stairs between them at the site of the split. We proposed constructing the building out of alternating layers of glass and stone to express the minuscule natural strata we found within our grain of sand.

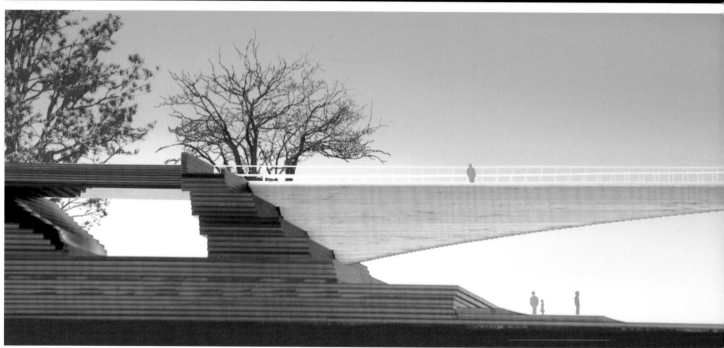

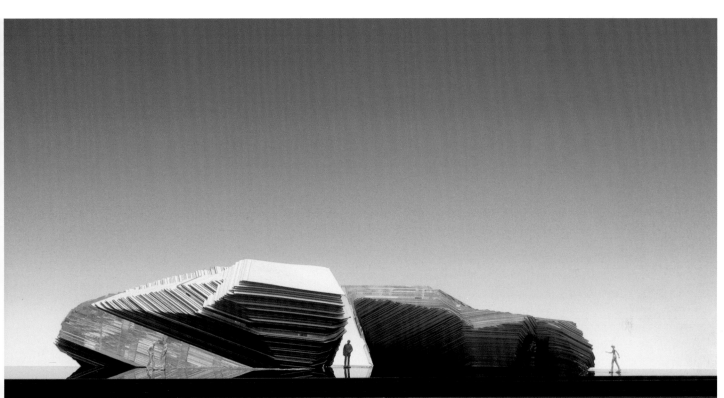

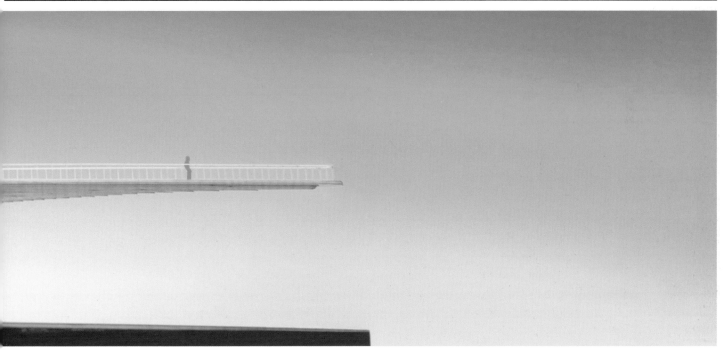

Christmas Card

What is underneath the Queen's head?

WE GAVE OURSELVES THE TASK of making a Christmas card that had no envelope but would not allow the postman to read the greeting. To do this we decided to hide the message under the postage stamps, and this meant that the stamps would have to move out of the way.

The card consists of a small wooden box with a transparent front and four stamps inside. Below the name and address etched on the back is a small silver star hanging on a cord, with the instruction, 'Pull gently'. As you do, the inner corners of the stamps peel open, revealing the studio's Christmas message written underneath. To make the stamps peel open and spring back, we manufactured micro-mechanisms, using fine wires that were so fiddly that they could only be handled with tweezers.

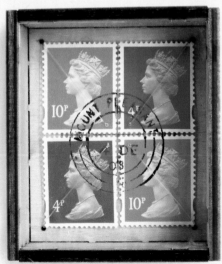

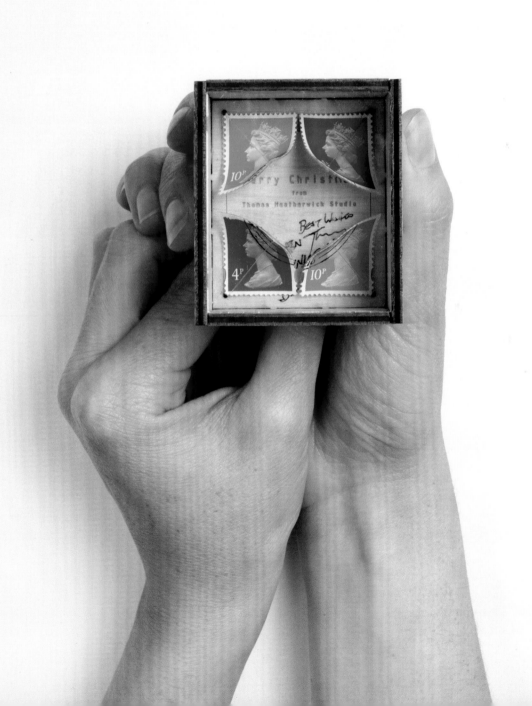

Colindale Tower

*Does a skyscraper have
to be monolithic?*

A PROPERTY DEVELOPER APPROACHED THE STUDIO to design a twenty-storey
tower of residential apartments in Colindale, a suburb of north London, next to
an Underground station. Despite the existence of the station, there was no iden-
tifiable town centre or any sense of being the hub of a neighbourhood, as several
main roads into the capital passed some distance away. There seemed to be
a need for not only a tower, but also a public space that could give the neighbour-
hood a heart.

Although the brief was for a single tall structure, we wanted it to have
a more human scale and more variety than a straight tower. Having seen a man
on a beach in San Francisco constructing sculptural piles of carefully balanced
rocks, we developed the idea of stacking three separate building objects on top of
each other and skewering them together like a shish kebab. A straight shaft con-
taining the lifts, staircases and services would pass through the entire building
and hold the three elements together.

The building's rounded, interconnected forms are built up in horizontal,
one-storey layers of varied shapes, so that each floor feels different, and terraces

and balconies are created on the surfaces that are exposed as the layers step backwards. The building sits on a new public square over the train platforms, with shop units at ground-floor level. The lower element is a public building that is part of the local university, while the two upper elements, which consist of apartments, each have their own distinct identity.

Because the asymmetrical, sculptural form of the tower looks different from every angle, people at a distance can orientate themselves in relation to the new town centre. And since the tower is visible from the nearby M1 motorway as it enters London from the north of England, it can act as a landmark that signals to travellers their arrival at the edge of the city.

Piggyback

A small table, a big table, a long table – or two tables?

THE ITALIAN FURNITURE COMPANY MAGIS asked the studio to design a table that would be more flexible than a conventional extending table with wings or other mechanisms. Instead, it should be a table that would divide into two separate tables that could also be put side by side to make a big table or end to end to make a long one. We decided that it should look like a completely normal table when the two parts were combined so that, when it separates into two, it comes as a surprise. This table with a secret, called Piggyback, consists of two tables, one sitting tightly on top of the other.

The special thing about the finished piece of furniture is the way that the legs of the tables combine. The legs of the upper table pass through holes in the surface of the lower one and then slot into the lower table's legs. The idea is similar to the plywood construction toys that come as a single sheet of plywood from which you press out the pieces and slot them together to make dinosaurs or insects. The tops of the combining tables are the same size but have slightly different edge profiles, so that you can easily get a fingerhold to lift the upper table up off the lower one. Also, when the tables are placed side by side, their tops sit snugly against each other.

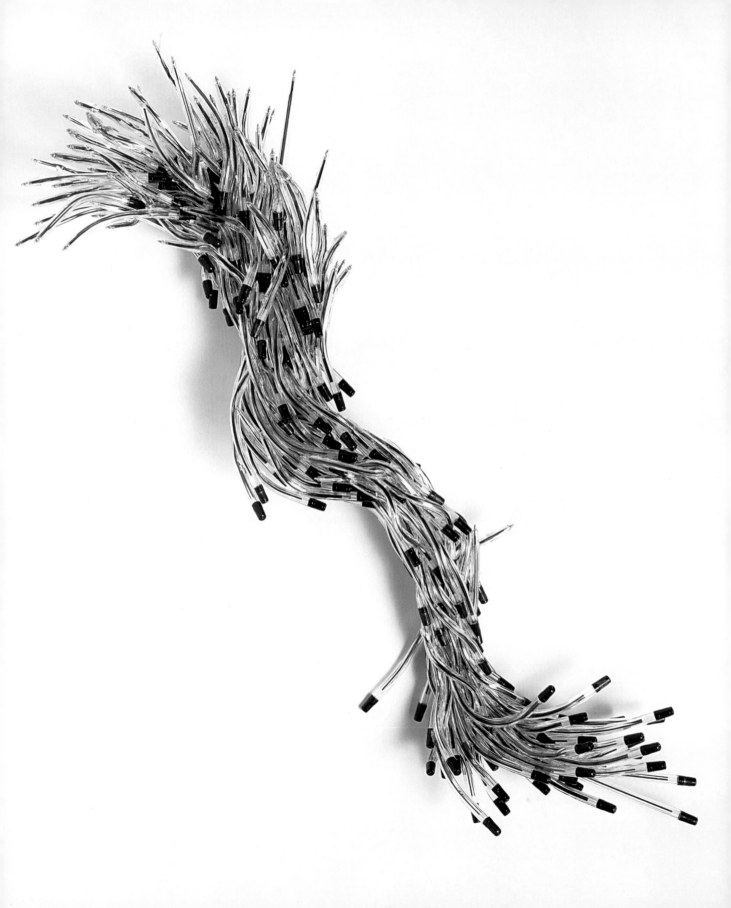

Ballpoint

*How do you celebrate
the ballpoint pen?*

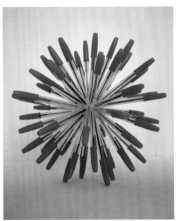

AN EXHIBITION WAS ORGANIZED to celebrate the existence and contribution to society of the ballpoint pen – the simplest, most unpretentious and commonly used tool for writing with ink. The studio was asked to participate by drawing a picture with one. But we decided instead to try to use lots of them to make a three-dimensional object.

We bought boxes and boxes of pens and experimented with heating, fusing, bonding and exploding them. In one test, carried out at the same time as we were working on B of the Bang (pages 232–243), we fused the ends of a pile of red ballpoint pens together to form a ball-shaped, multi-penned writing instrument, which made interesting marks on paper as long as you took enough of the lids off.

For the final object, we fused ballpoint pens together to make a piece that treats the pens like a shoal of fish – as in a David Attenborough wildlife programme where you see giant, silvery shoals racing under the sea, rapidly changing direction as they try and fail to dodge their predators.

303

Salviati Glass Furniture

Can blown glass be structural?

FOR AN EXHIBITION IN LONDON, the studio was invited to work with the artisan glassblowers of Murano, near Venice in Italy. We visited several times, working with the craftsmen in their workshop to develop ideas.

Glassblowing is almost always associated with making vases, but we wanted to try making something else. What was the largest possible scale of glassblowing? Could blown glass be strong enough to support not just water and flowers but the weight of a human being? Could we construct the seat, back and base of a chair entirely from bubbles of blown glass?

The size of a piece of blown glass is limited by the weight of glass that a glassblower can lift and by the dimensions of the door to the furnace that keeps the glass hot as the craftsmen work on it. With the glassblowers, we made separate pieces, which were then bonded together with ultraviolet adhesive to make chairs. As part of the project, we also created a free-standing table piece, a multiple cluster of blown bubble objects bonded together that serves as a container, and a design for a side table.

Having started out determined not to make a vase, we found that, because our chair consisted of open-ended bubbles, the back was a perfect vessel for flowers and water, so we had unwittingly made a vase anyway.

Milton Keynes Public Art Strategy

Does it matter if a new town loses sight of its original vision?

THIRTY YEARS AFTER IT WAS BUILT in a field in central England, the city of Milton Keynes was planning its next thirty years' development and appointed the studio to propose a public art strategy for the city.

With its grid plan layout and integrated landscape design, the city was famous for its roundabouts, its cycle path network and the squareness of its buildings. The confident use of the same planting, paving and street furniture throughout the city had given Milton Keynes a well-defined identity. It was such an aesthetically unified environment that the town itself seemed to us an artistic work. However, under pressure to conform to fashionable models of urban development, the city had recently begun to deviate from the consistency and quality of this earlier vision and risked diluting what made it distinctive.

The studio developed a public art strategy that was not a policy for siting pieces of art but a manifesto urging the city to reconnect with its tradition of innovation by once more applying artistic thinking at every scale. At the time, this seemed to be a new way of defining public art.

Although there were well-known examples of cities that had exercised creativity and innovation in specific areas, such as education, transport or street design, it seemed rare to find cities that were able to think about their future as an integrated whole. We proposed that Milton Keynes appoint a 'lead artist', whose role would be to reconnect the city to its original vision by crossing bureaucratic boundaries and working alongside key authorities, agencies, groups and individuals. The vision was for the city's functional infrastructure, such as car parks, to be given as much artistic thought as its galleries, libraries and street sculptures.

To communicate changes taking place in the city, we produced a special edition document consisting of tabs of printed paper mounted on a backing board. Lying in one direction, the pieces portrayed a muted map of the town, but when they were flipped over, like a Mexican wave, they revealed a colourful diagram of the city's latest projects.

artistic thinking in central milton keynes

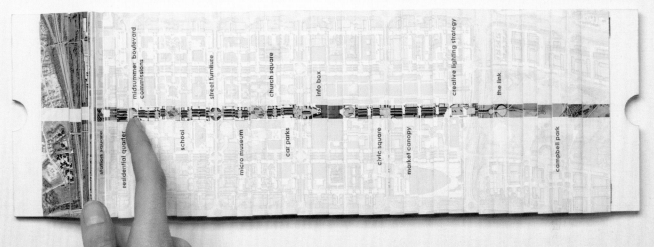

station square · residential quarter · midsummer boulevard commissions · school · street furniture · micro museum · church square · car parks · info box · civic square · market canopy · creative lighting strategy · the link · campbell park

Southorn Playground

How do you safeguard public open space in a city with the highest real estate values and the cleverest property developers?

THE BRITISH COUNCIL and the local authority of Wanchai, in central Hong Kong, invited the studio to find a site in the Wanchai district and work with local people to develop a project for it. We chose Southorn Playground, a flat, open space within the city that is crowded in on all sides by skyscrapers and supports an extraordinary slice of local public life. It contains a football pitch, four basketball courts, a children's play area and a giant seating stand, with a waste facility behind it. At any time of the day, you find people of all ages doing the things that, in the city, can only be done in a space like this: sweating away at games of football or basketball, practising tai chi, playing chess, taking caged birds for a walk, playing, sitting and talking – a mix of public and private, civic and personal, sport and relaxation. From a social point of view, this open space breathes life into an area.

Hong Kong is known for having recreation grounds embedded deep within the city, the Happy Valley racecourse being the most famous example. Though not on the same scale as Happy Valley, Southorn Playground manifests just as extreme a contrast between the tightly packed skyscrapers, which use land in a dense, efficient way, and public open space, which uses land in an unstructured, apparently inefficient way. The value of land is so high in Hong Kong that, by appearing scruffy and dysfunctional, we perceived that Southorn Playground was at risk of being earmarked for redevelopment. Already there had been proposals to put car parks underneath it or to relocate the park to a larger space with better facilities on the outskirts of the city.

There was no denying that in its current condition its quality and usefulness were limited by the disorganization of the space and the shabby, worn-out facilities. There was little greenery, the site related poorly to the surrounding streets and there was a waste facility on one corner that people felt was smelly. Later we also learned that women find the space intimidating to

311

walk through. There seemed to be a need to reassert Southorn Playground as a vital public space in the city.

We started by speaking to many people and analysing the space. We held public meetings in the playground, which up to four hundred people attended. By discussing our analysis, we learned which assumptions were correct. And only once we had agreed the priorities with everyone, did we begin to produce a final design. This consultation process was being recorded by a filmmaker, to enable more people to follow and participate in the process. We also held discussions with the urban renewal authority, activists trying to defend the local heritage and some of the area's major property developers.

The conundrum was that nobody was willing to get rid of any of the existing facilities – football pitches, basketball courts, chess area, children's playground – yet they wanted to add new uses. Since we could not make the site bigger, we would have to make the existing space work better. A lot of Hong Kong happens way above the ground. Its towers soar enormously into the air and there is a dramatic landscape of big signs and air conditioning units sticking off the buildings at high level and overhanging the streets. Our idea was to use more of the air space and, in doing so, give the park 50 per cent more usable public space.

To create space on the ground, we lifted the basketball courts into the air, setting them end to end into one long deck supported on legs, so that the ends of the basketball pitches overhung the streets, like the signs on the buildings. The raised deck would be translucent with its structure embedded visibly within it, constituting the markings for the courts. This deck could then cover a route underneath, protected from sun and rain, which could also be used by street vendors and form the roof for the seating stands overlooking the football pitch.

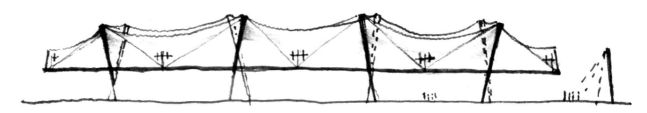

The football pitch itself would be dropped down a number of metres below ground level to allow more seating to be contained within the edges of it. This opened up the sightlines and created space for a separated green area, with a special design of linear planter acting as the divider for the spaces. This planter would contain fifty new trees and form seating, barriers and other features, making places for people to sit together, without being too aware of the sports or feeling that they were being observed.

Many people became involved in the scheme, lending their support, and a major local property developer even offered to fund half of the capital costs of the project if the city government would match their contribution. It has not been forthcoming and we continue to seek funding to safeguard and transform this site for the people of Wanchai.

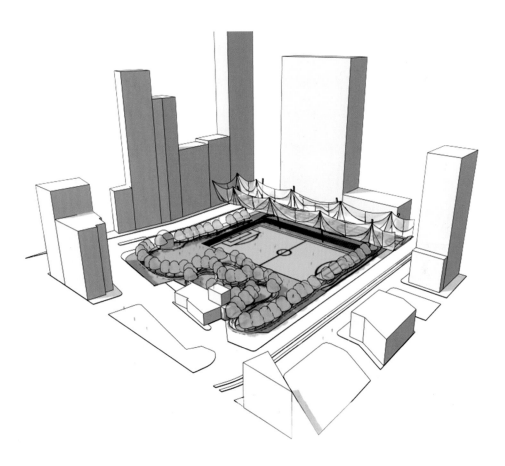

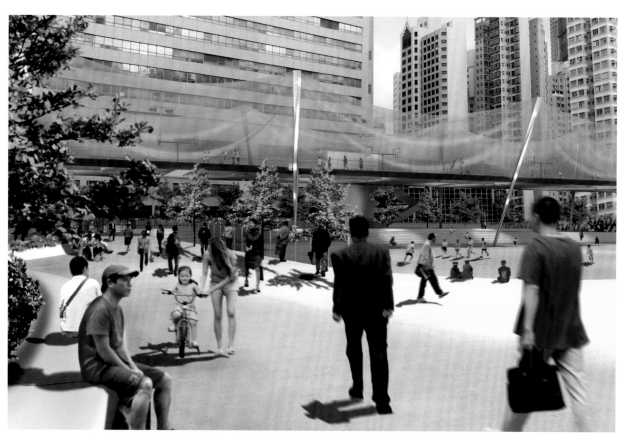
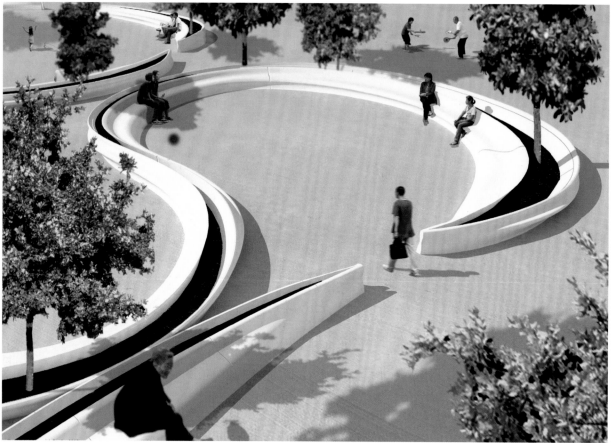

Motorway Bridge

How can the design of highway infrastructure help to give a sense of identity to monotonous stretches of motorway?

THE STUDIO ENTERED A COMPETITION to design a road bridge over a six-lane motorway in the English countryside, leading to a new business park. Our experience of long car journeys through featureless expanses of the country was the monotonous repetition of the same road markings, lamp columns, barriers, road junctions and bridges. As this bridge was to be located on a particularly characterless stretch of roadscape, the challenge was not only to awaken drivers from a state of near-hypnotic boredom from lack of visual stimulation but also to create a marker that gave the area an identity.

Although this was mainly a vehicle bridge, the brief also required it to incorporate a natural link to allow small animals, such as frogs and newts, to cross the highway safely. Noting the groups of mature trees growing on either side of the motorway, we looked for a device to connect them with each other.

Our plan was to allow a group of trees to hover above the road, forming a mini-arboretum across the motorway. The trees are planted in individual bowl-shaped containers, fused together to make a bridge of intersecting spherical forms, each bowl capturing a tree planted inside it.

Constructed from either steel or cast concrete, the bridge contains around thirty semi-mature specimen deciduous trees, held down firmly with tree anchors.

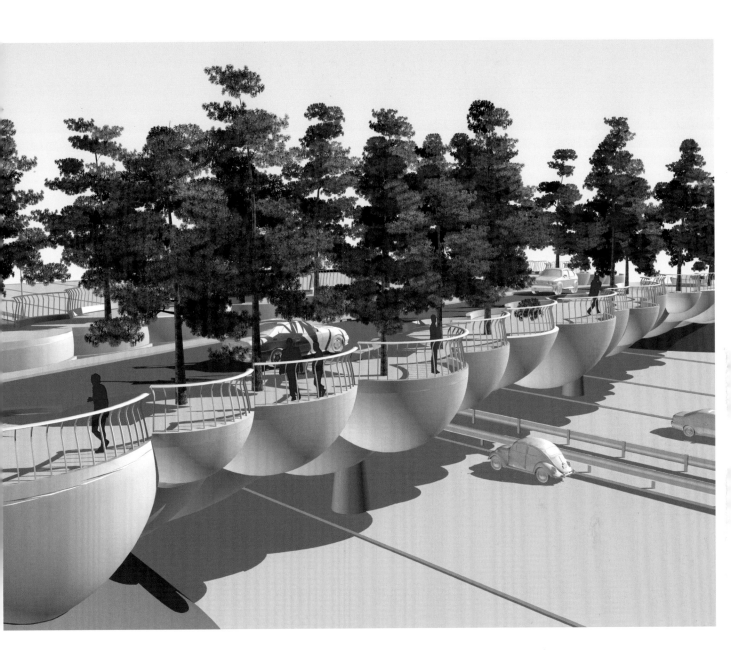

317

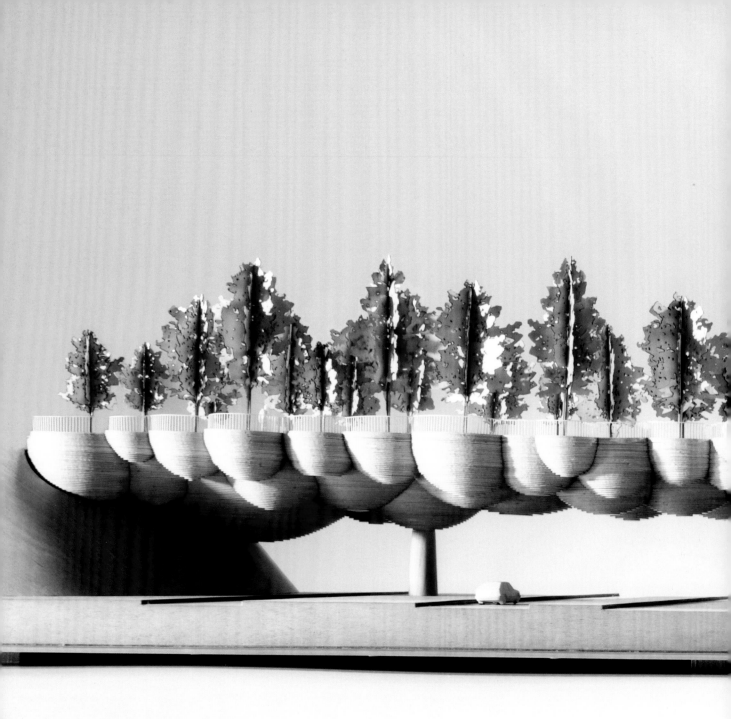

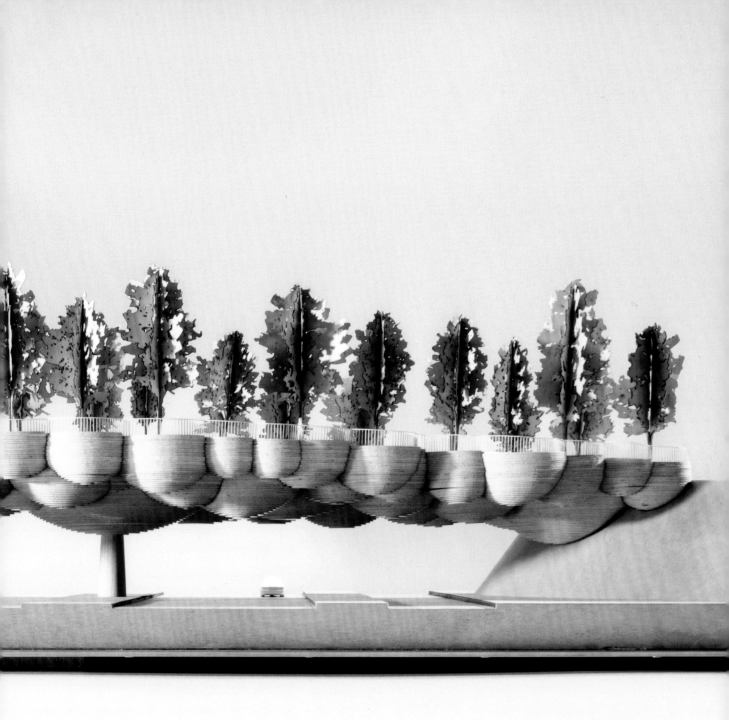

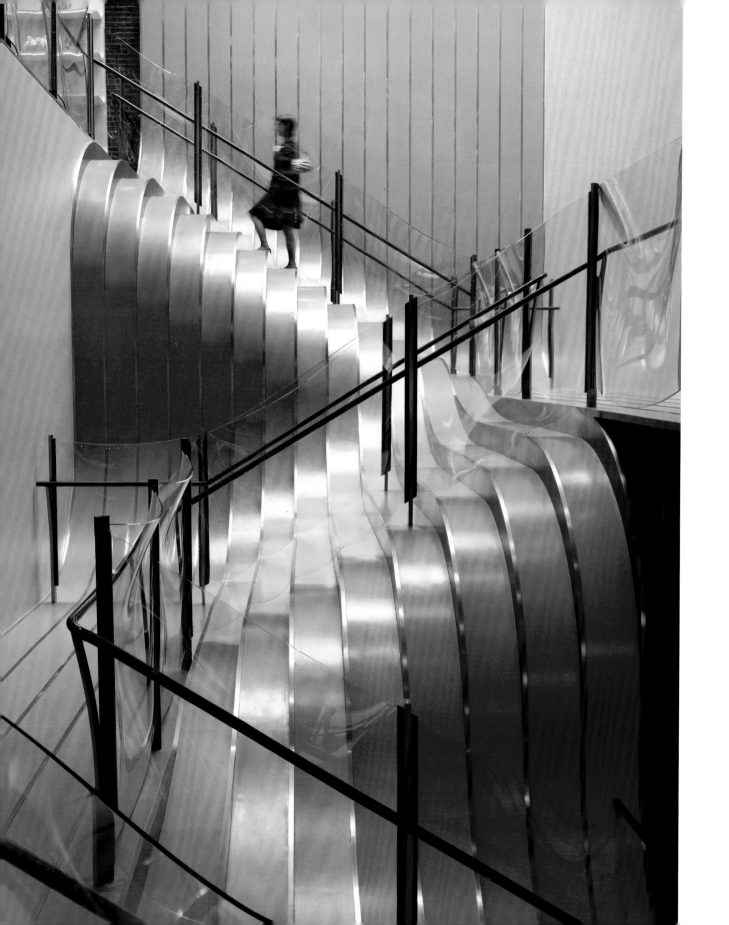

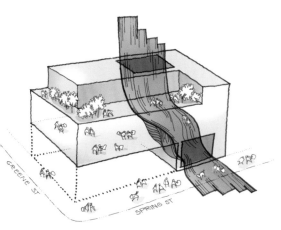

2004

Longchamp Store

How do you make customers overcome their inertia and walk up flights of stairs?

FOLLOWING THE SUCCESS OF THE ZIP BAG that the studio had designed for French luxury goods company Longchamp (pages 168–173), we were commissioned to design its flagship shop in New York.

The site was a building on a corner in SoHo, a district of downtown Manhattan known for its muscular, iron-fronted, industrial buildings. It was a two-storey structure, built in the 1930s, which had been given a new brick façade in the 1980s.

The problem was that the main retail space was not where it needed to be. Although it was large, it was upstairs, on the first floor. Its only connection to the street was a tiny space on the ground floor and its shop window appeared to be shared with the chocolate shop next door. Far from the eye-catching street frontage that is so valuable in retail, our site had almost no impact on the street. The challenge was to scoop people in off the street and make them go upstairs. A design solution that focused on the aesthetic character of the space alone would not do this.

The brief asked for a wholesale showroom as well as a retail space but there did not seem to be enough room for both. Instead of chopping away the retail space to fit in the showroom, we proposed adding another storey to the building, in which to create both a showroom and a garden terrace. This would be an unusual space to hold events and a place for the staff to relax.

The first part of our proposal was to draw people in using daylight, by cutting a hole down through the entire building. Normally, it is the window display at the front of a shop that seems illuminated and when you stand outside, the interior of the shop seems dark by comparison. The hole brought daylight down through the building to the back of the shop, which was previously constricted and dark, giving it a sense of space and drawing the eye upwards. Instead of poeple feeling that they were going up to a level above the ground, it would give them the impression that they were below ground and needed to make their way to the surface.

321

Our problem was still how to get people upstairs because, if you are worn out after a day's shopping and weighed down with shopping bags, a flight of stairs is an obstacle to be avoided. To counteract such reluctance, we needed to get away from the idea of a conventional staircase, and instead began to think about this as a piece of hillside. Recruiting the small ground floor area into the campaign to drive people upwards, we made a landscape stair device that reached right through the building from the window at the front of the shop to the giant skylight three storeys above. While the light well acts as the organizational device for the functions of the building, the landscape stair is the symbolic architectural element that stitches the three storeys together: the ground floor, the first-floor retail space and the wholesale showroom. Nothing is separated and it is possible to sense the activity going on throughout the building.

Working within the strict New York building code requirements, we used a series of ribbons, the width of steps, to make a landscape that flows in two directions. Starting at the front door of the shop, the ribbons flow up through the building, pulling apart to form steppable surfaces you can walk up, travelling on upwards past the second-floor showroom and out of the skylight. There is also the sense of a downward flow, like a waterfall falling from the skylight, dropping through the storeys, bouncing over, its big, generous, curved surfaces becoming stairs and landings and more stairs. Streets in New York are sometimes paved with giant sheets of thick steel. The landscape stair, which weighs 60 tonnes, was made with great precision from substantial, one-inch-thick steel plate, with strips of coloured rubber set into its surfaces.

The staircase had to have a handrail and balustrade, the kind of details that could easily ruin an idea like this. A balustrade would have to cut across the flowing energy of the ribbons and the sightlines of the space. The usual approach to making an inconspicuous balustrade is to construct it out of sheets of flat glass, which are transparent but to us felt rigid and opposed to the flowing ribbons. Window panes in London's nineteenth-century houses, which pre-date the industrialization of glass production, tend to have slight undulations and ripples that warp what you are looking at and give off reflections that are alive and magical. In contrast, modern glass is so perfect that it appears sterile and blade-like. The triumph of modern glass manufacturing techniques is that even the cheapest piece of contemporary glass is too clinically perfect. There is also an assumption that this kind of glass is totally transparent, but much of what you experience is its cold, hard, mirror-like reflections. It is also ubiquitous: whether you are in a Walmart store or the Museum of Modern Art in New York, the glass balustrades look and feel the same.

Instead, we imagined the landscape stair as a ski slope that had poles stuck into it, with a transparent fabric slung between them. We felt that something that draped would compete less with the flow of the ribbons than rigid panels. After a lot of experimentation, we found that we could make transparent panels behave

322

like fabric by heating the material to the point at which it began to relax and drape under the force of gravity, and then letting it harden. The reflections from these draped pieces were dramatically different from the cold, dead reflections from flat glass; there was a soulfulness and vitality in the way that they caught the light, turning everything they reflected into gorgeous shapes.

The pieces for the project were manufactured by a company that also fabricated windscreens for aeroplanes and cars. A giant toaster was specially made for the project, in which big sheets of PETG, a transparent polymer, were heated until they softened and sagged under their own weight. Every panel was unique, formed not by a mould but by allowing gravity to shape it into sculptural forms.

Needing to design furnishings for the shop, we thought about the way in which this upstairs space might be perceived from the street below. To someone looking up into a first-floor space from outdoors, what they predominantly see is the ceiling of that space. As the challenge was to draw people upstairs into the shop, it would help if the ceiling was special. For this reason, we tried to use the ceiling to make the furnishings of the shop, in a way that also related to the ribbons of the landscape stair. However, in retail environments, the ubiquitous solution is to install a suspended ceiling, although this reduces the height of a space and can feel like a way of concealing the problems of a building rather than solving them. The design we developed was a plywood ceiling that was sliced open and peeled down, the layers of wood delaminating to form sets of shelves for the bags. To create display spaces within the steel staircase, we were able to use industrial magnets to attach removable lights and display shelves directly to the steel, without having

to drill holes in it to attach fittings and brackets.

Finally, using a display system made from a single, continuous picture frame that mitres its way around images, sink, shelf and mirror, we made the staff toilet into a micro-museum of Longchamp, displaying photographic archive material from the company's history, including the leather-covered pipe that they had made for Elvis Presley.

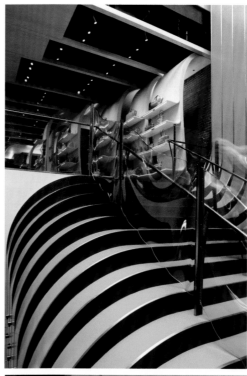

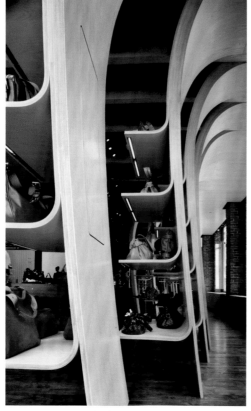

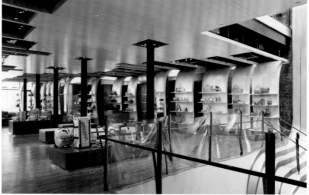

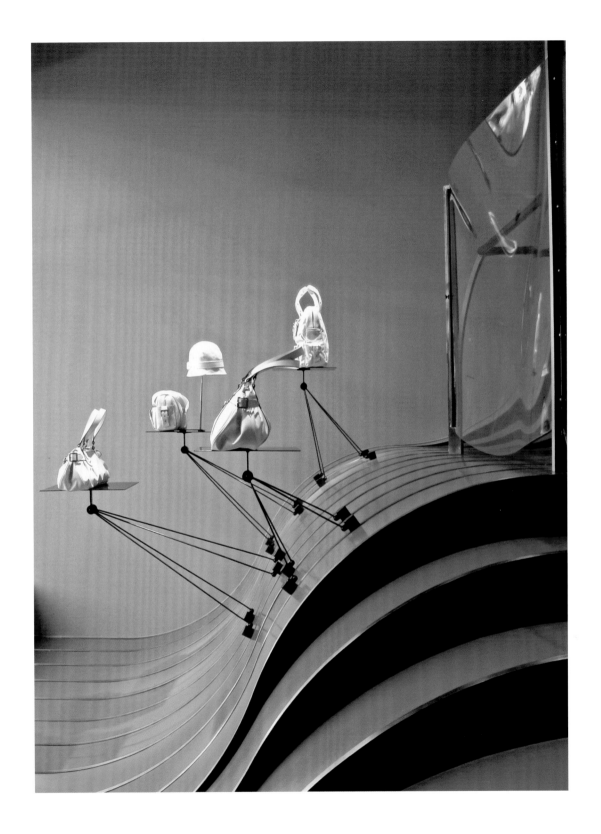

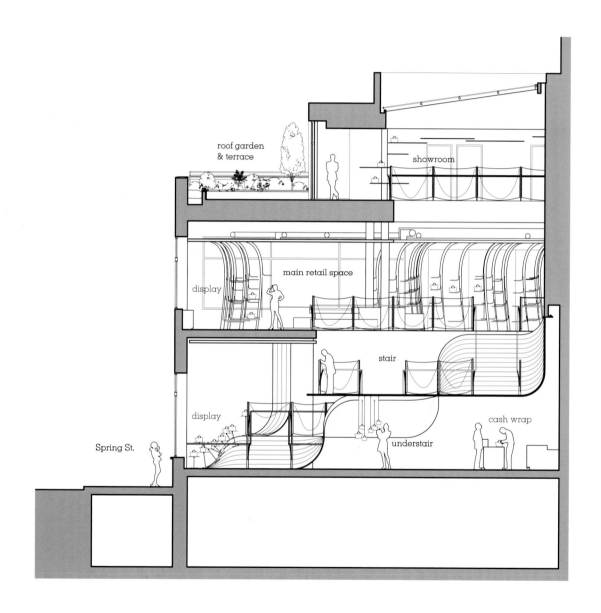

roof garden
& terrace

showroom

main retail space

display

display

stair

Spring St.

understair

cash wrap

326

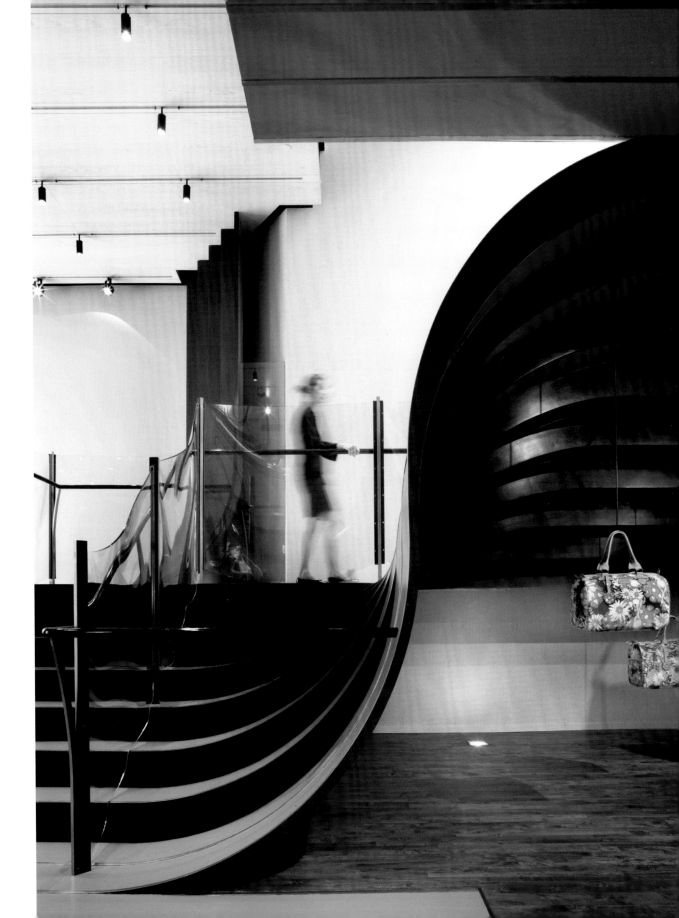

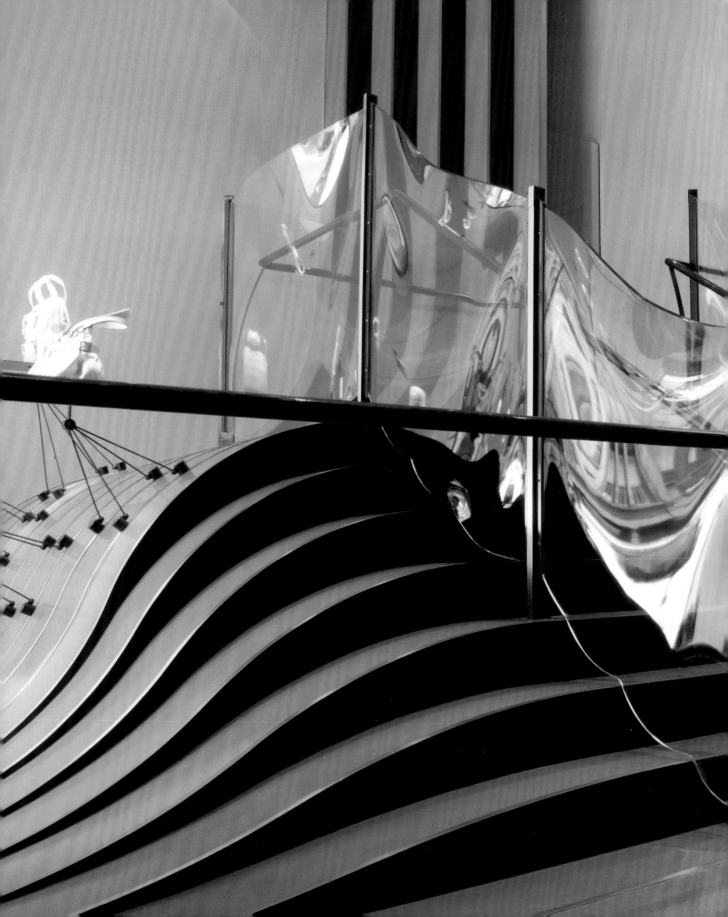

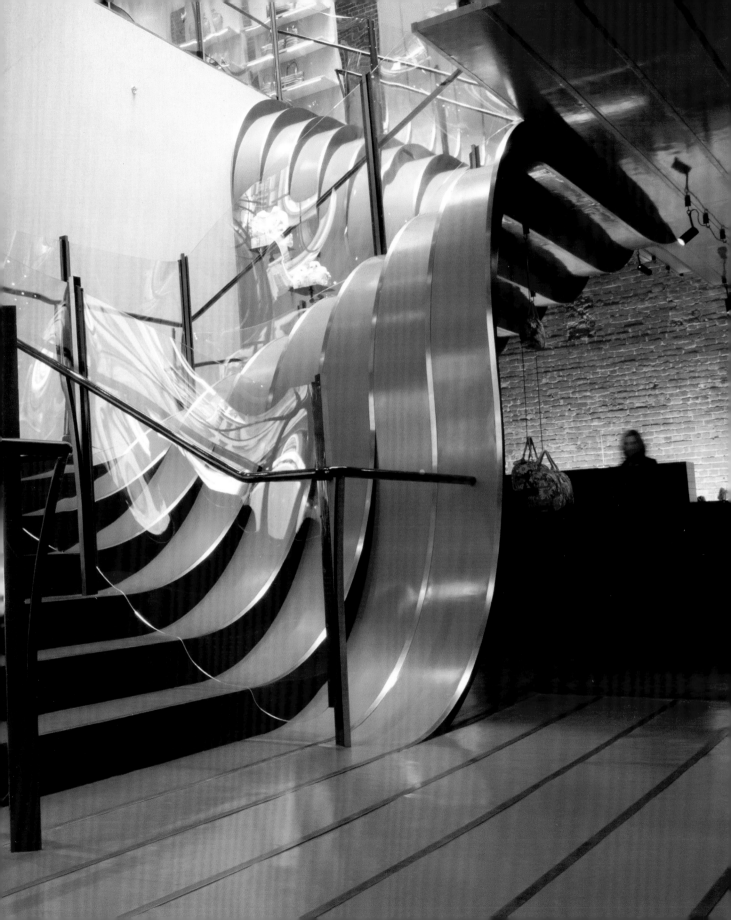

Expanding Furniture

How can inanimate objects change shape?

IN 2004, WHILE THINKING about another design problem, the studio began to develop an idea for a way of making a carpet that could change its proportions, based on a miniaturized version of the pivoting mechanism of a wooden garden trellis, normally used to grow plants up walls.

We found that slicing a square rug into strips and fixing them together on top of a criss-cross patterned mechanism allowed the strips to pivot past each other and produce a carpet that could metamorphose from a square into an elongated rectangle, making an interesting pattern as it stretched and warped. Seeing the first prototype of this transforming carpet gave us the idea to then use more rigid elements and attach legs to it to make a table-top that could change shape as dramatically as the carpet. While a square table-top became a long, thin rectangle, a circular version mutated into an ellipse.

Taking the idea a stage further, we wanted to see if the mechanism could become fully three-dimensional. Could we use multiple layers of the pivoting trellis mechanism to generate a fully three-dimensional substance that could be carved into any shape to make mutating objects? Through experimentation, we developed a large bowl that transformed into an extraordinary elongated elliptical form, and are now in the process of fully exploring the possibilities of this technique.

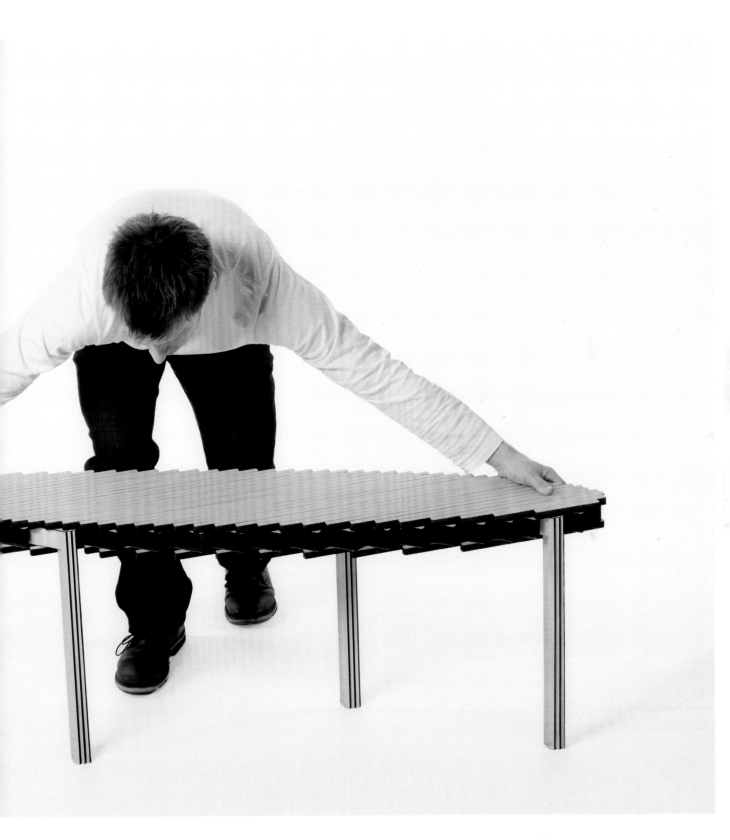

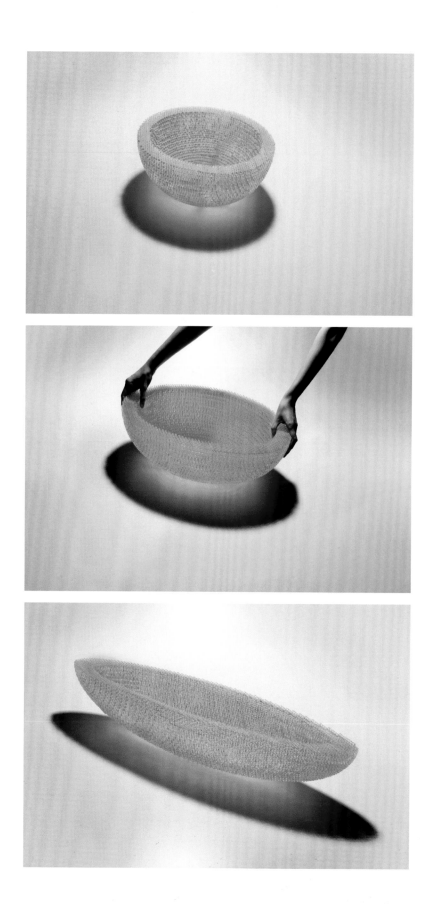

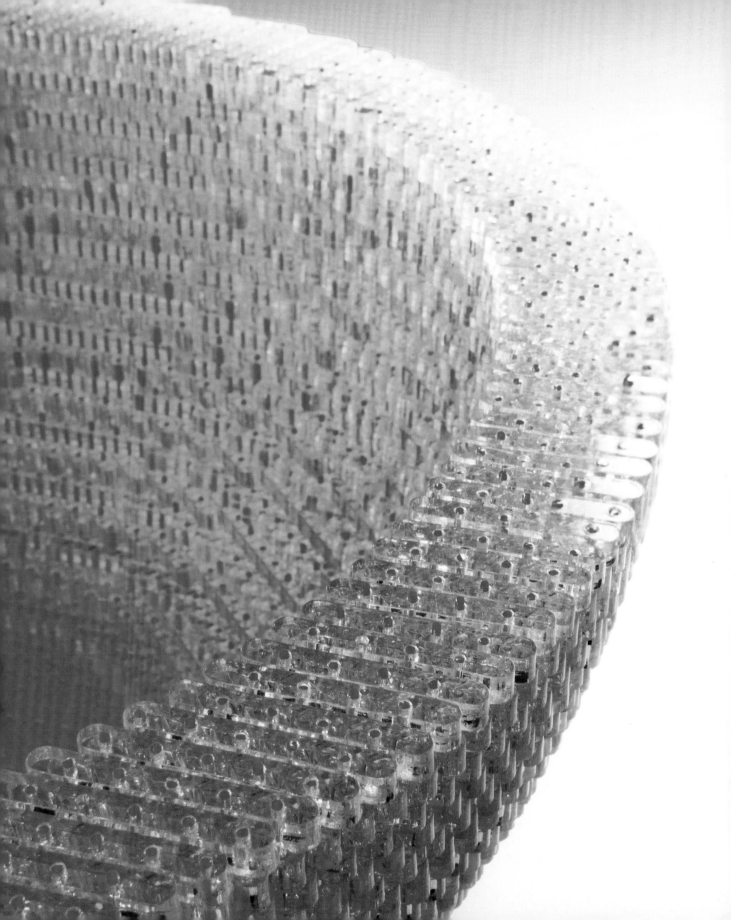

Guy's Hospital

*How do you turn the back door
of a hospital into its front door?*

BRITAIN'S HOSPITALS ARE KNOWN to be some of the worst public environments in this country, partly because they have a tendency to accrete more and more uncoordinated buildings as needs change, funding becomes available and new facilities are added. At Guy's Hospital, a teaching hospital in central London, this process had resulted in a confusing and ugly campus.

This project was initiated because the hospital's grand entrance, built in the 1970s, had fallen into disuse, and the back door had become the main entrance instead. Not only was it hard to find the way into the hospital but staff and visitors were forced to cross a chaotic car park to reach it. The main landmark on the way to this back door was the hospital's concrete boilerhouse. Its concrete was beginning to crumble, the equipment inside it overheated in summer. And staff had voted it the worst building on the site.

Rather than looking at just this one building, we worked in consultation with the hospital to look at the larger problems of the site, including the main entrance and all the approach spaces. We started by analysing the traffic. The car park was mayhem, with three routes in or out, and the main route into the hospital was jammed with parked cars. If you were taking an elderly relative to hospital, you would arrive at the entrance with the pavement on the driver's side and they would have to get out of the car into the traffic. Our first moves were to enlarge the pavements, improve the parking system and reorganize the traffic so that it became safe and easy to drop off a passenger. We also provided the hospital with a new shop in a better location and new cycle parking facilities.

The heart of the project seemed to be to transform perception of the entrance to the hospital so that it seemed like a proper front door. The boilerhouse next to it disorientated visitors because it did not look like the kind of building you would expect to see near a main entrance. As well as stopping it from overheating – which we did by ventilating it with a breathable skin and shading its south-west-facing windows – our task was to make the boilerhouse into the signpost that visually communicated the way to the main entrance.

In the rectilinear housing blocks and office buildings of the 1950s influenced by architects such as Le Corbusier and Lubetkin, you sometimes find a panel of sculptural concrete or ceramic tiles near the entrance, a gesture of

specialness that adds three-dimensional richness and complexity as you enter an otherwise flat, undecorated building. The tiles in these panels, maybe 30 centimetres square, are so small that from a distance their sculpted tiled surface appears virtually flat. The starting point for the design of the boilerhouse was to imagine what might happen if you enlarged these tiles.

We designed a system of square tiles, 2.5 metres across, which can be demounted to allow the replacement of boiler equipment. The panels are woven, their permeability allowing air to move freely in and out of the building and their highly textured surfaces discouraging graffiti. Four of these tiles, rotated relative to each other and arranged in a square, unify to make what looks like a single tile 5 metres by 5 metres. This four-tile form can be repeated to constitute even larger shapes, making the texture of the tessellated panels accumulate into a large, three-dimensional pattern that appears to ripple across the building surface. When you look at the finished boilerhouse, the texture is so large that it has almost become the form of the building.

We gave the project multiple layers of texture at different scales for the eye to read: from a distance, you see that the building is composed of a large pattern of undulations; as you get closer, you understand that each of these panels is made of steel ribbons woven on to a steel frame that acts as a loom; close up, it becomes clear that the ribbons are braided from hundreds of fine steel wires. The only colour is a very dark purple on the sides of the vertical steel ribs and the door and window openings.

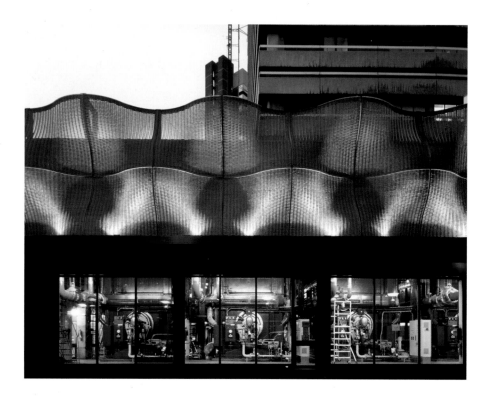

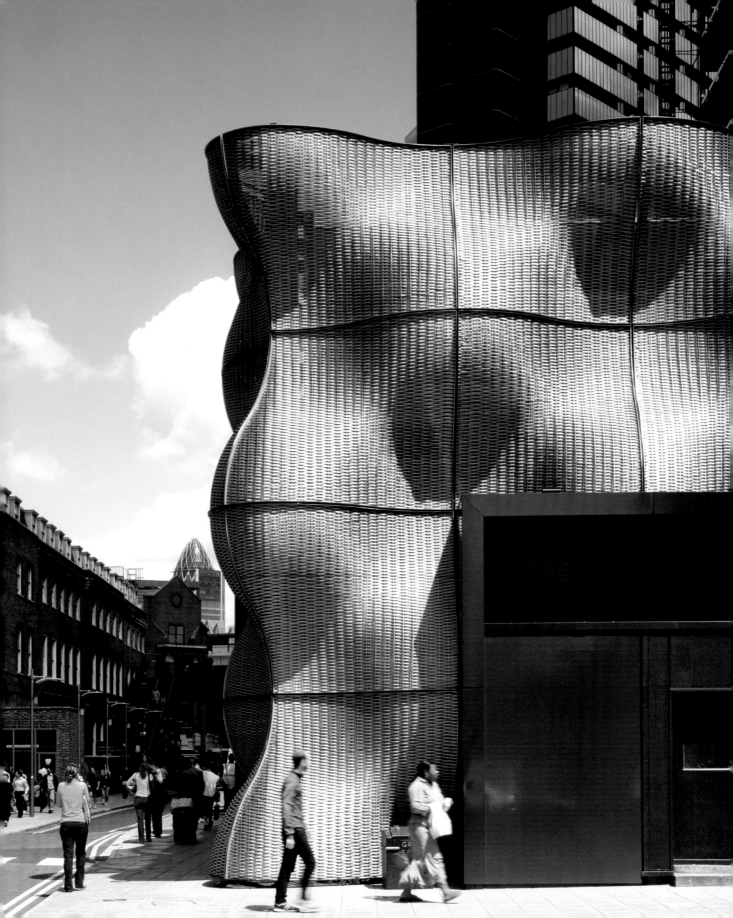

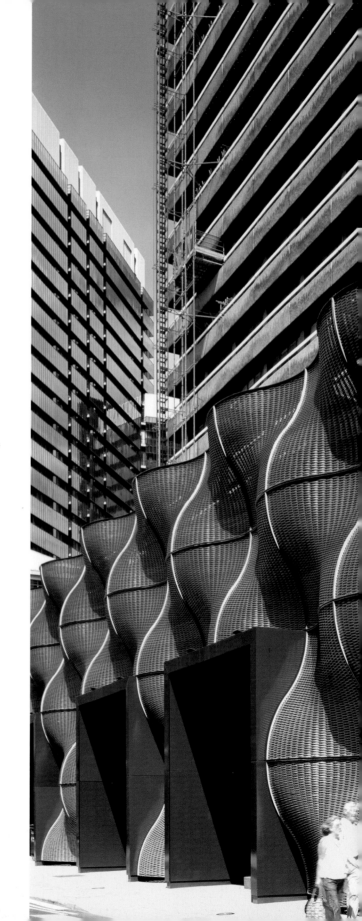

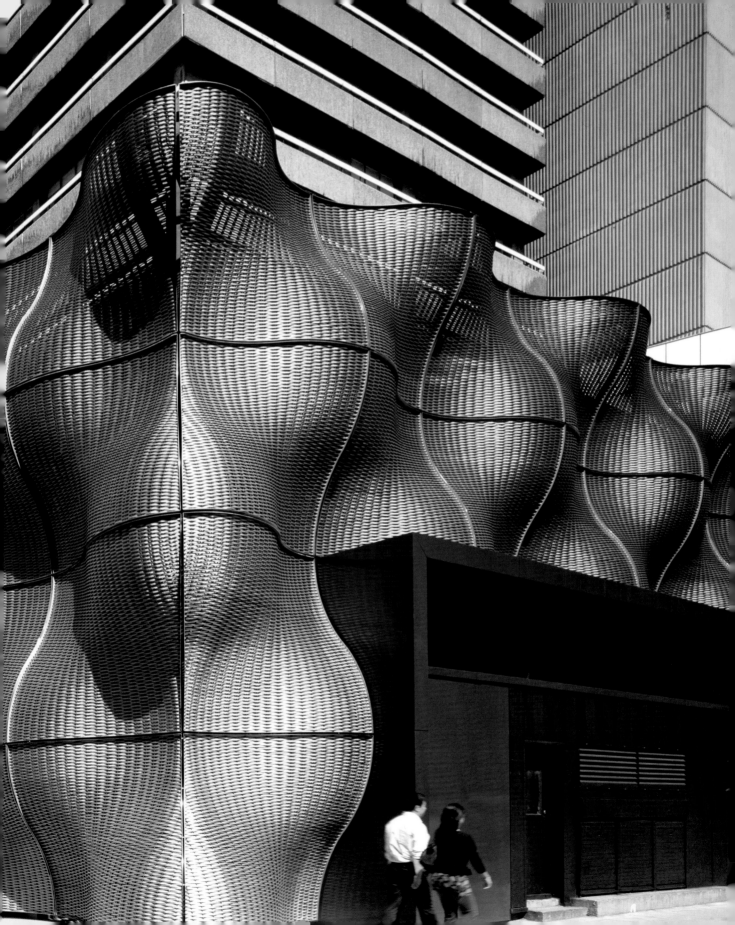

Christmas Card

2004

*How do you make saliva
an important ingredient of
a Christmas card?*

IT SEEMS STRANGE THAT PEOPLE are willing to lick postage stamps and envelopes with their tongues, with no concern about hygiene or the taste of the glue. Given the amount of saliva involved in sending things by post, we explored the idea of sticking these tiny, lickable pieces of postal stationery to each other, rather than to paper or card.

We wanted to make a three-dimensional object using only the twenty-five one-penny stamps needed to cover the cost of posting a first-class letter. We developed an object that had the scale of a pine cone, stuck together using the stamps' own adhesive and dipped in transparent resin to make it hard enough to send by post. Strung on racks in our workshop while the resin cured, these hundreds of cards looked like sleeping bats hanging upside down.

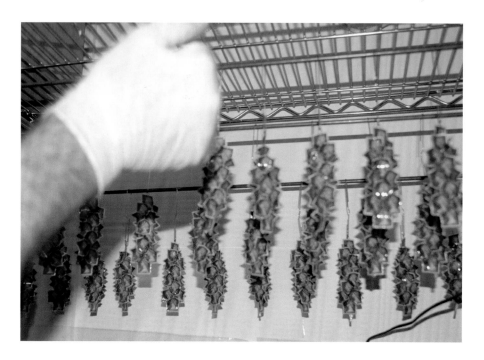

342

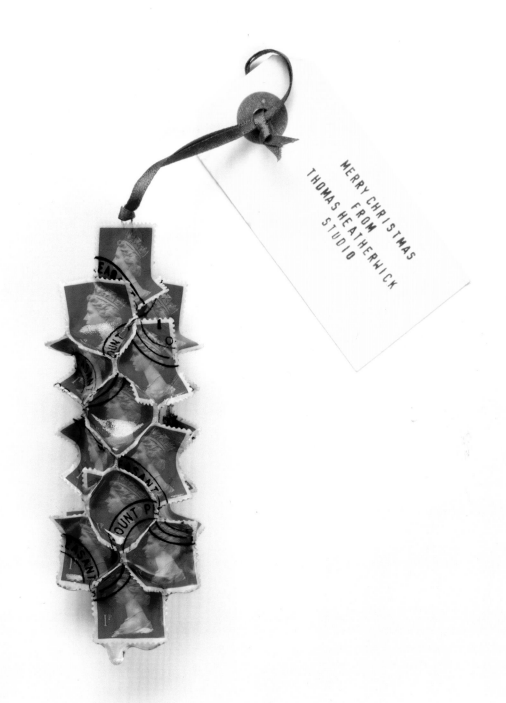

MERRY CHRISTMAS
FROM
THOMAS HEATHERWICK
STUDIO

East Beach Café

How can a seaside building relate to the sea?

WITH THE INVENTION OF SEASIDE HOLIDAYS in the nineteenth century, British resorts like Blackpool, Brighton and Scarborough and smaller seaside towns such as Littlehampton were visited by thousands of holiday-makers and day-trip-

pers. Consequently, there was investment in hotels, attractions and amusements and these towns prospered and grew; but in recent decades, when it has been fashionable and affordable to take holidays abroad, they have gone into decline. It was in Littlehampton, on England's south coast, that the studio was commissioned to design a café building to replace a kiosk that sold chips and burgers, as well as £100,000 worth of extruded ice-cream from its Mr Whippy machine every year.

The site was a long, narrow strip of land, layered between the seafront promenade in front of it (where a pretend train pulled carriages full of visitors up and down all summer) and a high-pressure sewage line behind it (which could not be built over), so the building was forced to take on the proportions of a cigarette.

The site was also bleak and exposed, causing a tension between the urge to shelter and protect people and the desire to give them a fantastic view of the sea. Our idea was to resolve this contradiction and create a place of both refuge and prospect by making a building that is solid behind you and transparent in front of you as you looked out to sea.

But how could we ensure that the back of the building, without windows, was not a flat, dead façade? Also, how could we protect 40 metres of glass along the front of the building from vandalism and weather?

It seemed to us that modern seaside buildings have tended to conform to a ubiquitous architectural approach, an aesthetic based on white sails and yachts, which seems to romanticize a bygone era of Art Deco steamships. However, in our view, the British seaside did not conjure up experiences of golden sand, blue skies and twinkling sea but of stumbling around on damp brown shingle, spotting all the objects the sea has abraded and offered up: slimy pebbles, matted seaweed, lumps of polystyrene, old shoes, fragments of wood and frayed and tangled rope. Rather than reference sun, sea and sailing boats, we were inclined to create a connection with this texture and richness of a British beach.

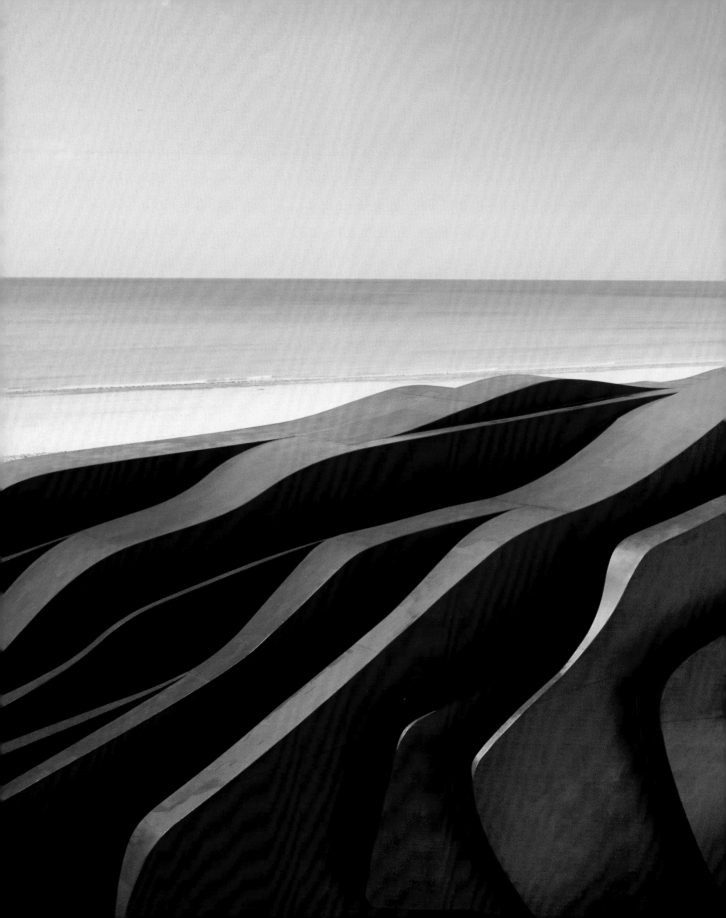

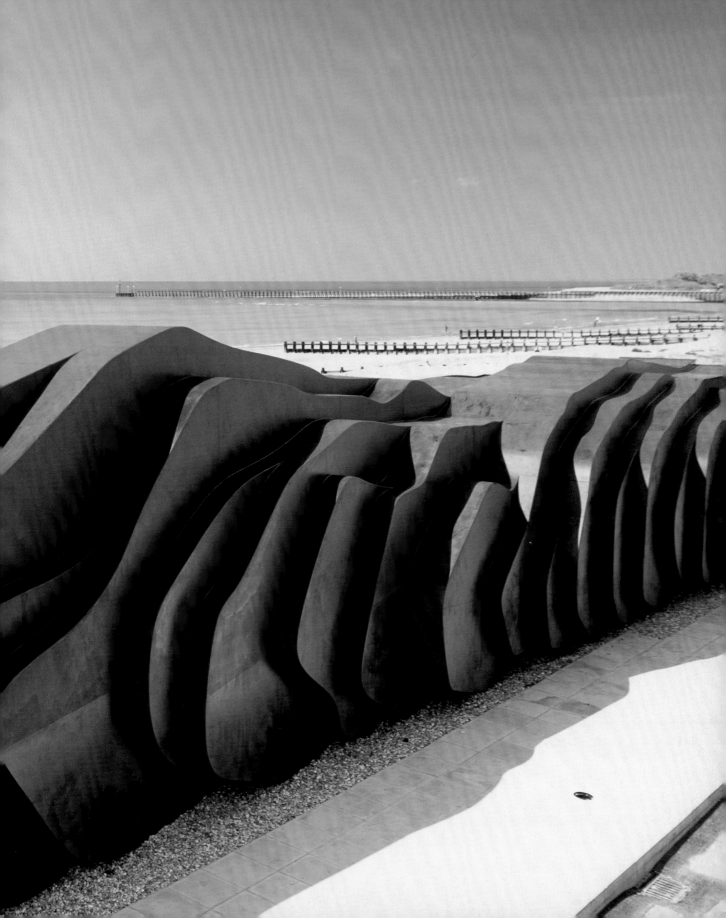

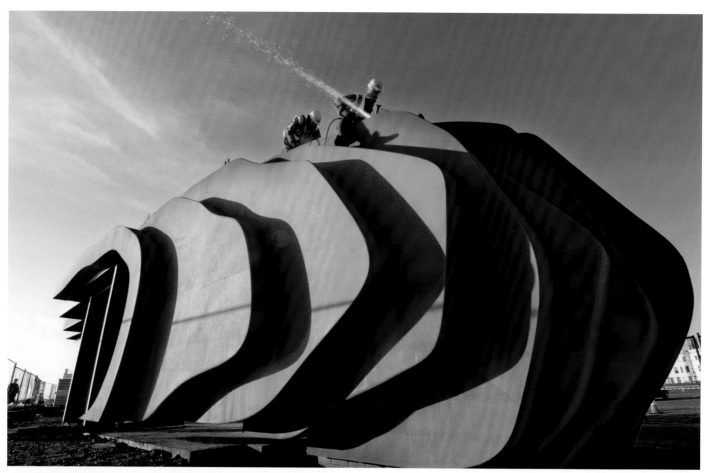

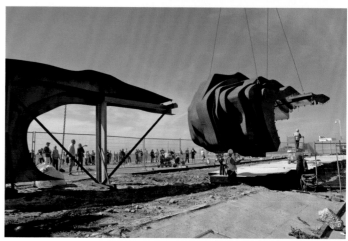

It was also in our minds that British architecture has for many years been burdened by the idea that new buildings must be in keeping with any surrounding old buildings. In Littlehampton, the first row of houses, a Georgian terrace, is set back a long way from the sea. The café being closer to the sea than to any of these buildings, we felt it could be more 'in keeping' with the beach than with the Georgian houses 100 metres away. The building could sit in the shingle like any other interesting seaside object.

Unexpectedly, the most critical influence on the design of the building was the roller shutters, which were the affordable way to protect the windows on the front of the building. We had ideas for buildings next to the sea, but ran into problems as soon as we tried sticking large metal boxes containing shutter mechanisms like big eyelids above the windows. In desperation, we wondered what would happen if we made the whole building out of steel shutter boxes.

We found we could use long, undulating ribbons of steel, the width of shutter mechanism boxes, and wrap them around a space to form both roof and walls, making a raw steel building sitting on the beach. By day, the roller shutters on the front could be hidden inside the building without looking like unhappy additions. Angling the geometry of the box ribbons across the building

from the back to the front articulated the otherwise flat façades, giving the building greater three-dimensional sophistication. The welded metal skin of the building could also be its structure, acting as a monocoque like the shell of an aeroplane. It also happened that our friends in Littlehampton, the steelwork company that had fabricated the Rolling Bridge (pages 260–265), were enthusiastic about the prospect of making the project.

Obtaining planning permission for the project could have been difficult; but our client had a talent for communicating her vision. While serving ice-creams and burgers from the existing kiosk, she would show people the drawings over the ketchup and vinegar, explaining the project and why it would be good for Littlehampton. She invited us to give windswept presentations on the beach to whoever would

listen and was so good at exciting people and stimulating their aspirations for the development of their town that planning permission was granted with not a single letter of objection, only letters of support.

The entire metal structure was welded by just two men. The building was longer than the factory, so they had to fabricate it in sections. To ensure that the sections fitted together, they would finish a section, slice off the end they were still working on, take the rest away to site and then carry on welding the next section, starting with the sliced-off end. The outside of the steel building was left as raw

metal and the interior was finished with a rigid insulating foam, sprayed directly on to the inside of the steel shell.

East Beach Café is open and there are nearly always queues to get in. As well as serving a loyal local clientele, the high-quality modern cooking draws people to Littlehampton from all over England.

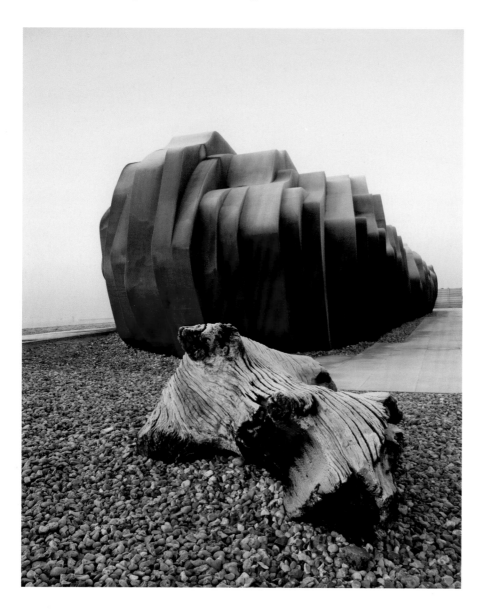

2005

Aberystwyth Artists' Studios

*How do you give individuality
to the skin of inexpensive buildings?*

THE ROYAL INSTITUTE OF BRITISH ARCHITECTS ran a competition to design artists' studios in Aberystwyth, a seaside town on the west coast of Wales. The competition was held on behalf of the Aberystwyth Arts Centre, which is part of the University of Aberystwyth. The university is known for the excellence of its arts courses and the gallery in the arts centre provides students and practitioners opportunities to exhibit their work. However, the lack of affordable workspaces was driving creative people away from the town to establish their working lives in Birmingham, London or other big cities. The arts centre wanted to create an incentive for creative people to stay in Aberystwyth by constructing eighteen new workspaces for rental at affordable rates to artists and creative sector businesses. The budget was extremely low, but the aspiration was to show that a low-cost project could still be special.

A site was identified on the university campus, close to the halls of residence and the arts centre building on a steep slope, covered in trees. Our first thought was that this woodland was precious and that placing a big campus building here would mean clearing away all the trees. We wondered if there was a way that the project could sit among the trees instead.

Rather than one big building, we decided to make nine smaller buildings, placed between the trees and connected by a path. Each building could house two units of workspace on a single floor. We liked the idea of making this a community, like a village, rather than a single unit accommodating everyone. It also better suited our limited budget. It would cost less than a single building with two or three floors, because we wouldn't need to spend money on lifts, stairs and corridors, and the separation of the buildings was a cheap and practical way to insulate them for sound.

The studios needed to feel special but not overshadow the creativity of the people using them and they needed to be flexible, functional spaces in which creative people could do whatever they wanted. We decided to keep the form of each building simple and to concentrate on making the skin of the buildings special.

Normally, inexpensive buildings are clad with industry-standard panel systems, selected from catalogues such as the Barber Index. Although these products meet the building codes and come with guarantees and warranties, to us

355

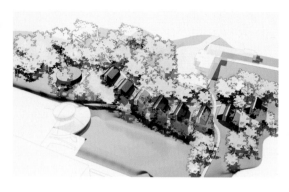

they often appear flat and dull. Instead, we decided to make the buildings feel fundamentally different by inventing a cladding material with its own life.

This material had to be long-lasting, and the most phenomenally long-lasting material is stainless steel. However, conventional stainless steel cladding, which is more than a millimetre thick, would be far too expensive for our budget. We had also noticed that buildings clad in steel of this thickness tended to look slightly crinkled because the material dents easily during construction, making the building look as if there hasn't been enough money to buy sufficiently thick metal.

If we could learn to love crinkles, rather than trying to avoid them, a metal that was much less than 1 millimetre thick could make an effective and affordable cladding material. We asked ourselves if very thin stainless steel sheet could be used like cling film or Sellotape and wound around a building to create a skin that would be tough, waterproof and corrosion-resistant and would not degrade in ultraviolet light.

After much searching, we found a manufacturer in Finland who produced stainless steel sheet that was one tenth of a millimetre thick. To our astonishment, this metal was priced by weight, so it was one tenth of the price of standard

stainless steel sheet. Once we got samples into our workshop we found that there was no way to stop it crinkling but that, as we let it crinkle, it turned into something mesmerizing to look at. This excited us because, for us, it felt that the way that a building feels has as much to do with the texture that is encountered at the human scale, as with the overall form of the building. A building that has dead, flat, sterile surfaces conveys a physical coldness, but if it has a richness of detail, such as the crinkles that this sheet made all by itself, your eyes touch a surface that is both unexpected and absorbing, as well as three-dimensional.

Also, when we held the crinkled metal next to trees outdoors, it was as if we had crinkled a mirror. The crinkles were the size and scale of leaves and their surfaces took on the colours of leaves and sky.

To be a viable cladding material, this had to be rigid enough to withstand damage, and also have insulating properties. In the East Beach Café project (pages 344–353), we sprayed the interior of a steel-shelled building with an insulation foam originally developed for use in pig sheds, which sets so hard that the animals cannot chew through it. So we sprayed the back of the crinkled steel with this foam. This combination of materials gave us a cladding system to use in the project that was lightweight, inexpensive and durable but also soulful.

The proposal was to create a family of nine small buildings, connected by a footpath, set in woodland. They are arranged in a curve, so that although the design of all the buildings is identical, each one sits in the landscape and relates to its neighbour in a different way. As the site is a hillside, they stand on stilts where the ground slopes downwards. Each building is divided into two independent workspaces, making eighteen units in all. The buildings are simple, pitch-roofed, timber-framed structures that have been split down the middle and pulled apart to make space for skylights, an entrance, ventilation and toilets. The building is clad with the custom-made crinkled metal cladding.

For the competition, we made a full-sized piece of the building, using steel we had crinkled in the studio and insulating foam from a builders' merchant. We hid the prototype in the woods and asked the judges to come outside during the interview to see it there, reflecting the trees and sky.

To build the project, the studio became the contractor for the skin of the building and invented a special crinkling machine, a giant mangle with nodules on the rollers, turned by a big handle. Feeding the stainless steel, which came on rolls a metre wide, through the knobbly rollers to manipulate it into a 10-metre length of uniformly crinkled metal made a thunderous noise.

As the long panels were much longer than normal cladding panels, we reduced the number of the joints that needed waterproofing; however, the lengths still had to be tailored together at the corners and edges. The process of crinkling the strips of metal seemed raw and rough but the detail was finely crafted, precise to a millimetre, so that each piece could be folded over to meet its neighbouring piece and become a waterproof sealed joint.

For each building, a timber frame was constructed and the metal skin was fixed on to it. Then the inside of the skin was sprayed with insulating foam. This was followed by the fit-out, which included flooring, boarding, electrics and plumbing.

All the workspaces were rented out before construction was finished. There are now sculptors, painters, textile artists, web designers and a theatre company working in the buildings.

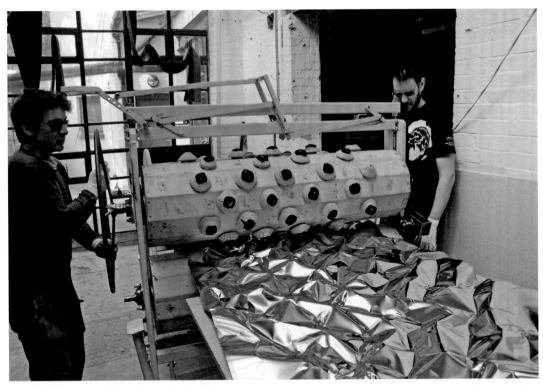

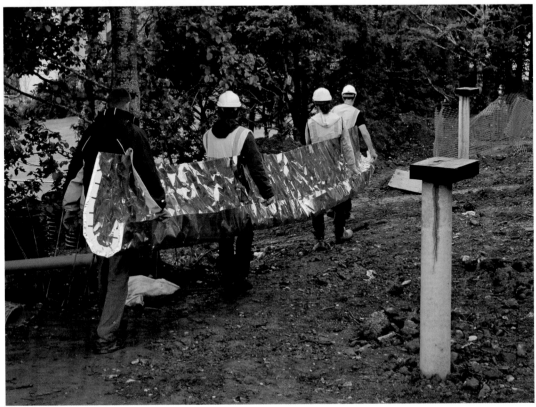

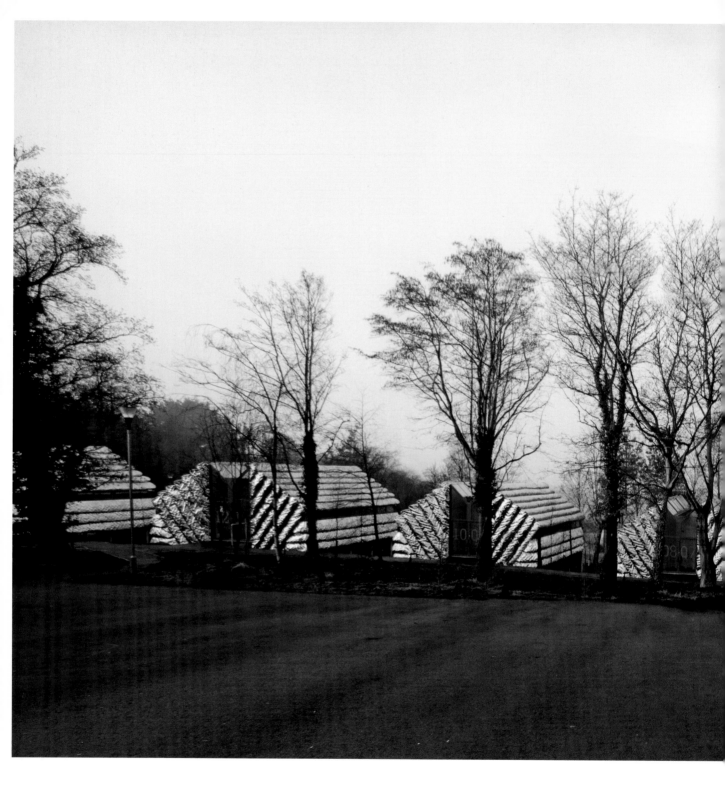

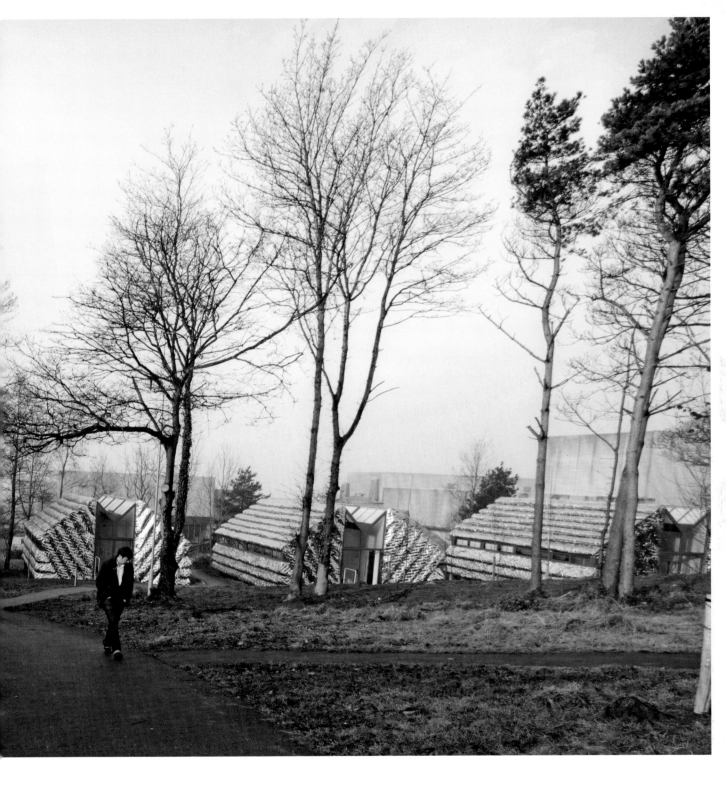

Aberystwyth Meeting House

How do you make a round building in a round way?

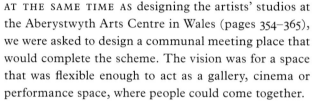

AT THE SAME TIME AS designing the artists' studios at the Aberystwyth Arts Centre in Wales (pages 354–365), we were asked to design a communal meeting place that would complete the scheme. The vision was for a space that was flexible enough to act as a gallery, cinema or performance space, where people could come together.

Because we wanted the building to relate equally to all the studio units, rather than forming a stronger relationship with the unit closest to it, we felt it was important that the building was round. We also wanted it to contrast with the rectangularity and shininess of the studio units.

The difficulty was that our round building needed to be built on a tight budget. All the inexpensive round buildings we had seen were made from flat panels, because they are cheaper than curved ones. But a round building made out of flat panels did not seem very round. To us it was a polygon wishing that it was a round building and it was the clue that told you that its commissioner could not afford curved pieces. Was there instead a way to make a round building in a round way?

With the engineer Ron Packman, we discussed the unrealized potential of aerated concrete, the building block material that is the concrete equivalent of an Aero confectionery bar or sugar honeycomb, formed from an aggregate-free concrete with thousands of air bubbles trapped within it. These blocks are cheap, structural and insulating, have low ecological impact and are easily cut with hand tools. They are used everywhere to build walls quickly and cheaply but are normally hidden under plaster or paint. We learned that, in freezing Latvia, entire housing projects were built using used

these blocks. Huge boxes were constructed with solid walls of aerated concrete blocks, 45 centimetres deep, with no doors or windows. Because the walls were so lightweight and soft, the builders could decide where to put these later. Having already built the rest of the building, they could pick up a handsaw and cut out a door or window wherever they wanted it.

Our proposal was to use aerated concrete blocks to build a thick wall, 5.4 metres high, in a circle, that would be both insulation for the building and the structure that held the roof up. Because it had been made from these rectangular elements glued together, the wall would be ugly and blocky. But, thinking about the way you draw a circle with a compass, we wondered whether we could rotate a cutting tool around the central point of the circle and rotationally carve the building. Could we shape the circular wall as if it was leather-hard clay, as a ceramicist works on a thrown clay pot?

As we carved the wall, we would be able to form seating, shelving and lighting details as one continuous section carved throughout the building. By giving the building a flat timber roof, we could then cut out two pieces, like slices of a cake, and replace them with glass, to create entrances and exits and bring light and ventilation into the building.

The idea was also influenced by the studio's interest in fibrous plasterwork and cornice-making. Cornices are made by pulling a metal profile across a slab of wet plaster, dragging it into an extruded shape. In this project the cornice is not

a decorative detail in the corners of the room; it is the whole building. When we were experimenting with profiles for the outside of the building, we happened to find that the profile of the face of Hans Christian Andersen, the children's writer, gave it the form we were looking for, although it was not our intention to attach significance to whatever shape we used.

Working with the main manufacturer of aerated blocks, who was very happy for its Cinderella material to be given some appreciation, we made a full-sized piece of the building at its test facilities. A large jig was constructed and attached to a cutting tool that had been specially designed for the project and tests began. Rotationally carving the concrete blocks worked well, and we unexpectedly discovered that using a coloured adhesive to bond them together produced wonderful patterns in the surface of the building, like the grain of cut wood.

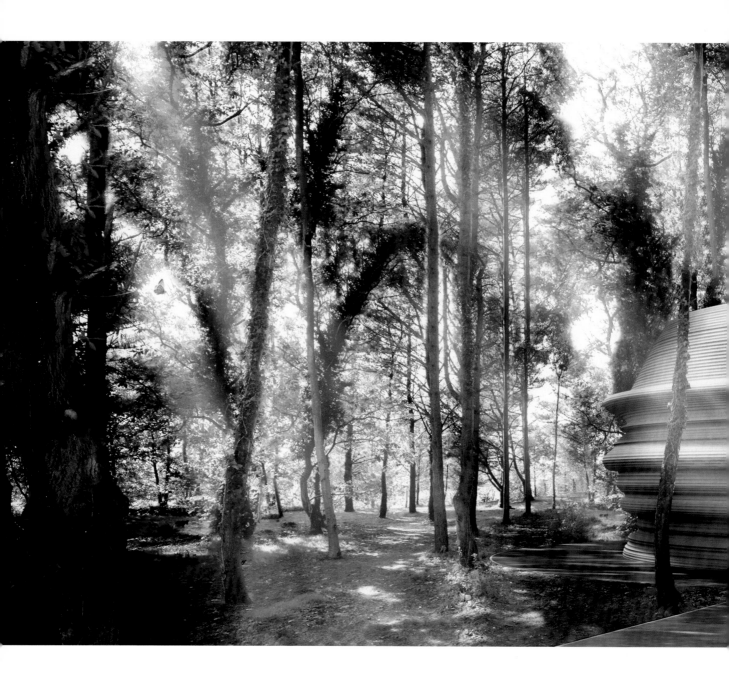

Konstam

*How do you make a new restaurant
in an old London pub?*

CHEF AND CAFÉ OWNER Oliver Rowe asked the studio to help him turn a run-down pub in King's Cross, London, into a restaurant. There was growing interest in the idea that, to reduce the energy used to transport food, it should be seasonal and locally sourced and Rowe planned to obtain all the food ingredients for his restaurant from within London. His television series *The Urban Chef* showed him searching out mushrooms grown under the M25 motorway, honey made in hives on top of tower blocks and mackerel fished from the River Thames. Instead of hiding Rowe and his kitchen away in the basement, our first move was to place the kitchen in the middle of the new restaurant, where people could see him work.

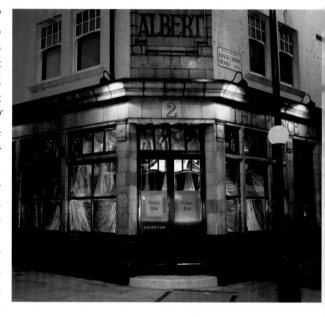

With its tiled exterior and small multiple window panes, there was no denying the identity of the space as an Edwardian pub. Because it seemed to have become a cliché in the world of restaurants to take an old pub, strip out the brown carpet, put hearty food on big white plates and call it a gastropub, we wanted to look for a different approach. Rather than imposing an aesthetic that fought with the character of the space, we looked for a way to acknowledge it.

The space had about fifty panes of window glass and, at the same time, the new restaurant needed to seat around fifty people, which led us to the intuitive idea of making an umbilical connection between every window and the light that would illuminate each table.

By putting a fringe of fine metal chain around every window pane and drawing these chains into the room in bunches, as if capturing the light from the window, we could then sling the bundles over hooks in

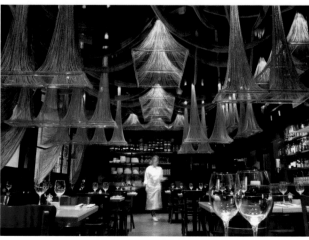

the ceiling, and let them hang down to form a beam of light over every table. Using only chains and gravity, we could make extraordinary, void-like forms smeared out of the window frames.

The finished project used 110 kilometres of nickel and stainless steel chain that crossed the ceiling in swathes, like ponytails or cobwebs, held in place over each table by square, clear acrylic frames. The rest of the restaurant – floor, walls, ceiling, window frames and chairs – is painted in a rich, dark turquoise to make a relaxed low level of light within which the small pools of light can stand out. Inside, you can play with the chains, running your fingers through the bunches. Daylight shines in through the windows but the area outside, known for its takeaway food shops and massage parlours, is filtered by curtains of beaded chain.

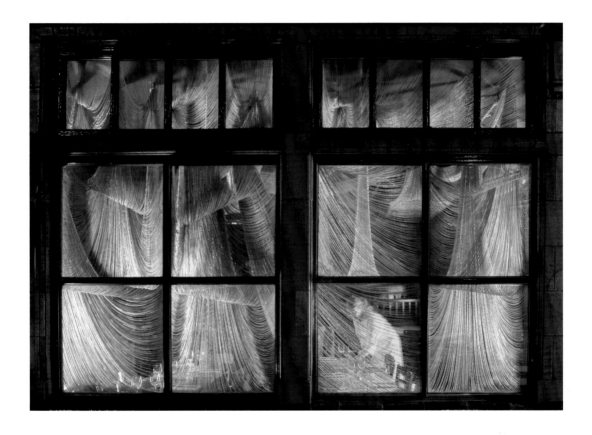

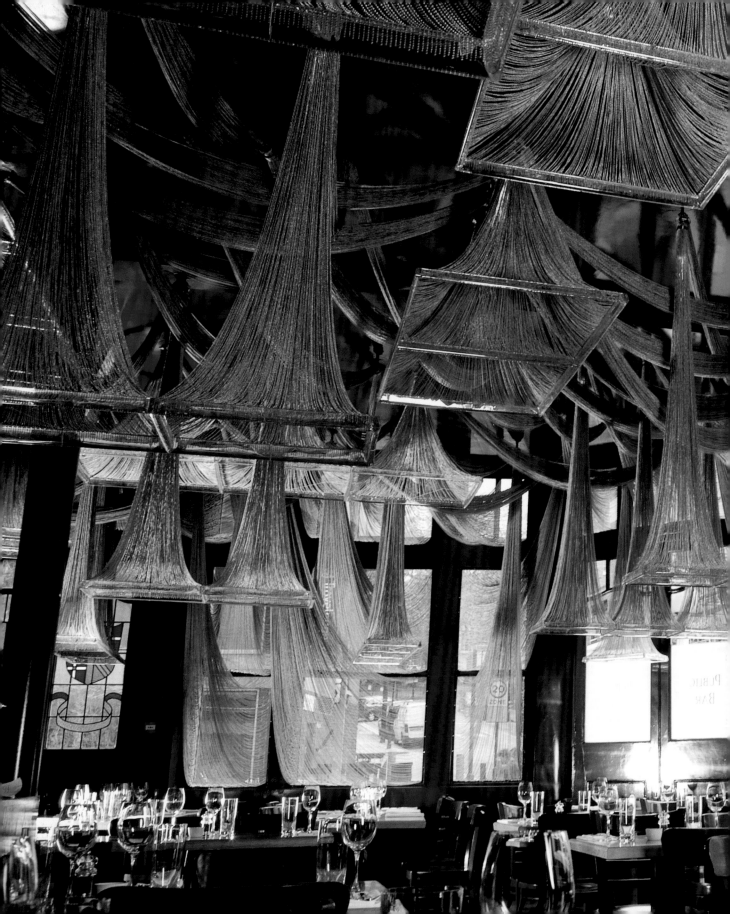

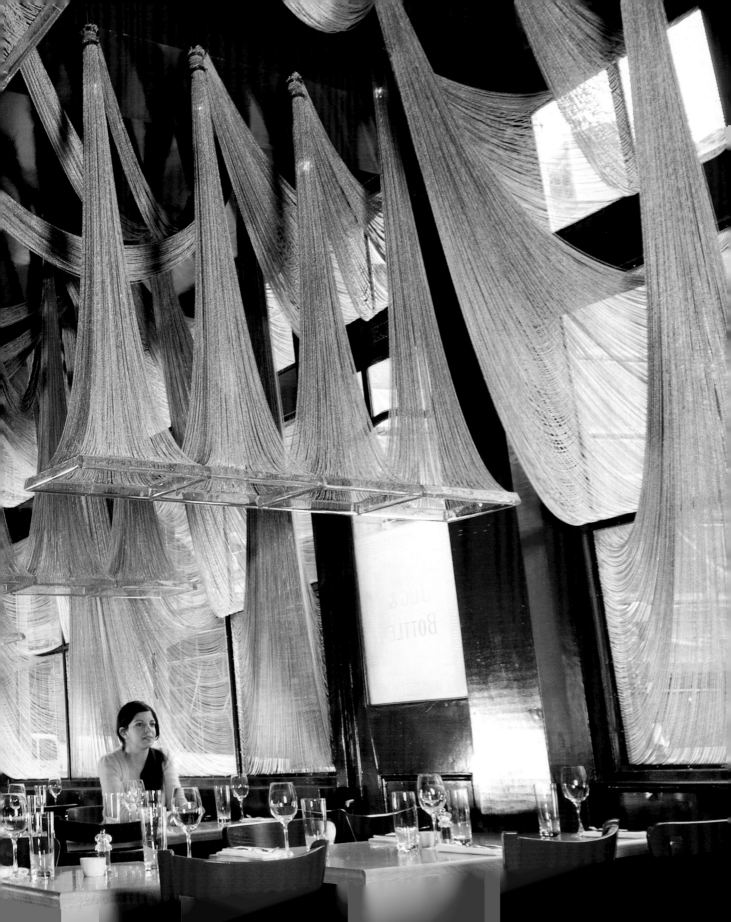

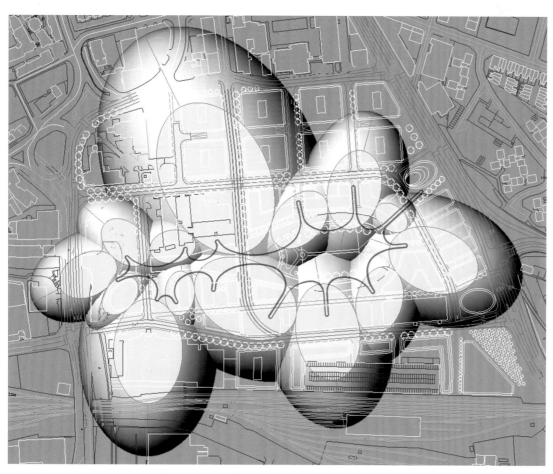

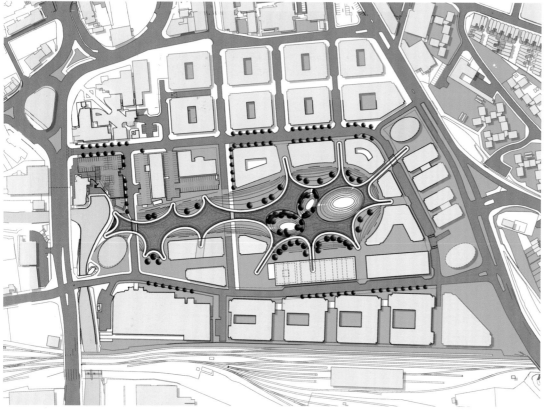

Nottingham Eastside

*Can the design of a body of water
make a place unique?*

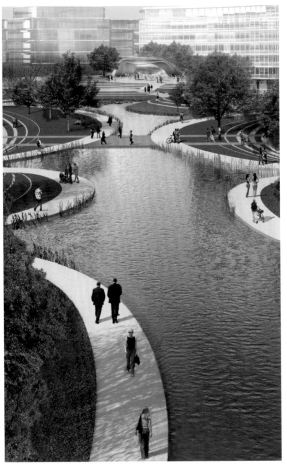

A PROPERTY DEVELOPER INVITED the studio to design a large public space at the centre of a mixed-use development in the middle of Nottingham, England. As the site had once been a canal dock, the team's proposal was to create a new identity for this part of the city by placing a major new water body within the site. Rather than dropping an isolated water feature into the middle of the development, we gave the water a form that engaged with the layout of the buildings in the masterplan.

Our idea was to create notional islands that collided with each other, put a building on each one and fill the spaces between them with water. Instead of making a rounded lake with a convex edge, a single giant shape that you can walk around, we gave the land a convex edge. The shape of this piece of water stitches the development together in a way that a single ellipse or rectangle of water could not do, making a landscape of intimate places for people to inhabit, rather than huge empty and impersonal spaces.

Like a plant with far-reaching tendrils, the water flows through slots down the side streets into the central space, maintaining its connection with the buildings and drawing people into the development. There is also an archipelago of three interconnected islands, which traverse the central piece of water. The project is constructed with substantial pieces of granite, similar to the kerbstones used on British roads, forming a water edge of contoured steps.

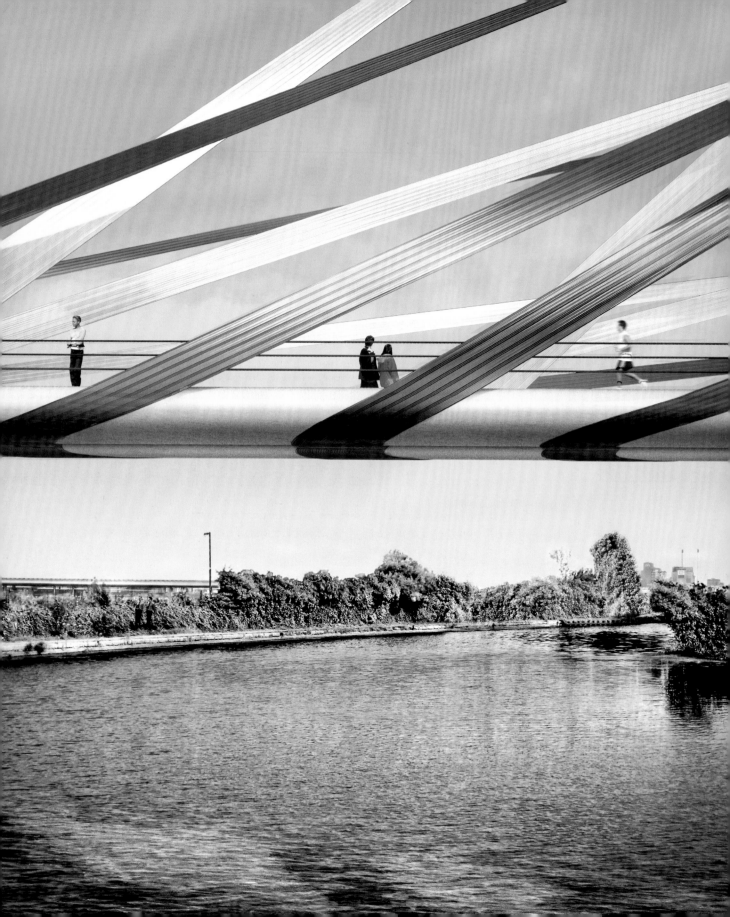

Ribbon Bridge

*Can a bridge borrow its structure
from nearby buildings?*

A LARGE HOUSING DEVELOPMENT was being planned for an isolated piece of ex-industrial land in east London at a time when much of the housing being built in Britain had a bland sameness. We were commissioned by a property developer to design a hundred-metre-long bridge across the River Lea, an essential piece of infrastructure that enabled residents to reach public transport facilities.

A straightforward and cost-effective way to make a bridge of this span would be to build columns on both banks of the river and suspend a walkway from them but, in this case, we could put columns only on one side of the river because the developers did not own the land on the other side. With two apartment blocks being built next to the landing of the bridge, there was not such space for column structures on this side either.

The relationship between the bridge and these apartment towers was crucial: the apartments would be unsellable without the bridge but no one would fund the construction of the bridge without the apartments. As the scheme depended on their being built at the same time, could they be made to depend on each other structurally as well?

Our proposal was to get rid of the need for bridge columns altogether and instead use the apartment blocks to hold up the bridge. The absence of columns would also create a public space around the buildings that was more open and welcoming.

At that time, it was fashionable for bridges to take inspiration from stringed instruments, such as harps, resulting in compositions of fine steel cables and white tubular columns. We wanted to use a different kind of bridge ingredient and to

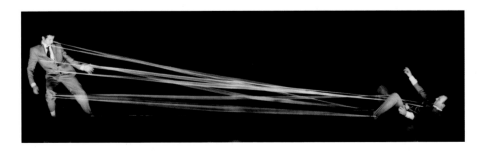

make our cables more expressive against the sky. Rather than a round cable, fashioned by twisting fine metal wires into a circular section bundle, we had the idea to use a flat ribbon of metal plate.

Polished strips of steel would be embedded between the floors of the apartment blocks and stretched down across the river to cradle the walkway of the bridge. The bridge would hang from the towers in a cat's cradle of twisting ribbons, its deck a wide walkway with a glass balustrade, with the long pieces of metal wrapping around and under it.

In collaboration with a team of specialist engineers, we developed a structural ribbon for the bridge that was 900 millimetres wide, constructed from 12 millimetre-thick stainless steel plate. A series of wind tunnel tests showed that putting small holes in the ribbon would allow the air to blow through it and prevent the bridge oscillating in the wind. We determined that the bridge was achievable within the budget and formulated a construction sequence for assembling it from prefabricated sections at the same time as the towers were going up.

With this bridge design, the intention was to give the site a strong visual identity and add value to the apartments. We thought, too, that it would be a talking point for residents to be able to say that their apartment was holding up a bridge.

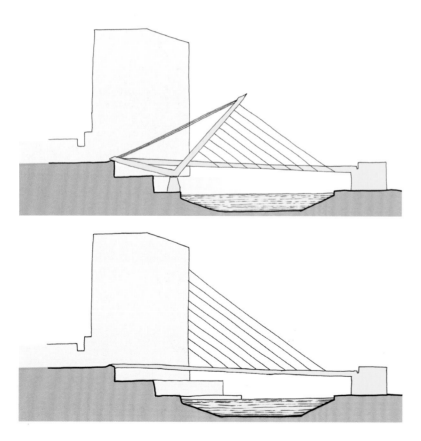

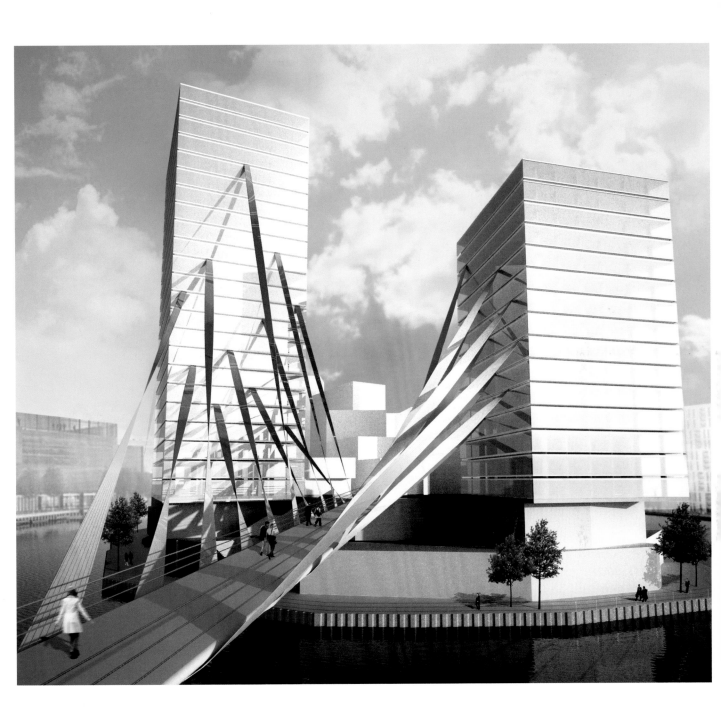

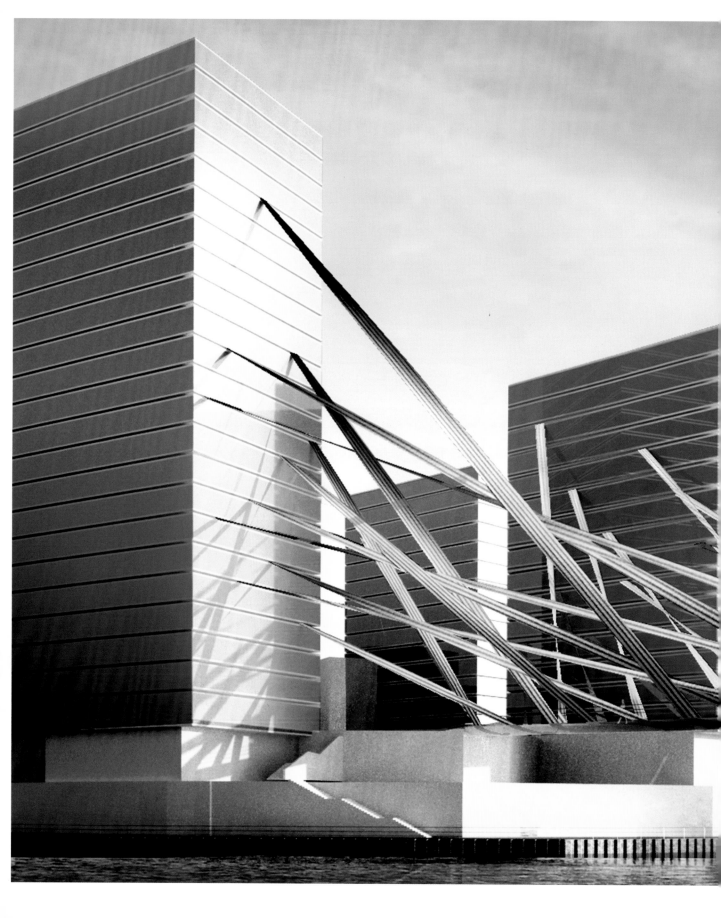

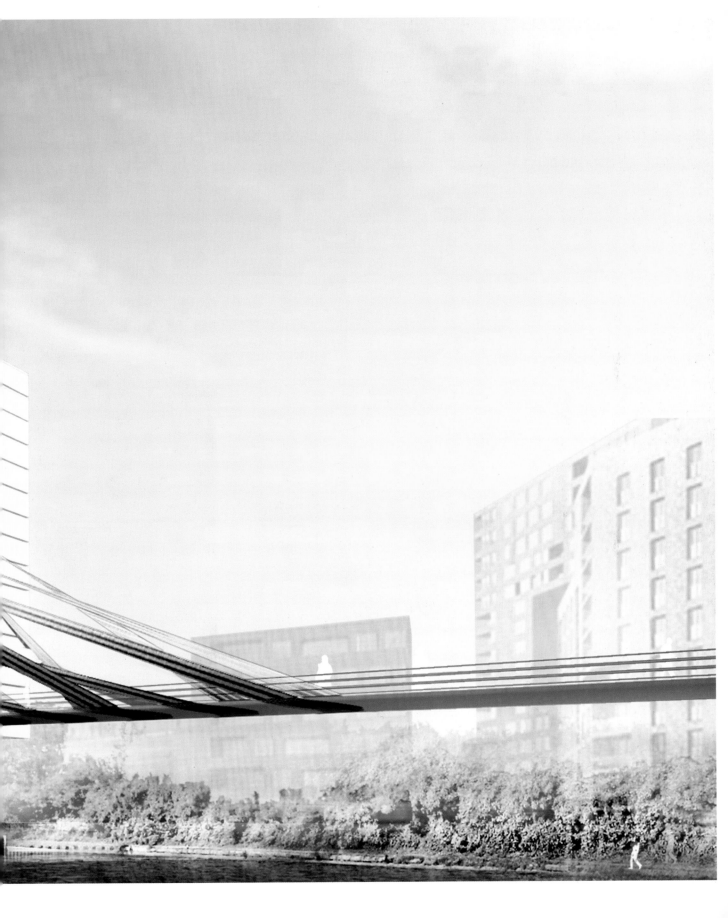

Pacific Place

2005

How do you deliver a £166 million programme of improvements to a shopping centre while keeping it open for business?

THE STUDIO WAS INVITED by the chairman of Swire Properties, one of the largest property development companies in Hong Kong, to propose ways to improve one of its most valuable and profitable holdings: the 5.2-million-square-foot, mixed-use complex in the centre of Hong Kong, called Pacific Place. Completed in 1990, it had been the company's first major retail project and its location and extraordinary success had made it one of the most valuable pieces of real estate in the world.

Like a small town, Pacific Place is a self-contained entity. It consists of a four-storey shopping mall housing 130 shops and restaurants that forms a podium for four fifty-storey towers sitting on top of it, occupied by offices, serviced apartments and four hotels. With its subway station, bridges into neighbouring developments and principal routes to Hong Kong Park and key government buildings, up to 130,000 people pass through Pacific Place every day. As well as shopping there, working there and staying in its hotels, people go there to see films, have clothes cleaned and mended, attend conferences, swim and use the banks.

Even though it was considerably older than some of its competitors, the generous scale of its spaces and a consistent use of materials gave Pacific Place an atmosphere of relative calm. But there was scope for substantial improvement. Within the mall, the sightlines between the open floors were obstructed by the edge detail of the floor plates, partly obscuring the shop fronts on other floors. The lifts and escalators did not go to all floors and the functionality of some of the public spaces was poor. Also, the rigid angularity and shiny surfaces felt outdated.

Since Pacific Place opened twenty years ago, its style and format had been widely imitated and our commissioner feared that it would one day be overtaken in its position as a market leader. Also, changes in the economic and political realities of Hong

383

Kong in the previous decades had created the potential for Pacific Place to function better and to become more profitable. However, the value of the development and its profitability precluded the possibility of knocking it down and starting again. Instead, the strategic decision was taken to spend £166 million on a project to bring the structure up to date in such a way that it could survive the next twenty years of changing fashions in an intensely competitive market. From the beginning we were also convinced that it was important to maintain confidence in Pacific Place's original vision. In an effort to redevelop and modernize, it seemed easy to erode the authenticity of a building or city and eradicate what made it unique and valuable in the first place.

Instead of designing a single large new building, our work at Pacific Place was the equivalent of designing and building fifteen separate but interrelated projects, making this a complex piece of construction management. The transformation had to be carried out without disrupting trade and the flow of rental income by keeping the highly profitable retail outlets, office spaces and hotels open for business throughout the project.

In a programme of changes to Pacific Place, we improved circulation by introducing new escalators and lifts, and also transformed the signage and way-finding systems. We modified and enhanced the sightlines inside the mall, increased the quantity of natural light and upgraded its environmental performance by reducing energy use. We designed new restaurant and café buildings and the exterior of a new hotel, created a large amount of public space and gardens and designed a pedestrian bridge.

As the project was not a rebuild, it became an exercise in detailing on a massive scale. Our task was to use these details assertively and consistently throughout the environment so that they accumulated and worked together to exude the confidence of the original design but at the same time communicate a new identity. We employed principally wood and stone, relying on their natural imperfections to bring life and warmth to the environment, and the details we devised were intended to create greater integration between elements within the space. For example, where the handrails of the balustrades met the moving handrails of the escalators, we made them meet with the same curve, rather than

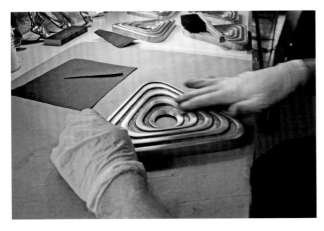

colliding arbitrarily. The detailing work extended to using our workshop in London to produce the casting patterns for the sand-cast bronze lift buttons and other metal elements.

Another unique detail we developed for the project was the toilet door hinge. Instead of putting box-like cubicles around the toilets, we chose to enclose them with a single undulating surface made of wood. It seemed to go against the spirit of this curving wall to break it by inserting doors with ordinary hinges. How could we make the doors open in a curved way, and eliminate the hinges completely? After extensive experimentation we found a means of making a wooden wall that bent on both the inside and outside without any visible hinge or line. To evaluate it, we developed a test rig that opened and shut a prototype door thousands of times using an electronic motor, which we constructed in our workshop in London. The device was shipped to Hong Kong and installed in the corner of the project office, where it operated continuously for two weeks to simulate twenty years of use, profoundly irritating the project team with its repetitive thwacking.

The greatest physical transformation was achieved by our work on Level Four of Pacific Place, which is the outdoor area on top of the podium that forms the base of the four towers. Dominated by the road that formed drop-off points, delivery access and turning circles for the hotels, this open space was barely accessible. The many glass pyramid-shaped skylights set within large raised planting containers let daylight into the mall below, but formed barriers within the space. For anyone arriving by car or taxi, this was the front door to Pacific Place, but it felt more like a service entrance.

We replaced the skylights with dramatic and substantial areas of flat glass, set into the podium surface, which could be walked on. This involved developing a special glass detail with a non-slip surface that also prevented people in the mall below looking up the skirts or trouser legs of others walking across it. In order to be strong enough for lorries to drive over and to achieve the accredited fire rating,

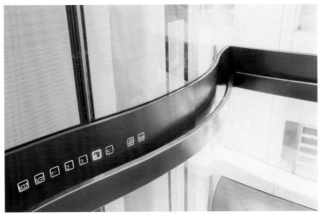

the surface had to be made up of seven layers of glass. Taking advantage of these multiple layers, we found a way to obscure the glass without blocking the light or hiding the sky. We put roughened dots on the top surface of the glass, making it non-slip, and then etched different-sized rings on each subsequent layer of glass, which accumulated to describe three-dimensional pebble-like forms within the layers. These one hundred walkable skylights both transformed the previously dead space on Level Four into a significant public space and increased the quantity of daylight in the mall below.

In addition, we designed and constructed a new café building and a stand-alone restaurant with a roof structure made in a Chinese shipyard from ribbons of steel. We also re-clad and unified all the surrounding façades with surfaces of shaped, cut Bedonia stone, which form flowing, curtain-like forms around the buildings and the new hotel entrance we designed. On this landscape, there are now areas of plants and greenery in containers made with the same stone as the façades, and the paving incorporates many special details, such as a sculpturally carved stone dropped-kerb detail, which has a contorted twisting form as the kerb squashes downwards to meet the road surface. With Level Four transformed into a new front door for Pacific Place, the shopping centre's most prestigious retailers have taken additional new units facing on to the space.

The project will be completed by the reconfiguration of all the office entrance spaces on Level Four and the construction of a hundred-metre-long footbridge across the road in front of the complex, which will incorporate garden spaces along its length.

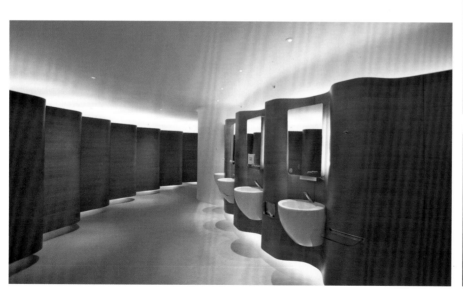

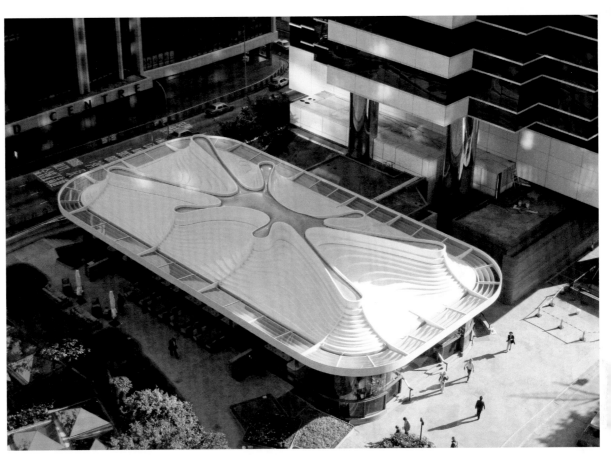

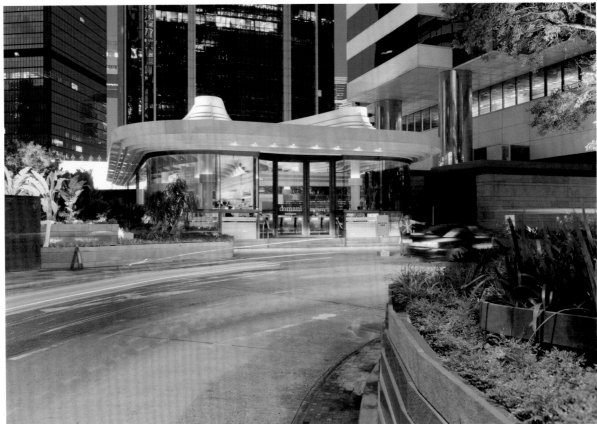

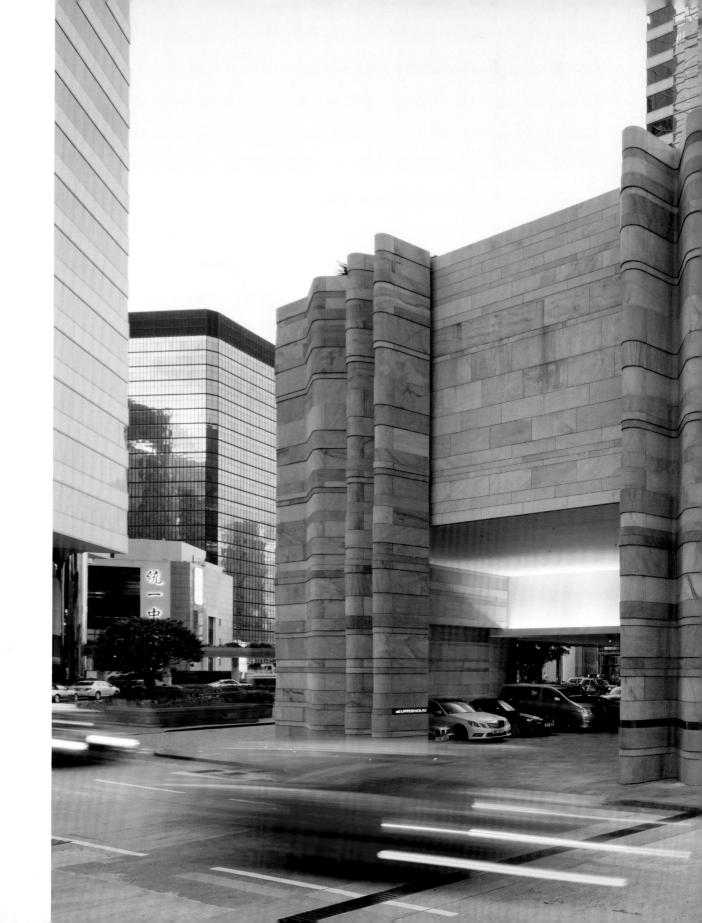

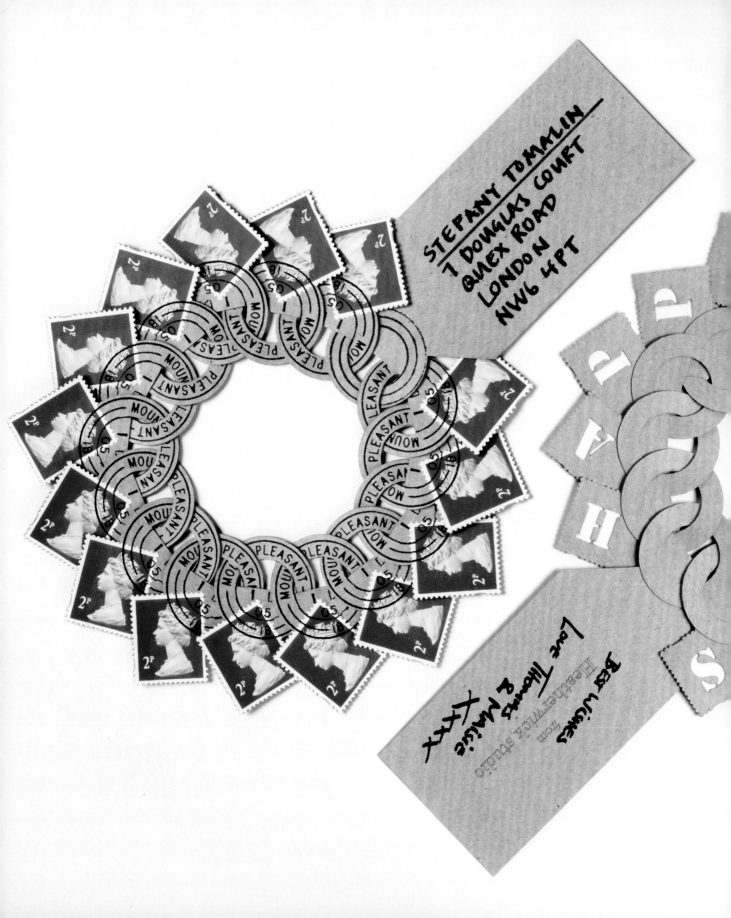

STEFANY TOMALIN
7 DOUGLAS COURT
QUEX ROAD
LONDON
NW6 4PT

Best Wishes
from
Heatherwick Studio
Love Thomas & Maisie
XXX

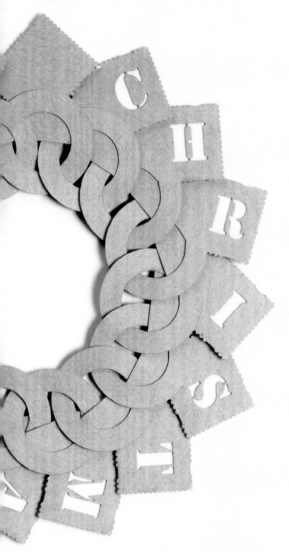

Christmas Card

*How can you turn a postmark
into the main ingredient of a
Christmas card?*

AS OUR CHRISTMAS CARDS had increasingly dealt with the processes of sending and receiving cards, the studio began to think about using the circular postmark that the Post Office prints on a postage stamp to prevent people from using it again. It is normally printed in the top right-hand corner of the envelope, overlapping the corner of the stamp, but we thought it might be interesting to cut around the postmark, leaving a piece of paper that was the exact shape of the stamp and its postmark. We could then break the postage charge down into many low-value stamps and treat each stamp and postmark pair as a link in a chain.

Working with the Post Office, we found a method of producing invisible joins in each postage stamp link, allowing us to form charm bracelets of stamps.

V&A Temporary Structure

Can water be used as a structural element?

THE VICTORIA & ALBERT museum in London asked the studio to design a reusable event pavilion, which could be put up in its courtyard in winter when the garden was not in use. With no crane or vehicle access to the space, the only way to bring anything into this courtyard was to carry it through the main entrance of the museum, so it became clear that this structure needed to be some form of portable tent.

The pond in the courtyard, which would be drained and boarded over when the pavilion was in place, led us to the idea of using the water in the pond to create the structure, instead of carrying structural elements in through the museum. Like a snake charmer who charms the serpent up out of a basket, we could freeze this water and turn it into a single column of ice and use this as the structural device that supports the pavilion. With its associations of icicles and stalagmites, the column would be the centrepiece of this seasonal event space, like a swan ice sculpture at a banquet. In spring, when the tent came down, we could simply let the column melt away.

With specialist structural and services engineers and ice companies, we developed a means of creating the ice column and maintaining it by running flexible refrigeration pipes through it. At night, it would glow from tiny lights frozen within it.

Like the lights going on in Oxford Street or the tree going up in Trafalgar Square, we imagined the raising of the V&A's ice tent becoming one of the signs that Christmas is coming.

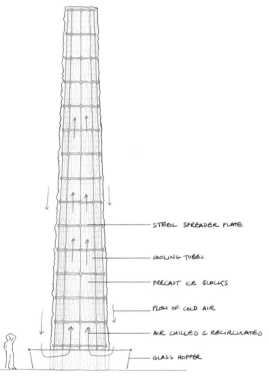

STEEL SPREADER PLATE

COOLING TUBES

PRECAST ICE BLOCKS

FLOW OF COLD AIR

AIR CHILLED & RECIRCULATED

GLASS HOPPER

Watch

2006

Can a watch strap tell you the time?

THIS PROJECT BEGAN at a time when the world of expensive watches seemed both absurd and lacking in originality. Describing their watches as 'timepieces', the costliest brands had succeeded in concocting an artificial connoisseurship around their products, based on the nostalgic evocation of 1930s aviation and a romanticized notion of the accuracy and diligence of the Swiss watchmaker. Such watches were further fetishized by the addition of mythical functions that few people need, such as the ability to tell the time in space or withstand strong magnetic fields.

In a number of our previous building projects we had used fibre-optic lighting, which allows light to be transmitted from its source along cables with glass or plastic cores. As well as enjoying the hairiness of the bundled cables that are normally hidden, we liked the aesthetic quality that they had when the bundle was sliced through and the cut ends were smoothed and polished to form a light-emitting surface. Curious to see whether we could use this smooth, round surface to tell the time, we developed a watch that, instead of having a separate face and strap, consisted of a flexible bundle of optic fibres that goes around your wrist and displays the time on the sliced ends of the cables. With each fibre end acting as a pixel in the display system of the watch, the time is projected through the flexible strands by a tiny light-emitting mechanism at the ends of the fibres.

To test the idea, we used plastic data transmission cable to create a bendy ponytail object that told you the time. Wrapped around your wrist, the fibres looked raw, like exposed nerves and sinews. Since then, we have been experimenting with using finer fibres made from glass, which give a higher-definition time display.

Baku Monument

*How might people interact with
a monument?*

THE STUDIO WAS INVITED TO PROPOSE a monument for one of the highest
points in the city of Baku, Azerbaijan. Although it had a spectacular view over
Baku to the Caspian Sea, the site was a park that was run-down and neglected.
On this spot there had once been a large statue, demolished when the country
gained independence from the Soviet Union.

Instead of a monument that people would just look at, we wanted the
structure to give them a monumental and engaging experience, by allowing
people to go up it. Topographically, the elevated site
was already very special, but lifting visitors up another
70 metres would make the view truly remarkable.
Feeling that the hard work of climbing would make the
experience still more rewarding, and liking the idea of
creating a greater sense of engagement, we conceived
of this monument as a heroic staircase. It would give
people stories to tell, such as the first time their child
had walked up by herself or the time that, having made
it to the top, a young man went down on one knee and
made a proposal of marriage.

As there were other vertical structures behind
our site, including a telecommunications mast, which
was taller than our structure would be, the monument
needed to be eye-catching without competing to be the highest. To differentiate
this structure, we determined that it should not rise straight upwards, putting its
emphasis on a single destination point at the top, but instead move from side to
side and contain a number of destination points.

Our idea is for a grand helical staircase that rises 70 metres into the sky
out from a circular performance space, surrounded by stepped seating.
Suggesting growth and continuity, this is a branching form that reaches up and
out in various directions, with several different summit points or stopping places
on the way, so that the top is not the only place that matters. As well as the 450
steps to walk up, there is an elevator within the structure and a slide offering
a quick route down.

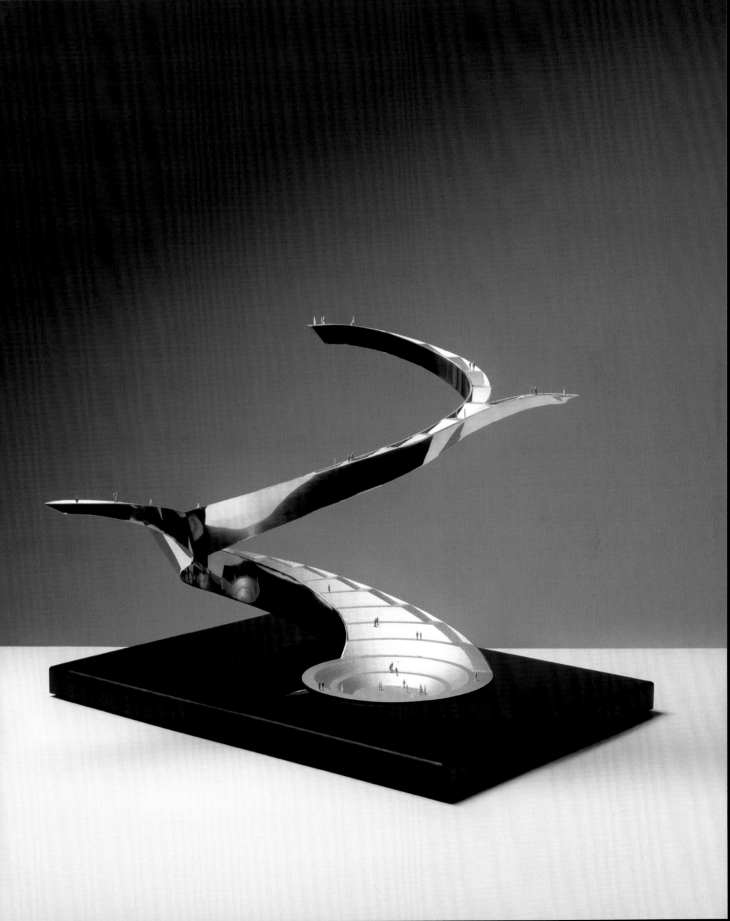

The concept included the renovation and reinvigoration of this neglected ex-Soviet landscape. Built into the underside of the outdoor performance space is a gallery and museum space, and the stairs of the structure also create seats from which to watch performances. During festivals and holidays the structure could draw many thousands of people and any visitor to Baku would feel obliged to go up it, pausing at the tea stalls and kiosks on the landings. The end points are the perfect size for a pair of lovers to sit in.

Engineered in a shipyard in Turkey, using shipbuilding techniques and huge sheets of welded steel plate, the structure would in effect be an enormous, curling cantilever.

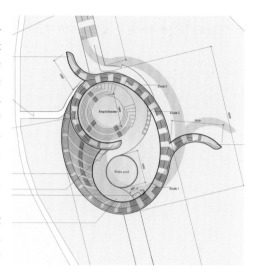

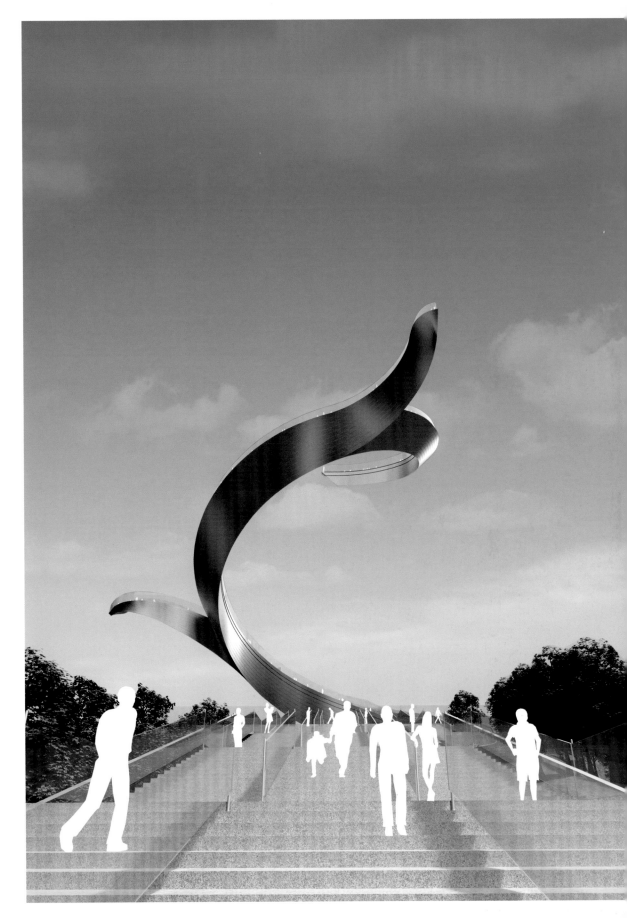

Christmas Card

What happens if the perforated edge of a postage stamp is allowed to grow?

THE IDEA FOR THIS CARD came from looking at the tiny stumps of paper around the edge of a stamp, made by the perforations that enable a stamp to be torn apart from its neighbour. Taking our cue from the shapes of these edges, we decided to try letting the stamp abandon its crew cut and become a long-haired hippy.

The final card design has strands that flow outwards from the postage stamp, like long hair floating across the water when someone lies down in the bath. The extruded perforations spell out the words 'Happy Christmas'. However, of the three hundred people we sent the card to, only one noticed the message in the hairs.

Worth Abbey Church

*How do you complete an
unfinished church?*

SET ON THE SOUTH DOWNS in Sussex, England, Worth Abbey is home to an
independent boarding school and a community of Roman Catholic Benedictine
monks. At its heart is the Worth Abbey church, which was designed in the 1960s
by Francis Pollen, following the decision of the Catholic Church to meet the
modern world by adopting contemporary architecture in its new churches.
Although the church had been in use since 1974, its interior had never been
properly completed and furnished and, over the years, the community had
grown accustomed to the unfinished space. There was now a need to tackle the
problems that had remained unsolved for many years, especially as the church
had become a popular visitor destination since being the subject of a television
series, *The Monastery*, in 2005. We found the church to be a spectacular space
with a powerful simplicity. Its brick and concrete construction and its circular
geometry were in contrast with the conventional orthogonal arrangement of
Gothic stone churches.

To learn about the community, the studio team spent time with the
monks, living with them through the cycle of a day, sharing their silent meals
and joining late night vespers. Working together to develop the project, it
became clear that improving this building would support the spiritual life of the
community by enabling them to practise the Catholic liturgy more fully, as well
as reinforcing and celebrating the monks' role within that liturgy. Difficulties
that stood out were the arrangement of the choir area, the church's lack of fur-
niture and the need to replace the confessionals. It was not that the church
needed refurbishing; the project was to 'furbish' it for the first time.

In a monastic church, the choir is a sacred space in which the commu-
nity of monks sits. In the unfinished church, the choir was a collection of
ordinary chairs. As well as looking untidy and disorganized, this space was not
clearly demarcated and, in the resulting confusion, members of the congrega-
tion could sometimes be found sitting among the monks. Sitting in these chairs,
the monks had nowhere to rest their choir books and no kneeler on which to
kneel and pray. Also, because they had nothing to lean against when standing to
sing for long periods, they tended to sing sitting down, which was not good for
the quality of their voices. Although monks are at the heart of a monastic

complex, this arrangement was failing to express their ritual importance to the congregation and the world at large.

The design of the new choir area consists of a single curved sweep of seating. There is also a desk element for choir books that incorporates a kneeler, and the upturned seats are designed to be leant against, to support the monks when standing. Through full-size testing on site, we worked out an exact geometry for the curve of the seating that would allow the monks to face in towards each other, to create a feeling of togetherness, as well as outwards to address the altar and congregation. The choir seating forms a backdrop that frames the monks and clarifies their position within the church, and its high back acts as an acoustic device to project the monks' voices into the church.

To help us think about the design of new furniture, the abbot took us to look at the basilica churches in Rome. Because these churches were originally unfurnished, the congregation stood or sat on the floor, and the vast floor slabs were a powerful element of the churches' design as the surface on which worship takes place. However, with 800 ordinary chairs, Worth's floor was cluttered with 3,200 wooden legs. To reassert its power, we set ourselves the goal of having as few legs as possible.

In the search for a form of seating that would be specific to this particular church, we began to analyse its geometry. With its vast round roof and the circular liturgical arrangement of a church 'in the round', it was clear that the seating had to have a circular arrangement. Yet Worth Abbey Church itself is a square building. In order to respect the architectural dialogue between these juxtaposed geometries, we sought to resolve this paradox by making round seating in a square way.

While the conventional way to form curved seating is by bending pieces of wood, creating identical curving seat pieces that are then repeated to form large circles, for this design we used straight pieces of timber, which are set out in parallel to the church's perimeter walls and then carved into circular seating. The grain of the timber follows the square geometry of the church, while the shape of the seats follows the radial geometry of the liturgy. All three elements of the seating – back, seat and kneeler – have a grain that continues through the entire space, disregarding its radial nature and connecting with the orthogonal walls of the church.

In contemporary ecclesiastical design, the tendency has been to choose furniture made in pale-coloured timbers, to get away from the dark varnished wood associated with old Gothic churches. We felt that this choice of pale wood was already too familiar and would sit badly with the colour of Worth's brick walls. Admiring the confidence and gravity that comes from a darker wood, we chose American walnut, which has a dusky tone without too much colour. A tiny layer of paler wood within the timber laminate quietly emphasizes the direction of the wood grain, forming contour lines as it appears across the curved surfaces of the furniture. The pattern of wood lamination mutates throughout the church as the seats radiate around, giving every seating position its own unique balance of end-grain and side-grain.

Another aspect of Catholic liturgy that the church was failing to support was the practice of confession. As its existing booths were not sufficiently open or flexible, they had fallen out of use, and we replaced them with new reconciliation rooms that were not enclosed in the traditional manner. In addition, the project involved working with acoustic engineers to improve the building's acoustic performance and specialist lighting consultants to replace the previous inadequate lighting scheme and introduce natural daylight into the windowless side chapels. We also reconditioned the building's stained concrete and replaced leaking windows.

The church reopened in 2011. For the first time since the church was built, monks and congregation were able to kneel down for prayers.

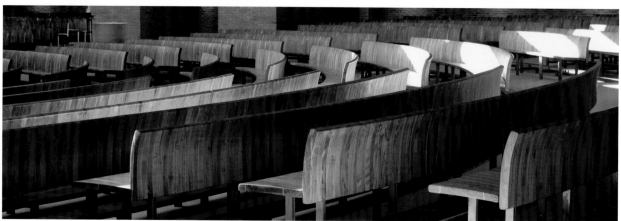
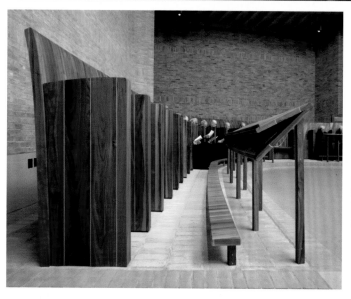
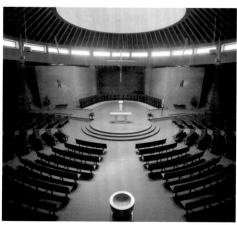

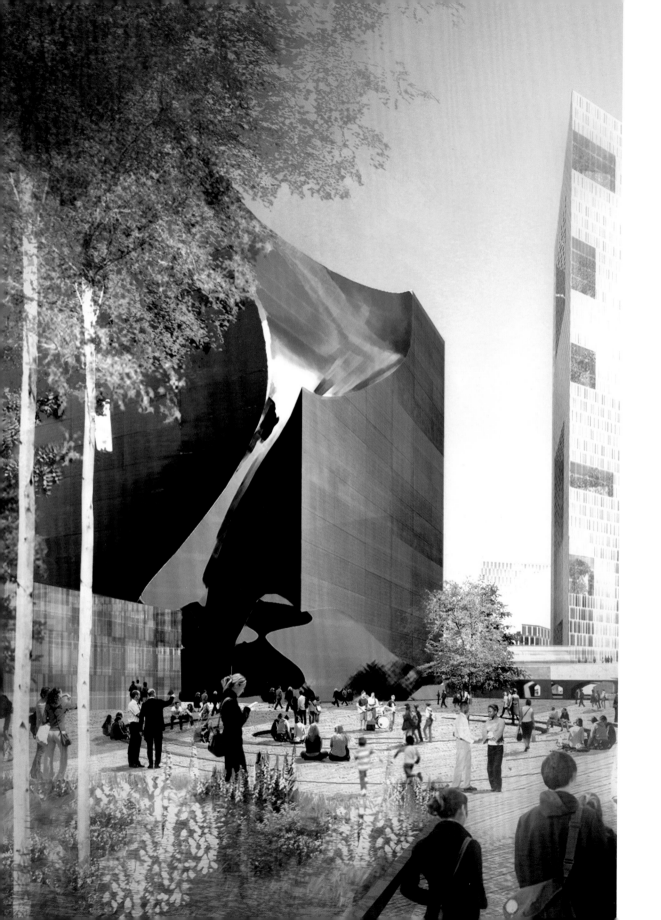

Southwark Town Hall

How can the character of adjacent infrastructure help to design a building?

WORKING WITH A PROPERTY DEVELOPER, the studio joined a team submitting proposals for the redevelopment of Elephant and Castle, an area of London that was notorious for poor transport planning, monolithic 1960s architecture and social deprivation. The brief was for a fifteen-storey tower at the centre of the scheme that would contain the town hall and offices of the local authority, as well as shops and homes.

While the aim of the masterplan was to open up a sequence of new public spaces in the area, the site of our tower suffered from the presence of a major railway viaduct that ran in front of it and risked blocking the movement of people through these spaces. Even though the viaduct would be opened up at ground level for people to walk through, the arches would remain deep and cavernous. Feeling that our design needed to work with this, rather than be hindered by it, we decided to try to use the presence of the viaduct to create a building that was more distinctive and site-specific.

We imagined the brick arches of the viaduct as holes that had been nibbled out by giant brickworms, mutant cousins of the woodworms that tunnel through wood. Having munched their way through the viaduct, they had set to work on our rectangular building block, forming holes that flowed out of the directionality of the archways. The proposal allowed us to open up the façades of our building, bring in daylight and ventilation and form entrances in intriguing and sculptural ways by carving dramatic sightlines through the building, surfaced in three-dimensionally curving coloured glass.

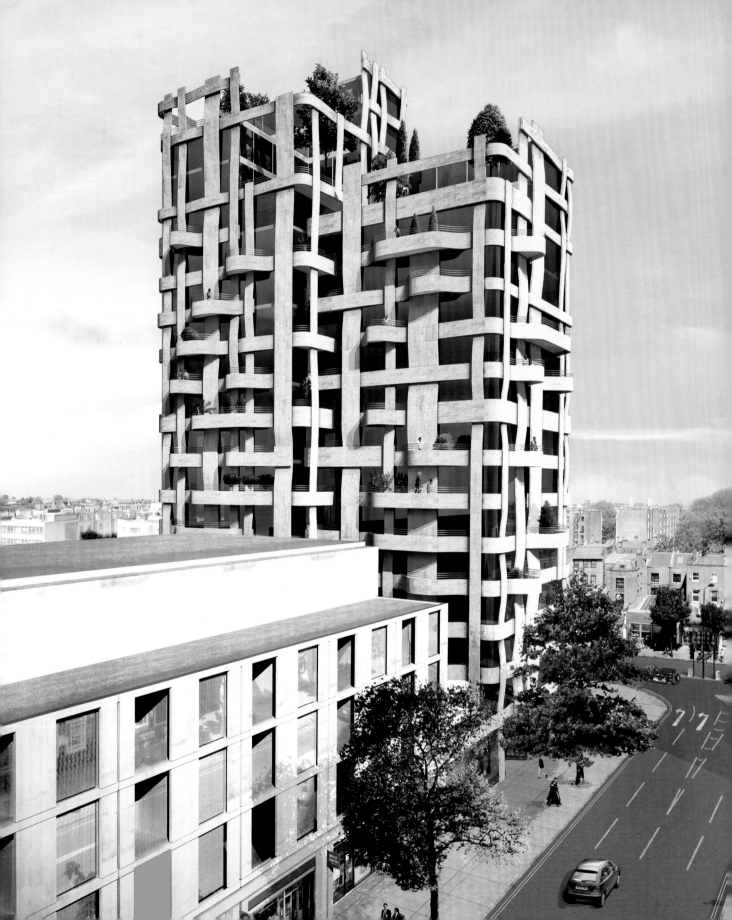

Notting Hill Residential Tower

*Can you make a new building
without knocking the old one down?*

THE STUDIO WAS GIVEN THE TASK of transforming a thirteen-storey concrete office block in Notting Hill Gate in west London into a high-value residential tower. The existing tower, constructed in the 1960s, was in a prestigious residential area close to major London parks and was an unpopular feature of the skyline, regarded by some as a blight on the streets around it. But from the property developer's point of view, demolishing the tower was not an option, as the local planning authority was unlikely to grant permission to rebuild to the same height. This meant that the challenge was to revitalize the building, retaining its concrete frame and increasing the existing floor area to create more space within it.

Our outline proposal was to reduce the perceived squatness of the single tower by breaking it into two interlocked towers and to add four storeys of pent-

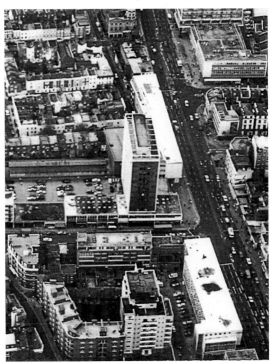

houses with substantial gardens on to the building. Our intention was to stop the building feeling as if it was sitting on a podium by bringing the tower to the ground at street level and configuring a better public space around it.

Looking for a way to make the building special, our first thought was to enliven the façade by allowing it to express the organization of the building's internal spaces. However, for this type of luxury development, the interiors of the apartments had to be arranged in a relatively conventional orthogonal manner so that they produced an ordinary-looking exterior, with regular repetition of rectilinear windows, framed by horizontal and vertical elements.

It was by imagining these elements around the windows as strips or ribbons that we developed an idea of weaving them over and under each other to contain the building in a woven surface, like an architectural basket. Formed from Portland stone pieces, some of the

417

ribbons could be pulled out of this composition to become balconies and gardens for the penthouses, giving the apartments outdoor spaces held within the woven façade.

Rather than a fixed design, we proposed a system for the building's skin that did not conflict with the squareness of its underlying architecture and arrangement of its windows. The three-dimensional composition of animated interrelated elements would give the structure a cohesive façade, stitching together and softening a building that was formerly hard and rectangular. Instead of demolishing the whole tower, the project would be added on to the structure of the old building.

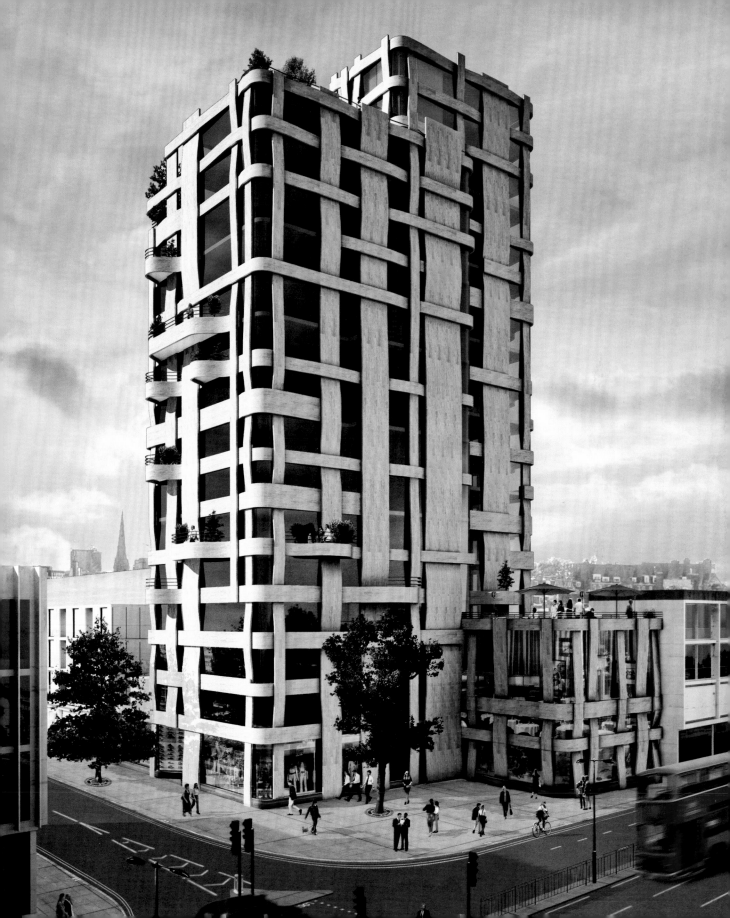

Olympic Velodrome

2007

*How can the design of an indoor
cycling facility capture the spinning
energy of racing cyclists?*

AS LONDONERS, WE WERE VERY HAPPY when the city won its bid for the
Olympic Games and, as a cyclist, I had a particular interest in the competition to
design the velodrome. The site for the velodrome was the former Eastway Cycle
Circuit, where I used to go when I was ten years old to watch human-powered
vehicles being raced by their inventors. The vehicles would disappear round the
corner of the mile-long track, and occasionally an inventor would reappear a few
minutes later, without his vehicle, limping back to the start line with bloody
elbows. This combination of cycling and hands-on inventing was
very exciting to me. Forming a team with the architecture prac-
tice Faulkner Browns, which at the time was the only British
firm with experience of designing and building a velodrome, we
applied to be in the competition and were one of six teams
invited to develop and present an idea, six weeks later.

In the brief, the Olympic Delivery Authority asked us to
design a permanent venue for track cycling, set in a park with
facilities for road cycling, BMX, mountain biking and speedway.
We had to take into account how the velodrome would be used
after the Olympics, so it needed to be flexible and cheap to run.
It had to be possible for some of the seats to be taken away and
for the venue to stage concerts and events.

We drew up a list of things we did not like about velo-
dromes. First, it was easy for a big building, with a vast roof, to feel like an
out-of-town shopping warehouse. Second, the standard composition of a velo-
drome always seemed to be a saddle-shaped roof with walls that bear little
relationship to it, since this is an efficient way to resolve the relationship between
an oval track and tiered seating. Third, the centre of the track, known as the
infield, is almost always cluttered with a confusion of warm-up areas, tunnel
entrances and commentary boxes, as well as spaces for judges and coaches. Last,
we found the heavy-handed symbolism of buildings shaped like cycle helmets or
wheels too obvious and direct.

We began by visiting the National Cycling Centre in Manchester, designed
by our collaborators, to learn about velodromes. When we arrived, however, there

423

were no bicycles, just hundreds of small girls in leotards competing to win the National Junior Cheerleading Championships. However, we did get a chance to spend time next to a cycling track. This experience confirmed for us that the hero of any velodrome is the track itself, which is the stage for the cyclists who are spinning around it. With its twisting wooden surface, the track is also a phenomenally beautiful thing. However, we had never seen a velodrome echo or draw inspiration directly from this gorgeous object that is at its heart and central to its purpose. In recent years, designers and architects had been fascinated by such sinuous forms, so it seemed strange that the track had been so over-looked. Could the rest of the building be designed to capture its movement and energy?

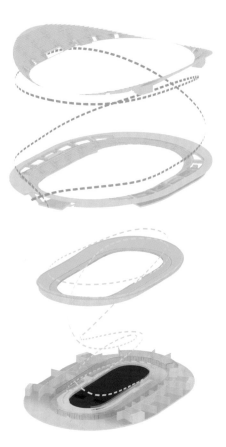

Thinking of this, we began to imagine all the crafts-people nailing and gluing the track together putting layer upon layer of wood. Nailing the pieces together, what if you left them to it and they went too far and were unable to stop, even though they had finished the track? Like a silkworm spinning a cocoon, spiralling around and around, they would spin the track and the seating around it, and then the walls and ceiling. It would be as if the spiralling motion of the cyclists on the track had made the wooden seating and the walls and carried on to make the ceiling and roof. We could make a spectacular building by harnessing this sense of energy, form and craftsmanship.

To translate this notion into a serious, viable design, we used the spiralling technique to make the most efficient, minimal envelope possible for a velodrome. We swept the wood from the track up into a kind of whirlwind, pulling it apart to let in daylight and illuminate the velodrome at night. This motion continues outside, fusing the building with the surrounding velopark, as its lines extend along pathways and planting, through the landscape to define routes into the building.

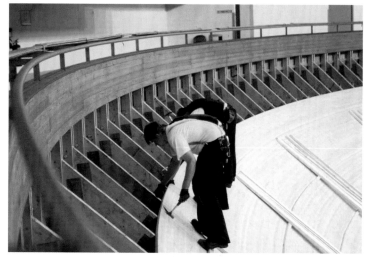

The idea also gave us a way to organize the building's different functions. The spinning geometry gave meaning and logic to all the circulation spaces, as well as the arrangement of changing rooms, medical facilities, physiotherapy spaces, offices, locker rooms, equipment stores and the organization of the infield. The ramps that take cyclists under the track and into the centre spiral upwards, following the same distinctive geometry, and even the pedestrian circulation ramps by which

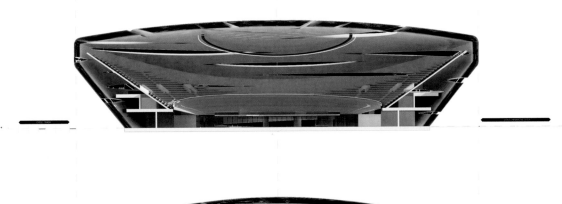

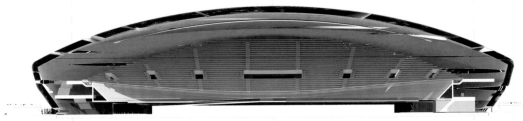

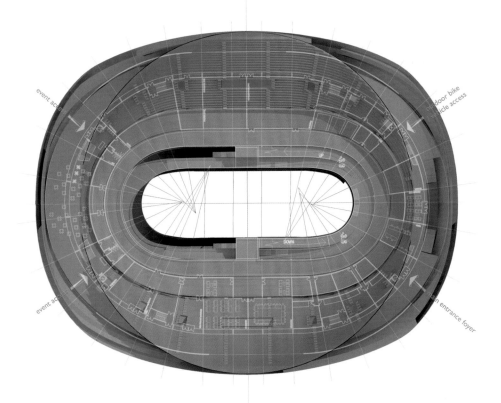

spectators reach their seats are configured to curve up and around the inside of the building.

The interior finish would have been timber, but the outside could have been made from any number of different materials, such as zinc, aluminium, concrete or even rubber. Our proposal was to innovate with the construction process in order to build the project quickly, by fabricating the building in a factory, in sections that incorporated the building's structure and waterproofing, and putting them together on site.

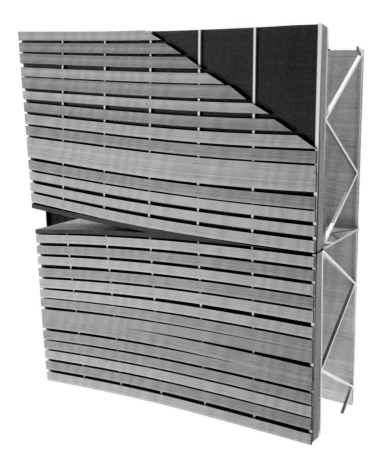

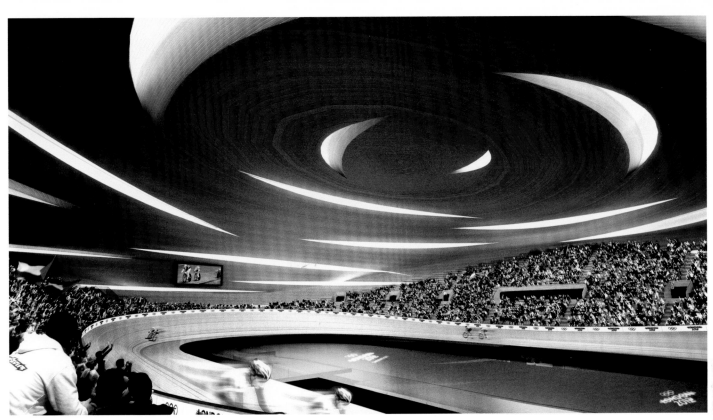

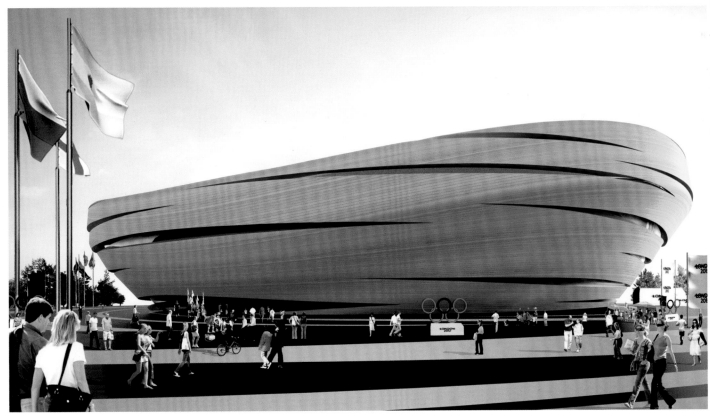

427

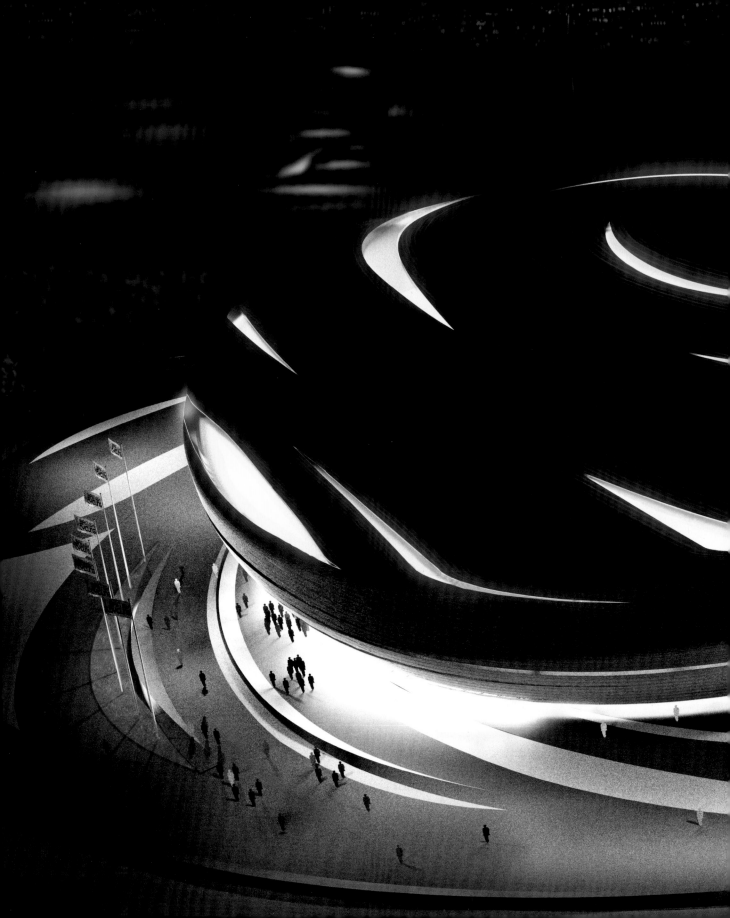

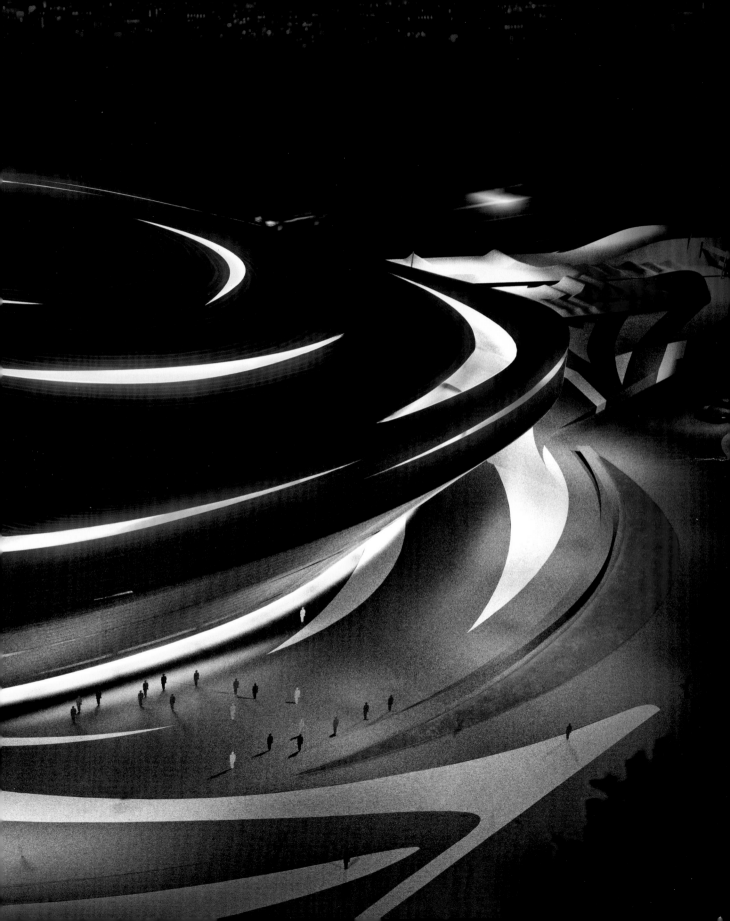

Spun

*Can a rotationally symmetrical
form make a comfortable chair?*

THIS PROJECT CAME ABOUT from wondering if it was possible to create something to sit on using the process of metal spinning, which is used to make objects such as lampshades and timpani drums. This traditional technique involves pressing flat sheets of metal against a shaped former while they both rotate, gradually forcing the sheet to take the shape of the former. If it was possible to make large drums from spun metal, was it possible to make a whole chair? And if it was, would it be comfortable to sit in?

This object would have to be a completely symmetrical rotational form and be able to work as a chair whichever way round it was rotated. So, the seat would have to be capable of serving as a back support, and the back support would also need to be comfortable to sit on. And how would it rest on the ground? When you sat on it, would it not fall over?

To understand the geometry and the ergonomics, we experimented with making full-size models that we could sit on. The most useful model was made from wood, MDF and a large amount of squashed Plasticine modelling clay, which we used to build up a seat shape. Spending many weeks making one subtle tweak after another, we felt as if we might be trying to force a functional idea on to a geometrical one. There seemed to be an endless trade-off; you either had a comfortable seat with an uncomfortable back or the other way round. But there was a moment when it suddenly seemed that we had found the optimum shape.

We translated the shape of this maquette into a set of drawings and asked a metal spinner to make a full-size prototype in aluminium. Before doing so, he had to fabricate the set of formers on which to shape the metal. The finished piece was not only comfortable but surprisingly enjoyable to sit on, with its capacity to rotate and rock in three dimensions.

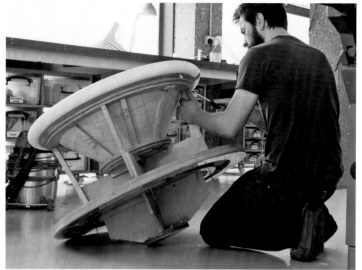

We produced the spun chair as both a craft object and an object of mass production. At Manchester Polytechnic I had been taught by a silversmith who used big sheets of silver to make large goblets and trophies, and together with our gallery, Haunch of Venison, we produced a series of highly finished pieces in different metals. Each chair was composed of six spun metal pieces fused together, with a leather detail protecting the metal where the chair touches the ground.

We also collaborated with the Italian furniture manufacturer Magis to develop a version made with a different kind of rotational process: rotation-moulded polypropylene. In this process, pellets of polypropylene plastic are placed into a metal mould that is heated and rotated until the inner surfaces of the mould are evenly coated with plastic before the finished object is released from the mould. Unlike our smooth metal versions of the chair, the plastic one is covered with a

detail of fine ridges, like the grooves on an old vinyl record, which reinforce the rotational shape of the form and give it the appearance of a clay pot that has been thrown on a wheel that still bears the marks of the potter's fingers.

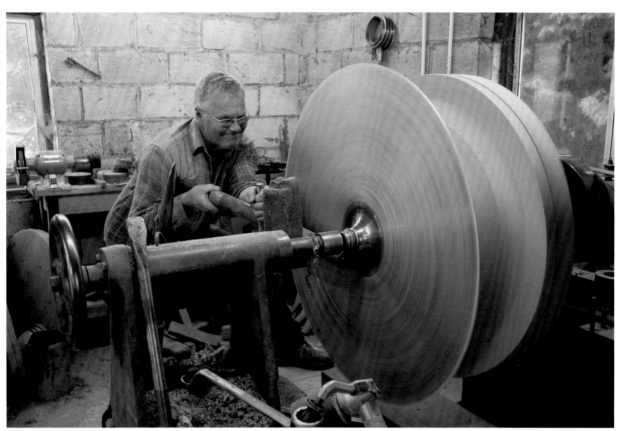

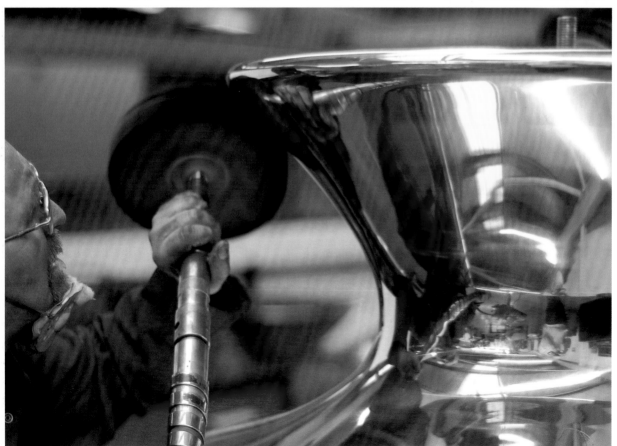

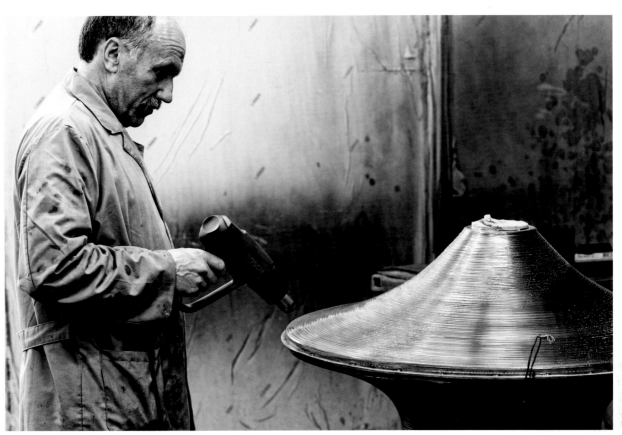
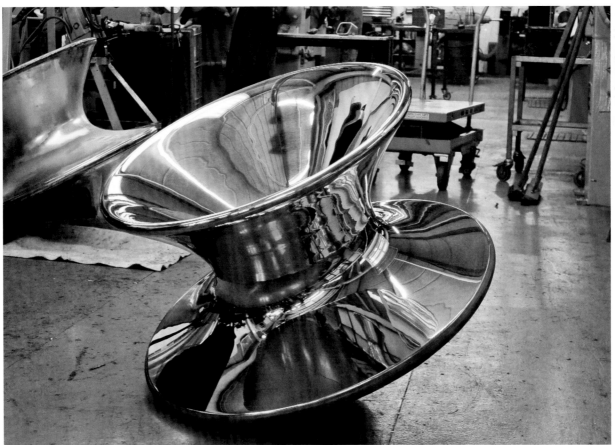

Harewood Quarter

*How can you make a meadow
in the centre of a city?*

FOLLOWING A COMPETITION, the studio was commissioned by a large British property development company to collaborate on the design of a retail and residential project in the centre of Leeds, in the north of England. An existing masterplan set out the scheme as five blocks, each consisting of two storeys of shops at ground level with apartments on top, arranged like a crown around the edges of the block. An enclosed courtyard occupied the well at the centre of each block, sitting on the roofs of the retail spaces, invisible from outside the development. Our first impulse was to create one special place instead of five separate entities and open up the development by freeing the gardens trapped in the middle of each block.

The idea was to achieve a strong relationship between the five blocks by pushing the mass of the housing to the outside edges and creating a single open, contoured meadow in the centre, floating over the retail units, accessible to both the public and the residents of the blocks. The green swathe is angled towards a central point, where it forms an amphitheatre-like public space. The meadow is accessed from ground level by public lifts and staircases and, with shop-lined routes cutting through it like canyons, its sweeping forms make extraordinary-shaped ceilings for the retail units underneath. With the apartment entrances opening on to it, the meadow acts as a communal front

garden for people living in the flats, while a shop serves tea and cake for people to enjoy as they sit on the grassy slopes.

By providing residents with a large shared garden, rather than enclosed courtyards, the proposal offers everybody a different kind of public space to use and prevents this complex from being yet another city block with shops.

438

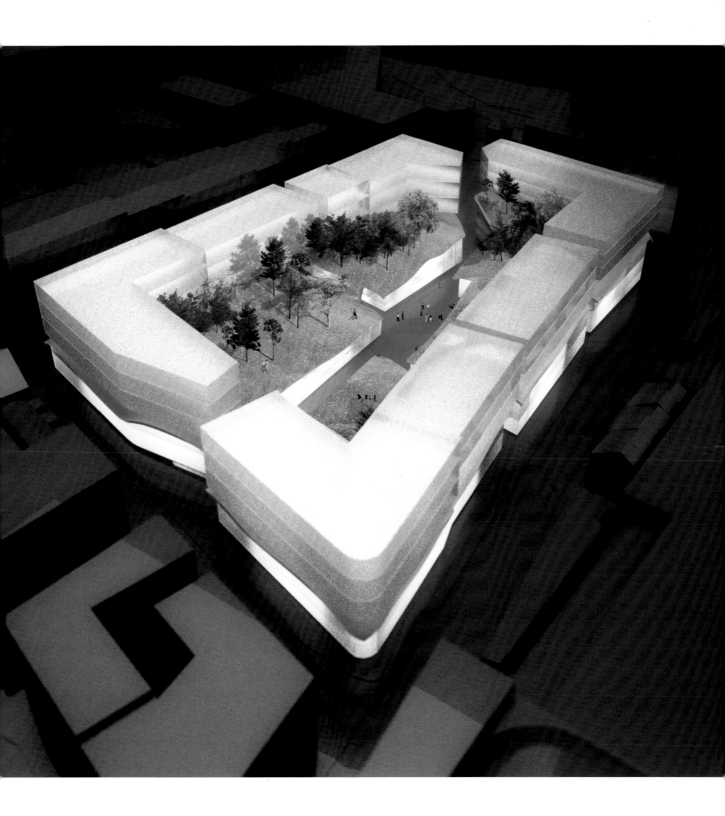

439

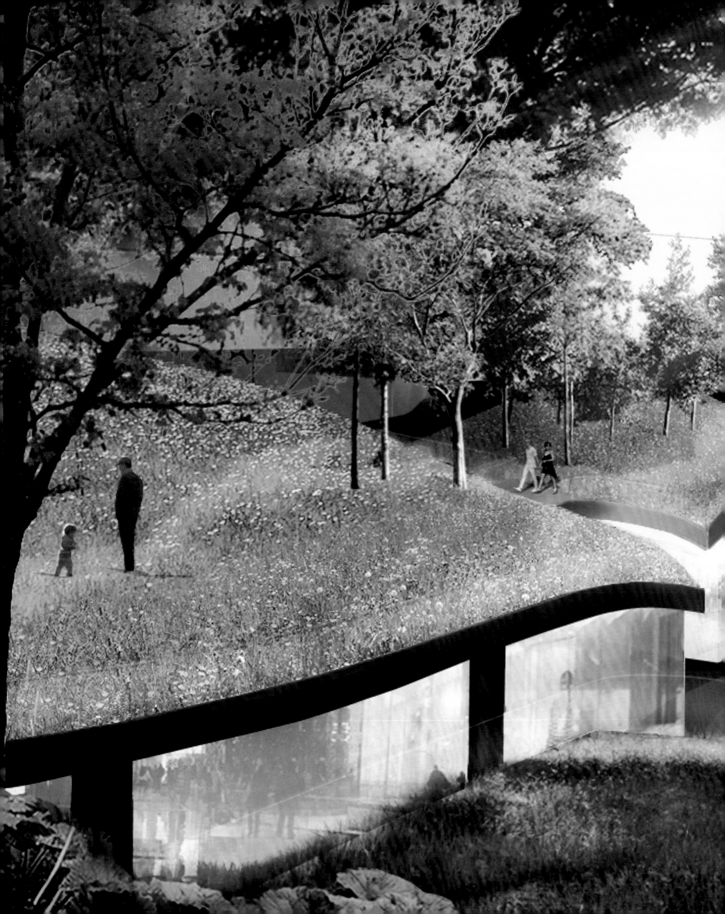

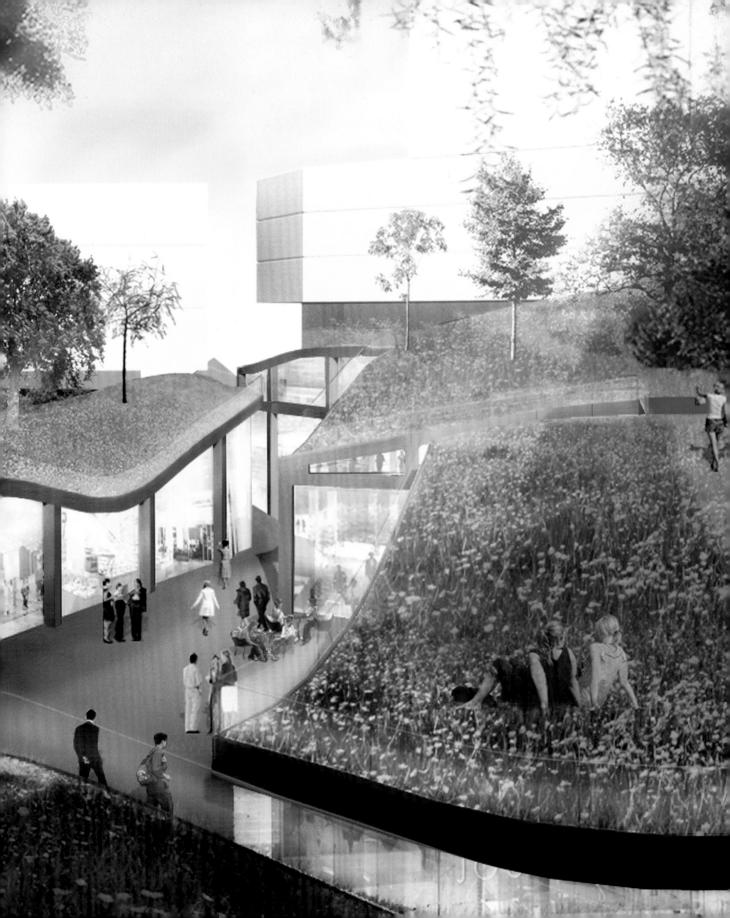

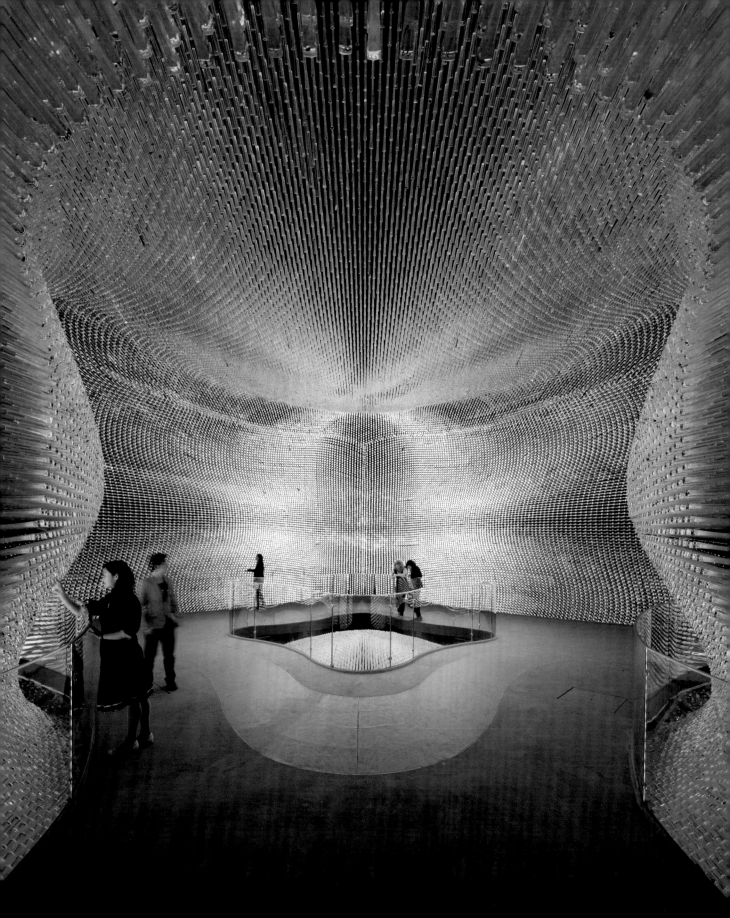

UK Pavilion

*How can a building represent
a nation?*

IN 1851 THE FIRST WORLD'S FAIR was held in Hyde Park in London. It began a tradition for an event that is now called World Expo and takes place every few years in a different city. Nations of the world create government-sponsored pavilions that promote their country, economy, technology and culture. The 2010 World Expo, held in Shanghai, China, was the largest Expo ever, consisting of

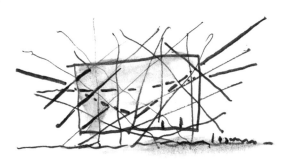

more than two hundred pavilions. With a team of collaborators, the studio won the competition to design the pavilion that would represent the United Kingdom.

As we were being briefed by the UK government, we could imagine governments of every country saying exactly the same things to their Expo designers: 'Show that our country has a strong economy ... Show our splendid industry ... Show that we are a good country for a holiday ... Show our cultural diversity ... Show that we are sustainable.' But in the final paragraph, the UK's brief changed tone and demanded that: 'When people vote for the best pavilion, make sure that you are in the top five!' This competitive order was useful to our design process because, having established that the objective was to win, we could work backwards to try to get to that outcome.

The brief posed another challenge. Like most of the other Western countries, the UK had been allocated a site the size of a football pitch. But even though our site was the same size as that of other nations, our budget was approximately half the size of theirs.

To meet the government's goal, the UK pavilion would need to stand out from the hundreds of other pavilions. Like us, none of the other countries had designed their pavilion yet, but we tried to guess what they might do, in order to avoid doing the same. Working with our initial collaborators, Casson Mann, we imagined what it would be like to visit the Expo and go into every one of its 240 pavilions. If every pavilion competed for your attention in the same way, the effect would be overwhelming. At the end of this sensory bombardment, you might well be so over-stimulated and numbed that you could stand in front of something incredible, but your eyes would be too dazed to take it in. Our challenge was to do one powerful thing that had clarity.

While seventy million people would visit the Expo and many hundreds of millions would see the pavilion on television, on the internet or in the press, only a small proportion of those people would actually go inside it. This told us that the outside of the pavilion mattered most. To make a powerful impression, the exterior had not only to be striking by itself but also to communicate the essence of the interior.

In Expo pavilions that we had seen before, there seldom seemed to be a connection between the architecture of the pavilion building and the content of the exhibition inside it. Instead we decided to do everything we could to make our building a manifestation of its content, so that if you took away the building, there would be no content.

We were also contending with assumptions that the pavilion should contain interactive television screens, buttons to press, projected film and images, pre-recorded sound and colour-changing LEDs. Such things are already familiar to people, being so widely used in museums, exhibitions and even retail displays that they have become predictable and exhausting. We were determined that our pavilion should surprise visitors with its simplicity and absence of technological devices.

We also understood that every pavilion was an advertisement for its country. What, in that case, could we say about the UK, and how could we say it? Research showed that the perception of the UK in much of the world still carried lingering stereotypes of London smog, bowler hats, Marmite, double-decker buses, the Royal Family and red telephone boxes. How could we get away from these clichéd, old-fashioned stereotypes and better reflect the inventiveness and creativity of many people working in contemporary Britain?

With its slogan 'Better City, Better Life', the theme of the Expo was the future of cities. We decided to consider the relationship of cities to nature, an area in which the UK has made a unique contribution. For example, the world's first urban public park of modern times was in the UK and, for its size, London is the greenest city in the world, with its hundreds of parks, squares, trees and gardens. London is also home to the world's first major botanical institution, Kew Gardens. The subject of nature and cities also touches on the broader relationships between plant life and human health and the meaning of these for urban development, economic success and social change.

In developing a masterplan, the budget forced us to be strategic and pragmatic. Most pavilions are as big as their football pitch-sized sites. As well as

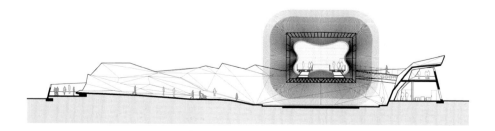

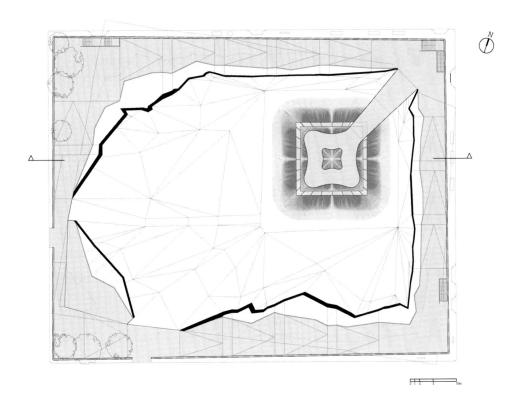

a public exhibition, they contain a large amount of space devoted to back-of-house functions, such as toilets, administrative facilities, hospitality spaces and storage. We felt that making all of this distinctive and extraordinary would be expensive and unnecessary.

We decided to break the UK Pavilion into two elements: a focal object, which we hoped would be unforgettable, and a broader architectural treatment housing the rest of the functional spaces, which did not need to be memorable. Instead of diluting the budget and spreading it across the whole of our site, we could concentrate our resources by making the focal object – the most expensive bit – take up only a fifth of the site. Its relatively small size would also mean that its internal space would require less energy to keep it cool than a larger pavilion. Then, within the other four-fifths of the site, the back-of-house requirements could be met separately in a quieter and more cost-effective way. We did this by building those facilities underneath a public space, on which our focal object would sit and in which visitors could sit down, draw breath and recover from Expo-exhaustion. This space also framed the focal object and separated it visually and physically from its chaotic surroundings. We also hoped that, by creating a large flexible space around the special object, we had built in the capacity to absorb any compromises that might be forced on the project. If a new government minister suddenly insisted that the UK Pavilion must include a Formula One car or a waxwork of Sherlock Holmes, we would be able to find somewhere to put it on the rest of the site, without damaging the main story.

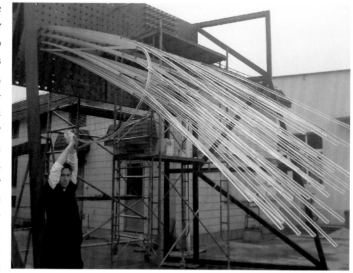

We imagined that many of the surrounding Expo buildings might follow the architectural trends in form-making. Instead we concentrated on exploring texture. Our starting point was the opening sequence of the 1985 film *Witness*, starring Harrison Ford, in which the camera pans across fields of grass buffeted into flowing patterns by the wind, like a beautiful kinetic sculpture. Was there any way to make the skin of a building behave like this? On the exposed Expo site, could we make a building façade move in the wind coming off the river?

Ten years earlier, we had put forward a proposal (pages 144–147) for treating a building like the Play-Doh plastic figure who grows hair and a beard when you squeeze coloured dough through holes in his head and chin. The idea is that the original object is lost inside the texture, but that the tips of the hairs can be conceived as forming an outward projection of its original shape. It seemed that if you magnified the texture of a building enough, there would come a point when the texture actually becomes its form. What was exciting to us was the idea of making the outside of the building so indefinite that you cannot draw a line between the building and the sky, because they merge into each other. This notion of texture gave us a way to relate to the pavilion's theme of nature and cities.

446

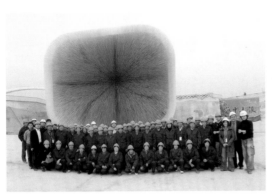

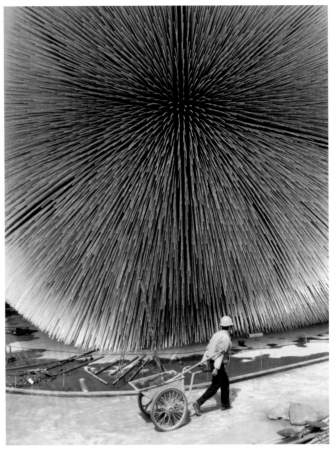

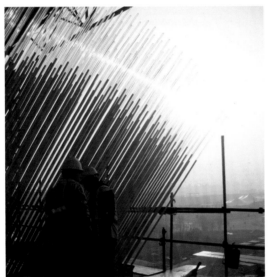

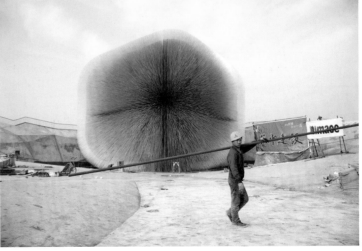

447

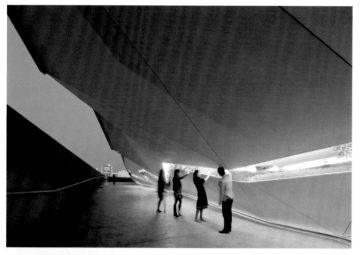
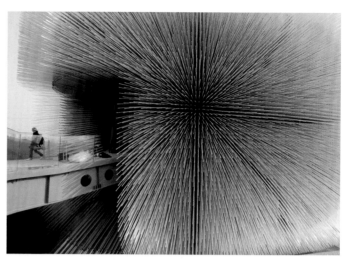
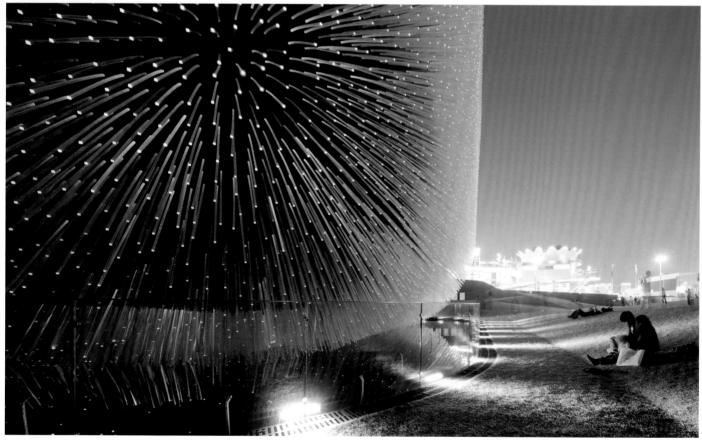

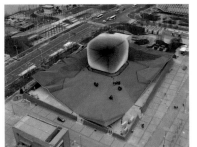

Most people find flowers, plants and trees beautiful, but seeds tend to be underappreciated, unceremoniously sold in garden centres in little paper packets. However, seeds are immensely significant for the ecology of the planet and fundamental to human nutrition and health. Wheat seeds and rice seeds feed nations; another seed could produce the plant that makes a drug enabling your elderly relative to live another fifteen years. For this future-gazing Expo, seeds seemed to be the ultimate symbol of unfulfilled potential and future promise.

For a number of years, Kew Gardens has been running a project called the Millennium Seed Bank, which is aiming to collect and preserve the seeds of 25 per cent of the world's wild plant species. Although it is well known, few people have seen this collection because it is based not at Kew Gardens but at a facility outside London near Gatwick Airport. Kew's seed collection gave us a way of connecting the texture of the building with its content. Our pavilion could be a cathedral to seeds.

The Seed Cathedral consists of a box, 15 metres wide and 10 metres high. Its 60,000 silvery, tingling hairs protrude from every surface, lifting it into the air to make a structure six storeys in height. The hairs are rods, identical 7.5-metre lengths of clear acrylic, which extend through the walls of the box into its interior. Inside the pavilion, the geometry of their tips forms a space described by a curvaceous undulating surface. Within this space, cast into the glass-like tips of all the hairs, are 250,000 seeds.

By day, the Seed Cathedral is lit only by the sunlight that is drawn into the cube along the length of each acrylic hair, in the same way that lightwaves travel along a fibre-optic cable. By night, tiny light sources concealed within the length of every rod illuminate both the seed ends inside the pavilion and the tips of the hairs on the outside. They appear as thousands of dancing points of light that sway and tingle in the breeze.

The Seed Cathedral sits on a landscape that is crumpled and folded like a giant sheet of paper, suggesting that the pavilion is a gift from the UK to China, still partly enclosed in its wrapping paper. Because it has inclined surfaces and lifted edges, the landscape creates a gentle amphitheatre that focuses on the Seed Cathedral. The form of the landscape is designed to guide people's experience of the Seed Cathedral in a particular way. Just as car advertisers know that a vehicle looks best from one of the front corners, rather than head or sideways on, the flow of visitors to the UK Pavilion is organized so that people's first glimpse of the Seed Cathedral is from a corner angle.

The entire surface is carpeted in silvery grey Astroturf, the artificial grass used for outdoor sports facilities, translating the softness of the Seed Cathedral into the landscape under your feet. An atmosphere of intimacy is created by the possibility that you can sit down anywhere and the suggestion that you might even lie down

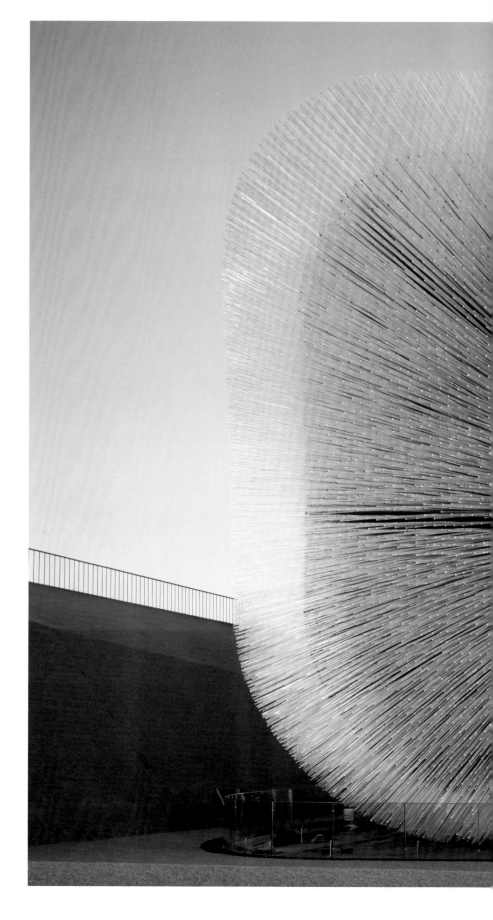

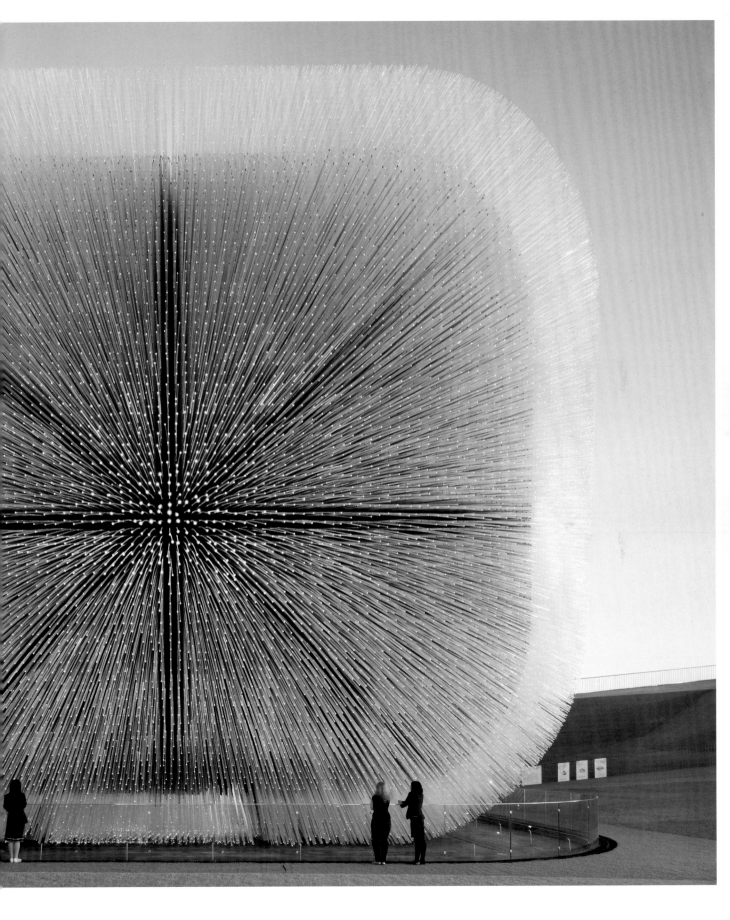

or roll down the slopes. The effect of the angled floor plane is to turn people into spectators and performers, generating an atmosphere of theatricality. It also means that people do not obstruct each other's view of the building.

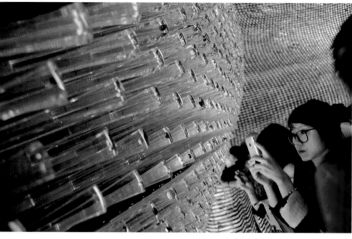

In order to protect visitors from the rain and sun as they go up the ramped walkways into the Seed Cathedral, as well as to exhibit interpretive material exploring the theme of nature in British cities, we placed the walkways underneath the edges of the sheet of landscape and then integrated a series of artistic installations into the walls, designed by Troika.

There was also a requirement for 1,500 square metres of space to accommodate a VIP suite, hospitality facilities, press and administrative offices, changing rooms, storage and toilets. All these functions are incorporated into space underneath the three-dimensional landscape. Though these spaces were simple and low-cost, their windows were developed with a particular detail that blended wall and glass, echoing the blurred silhouette of the Seed Cathedral.

The critical moment in the early stages of realizing the pavilion was when the director of Kew Gardens' Millennium Seed Bank agreed to provide us with 250,000 seeds, in collaboration with Kew's partner organization in China, the Kunming Institute of Botany. It then took many weeks to design and calculate the

geometry of the pavilion's hairs, based on a set of rules we had drawn up: that the rods had to be identical in length; they had to point to a single spot in the centre of the pavilion; and their tips had to be evenly spaced on both the outside and the inside and not spread out or crush together as they went around corners. We worked with structural engineers Adams Kara Taylor to define a spacing density that avoided revealing too much of the central cube and giving the building bald patches. Outside, the Seed Cathedral had a specific quirk that we had designed into its geometry, which meant that, from whatever angle you looked at it, the image of the British flag, the Union Jack, appeared within the hairs of the pavilion.

Building the Seed Cathedral took a year. It was constructed in Shanghai by a Chinese contractor, using materials sourced locally. The central cube was built from red-coloured plywood, drilled with 60,000 holes to accommodate all the acrylic rods. As all the hairs pointed towards a single spot, every one passed through the walls at a different angle, which meant that every hole had its own unique drilling angle. In addition to holding the rods in place, an extra challenge was to waterproof a building with 60,000 holes in it. The detail that we engineered involved threading each rod through two aluminium sleeves, slotted one inside the other, and securing every join with

rubber waterproofing rings, before attaching the tiny light sources that would illuminate each hair.

To develop the vast piece of carpeting for the landscape, we worked with a specialist manufacturer of outdoor sports pitch surfaces to formulate a version of Astroturf that has a red base and silvery grey hair, like the Seed Cathedral itself. Like shot silk, the red colour hidden in the depths of this surface came through as you moved your head.

Inside the finished Seed Cathedral, the space was like a cool, dimly lit cave filled with glowing jewels. As it silhouetted the seeds, the light had a calm, passive quality, like the light from stained glass, and the space was silent and serious. As the hours of the day went by, you could track the movement of the sun from inside by changes in the light coming from the seed ends, and pick out the shadows of passing clouds and birds flying overhead. The light would be strongest from the hairs that happened to be pointing directly towards you, wherever you were standing, so that it also changed as you moved around, becoming brighter towards the centre of the space. The UK Pavilion had no flashy electronics: just daylight illuminating the 250,000 seeds from the myriad hair ends. Inside the Seed Cathedral, you were at the most bio-diverse point in Shanghai.

Apart from a programme of events and performances that took place daily on the pavilion landscape, the purpose of the outdoor space was deliberately ambiguous, giving people the freedom to treat it almost like a village green. This little piece of Britain, with people sitting all over it and children rolling down the slopes, was designed to reflect the UK's record as a pioneer of the modern urban public park and the part this played in the UK's legacy to the design of the world's cities.

In a national competition to find a Chinese nickname for the Seed Cathedral, the winning name was Dandelion. The association with blowing a dandelion and making a wish was a good symbol for this temporary building, resonating with our plan to distribute the seed ends among Chinese and UK schools and botanical institutions after the project was dismantled.

The Shanghai Expo lasted six months, during which more than eight million people – including the Chinese premier, Wen Jiabao – went inside the Seed Cathedral, making it the UK's most visited tourist attraction, nearly 10,000 kilometres (6,000 miles) from the UK. Two weeks before the end of the Expo, a state ceremony was held, at which it was officially announced that the UK Pavilion had won the event's top prize, the gold medal for Pavilion Design.

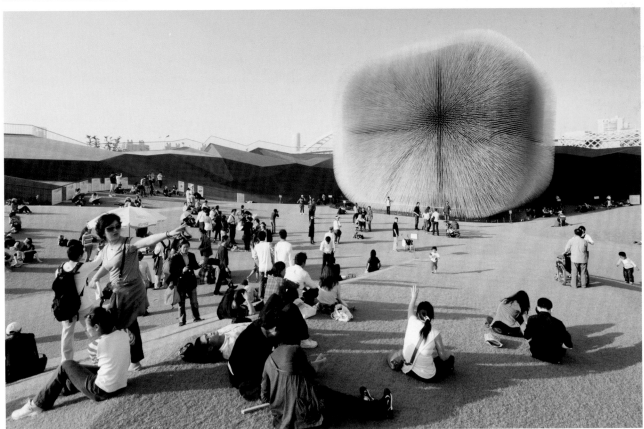

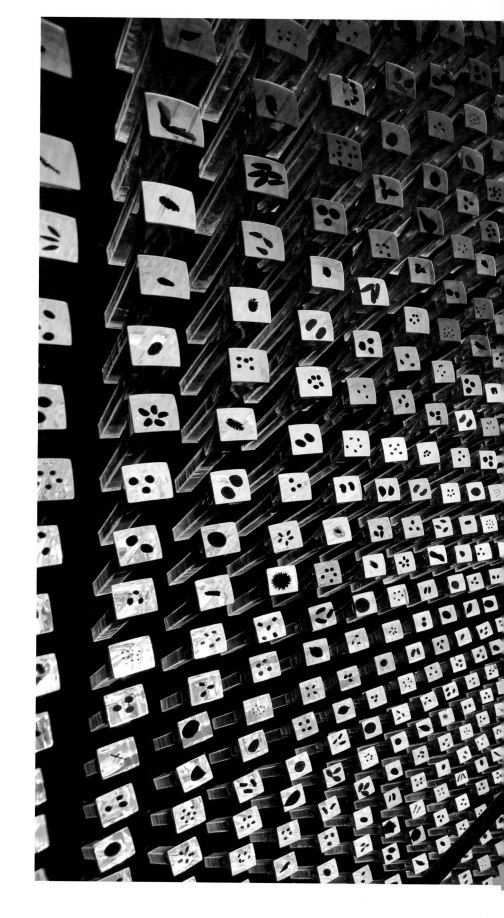

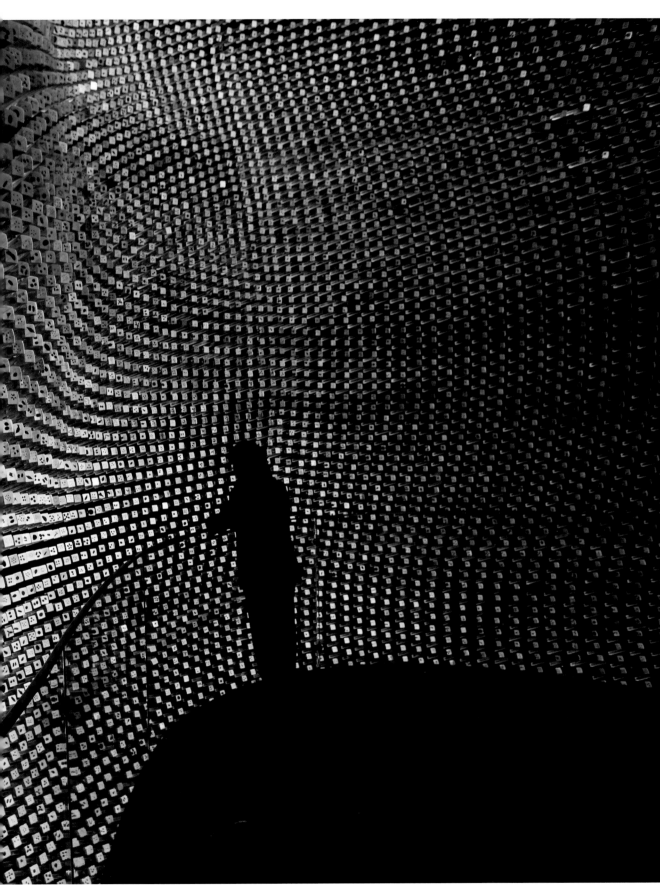

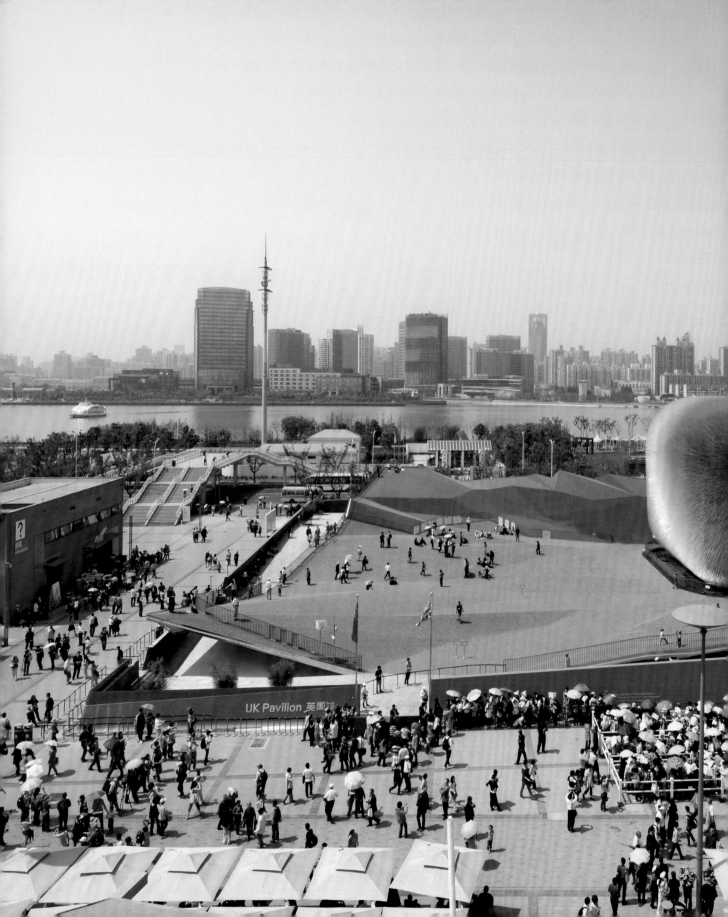

Cloud Bridge

Can a strong structure look delicate?

THE STUDIO WAS INVITED to design a footbridge for the gardens of a stately home in the north of England, to replace a small wooden bridge in a historic rock garden that had a stream running through it.

Instead of a conventional bridge, constructed from two structural beams with a separate deck and balustrades added to it, our idea was to use a single structural substance and sculpt the entire bridge, including its deck and balustrades, out of it.

To create a bridge that was delicate and floating, rather than solid and heavy, we wondered if it would be possible to fuse hundreds of stainless steel discs to form a structure that resembled a fluttering swarm of butterflies. Although fragile looking, this mass of identical elements creates an efficient triangulated structure, although it does not look triangulated. The bridge would be made by welding together circular plates of metal and applying a glass bead-blasted finish. Rather than being shiny and reflective, each disc would take on a different diffused tone, depending on the angle at which it caught the light.

Group of Towers

Can you make blocks of apartments without any corridors?

TYPICALLY, A TOWER BUILDING can be up to eight times as high as the width of its footprint. However, it had been suggested to us by the structural engineers Ove Arup that newly evolving ways of controlling the movement of tall structures might make it possible to build a tower as high as sixteen times the width of its footprint. The studio was interested in using this technology, not so much to strive for greater height, but to create apartment towers with particularly elongated proportions. We developed a proposal for a group of exceptionally slim towers with a single apartment on every floor. Because each floor is a single apartment, residents would be able to go up the building by lift and exit directly into their apartments and there would be no need for any corridors. Also, every apartment would have a complete 360 degree view.

Our idea was to make a collection of these slender structures, reaching up to different heights, which could sit harmoniously within a city or a wild environment. Compared with a single more substantial structure, they make a delicate composition in the landscape, resembling reeds or the multiple stems of bamboo.

Gradated Tower

Can a tower touch the sky gently?

THE STUDIO WAS COMMISSIONED to design an eighty-storey tower in the Middle East, containing offices, apartments and a hotel. In the region, there seemed to be a preference for landmark towers that rise up and terminate abruptly in a pyramid, sphere or pinnacle, giving the building a hard-edged silhouette against the sky. Reacting against this, we proposed a structure that is dense at the base but graduates to near-transparency at its top, fading into the sky.

The building is conceived as a stack of separate, circular forms that grow progressively more delicate and further apart as the building rises upwards. The rings are supported by the building's vertical structural elements, which contain lifts and service cores, and are held apart from each other so that their upper surfaces can make shaded open terraces, lush with plants.

Lined with pink bronze-coloured ceramic, the rings' inner surfaces constitute a circular shaft that runs through the core of the tower, bringing daylight to the gardens and creating unusual opportunities to look up and down the building's internal space. At night the lighting of the building becomes progressively more ethereal towards the top.

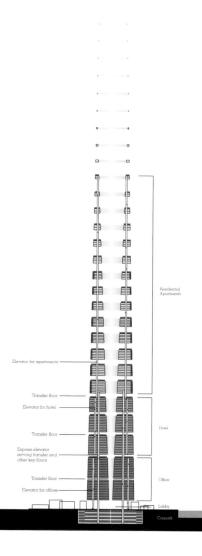

Residential Apartments

Elevator for apartments

Transfer floor

Elevator for hotel

Hotel

Transfer floor

Express elevator serving transfer and other key floors

Transfer floor

Office

Elevator for offices

Lobby

Carpark

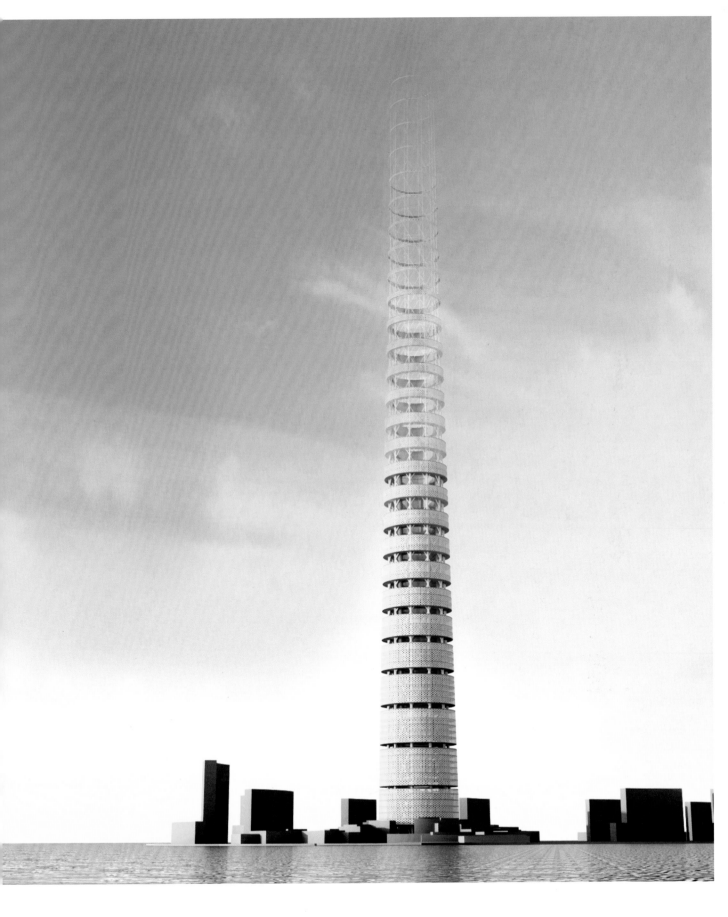

Doha Grand Hotel

*How should a large new building
meet the flat surface of the desert?*

THE EMIR OF QATAR commissioned the studio to design a complex of buildings in Doha incorporating a major hotel, office space and apartments, as well as a marina, conference centre and shops. It was to be sited on a triangular piece of bare desert next to the sea.

To us, many of the new tower buildings of this region seemed to look as if they had been dropped on top of the flat desert terrain, like trophies, so that all the emphasis was on the height of the tower or the shape of its top. It was also clear to us that, in the searing heat, plants were important to make an environment feel pleasant, which was why a lot of money seemed to have been spent on importing and planting large areas of trees in the desert. However, not only were these planted areas expensive and environmentally costly to irrigate and keep alive, but their visual impact on such a flat landscape was limited as all you see is the first rows of trees, and the rest are hidden behind them.

Wanting to forge a more meaningful relationship with the flat landscape, we conceived a building that could rise up from the ground instead of dropping down on to it. Then, as we looked for ways of using trees and plants, we realized that putting them on terraced slopes would make them visible over a wider area, allowing us to use a smaller quantity of greenery in a more effective way.

Our proposal was to pinch up the surface of the ground to make three draped forms emerge from the landscape, forming towers that lean against each other and create a large shaded space between them. By terminating these towers cleanly, at different heights, we kept the emphasis on the connection of the building to the ground plane. The hotel, apartments and office space are each accommodated within one of the three towers, individually accessed from lobbies in the central space.

To arrive at the site, which we surrounded by water, you travel over a bridge above a busy quayside, with moored boats and a souk, or traditional marketplace, before passing through the gateway formed by the opening between the towers and on into the calm shade of the central public space.

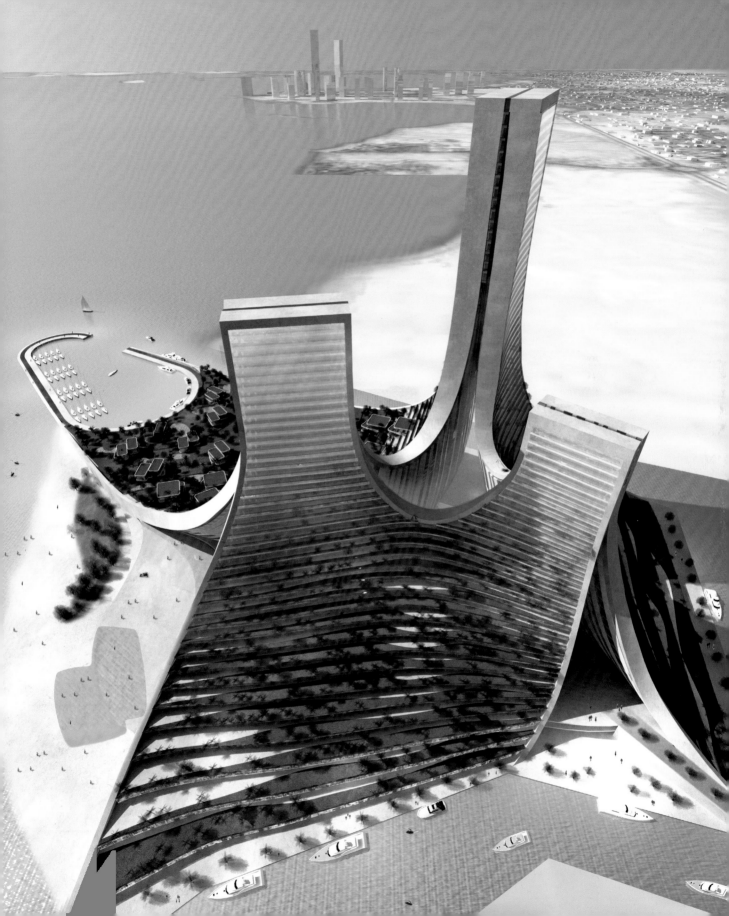

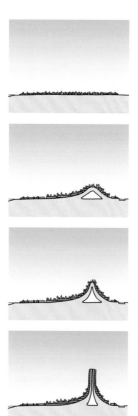

Arriving from the sea, your boat docks in the marina, which is incorporated into the skirt of the structure as it emerges from the sea. Villas and apartments are built into the contours of the slope above it, with planting and pools within terrace gardens forming an exotic and publicly accessible green landscape.

The proposal takes advantage of recent advances in elevator technology that use standard components to make high-speed lifts that can follow the curving shape of the building, providing a single connection between the marina, the lobbies and the tops of the towers. Where the towers come together halfway up the building, their internal space becomes connected by a dramatic glass sky lobby, on the scale of a street, accommodating shops, restaurants and spa facilities.

Since constructing the giant curving forms of the lower sections in cast concrete would require vast quantities of expensive formwork and scaffolding, the engineering proposal was to give the building a steel structure up to the point at which the towers meet, and then to use cast concrete to construct the upper storeys.

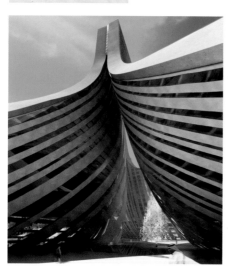

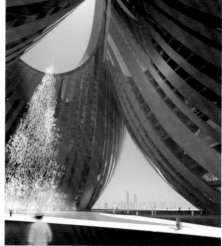

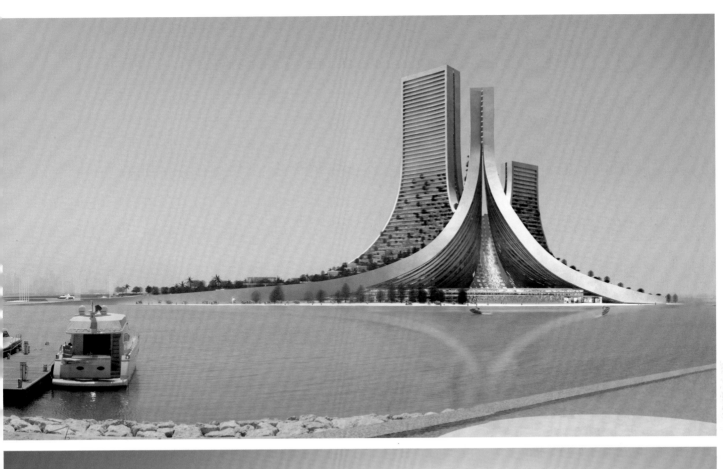

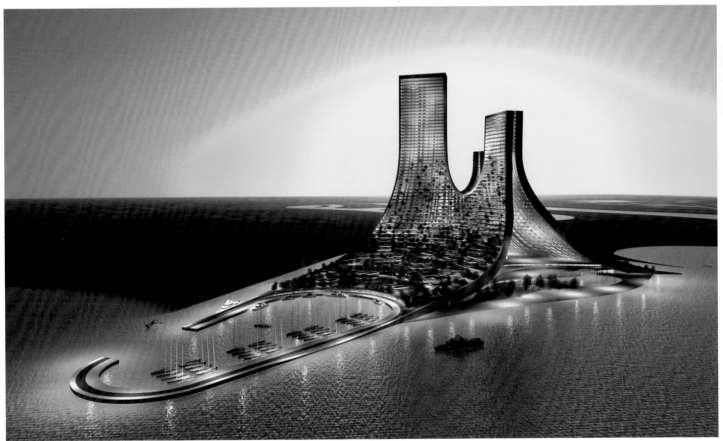

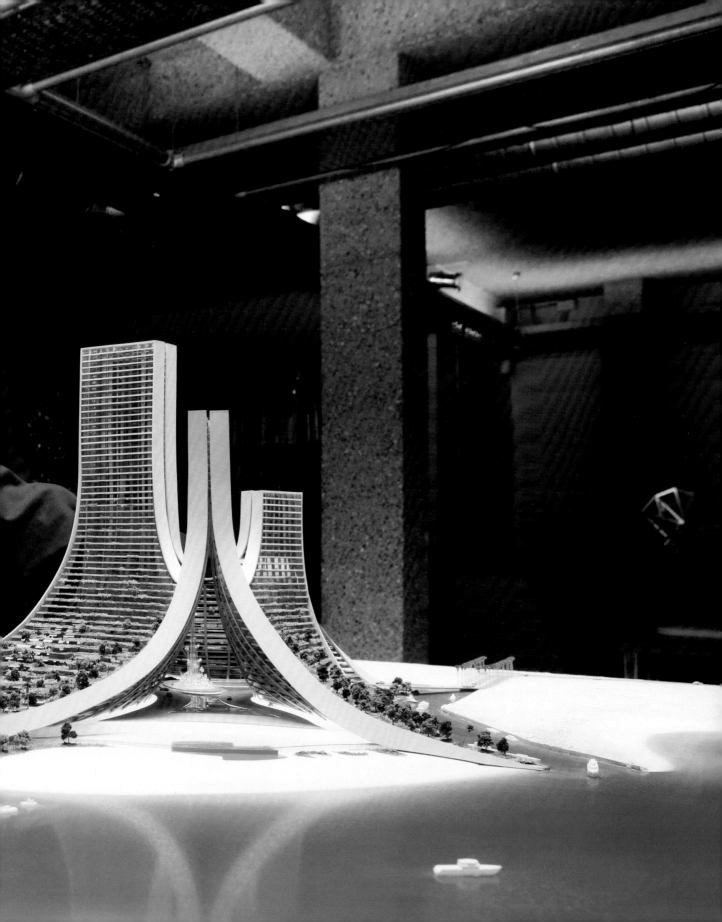

Chelsea Barracks Landscape

How do you build a park on top of a car park?

AS PART OF THE MASTERPLAN for the redevelopment of the former Chelsea Barracks site in London, the studio was invited to design the public spaces and landscape around the new buildings. Because this huge site would be excavated to a depth of four storeys to create underground car parking and service spaces, we began picturing this planted area as the crust that covered a busy subterranean world. Instead of pretending that the underground space did not exist and concealing it beneath a skin-deep landscape replicating a conventional park, our idea was to acknowledge its existence in order to make the ground level more distinctive.

Our proposal was to form tectonic plates around the rectilinear footprints of the buildings and allow them to grow outwards until their edges met. The gaps between these imperfectly meshed plates form dramatic openings in the ground that let light down into the underground spaces by day and at night allow the voids to glow with richly coloured light. Instead of placing freestanding artworks in the landscape, the intention was to commission new artistic works for each opening in the ground, integrating combinations of colour, text, imagery and sound.

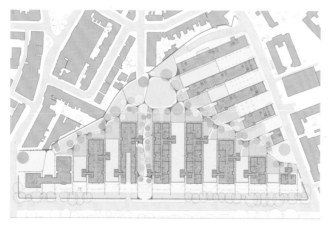

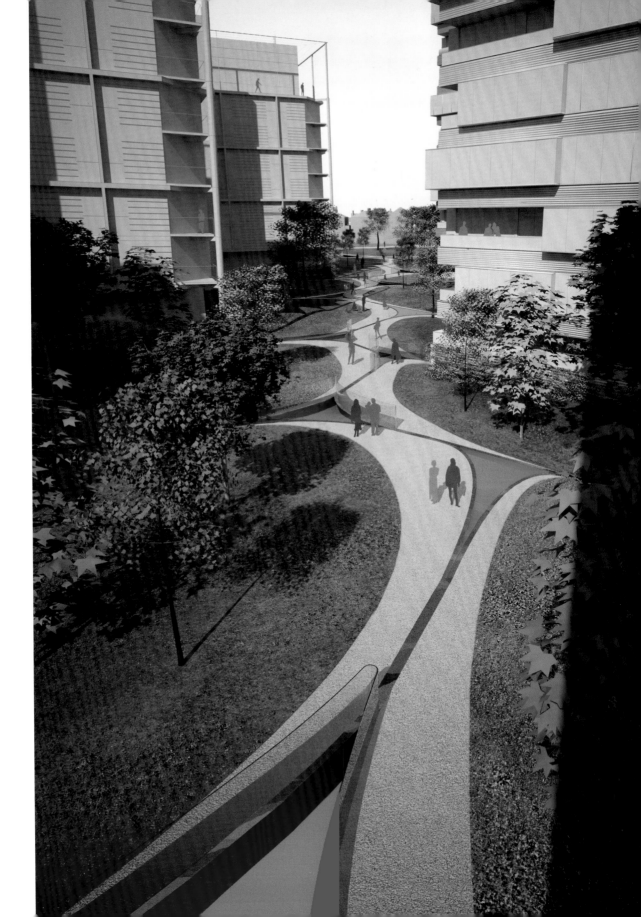

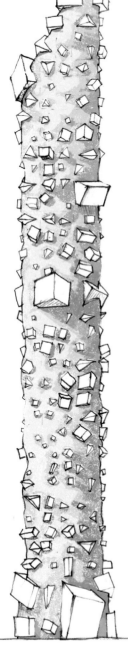

Sheung Wan Hotel

How can a new building fit into the atmosphere of a busy old district of Hong Kong?

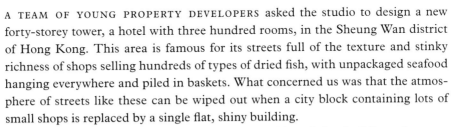

A TEAM OF YOUNG PROPERTY DEVELOPERS asked the studio to design a new forty-storey tower, a hotel with three hundred rooms, in the Sheung Wan district of Hong Kong. This area is famous for its streets full of the texture and stinky richness of shops selling hundreds of types of dried fish, with unpackaged seafood hanging everywhere and piled in baskets. What concerned us was that the atmosphere of streets like these can be wiped out when a city block containing lots of small shops is replaced by a single flat, shiny building.

New hotels are often just new interiors within existing buildings that were once offices, apartments or previous hotels, so that their design is often arbitrary and lacking any connection with the architecture of their exteriors. This project was unusual because it was being built from scratch, so it was an opportunity to conceive the inside and outside at the same time and build in a relationship between the two.

Typically, a hotel room contains a familiar set of objects – bed, window, mini-bar, safe and somewhere to keep the iron – which we interpreted as a series of boxes. This became the logic for our scheme, in which all the furniture and fittings for each room are formed out of boxes of four different sizes. These boxes are either open-ended and glazed to form windows or solid and enclosed to contain refreshments or valuables; the building's façade is composed of the outsides of these thousands of boxes. By varying how far the boxes protrude relative to their neighbours, we can give the façade an eroded, rugged feel, very different in texture from the smooth, shiny frontages that are normally seen on newly constructed buildings. Every room in the hotel is unique, giving guests different spatial experiences.

Hong Kong regulations encourage tall buildings to take the form of a tower set back on top of a podium building, an arrangement also seen in some British architecture of the 1960s, such as the British Telecom Tower in London, where the separation of the building into two distinct parts disrupts its relationship to the street. In an effort to avoid this, we pushed the tower component right to the front of its podium, so that from the street it appears cleanly and confidently as a single entity, rather than sitting back on a separate mass of podium.

The building is a concrete structure, filled in with metal boxes, which are manufactured employing the same technology that is used to make air conditioning ducts and water tanks. Sheet metal is folded, riveted or welded together and then painted and waterproofed. Inside the building, the metal boxes can be lined with bronze and sprayed directly with rigid insulation foam, a cost-effective and characterful technique that the studio has been developing in other projects, or upholstered to make beds and seats.

From the street, an elevator takes people up to the main lobby, which has a ceiling height of 7.5 metres. For coaches and cars, there is a loading bay that contains a turntable and a vehicle lift up to a car park.

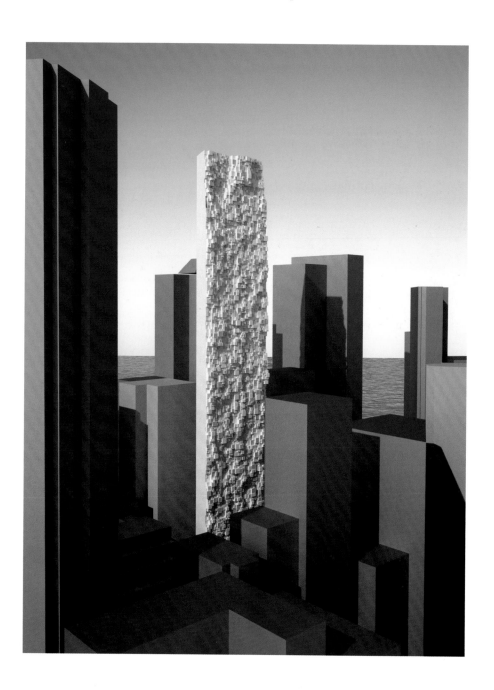

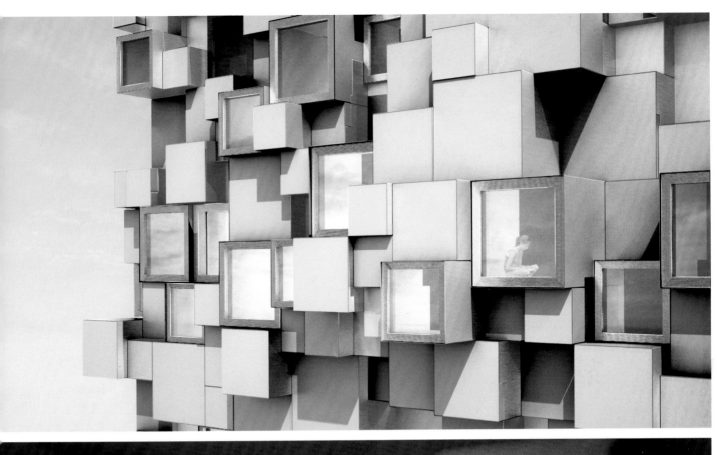

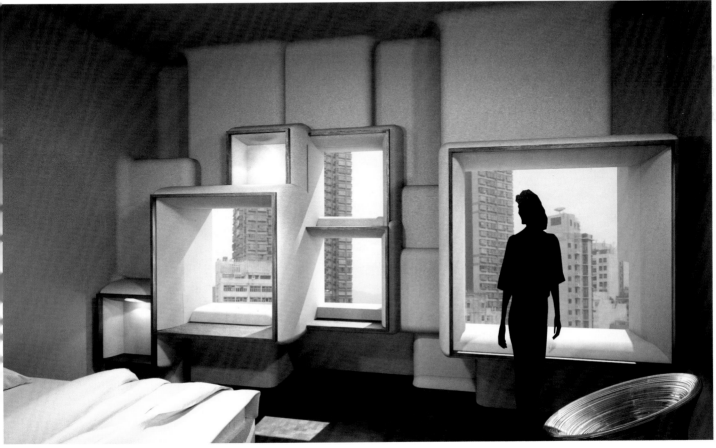

Christmas Card

*Can you turn somebody's name and
address into their Christmas card?*

THE IDEA FOR THIS CHRISTMAS CARD came from hand-writing the recipients'
names and addresses on previous cards. We wrote out every name and address by
hand, attached to its stamp and postmark. Then, thinking of the snowflakes that
small children make by folding circles of paper into triangles and cutting into
their folded edges with scissors, we turned each person's address into a snowflake
by cutting away the empty space around, within and between all the letters.

What people received was just their own name and address, plus a stamp
and postmark, cut into a folded piece of thin, white card. When they unfolded the
card, it became a snowflake-like formation, which had the richness and detail of
a piece of filigree lace. We made 350 cards and each one was unique, like a finger-
print or a DNA profile.

484

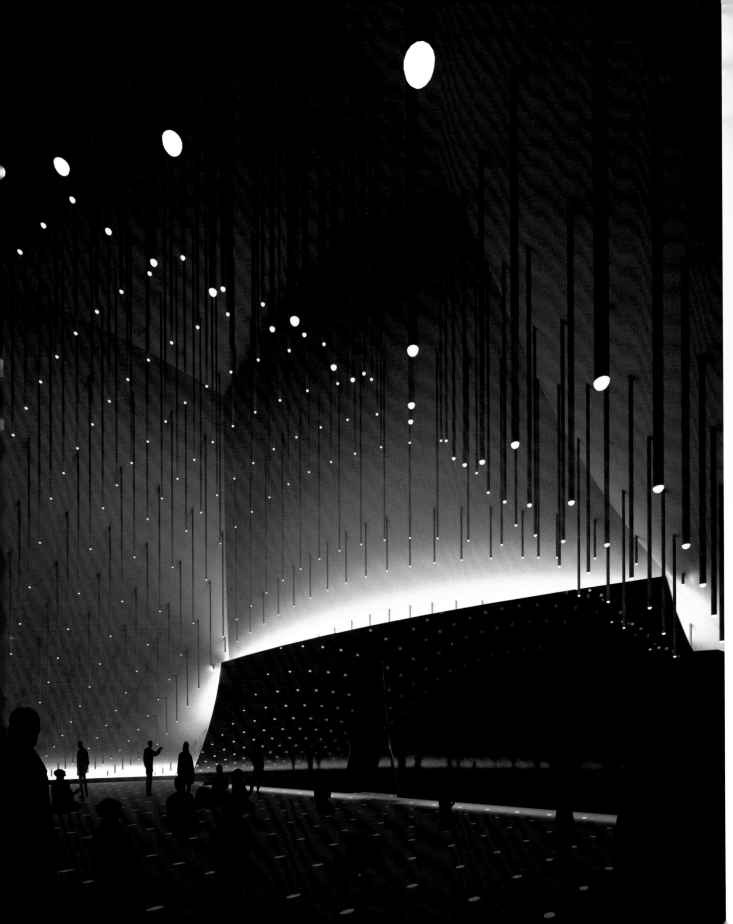

Masdar Mosque

What might a twenty-first-century mosque be like?

THE STUDIO WAS INVITED TO DESIGN a community mosque in Masdar, Abu Dhabi, a new city being masterplanned by architects Fosters + Partners and conceived as the world's most sustainable city.

The plan for Masdar is to build the city two storeys up in the air, as if on a table, creating an underground service zone containing the transport system and all utilities. Removing cars from the streets and putting all transport below the raised ground allows buildings to be positioned closer together to create cooler, shadier streets that will never need to be dug up to mend cables or pipes. Because one of the main environmental issues in this climate is to reduce the energy used in air-conditioning systems, the city is laid out on a strict rectilinear grid that consists of tightly packed buildings, oriented to capture the cooling breezes that come off the desert by night and off the sea by day.

The mosque, however, breaks these rules because it has to be oriented to face Mecca, setting it at almost 45 degrees to the city's grid. We felt that this gave it permission to be different from the other buildings sitting on top of this table.

The Prophet proclaimed the whole earth to be a 'masjid' (mosque), meaning a place of prostration or prayer, so originally a mosque was simply a space where worshippers gathered to pray. A piece of open desert could be a mosque. There are now rules governing the layout and facilities of a mosque but there is nothing to say that it must have minarets and domes. Such features evolved out of pragmatic needs: before steel and concrete came into use, a dome was the only way to create a large, spanning roof to protect worshippers from the sun; before electronic amplification, the only way to enable people in the surrounding area to hear a call to prayer was to proclaim it from a minaret.

Muslims kneel and place their heads on the earth to pray, but the extraordinary thing in Masdar is that worshippers will be elevated above the ground, placing their heads on a tabletop 7 metres above the desert. As a mosque should be a particularly precious place, we felt that there was an opportunity to step off this futuristic slab of sustainable living and reconnect with the earth. If we made an opening in the surface of the table top and lifted the ground, then the worshipper could step through the opening and back on to the desert. Kneeling down to pray inside, he or she would be reconnecting with the earth.

Our idea was to take the flat plane of paving that supports the buildings of Masdar and raise it to become the enclosure of the mosque, introducing no new elements and making the building as pure and elemental as possible. Unlike the other buildings in Masdar, the mosque and the public space around it would not sit on top of the raised table but be constructed from it.

As well as covered walkways and planting, the public square around the mosque has paving that mutates into the skin of the religious building. The paving has a pattern of perforations, with optical fibres threaded through them that transmit daylight into the space below, softening the harsh glare of the sunlight. These optical fibres hang down inside and correlate with patterns in the carpet, letting worshippers know where to kneel and pray. The perforations in the paving have a second use: they demarcate spaces the size of prayer mats, so that if necessary worshippers can also pray outside the mosque.

The building design that we developed meets all the requirements of a mosque – the qiblah wall faces Mecca and there are separate entrances for women and men, ablution areas and a library – while also having a clear connection with the surrounding city. The design also takes advantage of the city's raised table level to draw in cool air from beneath.

The project did not go forward. However, we believe there is a place for mosques that do not pretend to be historic structures and which speak strongly to the world of a forward-looking faith.

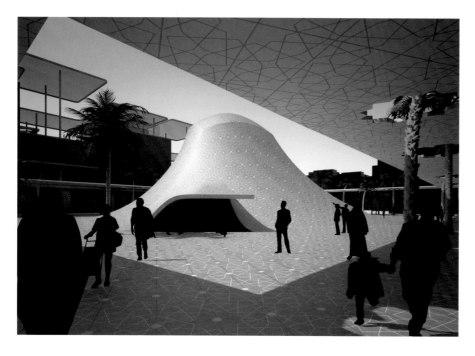

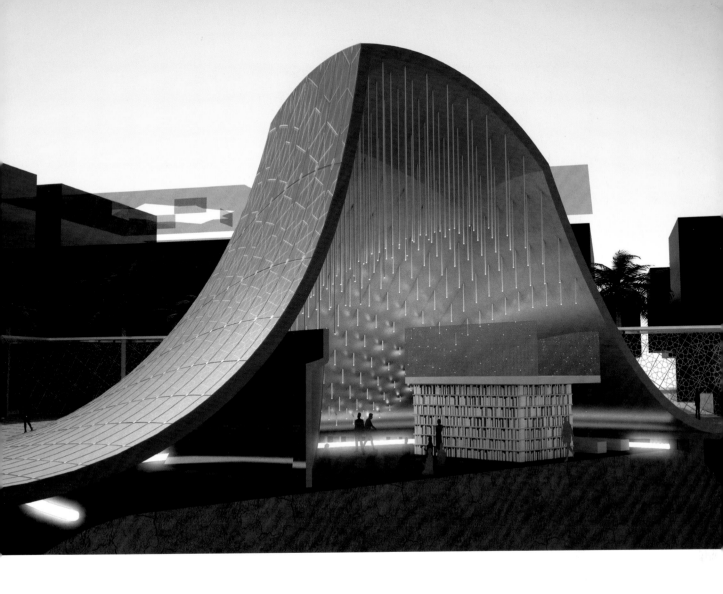

Stratford Olympic Sculpture

*How can water be used to power
a fifteen-storey-high mechanism?*

PART OF THE PEDESTRIAN ROUTE into the Olympic Park at Stratford, in east London, passes through a new shopping centre, with many thousands of people due to come through this centre on their way to the Olympic Games. A competition was held for the design of a landmark, to be located at a point at which two routes converged and then went off in a third direction, towards the Olympic site. The competition brief asked for two elements – a sculpture and a water feature – and suggested that some kind of vertical marker was required.

In order to avoid obstructing the flow of pedestrians, we ruled out the possibility of big pools of water and decided to combine the water element and the sculpture into a single structure. We wondered whether we could make a connection between a notional 50-metre-high vertical element, placed at the intersection of the incoming routes, and the 50 metres of horizontal space in front of it, pointing towards the Olympic site.

Our proposal was a giant version of the water feature that is sometimes seen in Japanese gardens, which fills with water, then tips over and empties itself, coming back up as its centre of gravity shifts. Fifty metres high, our structure would gradually fill with water until, with a stately movement, it pivoted down to a horizontal position, emptying itself of water on a spot on the ground 50 metres away from where it began. Then, using gravity, it would slowly rise back to a vertical position to begin filling with water again.

With no mechanical assistance, the weight of the water alone moves a structure that weighs many tonnes. In its upright state, it might be mistaken for a contemporary sculpture, but the power of this massive object would be in the unexpectedness of its automaton-like movement, on a vast scale. We envisaged people gathering next to it while the structure filled with water, waiting to witness the drama of its tipping over and pouring out its water.

In our workshop we built a working model that used real water, which showed not only that the idea could work but also how a dampener could be put on it to prevent the structure moving down too fast and splashing water

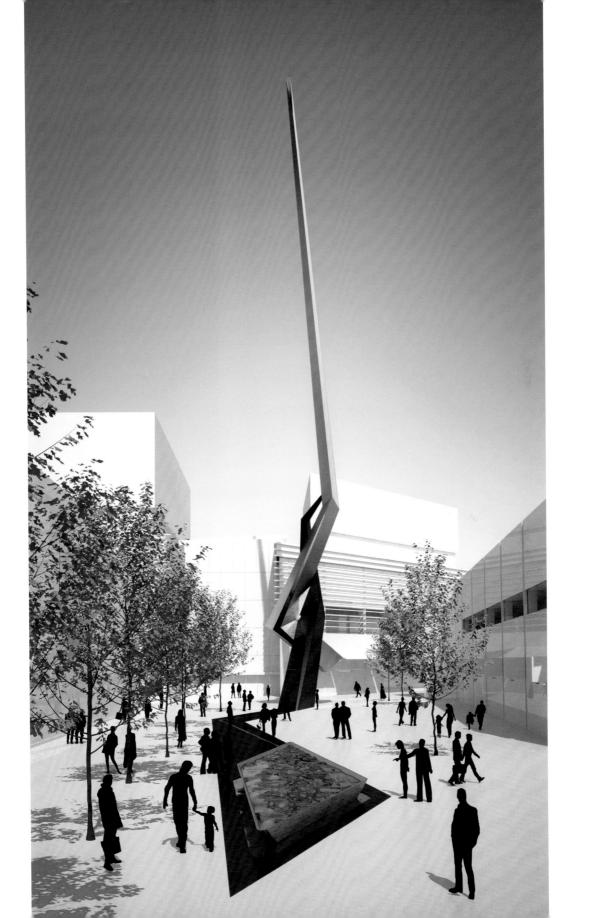

everywhere. The finished project would have been made in steel sections by the steelwork fabricator that had constructed the East Beach Café in Littlehampton, with glass panels set into it that allowed you to see it filling up with water.

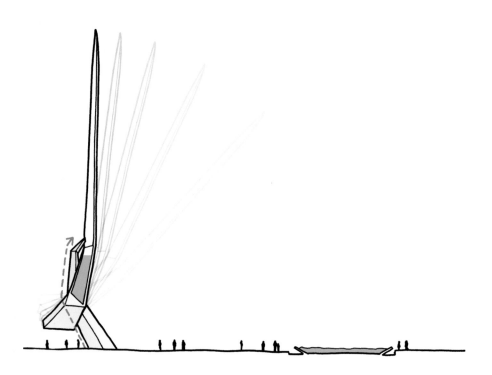

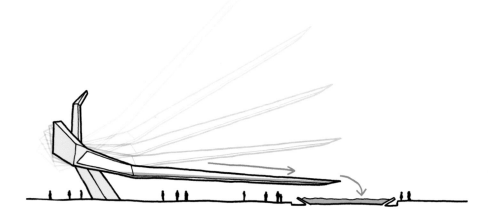

Centrifugal Chandelier

*How can you make
a real virtual object?*

WHEN VISITING RELATIVES in Argentina at the age of fourteen, I was taken to a remote cattle ranch, where I met an elderly gaucho who, in his youth, had brought down running cattle with an implement called a boleadora, which consists of three heavy balls connected with ropes. The gaucho swings it around his head and then lets it fly at the cattle, tangling the ropes around their legs. As they spin, the balls seem to draw a circle in the air.

Because the human eye perceives a bright light moving through a dark space as an illuminated trail, like drawing in the air with a sparkler on Bonfire Night, we experimented in the studio many years later with swinging multiple points of light. If your eye reads these as rings of light, perhaps spinning lights could be used to describe a three-dimensional, rotational form in the air, such as a sphere, cylinder or hourglass, or even the profile of somebody's face.

The proposal is for a vertical spinning rod that is initially straight and lifeless. Beginning to spin, it becomes centrifugally orbited by points of light on wires that move in and out of the rod, drawing constantly changing, rotational forms in the air. Powered by an electric motor, the spinning tube contains stacked reels of fibre optic cables, individually controlled to reel in and out their corresponding points of light.

494

Worthing Swimming Pool

How can you give a building a specific relationship to its site?

AS PART OF A COLLABORATIVE TEAM that included experienced swimming pool designers Saville Jones, the studio was shortlisted in the competition to design a new swimming pool in Worthing, a seaside town on the south coast of England. The pool was to replace the Aquarena, where the British Olympic champion, Duncan Goodhew, used to train.

The local authority intended to sequentially redevelop the entire pool site, with its strategic position on the town's seafront promenade, by building the new pool next to the existing one, then knocking the old pool down and using that part of the site for a second development.

The team developed a simple masterplan for the building. Given the footprint of the site and the complex sequencing of the development, we felt that the optimal shape for the building was an uncomplicated rectangular shed. Its main entrance could be on the long side of the building, facing the new development, so that as the swimmers came in and out of the building, they would bring life and activity to the development. All the changing rooms were also in this side of the building, leaving unobstructed views out of the pools on the far side of the building towards the sea and the next-door park. For the materiality of the building, we were drawn to wood, rather than concrete or painted steel, as there seemed to be good precedents for using timber to make pool buildings because it deals very well with moisture and condensation.

While trying to develop an idea for this building that could be unique to Worthing, we remembered the Worthing wood slick. Four years earlier, a ship named *Ice Prince* had capsized close to the town in a storm and its cargo of wood was washed overboard. Astonishing quantities of shipwrecked timber were deposited on Worthing beach, tangled up in vast piles. For a brief moment, Worthing made world news with the powerful imagery of this wood slick. In subsequent years, the town found itself celebrating this strange occurrence with a week-long arts festival and the installation of a commemorative stained glass window on the town pier.

The raw quality of the piles of wood deposited on Worthing's beaches made a connection in our minds between the rectangular box of our swimming

Worthing Herald

Thursday, January 24, 2008 — An edition of the Herald/Gazette series — www.worthingherald.co.uk — Price 40p

'The best start for your child'

Vacancies now for babies and toddlers at Worthing's newest Nursery Grosvenor Road, Worthing
01903 202847
www.littlemonkeysnurseries.co.uk

WOW!

SOUVENIR PULL-OUT PACKED WITH PICTURES

the winter sale

up to **75%**

ghp
G H Pressley & Sons
100 years of excellence

OFF many items including jewellery, diamonds, silver, gemrings and watches

starts Saturday 2 February, 9.15am
for a limited period

46 South Street Worthing West Sussex
01903 238997

pool and the rectangular bundles of wood that had been broken apart by the sea. Our idea was for a building that was like one of these pallets that had burst apart. While maintaining a simple box-like configuration on the inside, the building would be very dynamic on the outside, its disordered external elements forming structural cross-bracing, at the same time as creating practical solar shading in front of the glass. Lit up by night, the pool would glow from within like a lantern.

While being relatively straightforward to build, the idea was strong and relevant: it would be hard to find an idea for a building that was more specific to Worthing and its wood slick.

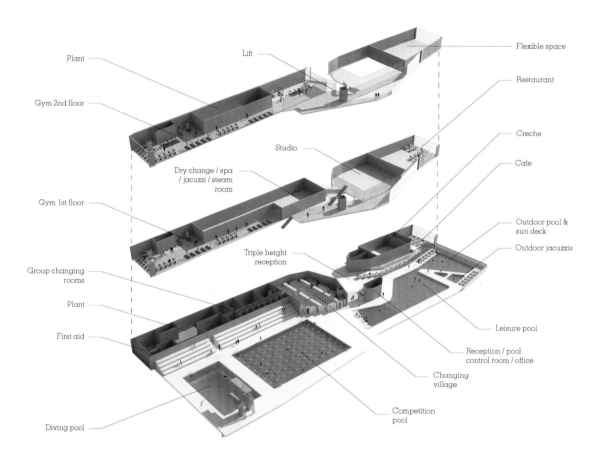

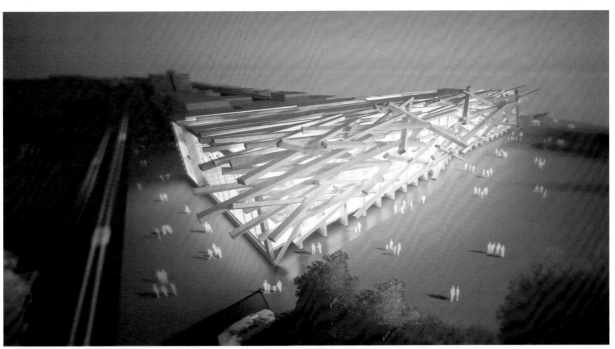

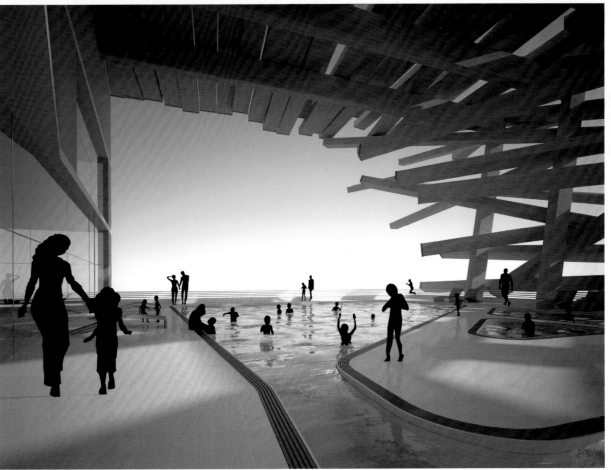

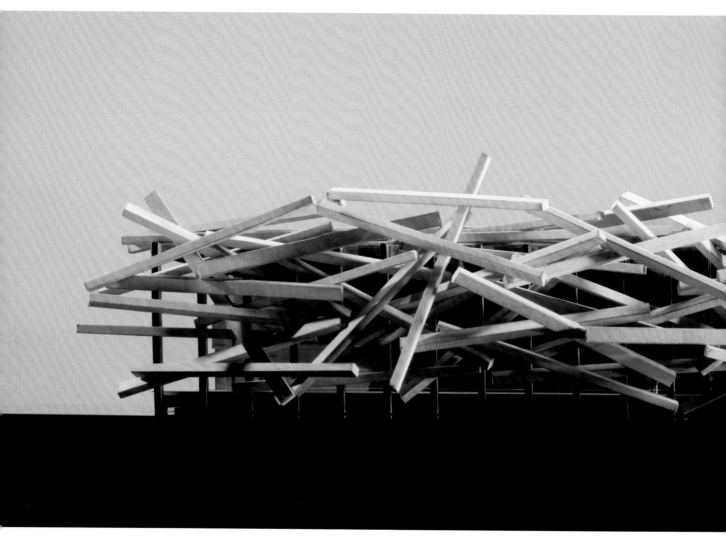

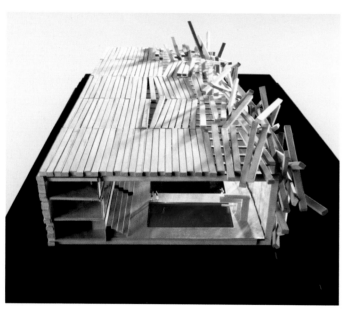

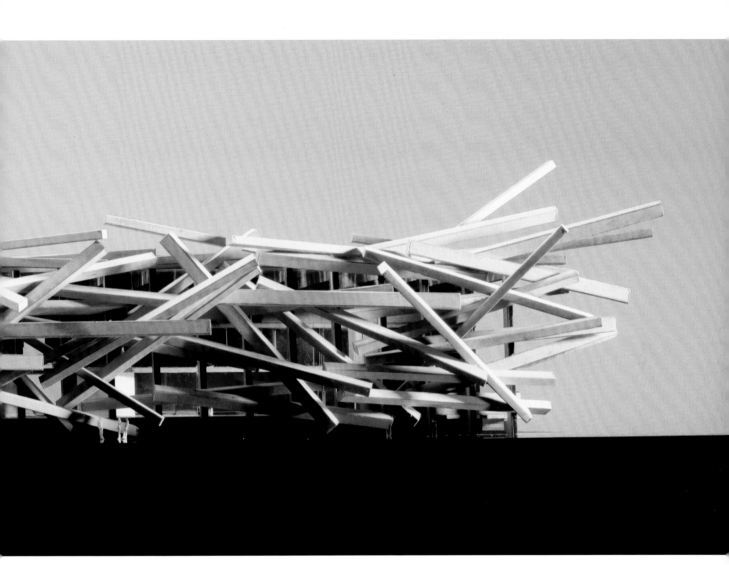

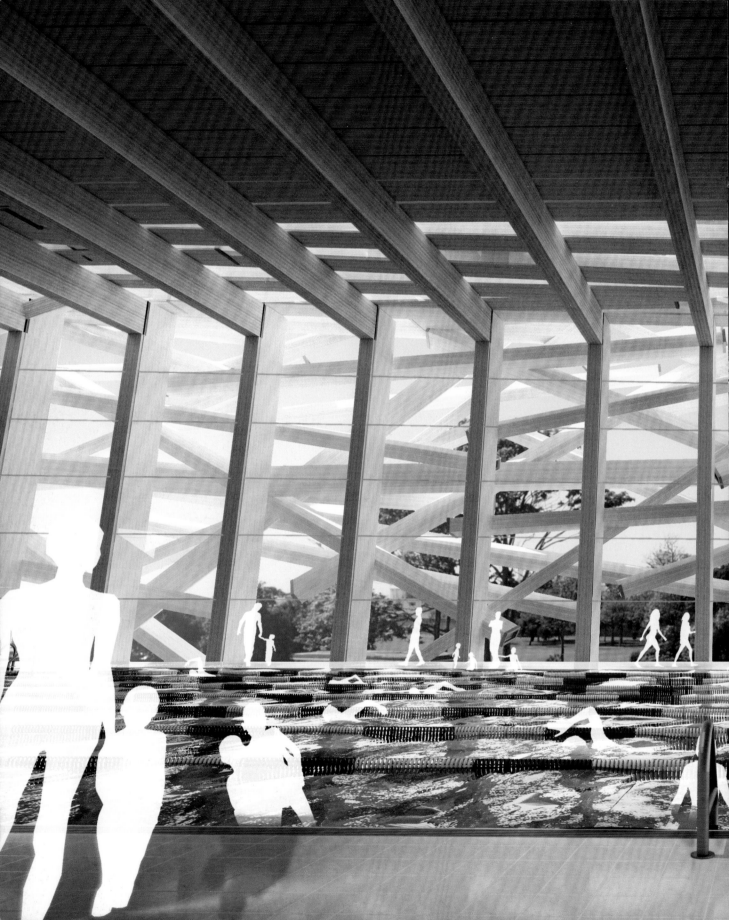

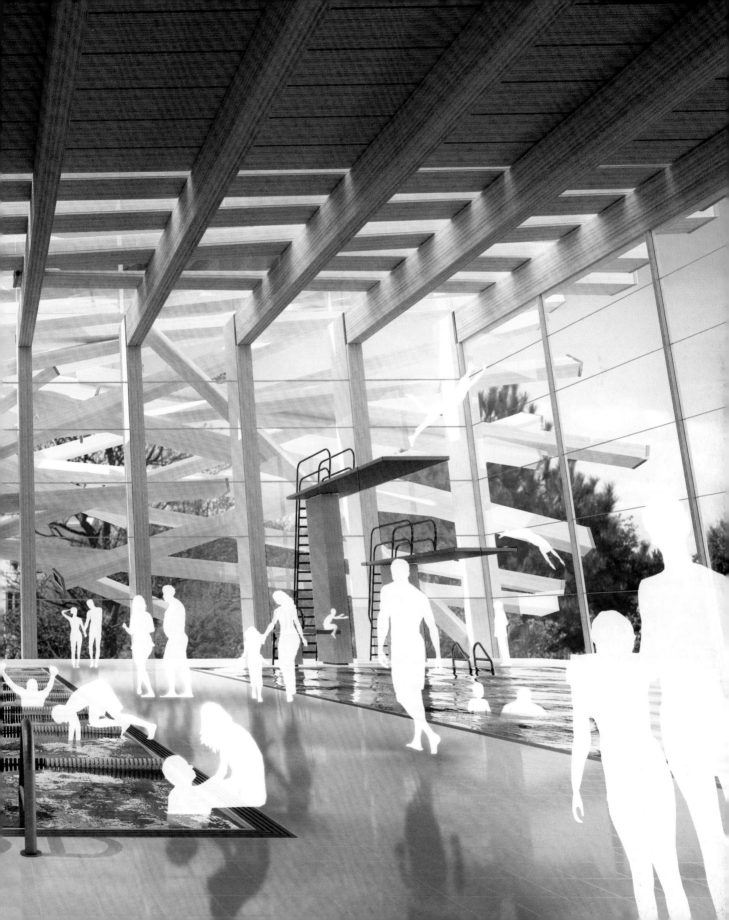

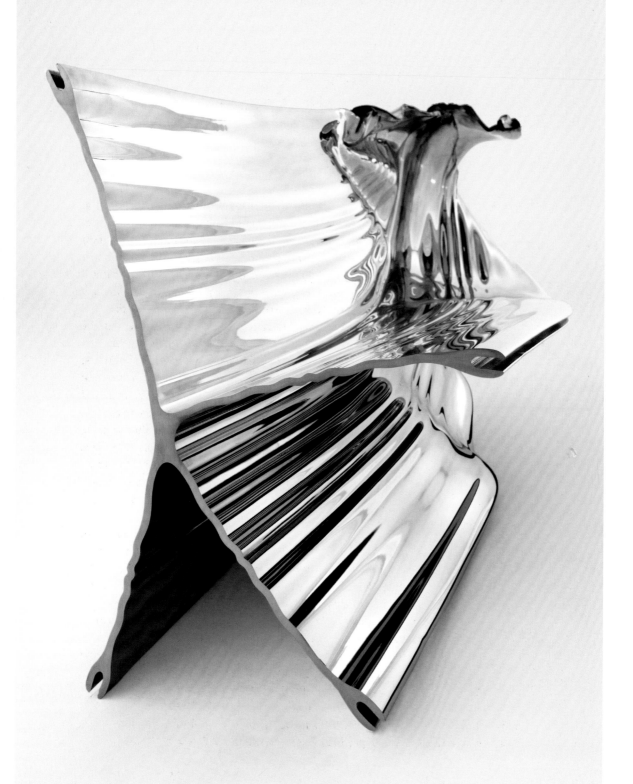

Extrusions

*Can you squeeze a chair out of
a machine, the way you squeeze
toothpaste out of a tube?*

WHEN I WAS CONSTRUCTING THE PAVILION (pages 32–37) as a student at
Manchester Polytechnic, the aluminium components I was using were manufac-
tured for me at the British Alcan factory in Banbury using an industrial process
called extrusion. Commonly used in inexpensive, double-glazed window frame
systems, extruded aluminium is made by heating a billet of metal and forcing it
through a shaped hole in a steel plate, known as a die, which produces a straight
length of aluminium with a cross-section determined by the shape of the die.

Watching this being done, I was surprised to find that this was not the
rigid, clinical industrial process I had imagined. Even in this technologically
advanced manufacturing process, warped imperfection was unavoidable. As the
metal began to squeeze out of the machine, the first part of it caught unevenly on
the surfaces of the die, contorting as it struggled to work out what shape it should
be. After that, it straightened out and became perfect. Once the extruding process
was complete, the straight parts were stretched with a special machine to make
them even straighter and the imperfect beginning bits were
chopped off and melted down. To me, though, these unwanted
mutated sections were the best part, and I wondered if it was
possible to produce warped lengths of extruded aluminium on
a larger scale.

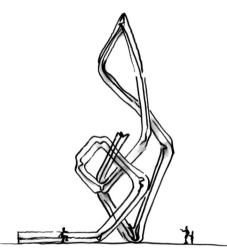

With so many new airports and stations being built
around the world, there is a need for many linear kilometres of
new seating. Could we use the extrusion process to create this
seating? Furniture usually consists of numerous separate com-
ponents. Instead, could we form a seat from a single component
by squeezing it like toothpaste, in one go? As all you need to
make a long bench is a seat and a back, could we extrude this as
a consistent, elongated L-shape? Instead of attaching separate
legs, the contorted ends of the profile could be twisted down to
the ground to support the seat.

At the time I was studying at the Royal College of Art,
and I telephoned every main aluminium manufacturer I could find, to see if there
was a machine capable of producing an extrusion on this scale, but no such

machine existed. Instead, I made a three-dimensional sketch of the form, a full-size, functional test piece, using hundreds of layers of laminated birch plywood as a substitute for the metal. In the studio, we continued to look for an extruding machine large enough to make the aluminium version. Sixteen years later, we learned that a new extruding machine had been built in the Far East that was the largest in the world. Capable of exerting 10,000 tonnes of pressure, it was being used to make rocket components for the aerospace industry. Its capacity was so great that it could extrude a shape to form not only the seat and back, but the legs as well. All we needed to do was to design a single cross-section from which the metal die would be made. As the machine was new and had not been tested to its full potential, the factory could not say if it would be possible to squeeze the metal into the fullest extents of what would be the largest extrusion die ever produced. However, we were determined to try. We travelled to the factory and watched the machine manage to realize our idea. Working with our gallery, Haunch of Venison, in London, we were able to produce a series of pieces, in which a straight, clean, extruded length is contrasted with its raw, contorted end.

Although the original idea was for infrastructural seating, we are currently exploring the use of large-scale extruding in other architectural and furniture applications, such as building structures, load-bearing columns, cladding systems and bridges. We also plan to produce a 100-metre-long extrusion that is not only seating but contorts into a 20-metre-high structure.

Theoretically, there is no limit to the length of seat that this machine can extrude. If we decided to make a kilometre-long bench to seat 1,500 people, the factory could just open its doors and carry on squeezing. But because we could never transport a piece this long, the only alternative would be to carry on extruding until the extrusion reached around the planet to wherever it needed to go.

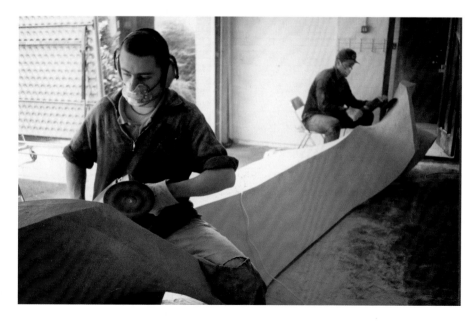

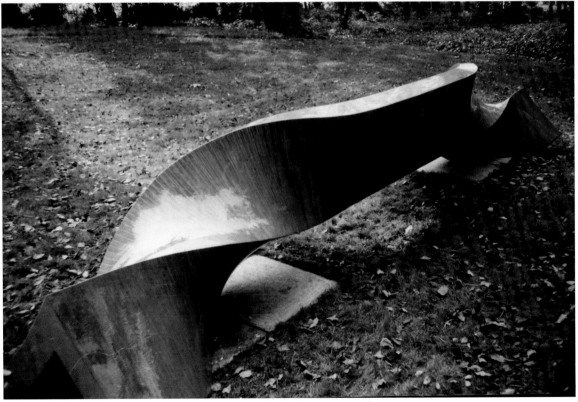

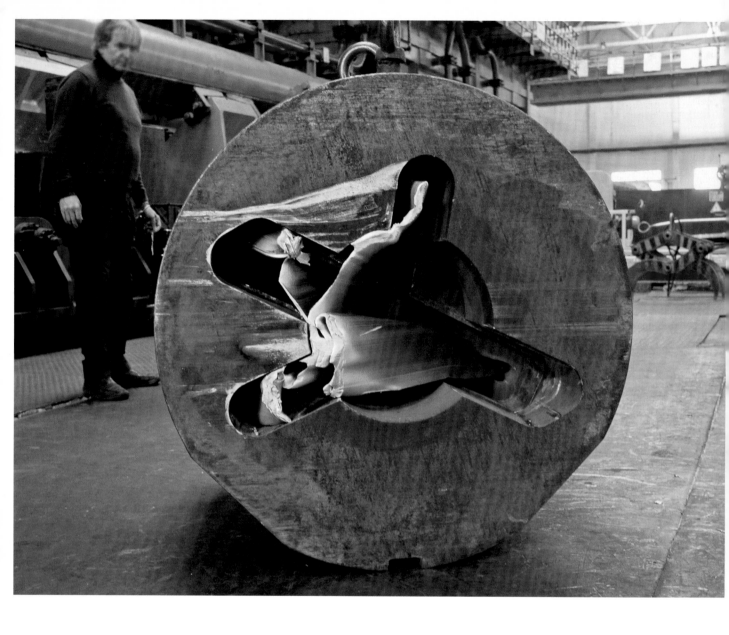

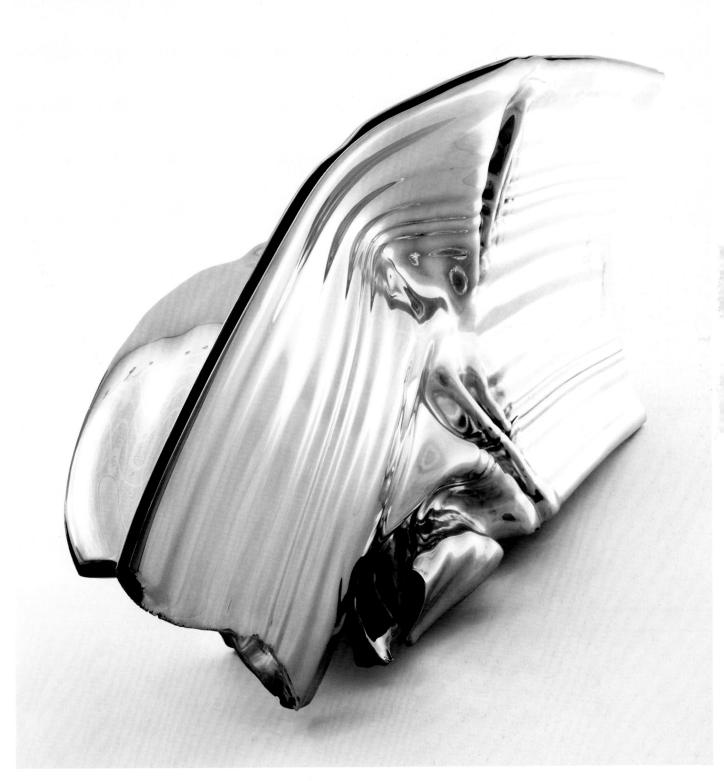

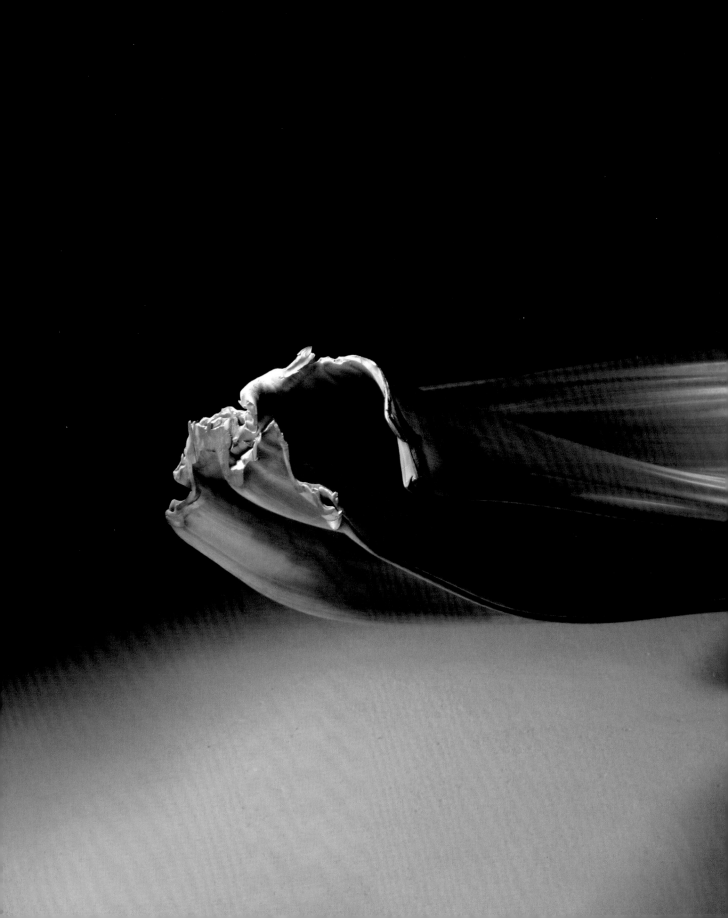

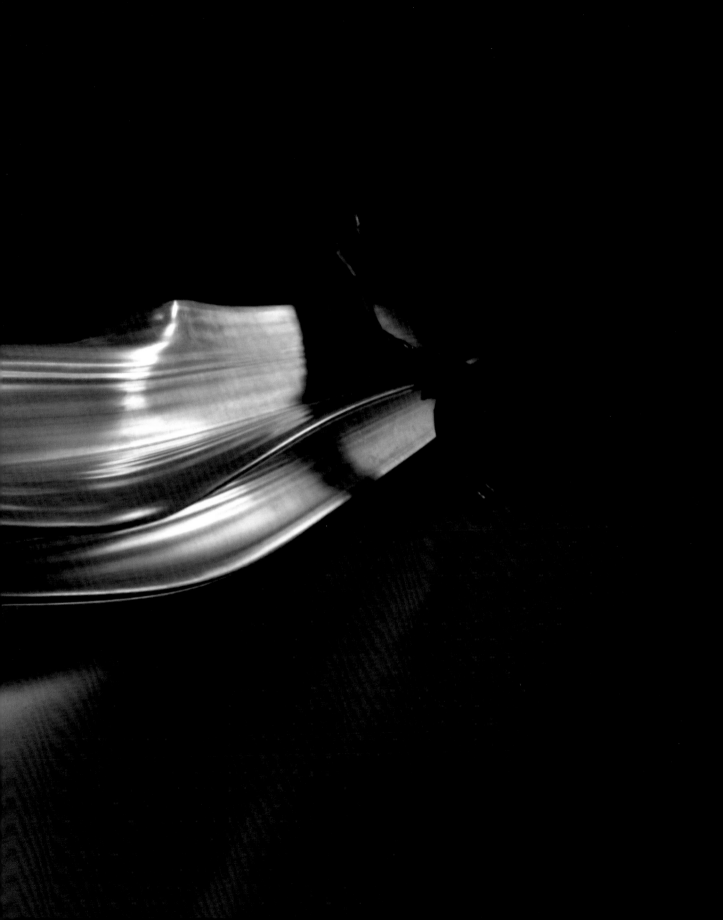

Large Span Rolling Bridge

Is it possible to make a rolling bridge long enough to span the River Thames?

AFTER BUILDING THE ROLLING BRIDGE (pages 260–265), which spanned a small section of London canal, the studio wanted to develop the idea by making a rolling bridge long enough to cross a large river. The City Bridge Trust, the six-hundred-year-old charity that maintains London's bridges, gave us the opportunity to work on this when it asked us to design a float for the Lord Mayor's Show. This annual procession through the streets of the City of London brings the City's livery companies, charities, emergency services, businesses, community organizations and marching bands together in a huge mobile exhibition about London life. Many of these organizations produce a float, which is an extravagant display mounted on a lorry or special trailer.

Our float, which was to symbolize the work of the City Bridge Trust, would be an 8-metre-long working model of the new Rolling Bridge. Opening and closing as it travelled through the streets, the model gave us a chance to test the idea.

As part of the project, the studio collaborated with the Hackney Building Exploratory, a charity that encourages young people to discover London's architecture, and began working with forty children from an east London primary school. When asked to suggest other ways in which bridges might get out of the way of boats, they had some very interesting ideas, including one that we particularly liked, for a bridge that vanished by submerging itself underwater.

The Large Span Rolling Bridge is simpler than its predecessor. Instead of multiple hydraulic rams, it uses cables, gravity and an electric winch. The winch reels in the cables, which make the bridge sections fold into each other, one by one, opening the bridge. When the cables are allowed to unwind again, the bridge sections open out under the force of gravity. Long enough to cross the River Thames in London, the 200-metre bridge consists of four of these rolling mechanisms, mounted on two pillars in the river. When the bridge opens and the four decks are rolled up, the bridge is transformed into two heart shapes, balancing on the columns.

The 8-metre model was built by our workshop team from machined aluminium and welded steel and contained around two thousand parts, which we laser-cut from 2-millimetre-thick aluminium sheets. The model is powered by

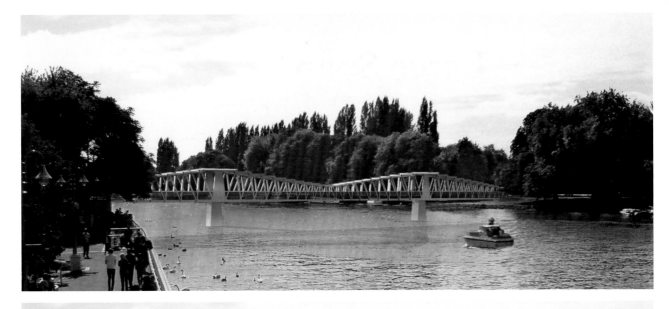

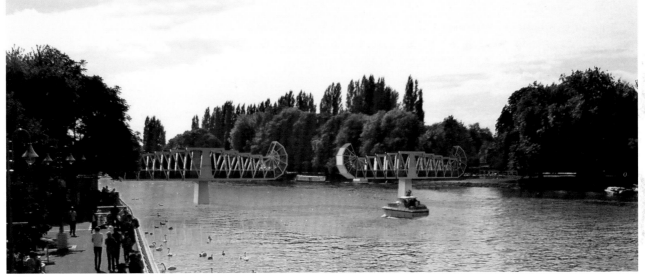

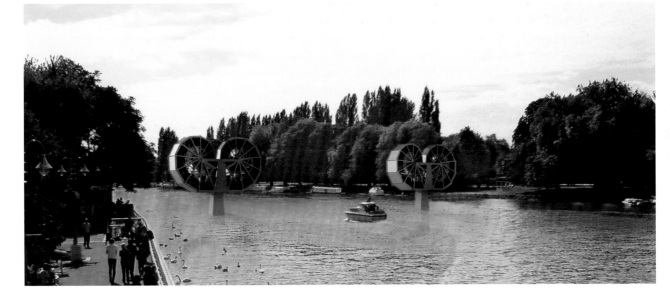

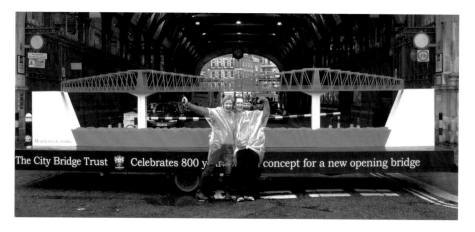

The City Bridge Trust ⚜ Celebrates 800 y... ...concept for a new opening bridge

turning a single handle, which operates a winch that pulls all four sets of cables, synchronized by a system of pulleys.

For the procession, the schoolchildren devised a dance inspired by the bridge. On the day of the show, the bridge withstood the bumping and lurching as it travelled through the streets on the back of its specially designed trailer, opening and closing all the way. Studio team members took turns to wind the handle while the schoolchildren walked next to the float, performing their Rolling Bridge dance moves. Thousands of Londoners cheered us on. By lunchtime it was pouring with rain and the children were sent home by their teachers. We found that the rain washed away the studio team's shyness and we all began dancing through the streets, beside our bridge, in the pouring rain.

This project demonstrated that the Large Span Rolling Bridge idea could work. Now it requires a home: a city somewhere in the world divided by a river that needs connecting together with a special bridge.

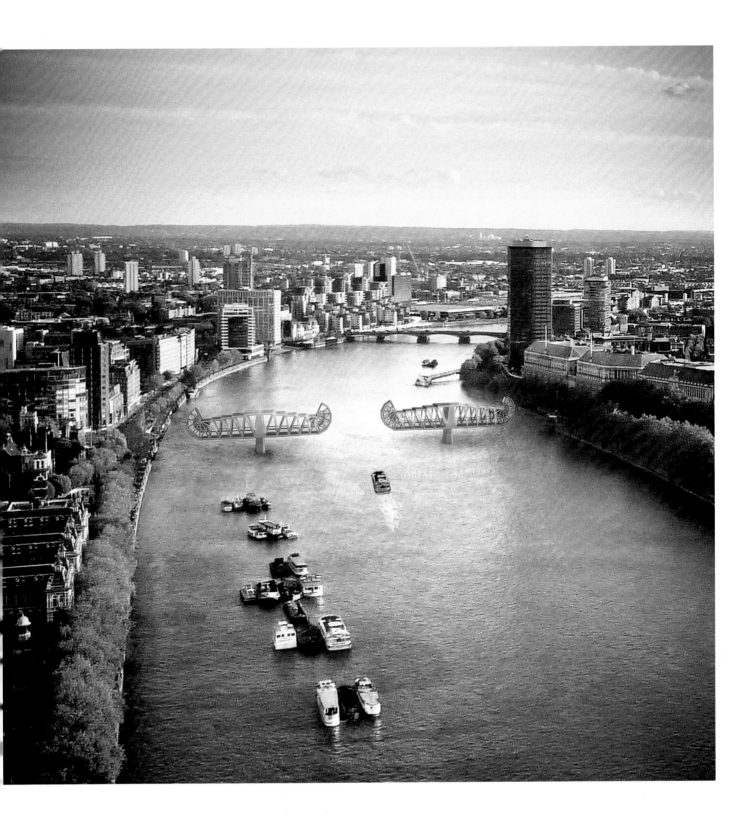

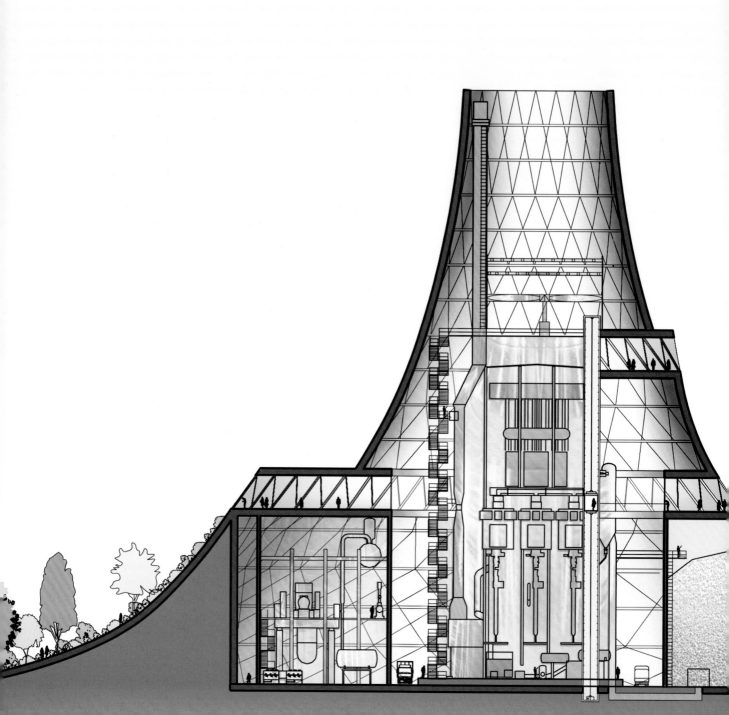

Teesside Power Station

Can the regeneration of a post-industrial area be driven by a new power station rather than a new art gallery?

THE STUDIO WAS COMMISSIONED to design a power station that will provide both heat and power for two thousand new homes in Stockton, near Middlesbrough, in the north of England. It will be the second power station of this size in Britain to generate renewable energy by burning biomass, the organic waste products from industry, instead of fossil fuel. Located on the banks of the River Tees, the biomass fuel will be delivered by river transport to minimize carbon emissions.

Once a prosperous industrial heartland, Stockton and Middlesbrough suffered in the 1970s as Britain's heavy industries went into decline, becoming one of many deprived, post-industrial areas in Europe. With so many of these areas hoping to regenerate themselves by constructing prominent new cultural facilities, we asked ourselves if this project might offer the region a different kind of catalyst for economic development.

We also thought about the pride with which the early power stations, such as Battersea and Bankside in London, had been designed in a way that celebrated the bringing of electrical power to the homes of Londoners. Meanwhile, the power stations of today are barely thought of as buildings and receive very little architectural care. To get planning permission for a biomass power station, you need submit little more than a sketch of the box-like structure that will house the pieces of equipment.

Despite the need, more than ever, to think about where electrical power will come from in future, this reluctance to think about power stations themselves seemed to reflect unease with the idea of generating electricity at all. On the cover of its annual report, an energy company is more likely to put an image of a child running across a field of green grass than a picture of a power-generating facility.

With its famous landmarks, such as the Transporter Bridge, the stadium of Middlesbrough Football Club and enormous industrial structures, which all sit on a flat, open landscape, the Stockton and Middlesbrough area is sometimes described as the Land of Giants. Instead of placing a new large object on top of

this landscape, we began to think about making a structure that had a more intimate connection to the ground.

We began the design process by analysing the arrangement of existing biomass-fuelled facilities. The normal design seemed to be a collection of separate sheds, placed on the ground, housing the fuel store, boiler island, cooling plant, turbine room, switchgear and 85-metre-high chimney stack. Working with structural and mechanical engineers, we brought these pieces of equipment together into a single structure, clustered around the stack. This improved the power station's functional efficiency, as well as simplifying its composition.

We also observed that these existing biomass facilities seemed remarkably noisy, as the sheds that housed the equipment had no sound insulation. Although their filtration systems purified the emissions so effectively that they produced virtually no pollution, the loud, factory-like vibration created a perception of the power station as polluting and dirty. Because it seemed that the power station would feel much cleaner if it was almost silent, we proposed that the large quantity of spoil, currently mounded up on the site, might be used to dampen the noise of the generating equipment by piling it against the structure. Sculpting the ground would also allow the building to fuse with the landscape rather than sit on top of it.

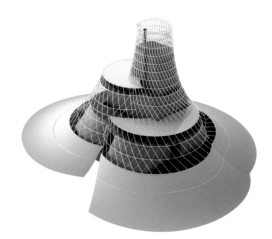

We wanted to get away from the idea that a power station must be isolated from society, cordoned off by barbed wire and danger signs, and instead to create a public space of civic and recreational value for the people of Stockton and Middlesbrough to use. Planted with grasses and other plant species, the slopes of the power station and its surrounding landscape become a Power Park, a place for walking, picnicking, tobogganing or looking out. And, instead of attaching a visitor centre, displaying simulated representations of what goes on inside the power station, the whole building becomes a living museum and school of power, creating a touristic attraction and local resource by bringing people into contact with a working power facility. Inside, a series of large multi-functional spaces would also make this a public venue, where people could even get married or hold their Bar Mitzvah.

Drawing on the post-war technology of Russian telecommunication masts, the power station's structural geometry is based on the repeated use of identical steel elements and aims to minimize the area of the building envelope. By leaning on the largest pieces of machinery, it borrows their structure in order to reduce the need to construct large and costly column-free spans.

This piece of engineering will not only celebrate and connect with the area's industrial heritage but also create jobs and facilities for the locality.

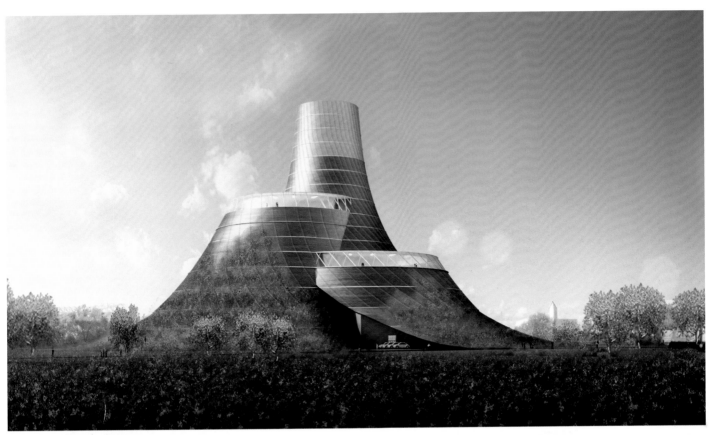

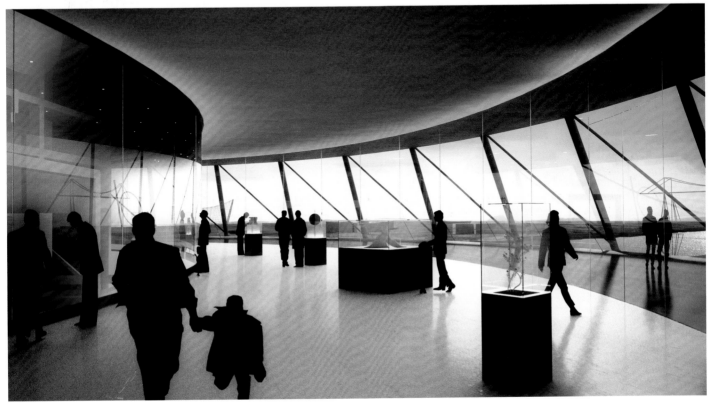

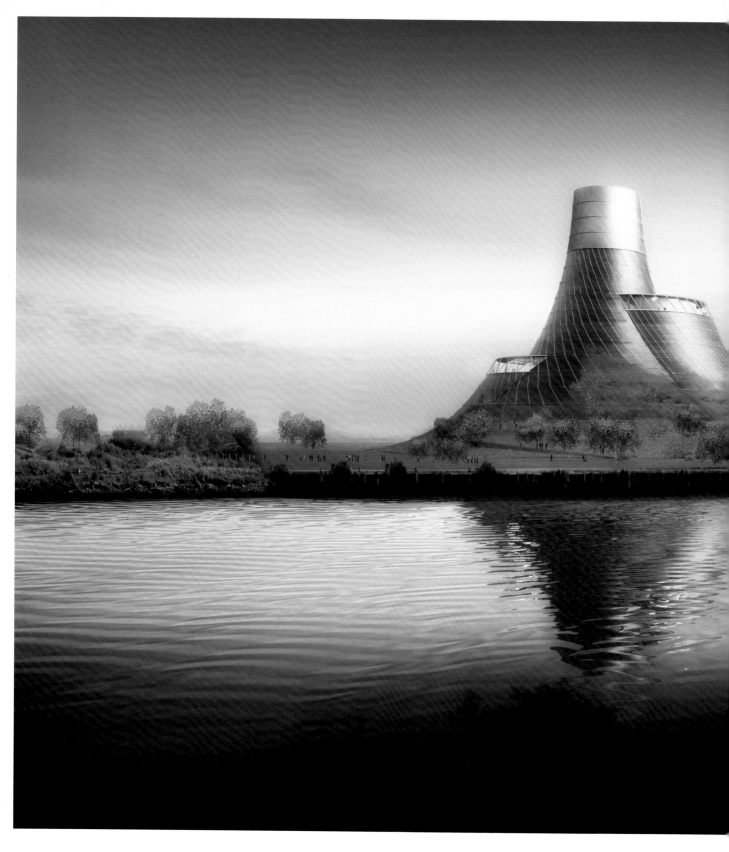

Baku Tea House

2009

*Can a building be made out
of a park?*

AS WELL AS THE MONUMENT IN BAKU, Azerbaijan (pages 402–405), the studio
was asked to design a tea house, offering hospitality and refreshment, for the same
site in Kirov Park. Incorporating gallery spaces and other cultural facilities, the
project was conceived as part of a strategy to regenerate the run-down park.

Although the existing tea house was underused and dilapidated, it was
still a memorable experience to participate in the Azeri tradition of tea drinking
while looking out across the city to the Caspian Sea. Tea was served in tulip-
shaped glasses with a bowl of jam, to eat on its own with a spoon, a bowl of nuts
and a Snickers chocolate bar on a plate, cut into pieces as if it were a tiny cake,
still wrapped in its packet. In Kirov Park we also could not help noticing the
country's fondness for lovers; at almost any time of day, many
couples could be seen wandering together, arm in arm.

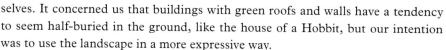

People feel comfortable looking out at a view from a place
of protection and shelter. Knowing the site well, we planned to
combine these experiences to create a place of both prospect and
refuge. However, we did not want to plonk an object on top of
the hill, as if we were putting a statue on a plinth, and instead
decided to make the structure from the park and the hill them-
selves. It concerned us that buildings with green roofs and walls have a tendency
to seem half-buried in the ground, like the house of a Hobbit, but our intention
was to use the landscape in a more expressive way.

Our proposal was to pull a substantial piece of the park's landscape up
into the air, with its greenery, and allow it to drape like fabric to create sheltering,
tent-like spaces. The tea house is both embedded within the park and materializ-
ing out of it. Entering at ground level on one side of the building, you walk
through the structure and emerge on to terraces that cantilever out over the park.
These multiple terraces, at different levels, create lots of places to sit, as well as
giving as many people as possible an unobstructed view out over the city.

In addition to functioning as a tea house, the building offers gallery space
and cultural facilities. Because the country's climate is characterized by hot
summers and cold winters, and as we wanted the building to be very flexible, the
tea house contains enclosed indoor space, open-air outdoor space and covered

526

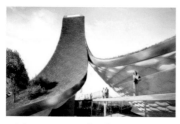

outdoor areas. It is also divided into two so that one half can be a venue for official occasions and functions, while the other remains open to the public.

Given that the tea house was to be the catalyst for the regeneration of Kirov Park, we designed it as a continuation of the park, without strongly demarcated boundaries with the landscape. We liked the idea that people can sit and play and sunbathe on its slopes. The surfaces of its simple, strong forms can incorporate plantings of wild grasses and other species that can grow free and untamed rather than being overly manicured. Lit up at night, the building glows like a beacon over the city.

In collaboration with structural engineers Adams Kara Taylor we developed engineering techniques for holding up the planted ground, using tension cables, columns and geotextile structures.

Sheikh Zayed Memorial

Can an object be both abstract and representational?

THE STUDIO WAS INVITED to design a memorial in Abu Dhabi to the late Sheikh Zayed, an extraordinary man who had brought warring factions together to found the United Arab Emirates and served as its elected leader for many years. Sheikh Zayed is remembered very fondly as a leader who championed peace and women's rights, helped his people to prosper and was also a writer, philosopher and hunter. How could we physically embody these memories in a way that was celebratory rather than morose and, though not representational, specific to him? We set about finding a form that was abstract but that also had a meaningful narrative for people.

Sited on the breakwater facing the centre of Abu Dhabi, the memorial needed to be of a substantial scale to be visible from far around, but our feeling was that the large site needed more than a large object placed on it. Thousands of people would visit the monument, so it seemed important to consider the whole site as a public landscape, for which the memorial would be the catalyst.

We learned that in his early childhood, before Abu Dhabi had acquired its great wealth from oil and gas and was still a land of pearl fishermen and nomads, Sheikh Zayed was brought up in the desert, living in a tent, and that he repeatedly returned to the desert throughout his life. It seemed appropriate to represent him as a person of the desert.

Researching stone formations, we came across the desert rose, an astonishing crystal that is found beneath the sand in the desert. With its sculptural and architectural form of intersecting plates, it seemed to embody the story of this man who had come from the desert to make his nation bloom. Our research also confirmed that no one had used this idea before.

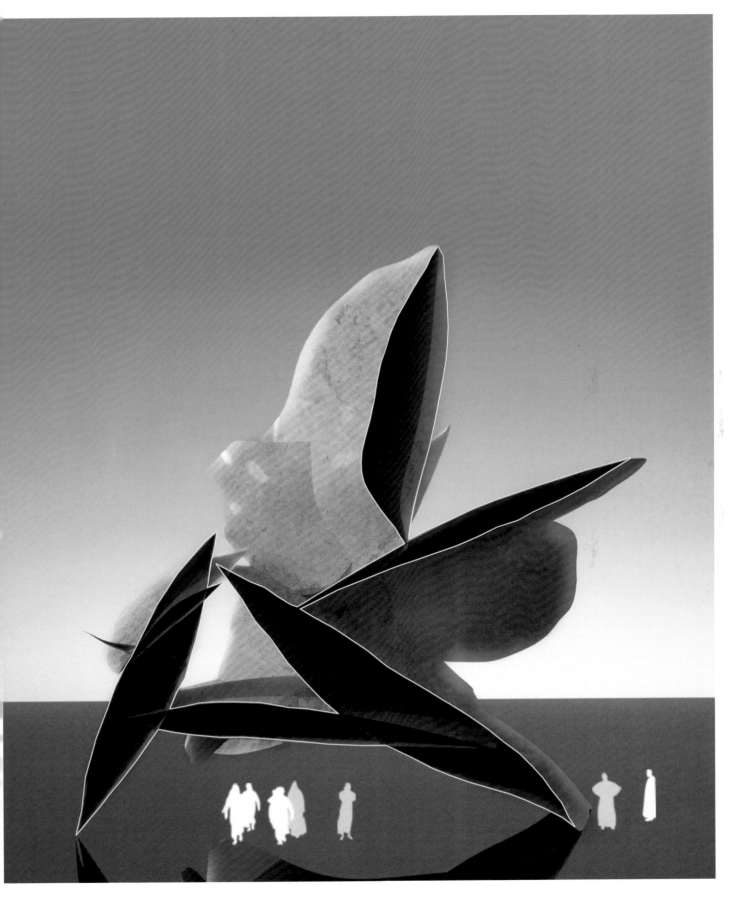

We proposed a Zayed garden, a large public park in which to set a 70-metre-high memorial formed of intersecting plates. We would invite local people to articulate their memories and thoughts of Sheikh Zayed and then work with stonecarvers to inscribe these in the surfaces of the memorial. While contemporary buildings tend to be shiny and smooth, this richly carved stone seemed to create a dynamic chemistry between an apparently modern form and an ancient culture, to make a new piece of heritage for a nation of people who had been largely nomadic and had remarkably few surviving pieces of distinctive architecture.

The form of the desert rose also gave us an aesthetic direction for the design of the park landscape, because we could use the crystal plates to create shade structures and define different areas of the park, which included date gardens and botanical planting, as well as drinking fountains, library areas and the traditional meeting places known as majlis.

Some months after we presented our proposal, the French architect Jean Nouvel published pictures of a design for the National Museum of Qatar, based on the interlocking plates of the desert rose. It showed that at the same time, different people can independently come up with surprisingly similar ideas.

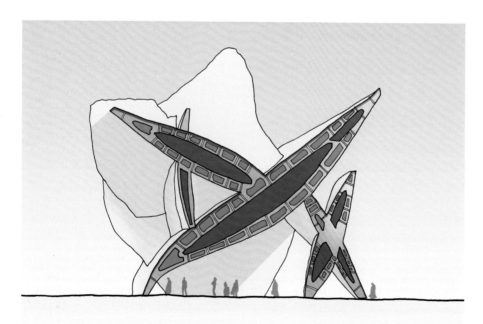

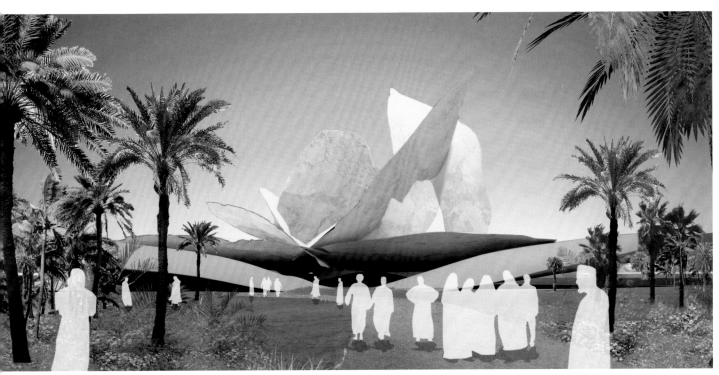

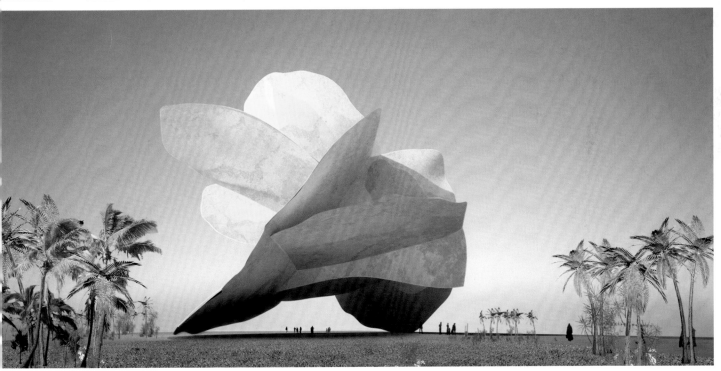

533

Christmas Card

*Can a Christmas card be made from
the postbox that it will be posted into?*

THERE IS A MOMENT when a card or letter is pushed irreversibly into a postbox and begins its journey through the postal system. Our idea was to make a cast of the actual slot that your card will be posted through and make this our Christmas card.

The studio's cards are posted using the postbox near our building on Gray's Inn Road in King's Cross. For this card, members of the studio went out at four o'clock in the morning and took casts of the slot of this postbox. These casts were later used to make the cards from clear, glass-like silicon.

London Bus

*Can a London bus be better
and use 40 per cent less fuel?*

THE LAST BUS DESIGNED specifically for London was the famous Routemaster, developed between 1947 and 1956, which had an open platform that allowed passengers to jump on and off when it was stuck in traffic. After production ceased in 1968 and London's bus routes were contracted out to private operating companies, new types of vehicles, without open platforms, were ordered from the catalogues of bus manufacturers. The only aesthetic criterion that the transport authorities applied was that the bus had to be red. However, as legislation imposed ever more requirements, the design of London's buses, particularly their interiors, became increasingly compromised and uncoordinated.

Dissatisfied with the city's buses, the Mayor of London decided to commission the first new bus for the capital in fifty years and the studio was excited to be asked to collaborate with the vehicle's manufacturer on its design.

Even though it had been much loved, the brief was not to replicate the Routemaster, which had been inaccessible to wheelchair-users and difficult for people with prams. The new bus had to be completely accessible as well as minimizing the time it would take at bus stops to load and unload passengers. To do this efficiently, it needed to have three doors and two staircases, making it almost 3 metres longer than a Routemaster. At the same time, it needed to substantially reduce its energy consumption by using 40 per cent less fossil fuel than existing buses, and, as the fleet would potentially number several hundred, it had to be affordable.

The main similarity to the original Routemaster was that the bus would have an open platform but, because a conductor would be on duty only during peak hours, it had to be possible for the platform to revert to an electronically operated opening and closing door for the rest of the time. The bus also had to comply with a vast body of new regulations, European laws and good practice guidelines. (One of the stranger requirements was to make it impossible for anyone to insert a sword through gaps in the protective screen around the driver.)

To meet the environmental performance target of using 40 per cent less energy, the team took two steps. The first was to develop a hybrid vehicle powered by both electricity and diesel and the second was to make the bus as

lightweight and therefore as efficient as possible, which greatly affected the type and quantity of materials we could use in the design.

As the 11-metre vehicle would be longer than most double-decker buses currently in use on London's streets, its rounded corners and edges came from the need to reduce its perceived dimensions, notably the apparent size of its huge, flat sides. The bus would function asymmetrically, its three doors on one side creating an uneven flow of people inside, and we allowed this eccentricity to generate the geometry of the external design. The first ribbon of window begins next to the driver, where it forms the windscreen, then wraps around the bottom deck, enclosing the rear platform, before spiralling up the rear staircase to become the windows for one side of the top deck. The second strip of window angles up the front staircase to form the windows of the rest of the top deck. Running the windows up the staircases in this way makes passengers visible from the street and transforms the staircase from a dark, constricted shaft into a lighter and more generous space.

In recent years, bus interiors had grown increasingly chaotic, with their peculiar seating arrangements, fluorescent yellow handrails suggestive of radiation warning signs, protruding lumps of machinery encased in mysterious fibreglass housings, over-bright strip lighting that reflects harshly off the windows at night and floors covered in the same brightly coloured sluice-downable vinyl that you see in the accident and emergency department of a hospital. Our priority was to

improve this environment for passengers by recalibrating the numerous separate design compromises that had accumulated over the years, trying to bring them together into an interior that felt as calm and coordinated as possible.

Using a simple palette of colours and materials, we developed a family of details that included new stairs, lighting and hand poles, as well as new stop buttons. Feeling that the individualized bucket seats now fitted to all buses make their interiors feel cluttered and untidy, we argued instead for a return to benches that two people could share. We then designed a new pattern of moquette, the tough woollen furnishing fabric traditionally used to upholster the seats of London's buses. Rather than a continuous, small, repeating pattern that could go on any piece of transport furniture, it has a pattern that is specific to this seat,

based on the contour lines that outline the form of a seated person.

In November 2010, a full-size prototype of the bus was unveiled and put on display in London's Transport Museum and a few months later, in the spring of 2011, a working test vehicle was successfully trialled at Millbrook Racecourse. London's transport authority is planning to commission six hundred vehicles, the first six of which are due on the streets in time for the London 2012 Olympic Games.

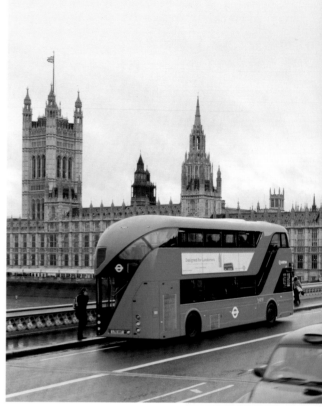

Capitol Theatre

How do you reconcile the need to build new buildings with the desire to retain old ones?

FOLLOWING AN INVITATION from a property developer, the studio entered a competition organized by the government of Singapore to select a development team to rebuild a city centre site that included two heritage buildings and a derelict theatre. The brief dictated that the heritage buildings be used as a hotel but asked us to propose a use that would bring the 1,600-seat theatre back to life. The scheme also included the design of new homes, shops and public space, and needed to make a connection to the city's underground train system.

Although we felt that the old theatre should be the symbolic heart of the project, the building itself was set back unassertively from the main road and, with its blank rendered concrete walls, its only special external feature was its Art Deco signage. Having never functioned well as a theatre, it had been used mostly as a cinema. The other two heritage buildings both had decorative façades that faced out of the development but their other elevations were characterless. Although heritage structures are conventionally treated with reverence and restraint, the lack of architectural character in substantial parts of these buildings meant that a light touch would not be enough to bring the development to life and that a bolder approach was needed.

In creating a new identity for the theatre building, we were determined not to duplicate what already existed in the city, so, as Singapore already had very good theatre facilities, concert halls and cinemas of this size, we developed a proposal to give the city a music hall. Historically associated with a form of popular entertainment that predates the invention of television, the concept was to provide what the city lacked at that time: an informal venue for alternative entertainment in which bands and avant-garde musicians could perform, as well as cabaret artistes and comedians. This venue would give the development a distinctive, vibrant identity. However,

it was a relatively small building, while the scheme's housing and retail component needed to be a ten-storey structure, so the challenge was to build a ten-storey building that was in some way subservient to the three-storey theatre.

As the developer was planning to make these apartment units small and affordable, we

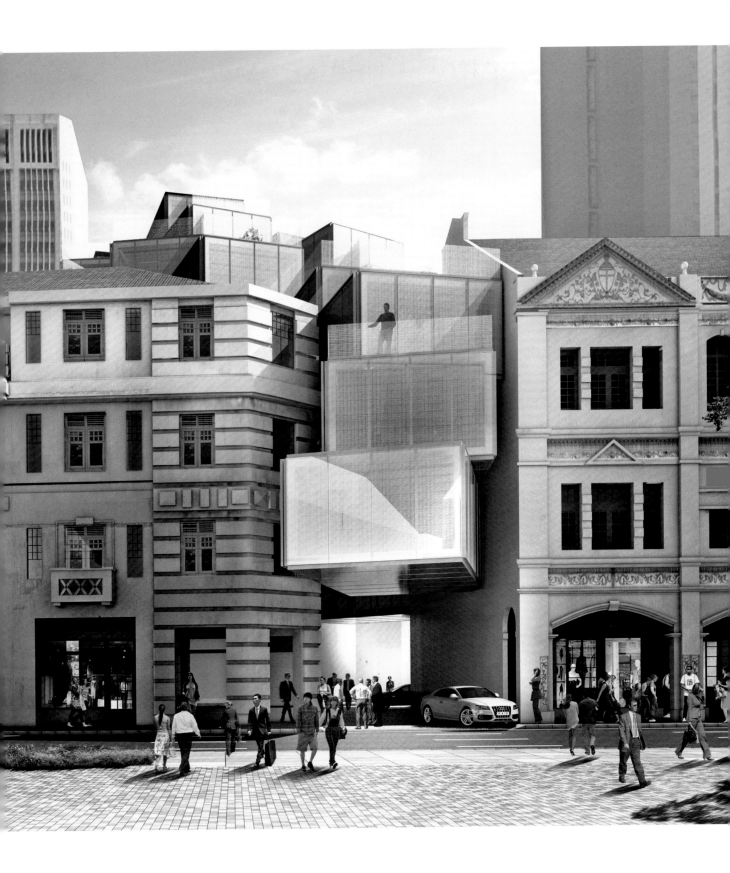

began to think of them as a constellation of individual residential units orbiting around the theatre. We imagined the theatre as a magnet and the apartments as iron filings caught in its magnetic force field. Jostling and twisting, the apartments sweep into a sculptural cantilevered form, which frames the theatre and interacts with the other heritage buildings by squeezing through the gaps between them. The circling flow of the architecture also organizes the shops, cafés, bars and restaurants at ground level, and the same geometry informs activity below ground level, including the connection to the underground trains.

Singapore is known as a garden city, and with a disparate site to unify and a hot and humid climate to deal with, we decided to integrate substantial quantities of green planting into the development. By making the apartments as individual blocks, we were able to give significant gardens to the flats on the surfaces of the blocks as they overlapped each other. Within the development, it was also possible to create dynamic public spaces that were both open to the air and sheltered from the sun.

The design's emphasis on repeated units would enable these elements to be fabricated in a factory, where they could be built to a high quality and later assembled quickly on site, reducing noise, pollution and the length of the construction period to a minimum. The team developed this proposal into an affordable, worked-up scheme that included costings and engineering details.

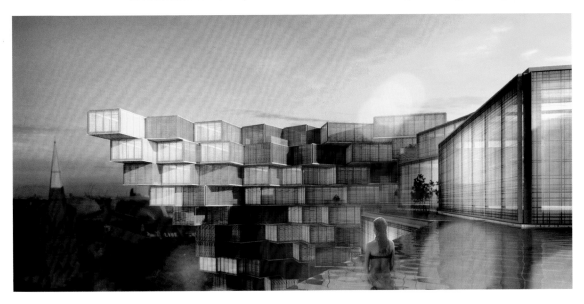

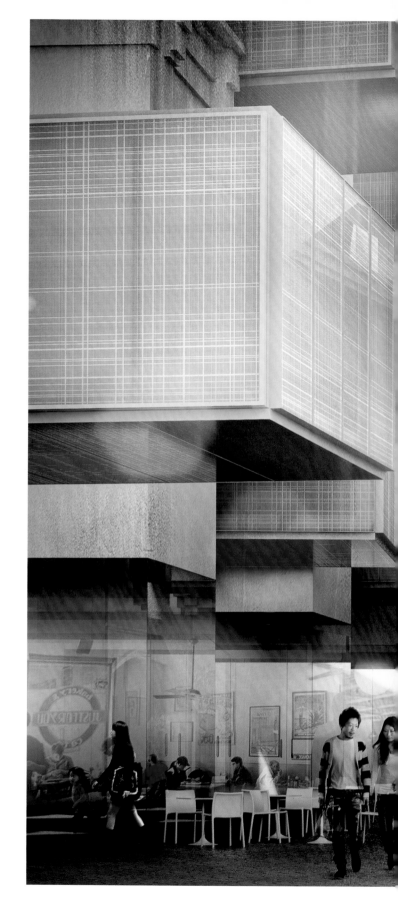

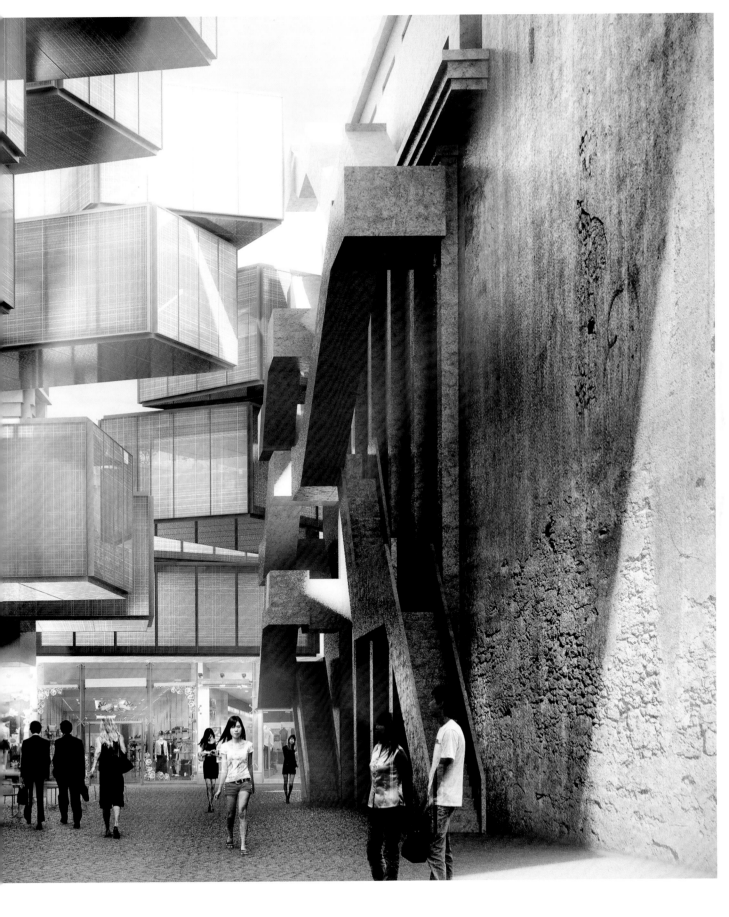

London Cable Car

*How do you make new
transport infrastructure that
is unique to London?*

LONDON'S TRANSPORT AUTHORITY was running a competition to design a cable car system spanning the River Thames, connecting the Greenwich peninsula with the Royal Docks in east London, and the studio was invited to enter it. As there are already hundreds of cable car systems in operation throughout the world we argued that London's first cable car needed to be different, in order to build on the city's tradition for ingenuity in infrastructure that began with the world's first underground train system and continued with the double-decker bus. We looked for a way in which the three elements of a cable car system – the car, the three columns and the terminals – could work together as a family. If we used standardized equipment and existing components supplied by cable car manufacturers, it would make it possible to build our design quickly and affordably.

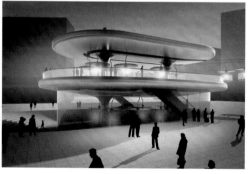

The system we developed is based on a circular geometry, influenced by the iconic image of the fictional figure of Mary Poppins flying over the rooftops of London, holding her umbrella. Like an umbrella, the capsule is based on a central column, which connects together the three discs that make a floor, seat and roof and attaches the capsule to the cables. With nothing but glass around the sides, there would be no columns to block the view out

and, at night, when lit up, the cars would look like delicately illuminated Chinese lanterns flying across the river.

Whereas the main columns that hold up the cables are normally busy-looking lattice structures with awkward runner mechanisms at the top, we made these 75-metre columns into simple, tapering tubes with a circular finial detail that integrated the runner mechanisms, to differentiate them from local electricity pylons and the masts of the nearby Millennium Dome. This thinking was carried through into the design of the terminal structures, which are stretched versions of the capsules with generous umbrella roofs and open sides that allow the cars and their mechanisms to remain visible as they come in, turn around, collect passengers and take off again.

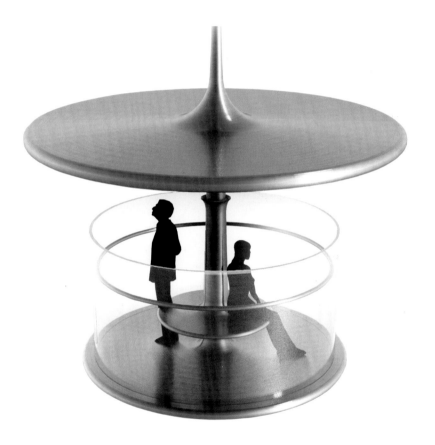

553

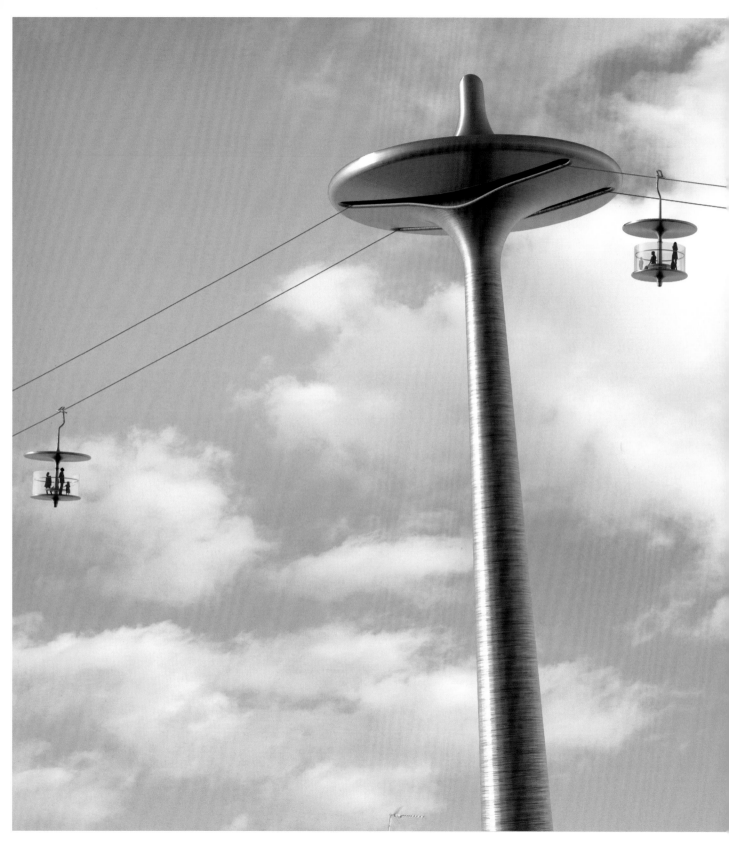

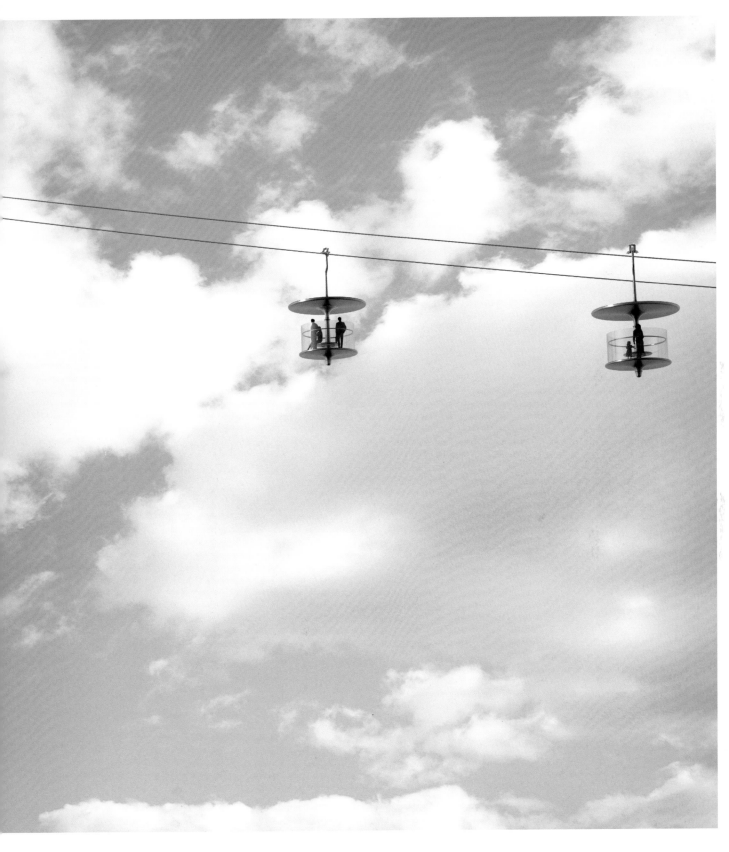

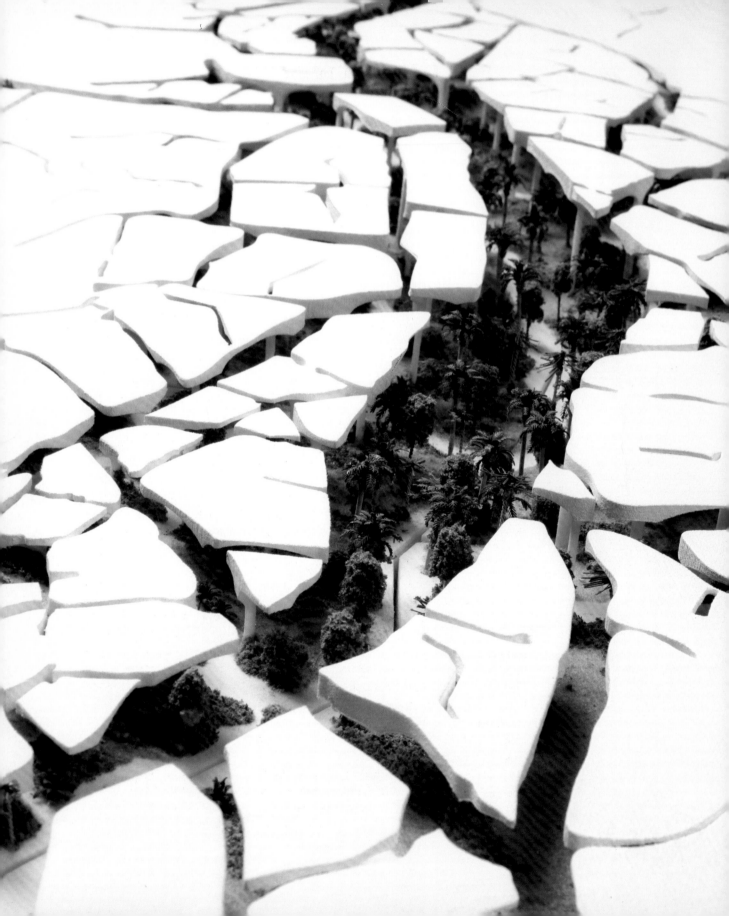

Old Airport Road Park

Can you make a park out of a desert instead of placing a European garden on top of it?

THE ROYAL FAMILY OF ABU ÐHABI asked the studio to redesign an under-used park on the outskirts of the city, next to a hospital and the national sports stadium. Given the rapid pace of the city's development and its focus on projects catering for international visitors, there was an aspiration for a park that could enhance the health, well-being and fitness of local people. As well as market and community gardens where people could grow fruit and vegetables, it was suggested that the new park might include an organic café to replace the air-conditioned outlet selling fried chicken, which was also the only place in the existing park that offered any refuge from the burning sun.

The site and its location gave us a clear set of problems to solve, the most immediate of which was that the park did not offer enough shade in this fiercely hot climate and so was an inhospitable place to spend time in. Irrigating plants and grass used vast quantities of water, which had to be produced from salty seawater by an expensive and energy-intensive process of desalination. Also, the noise of traffic on a busy highway running alongside it could be heard throughout the park.

To us, the main aesthetic challenge was the flatness of the desert terrain. The existing design appeared to be imitating the style of a European park, treating the desert as something to be covered up with greenery. We remembered that when Sheikh Zayed, the founding father of the country, was told by a boastful friend of his plan to build a large office development, he had famously said, 'What a shame to build on our beautiful desert!' Instead of copying European ways of making parks, we wanted to create a park that celebrated the desert. We were also interested in finding ways of dealing with the extreme climate by using the region's traditional horticultural strategies, such as growing fruit and vegetables in the shade of palm trees in order to conserve water rather than relying on excessive irrigation. Instead of denying the presence of the desert by rolling out a conventional European park on top of it, we set ourselves the task of making a park out of the desert itself.

Imagining the cracked and fissured earth of a dry desert floor, we developed a proposal to elevate the surface of the desert and allow it to crack apart, revealing underneath it an oasis of rich plant and tree growth and shaded public spaces. While this upper surface rises 10 metres above the desert, the underlying

landscape has a dished topography that dips down by 10 metres, creating partially covered spaces at the centre of the park that are up to 20 metres high.

Conceived as a place for friends and families to gather and picnic, as well as a venue for events and festivals, the colonnaded spaces below ground are protected from the harsh sunlight by the fragmented pieces of desert supported overhead on columns. Within this environment are cafés, public baths, pools and streams, as well as community vegetable gardens, market gardens and date palms. As the plants are both concentrated and shaded, reducing evaporation, the park needs 50 per cent less water to irrigate it than the existing park. Above this, the elevated plates of the desert landscape have bridges and balustrades discreetly incorporated into them, producing a dramatically contrasting place of relaxation and recreation that can be used in cooler evening hours, with views out to the city and the desert.

Working with structural engineers familiar with the region, we devised a method of delivering the proposal in a cost-effective way that used carved local sandstone and special concrete constituted from the local desert sand.

In a region fascinated by trophy buildings, we felt that this piece of landscape might offer a different kind of attraction and at the same time look

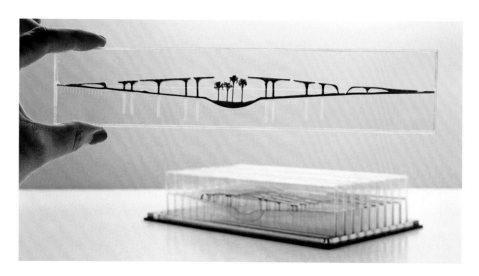

interesting on Google Earth. As a celebration of both absence and abundance, the park would be a strong statement of Abu Dhabi's commitment to inventing its own ways of providing recreational space for its citizens.

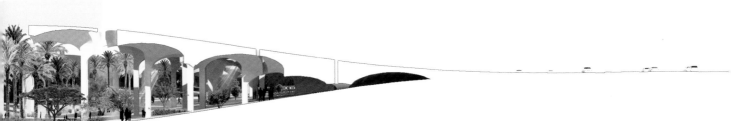

Khalidiyah Park

How can you make a three-dimensional landscape in a flat piece of the Middle East?

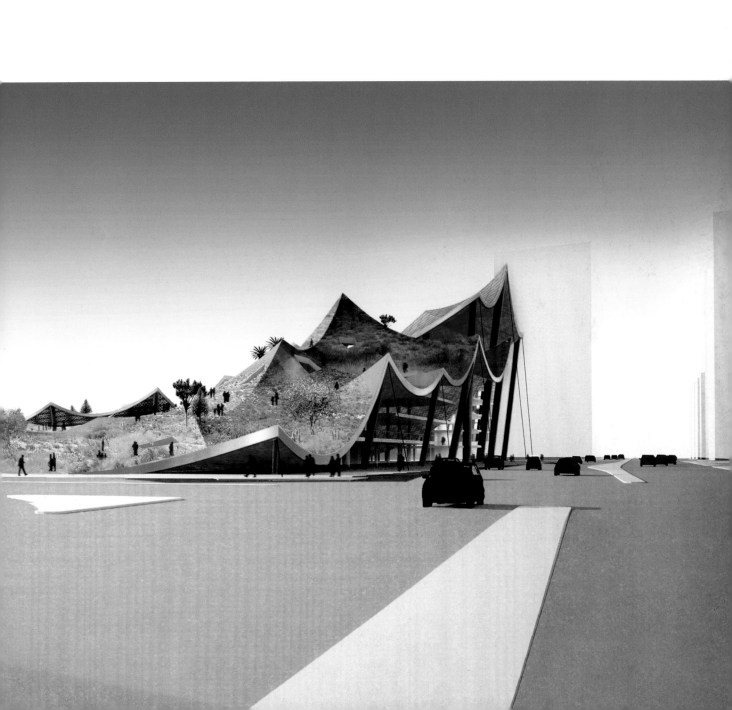

WHILE THE STUDIO WAS WORKING on the design of Old Airport Road Park on the outskirts of Abu Dhabi (pages 556–561), we were asked to redevelop another under-used park, currently known as Khalidiyah Women's and Children's Park. This site was in the centre of the city, separated from the sea and the Corniche seafront park by a single row of low houses, and towered over on another side by thirty-storey blocks. Like other parks in Abu Dhabi, it had been laid out on flat ground in the 1980s, in a quasi-European style.

With the city developing rapidly and national cultural facilities springing up throughout the region, the brief was for this park to be a more informal cultural resource, aimed at local people. It should incorporate theatre and cinema spaces, permanent and temporary artworks, artists' studios and children's play spaces. At the same time, however, the competing demand in this part of the city was for more car parking space. The conundrum was how to meet this need without either reducing the size of the park or resorting to excavating a huge underground parking space, which would be a disruptive, prolonged and expensive process. In addition, the existing flat landscape of trees and grass provided too little shade.

To make both a park and a car park, as well as to provide shade, our idea was to use the car parking spaces to lift up the surface of the park and make a less monotonous, more three-dimensional landscape. But when we began to contemplate three-dimensional landscapes, what came to mind were the snowy mountains of Europe or the green, rolling hills of England, which have no cultural relevance to Abu Dhabi. We found an answer in the tents of the Bedouin, the nomadic desert people of the Middle East, whose shelters are made by draping heavy woollen fabrics over poles and cables. Taking these tension structures as a model, we could construct a different kind of landscape, using gravity to make surfaces with large and efficient spans.

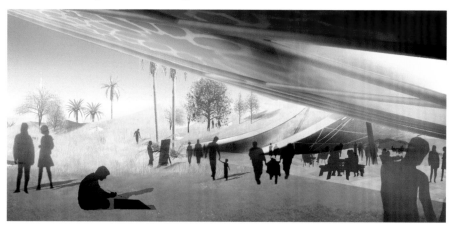

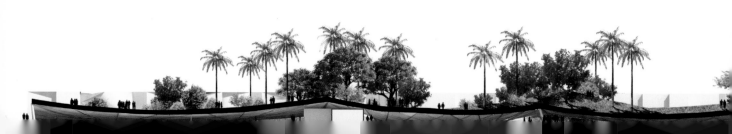

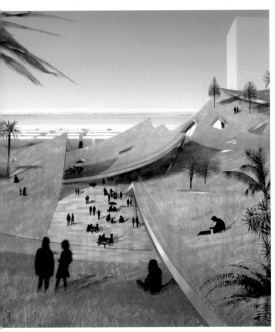

We planned to create a park by lifting the ground plane and draping it over columns and cables to make giant, tented structures with heavy surfaces, planted with shrubs and grass. Within this landscape of concave hillsides and sloping silhouettes, people could walk, play, roll down and explore. Underneath the landscape it is possible not only to install shaded playgrounds, performance and exhibition spaces, café facilities and areas for prayer but also to fit in an area with hundreds of car parking spaces, without excavating the ground or reducing the size of the park.

Starting at ground level, where the site is edged by small, seafront buildings, the park slopes gradually upwards towards the tall buildings along the site's other edge. As well as mediating the change in scale within the surrounding city, this allows views from the slopes of the park over the roofs of the houses to the sea. In contrast with a flat landscape, in which all parts are equal and similar, these slopes create distinct places and favourite spots, as well as raked surfaces on which to sit in the evenings to watch outdoor film screenings and live performances.

The project is constructed from five giant sheets of a special heavy-duty geotextile, reinforced with a net of stainless steel cables and designed to hold a layer of irrigated soil, making a surface that is 700 millimetres deep. This extraordinary planted fabric has openings in it, to allow light into the spaces below, and is supported by a structure of larger steel cables and columns.

This proposal gives the city a new local cultural resource, an exciting and distinctive park landscape unlike any found in other countries.

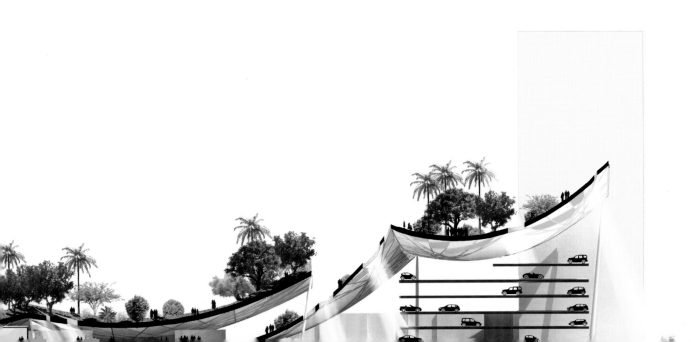

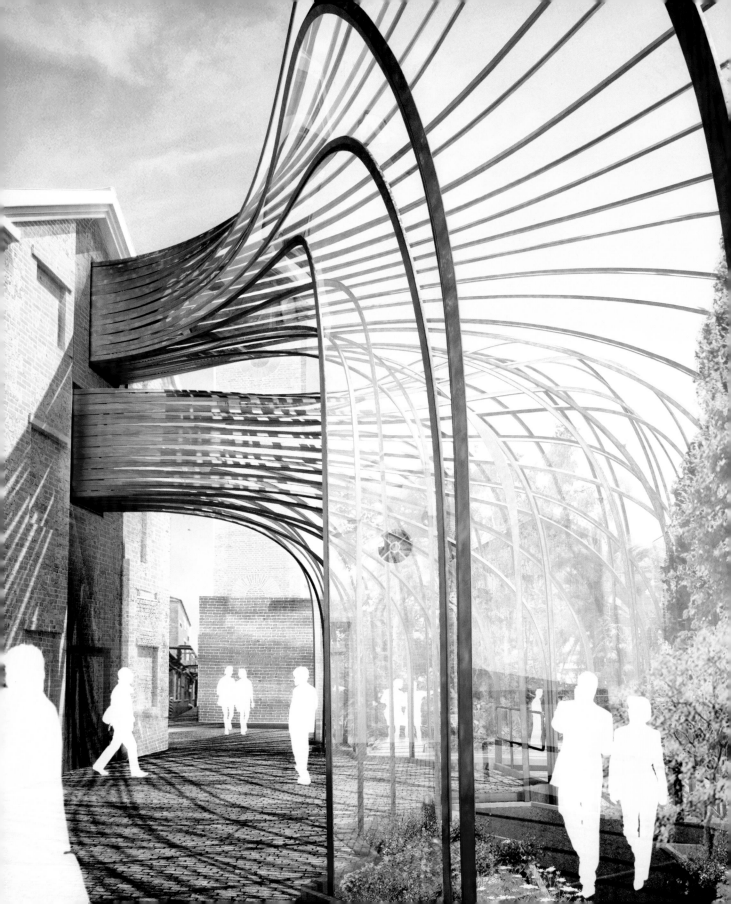

Distillery

*How do you turn a paper
mill into a gin distillery?*

TEN YEARS AFTER WINNING A PRIZE, awarded by gin-maker Bombay Sapphire, for its Glass Bridge design (pages 280–285), the studio was commissioned to design the company's new distillery. Having previously operated from shared production facilities, this would be Bombay Sapphire's first distilling facility of its own and was an opportunity for the company to make its production systems more efficient and sustainable.

The chosen site, in Laverstoke, southern England, was a former water-powered mill where, for two hundred years, much of the paper used to make the world's banknotes had been produced. With the River Test running through it, the site had accumulated more than forty different buildings, many of them of historical significance, but lacked a focal centre. Also, contained within a narrow high-sided concrete channel, the river was almost invisible. We wondered how to make this jumbled site make sense to a visitor.

Our proposal uses the river, which is currently hidden and undervalued, as the organizational device for the site. On arrival, visitors leave their cars and walk to the newly opened-up river, before crossing a bridge and making their way along the riverside to the main production facility, which sits next to a courtyard at the centre of the site. The selective removal of a bridge and a small number of building structures allows the surrounding countryside to be seen from within this space, while the widening of the river and reshaping of its banks creates sloping planted foreshores that make the water visible and valuable once more.

While the initial brief had included a visitor centre, the sculptural forms of the vast copper gin stills – one of which is more than two hundred years old – suggested to us that the

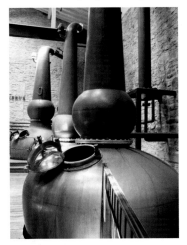

authentic distillation process was far more interesting and memorable than a simulated visitor experience could be. This process, which is carried out in accordance with a recipe devised in 1761, involves infusing the gin with the vapours of ten herbs and spices. This led us to think about growing these botanical herbs and spices on the site, which in turn pointed us towards a rich British heritage of botanical glasshouse structures, including the Kew Gardens palmhouses and the Victorian craze for Wardian cases, ornate indoor glasshouses for growing and displaying collections of exotic ferns and orchids.

This thinking evolved into a proposal for two new glasshouses that emerge out of the production buildings to sit within the water of the widened river, in which the ten species of botanical herbs and spices that infuse Bombay Sapphire gin are cultivated. While one glasshouse contains a humid environment in which to grow the plants that originate in tropical climates, the other houses a dry temperate zone, in which the Mediterranean species are grown.

569

Towers of Silence

*Can a structure you can hardly see
have a strong presence in your mind?*

LEADERS OF THE PARSI COMMUNITY of Mumbai, India, commissioned the studio to help them solve problems that have arisen in relation to their ancient burial practices. As practitioners of the ancient Zoroastrian faith, it is their custom not to bury or cremate their dead, but to place the bodies in a ritual space known as a Tower of Silence, or Dakhma, where they are exposed to the elements and consumed by vultures. Although the Parsis originated in Persia, they are most numerous in Mumbai, where the community holds many hectares of forest land in the centre of the city in which these sky burials are carried out. However, the faith faces serious challenges to its future.

First, since it requires both husband and wife to be Parsi to carry the faith on through the family line, the population of Zoroastrians is in decline. Second, a veterinary painkiller called Diclofenac, widely used to dull the pain of working cattle, has proved so toxic to the vultures that feed on the dead carcasses of these animals that the vulture population has been virtually eliminated. Across India, vultures were an effective way to hygienically dispose of polluted and inedible meat, but this meat is now consumed instead by a growing population of rats and feral dogs, which spread disease. The Parsis can therefore no longer rely on vultures to consume the bodies of their dead, which become bloated and foul-smelling when left untouched. Finally, the rapid

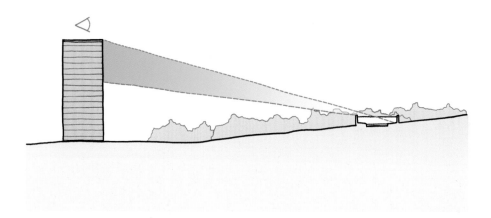

SITE ENTRANCE

FUNERAL PARLOURS

TAH BUILDINGS

TEMPLE

BANAJI DAKHMA

BISNI DAKHMA

TEMPLE

SETNA DAKHMA

ANJUMAN DAKHMA

TAH BUILDING

urbanization of Mumbai is creating another set of challenges. The Parsi burial site falls within the area of the city with the highest land values, equivalent to London's Mayfair. While the Towers of Silence were originally designed to be impossible to look into from the ground, people are increasingly able to peer down into them from the tower buildings that are springing up around the edges of the site, giving the residents of luxury penthouses an unwelcome view of decomposing corpses. Although this piece of land has been used in this way since the fifteenth century, there is growing pressure from property developers and local residents to discontinue the Parsi burial practices and redevelop the site, with potentially disastrous consequences for the community.

Since the future of the faith seemed to depend on helping the vultures to do the job of disposing of human remains, we were asked to look for ways to make an aviary around and over the Towers of Silence, to create a sanctuary in which to nurture a new vulture population, safe from contamination, as well as solving the problem of overlooking. Analysing how this aviary would be perceived, we found an unusual contradiction.

As the family bids farewell to a corpse before it is placed in the Tower of Silence, the tower itself plays no liturgical role in the funeral ceremony. Parsis do not need to be reminded that there is an aviary over their Towers of Silence, but at the same time other people in the city should not readily see something that makes them think about vultures eating dead bodies. Yet for the vultures to fly between the towers and have a good quality of life, this could well have to be the world's largest aviary. Although you might normally want to make a feature of such a structure, the need for discretion ruled out an extroverted building like the aviary in London Zoo, which has an expressive shape that can be seen for miles around. However, if you were a Parsi, you would want to know that your body would be left in a special place. Although it might be inconspicuous, it would still exist in your mind.

The aviary that we designed faces towards the sky, putting its entire focus upwards. Completely flat on top, it is based on a structure of tension cables and netting supported

by simple columns. Its shape derives from the layout of the Towers of Silence, its volume comes from the numbers of vultures it has to support and its height is defined by the need of the birds to be able to fly above the tree-tops. The sides that could be visible to surrounding tower buildings are planted with climbing plants to form natural camouflage screens, blending them into the wooded site.

This project has significance for the future of Mumbai's Parsi community, as well as providing a catalyst for the restoration of the wider site, which contains heritage buildings and other structures that are crumbling.

Jiading Bridge

*How can a traditional Chinese
moon bridge meet today's standards
of accessibility?*

AS THE CHINESE CITY of Shanghai expands rapidly, the satellite settlements on its outskirts are undergoing an intensive process of planned growth, with new high-speed rail links connecting them to the main city. The mayor of one of these towns, Jiading, invited the studio to design a new pedestrian bridge with a span of 20 metres to cross one of the town centre's many waterways.

Referring to the historical Chinese bridge form, we encountered a phenomenal heritage of interesting structures. Traditionally, while European bridges tended to take the form of a basic convex arc, often raised on stilts, the typical Chinese bridge was based on using two S-shaped curves, one at each side of the bridge. This concave–convex–concave curve form gives the steeply hump-backed Chinese bridge a distinctive and beautiful elevation, similar to the shape of an eye, but it requires steep flights of uneven stairs, which present obvious access difficulties. Crossing such a bridge is like climbing over a steep little mountain; difficult enough for an able-bodied person, challenging for the elderly and impassable for a wheelchair-user. As well as allowing boats through, Jiading's new bridge needed to meet today's standards of accessibility. The question was how to do this without giving it ramps that were steeper than the 1:20 gradient, which is agreed to be a safe and comfortable limit for wheelchair access. At this gradient, the bridge would either have immensely long ramps or be too low to let boats through.

Rather than import a European idea of a bridge, we wondered if there was a way to employ this s-curve form, which we loved, but make it more functionally relevant to modern needs. Could a bridge with that gorgeous shape be made to flatten itself? Or, conversely, could a flat bridge transform itself into this shape?

The idea is for a bridge made from threading together C-shaped sections, each one forming a single step with its own piece of balustrade. Each section is able to move relative to the others. In their flattened state, the sections align to form a level surface that allows a wheelchair-user to cross the bridge, before rearing up to produce a flight of steps and allowing boats to go underneath. Rather than a conventional opening bridge, which splits in the middle as it lifts,

574

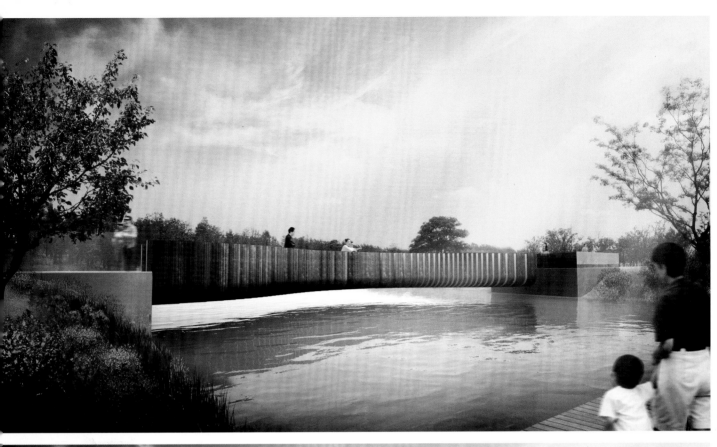
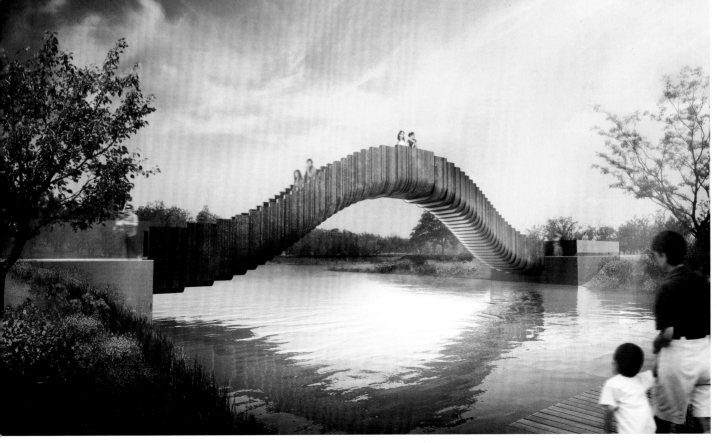

making it temporarily impassable to pedestrians, this bridge can be crossed in any position – up, down or somewhere in between.

Despite its apparently complex movement, the bridge is operated by two rotating arches that run through every step section of the bridge and which, spanning the river, are made to rotate parallel to each other by hydraulic rams. As the bridge is lowered, the arches begin to tilt over towards the water, causing the step sections to shift and gradually transform the stepped deck into a flat surface.

The bridge sections will be constructed with machined steel on their external surfaces and bronze on the faces that move past each other, the contrast between the materials visually accentuating the transformative movement of the bridge.

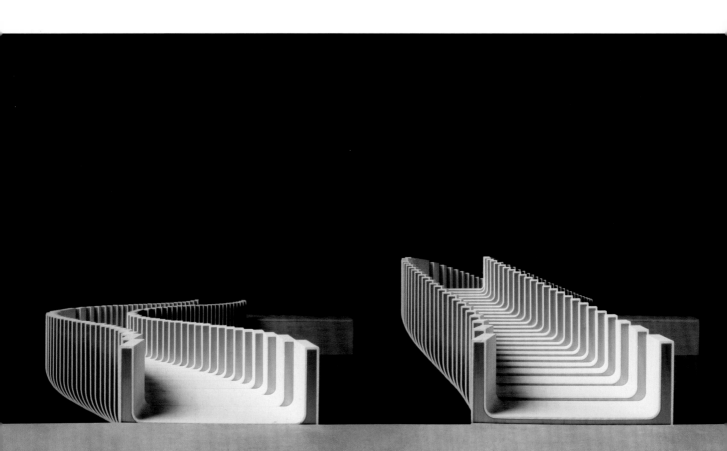

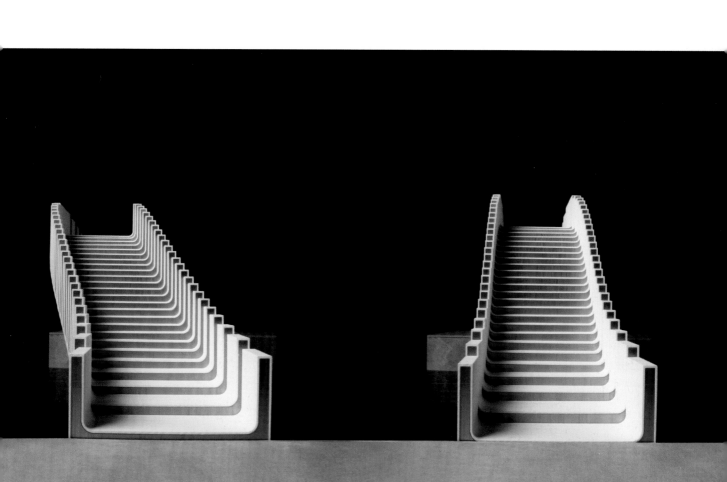

Christmas Card

*Can you make someone open your
Christmas card twenty-four times?*

THE DESIGN OF THIS CARD is based on the Advent calendars that are given to children at the beginning of December to allow them to count down the days to Christmas Eve. We hoped to recreate the feeling of opening the tiny doors of your Advent calendar to find the coloured picture behind each one.

The card that we sent out at the end of November consisted of twenty-four miniature manila envelopes, glued to each other to form an object that was the shape and size of a normal postal envelope and could be posted for the cost of sending a first-class letter. Each day, you opened an envelope and a small card popped out, held by a tiny stalk. The cards appeared to show nothing more than a few letters, a random word or some disconnected lines but, as the month of December went by, they accumulated to reveal an image and caption. The illustrator Sara Fanelli, who we invited to collaborate with us on the content of the envelopes, chose a phrase that was both beautiful and apt, with a final word that was hard to predict until Christmas Eve, when the full picture revealed itself.

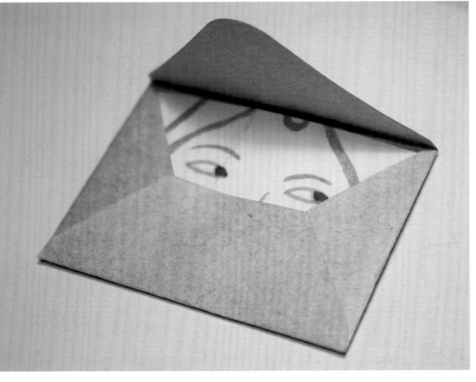

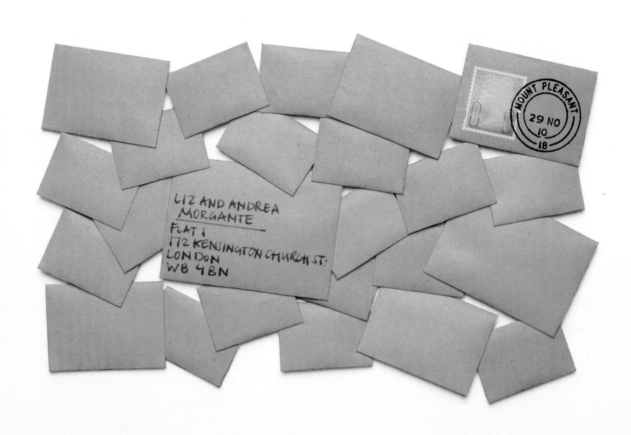

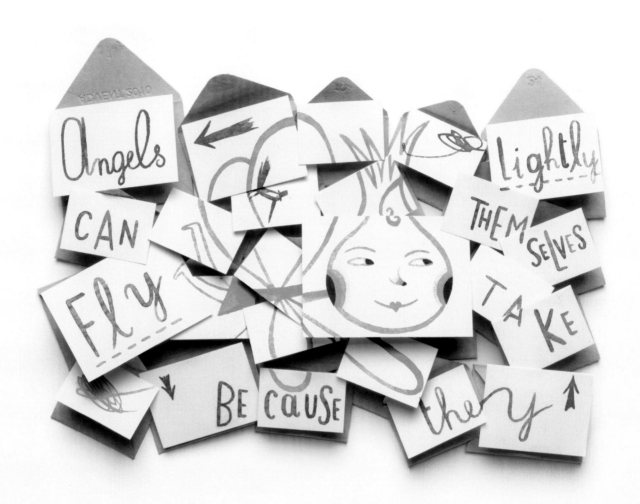

Electricity Pylon

*By using smaller steel elements, in
greater number, can you give an
electricity pylon a less obtrusive
silhouette on the British landscape?*

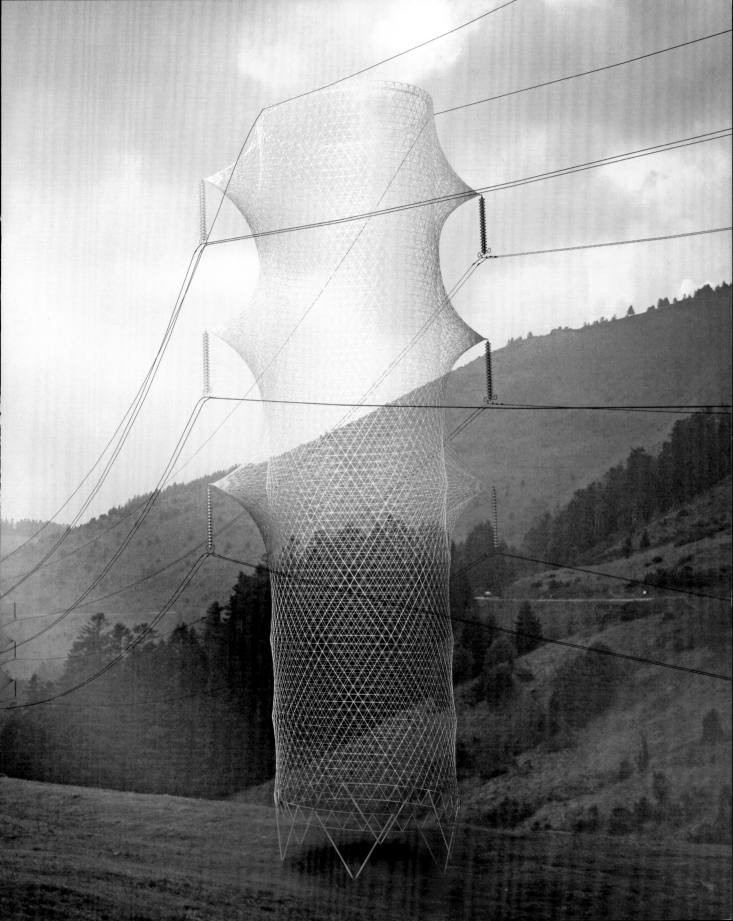

Boat

Can a whole boat be made of its hull?

IN 2007, THE CITY and regional authorities of Nantes, in France, set up 'Estuaire', an innovative project led by the city's progressive mayor. The aim of the project was to construct a large work of art in every waterside community situated on the banks of the River Loire, between Nantes and the port town of Saint-Nazaire. The strategic decision was also taken to strengthen the connection between Nantes and Saint-Nazaire by commissioning a new river boat that would travel between the two towns, to symbolize their closer union. The studio was invited to propose a design for this vessel.

As well as running daily trips along the river to see the artworks, the boat would provide a place for politicians to hold civic functions and meetings. In addition, it would be made available for hire, so its accommodation needed to be very flexible. Instead of facing forwards as they do in a bus, the two hundred passengers would want to look in different directions to get good views of the landscape and the specially commissioned artworks. As it would take people to the mouth of the River Loire estuary, the boat had to be seafaring, as well as manoeuvrable, to bring people up close to the artworks in the shallow waters at the edges of the river. The most suitable type of vessel seemed to be a catamaran, a boat with two connected hulls, which is agile and stable and has a shallow draft.

River boats of this size are, it seemed to us, normally given the aesthetic character of a sports car, with a showy, go-faster design. Although this vessel should be able to go at high speed, we wanted it to be equally adapted to pottering along at a relaxed pace. We also noticed that, although the hulls of boats and ships are frequently very beautiful forms, the top of a boat rarely has much of a relationship to the hull. We gave ourselves the challenge of making the upper part of the boat, which sits above the surface of the water, relate to the part that lies under

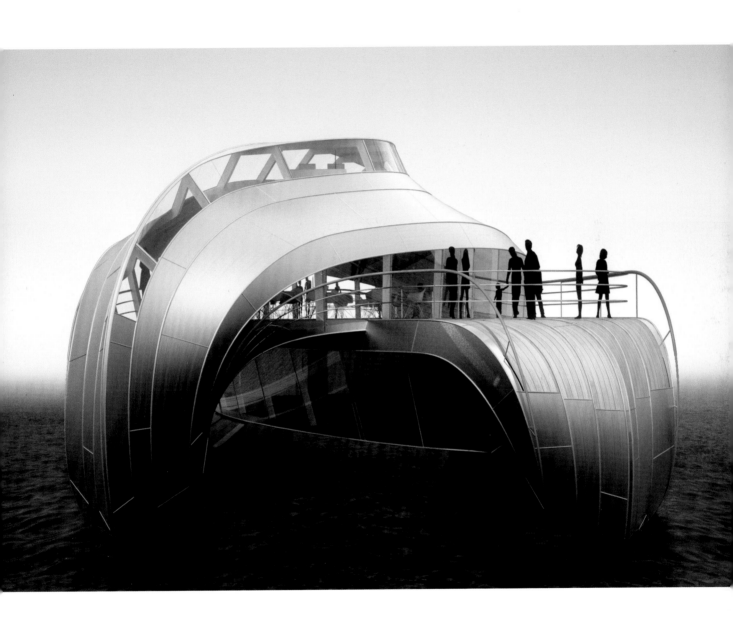

the water. This meant that we should avoid treating the twin-hulled catamaran chassis as a pair of skis with something separate on top.

Instead, we developed the notion of growing the complete boat from a single hull element that is manipulated to form the boat's two hulls below the water as well as its accommodation and decks above. The continuous strip is a closed loop, which, having formed both hulls, crosses over itself to create two storeys of decks and indoor cabin space.

The vessel is to be constructed from aluminium in the shipyards of Saint-Nazaire.

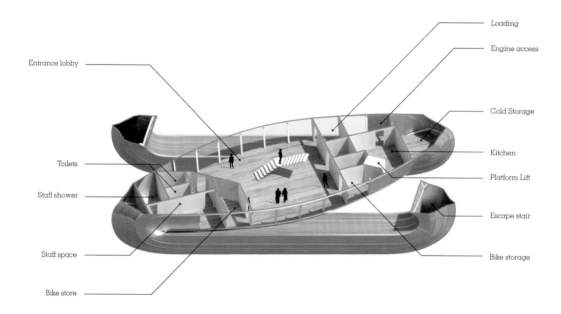

Entrance lobby
Toilets
Staff shower
Staff space
Bike store

Loading
Engine access
Cold Storage
Kitchen
Platform Lift
Escape stair
Bike storage

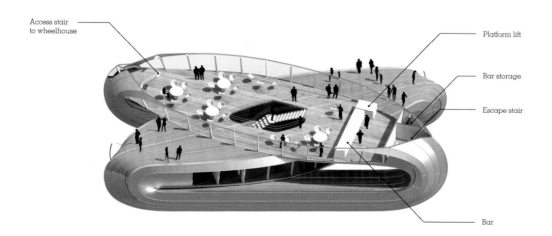

Access stair to wheelhouse

Platform lift
Bar storage
Escape stair

Bar

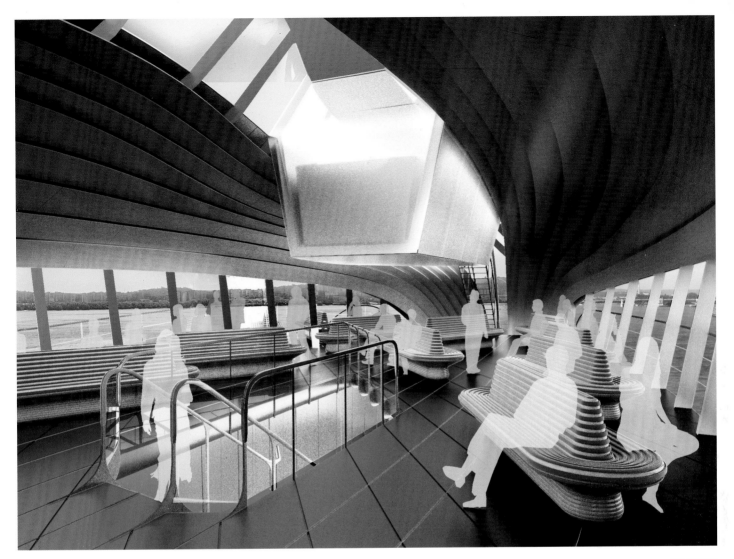

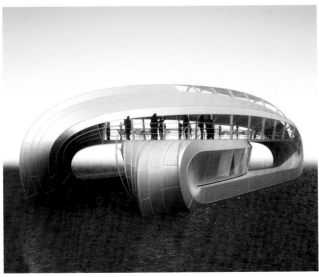

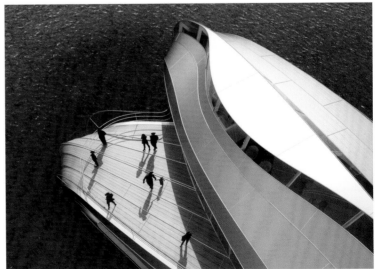

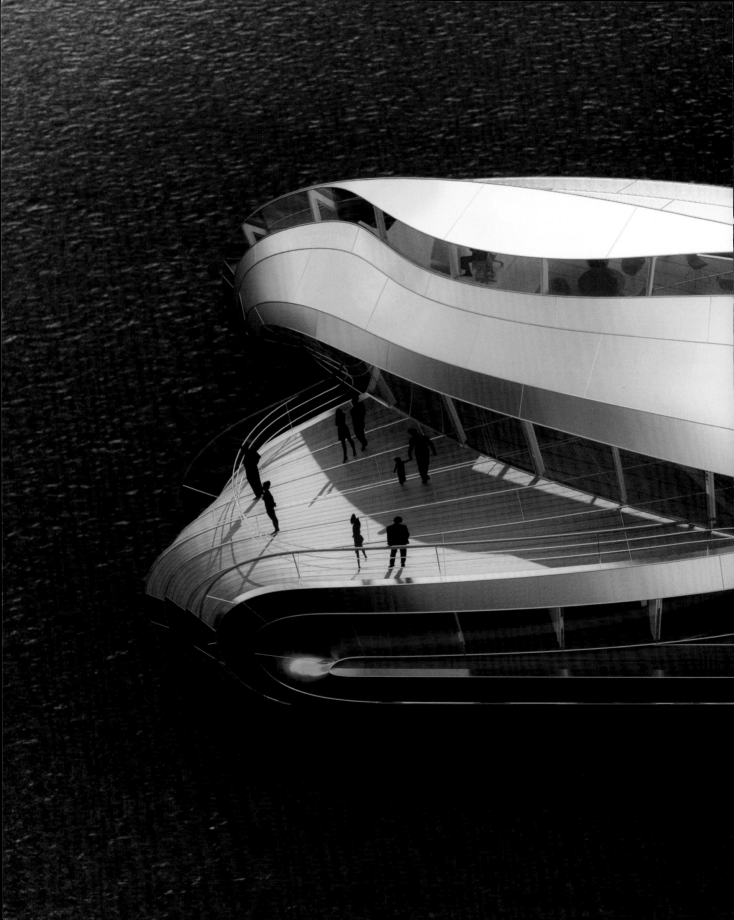

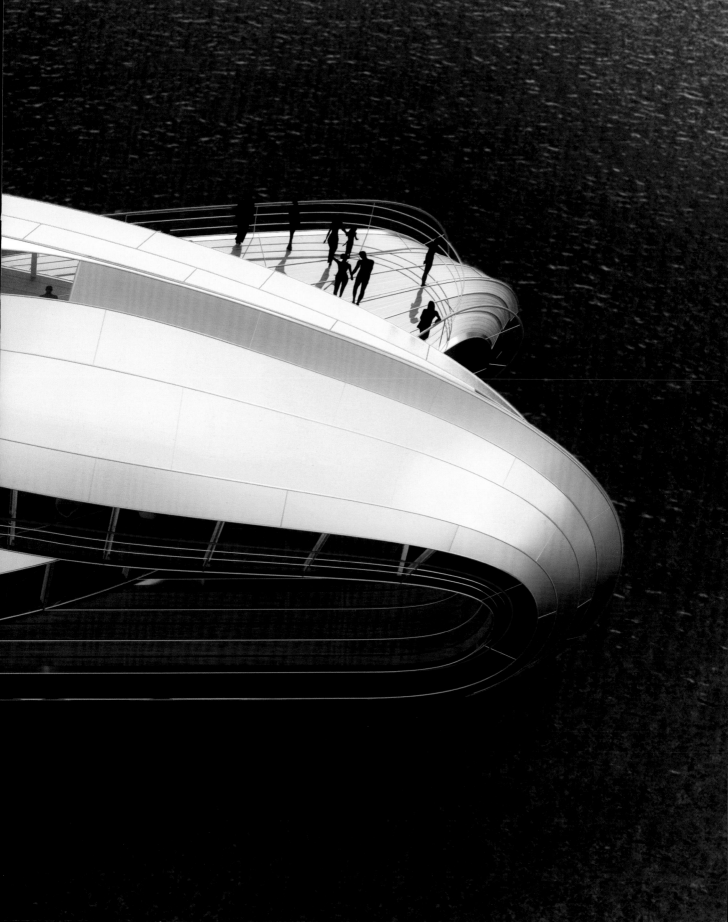

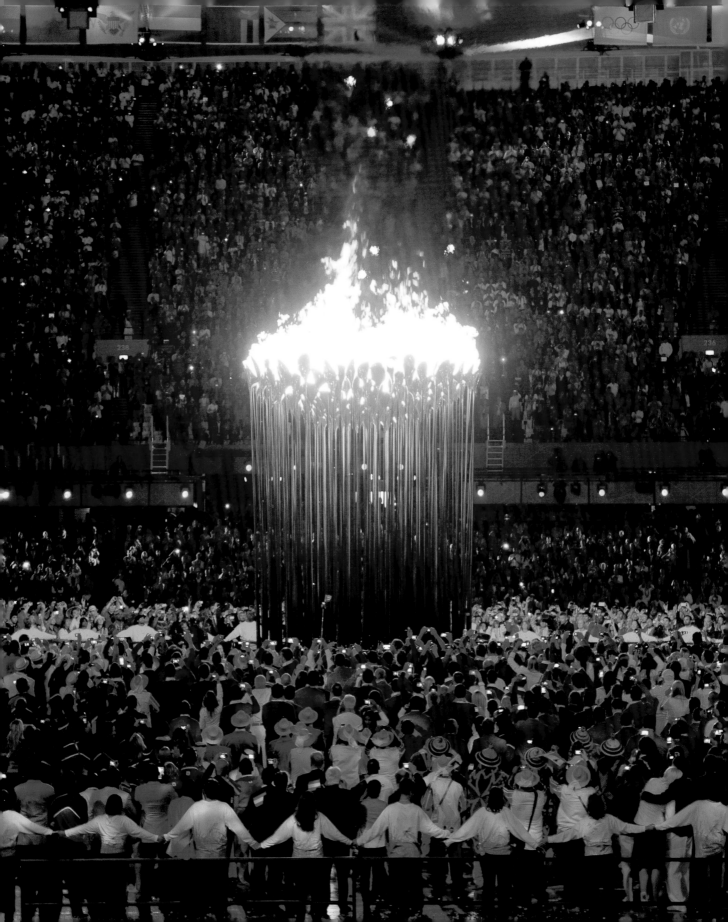

Olympic Cauldron

*How can every country in the
Olympic Games take part in making
and lighting the Olympic cauldron?*

The studio was invited by the organizing committee of the London 2012 Olympic Games and Danny Boyle, creative director of the opening ceremony, to design the vessel for the fire that burns throughout the games, which is known as the Olympic cauldron. Ignited ceremonially in Greece and brought to the host nation, this fire makes a symbolic connection to the flame that was kept burning throughout the original games that took place in Ancient Greece almost three thousand years ago.

While parts of the world grow increasingly secular, the Olympic Games seemed to us to represent a faith that everyone can subscribe to, transcending the boundaries of nation and religion to unite the world in a celebration of human achievement. With the stadium as its temple and the Olympic protocol as its liturgy, this faith even gives us the modern-day equivalent of miracles – except that these are human miracles, which we can all see with our own eyes and believe in. It felt to us that the Olympic cauldron is the high altar of this faith.

Given that the games only last a few weeks and the cauldron can never be re-lit, we wondered what would become of this big object afterwards. Olympic cauldrons are sometimes converted into monuments or water features but once they are stripped of their ceremonial function and context, it is difficult for them to look anything but forlorn. This made us want to give London's cauldron a meaning that went beyond its identity as a physical object.

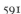

Rather than the cauldron itself, it seemed to be the ritual and theatricality of lighting the flame that people remembered. Moments of drama, like the archer igniting the cauldron with a burning arrow at the Barcelona Olympics, had become embedded in collective memory while cauldrons as objects had been largely forgotten. Instead of finding an unforgettable way of lighting a forgettable object, we wanted to look for a connection between the cauldron as an object and the ritual of lighting it. Could the cauldron itself be a manifestation of the way it was lit?

591

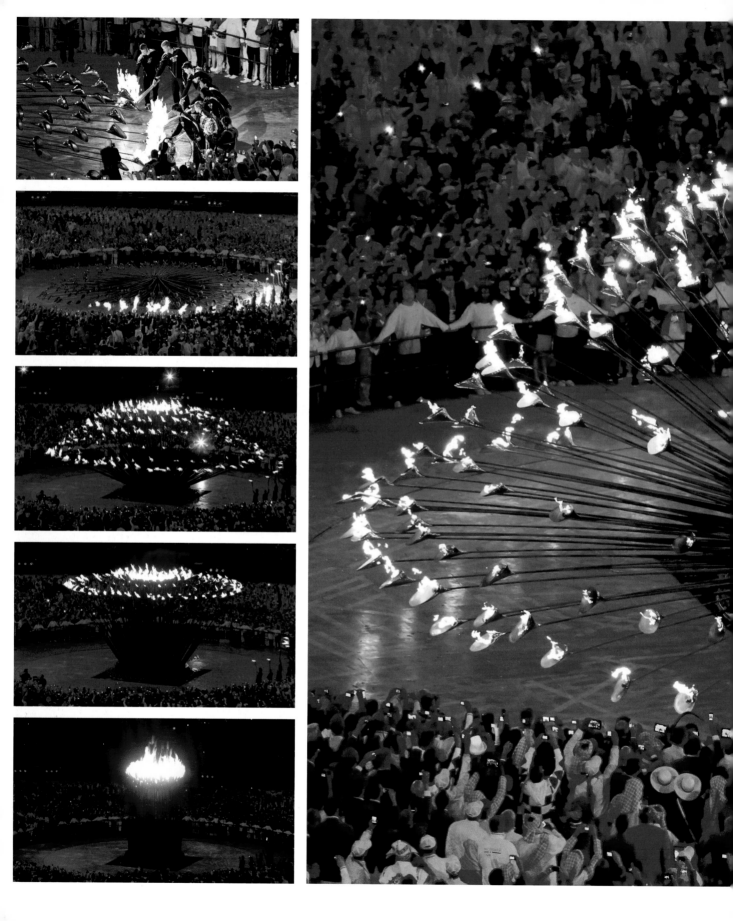

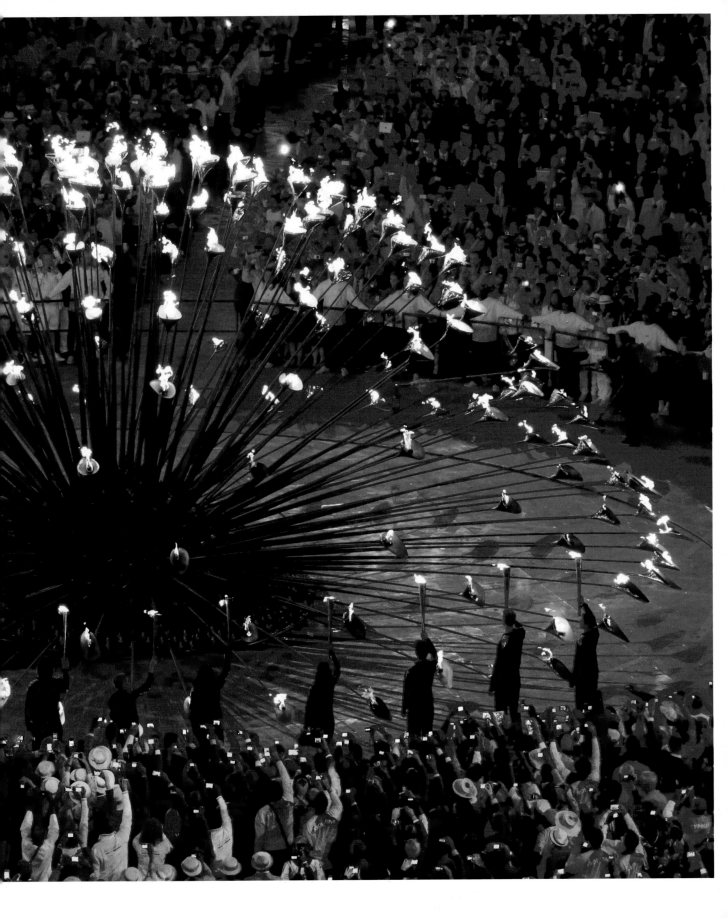

We also noted that it was normal to locate the cauldron on the roof of the stadium, far removed from the spectators, and since stadiums had grown in scale over the years, Olympic cauldrons had tended to become larger and larger in order to make the greatest impact. But it interested us that in 1948, when London last hosted the

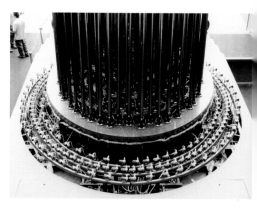

Olympic Games, the cauldron had been placed inside the stadium. This precedent suggested that rooting it to the ground among the spectators could again give the cauldron a more intimate relationship to the crowd. Also, it felt arbitrary to us to pick one particular bit of the roof on which to place the cauldron, since no one part of its circumference had greater significance than any other. Instead, it occurred to us that the most powerful point of a circular space is its absolute centre, and so it was here that we chose to place the cauldron.

As well as connecting with the circularity of the stadium, this central position seemed more fully to express the cauldron's ritual importance as the altar of the Olympic Games. Bringing the cauldron closer to the crowd enabled us to give it a more human scale. Also, during the opening ceremony, the cauldron could become a way of organizing the crowd of 10,500 parading athletes.

Rather than milling around in a disorganised throng, teams could be arrayed around the cauldron like segments of a pie-chart, with the colours of their uniforms forming vast radiating patterns, connecting the athletes themselves with the combined geometry of the cauldron and stadium.

Instead of trying to reinvent the shape of a bowl of flame mounted on a column, we started looking for an idea that would relate more directly to the phenomenon of countries around the world gathering together in pursuit of sporting achievement and not squabbling with one another. Because this only lasts a few

weeks, we wanted to make a cauldron that would only exist during this time. Our idea was that each country would bring a unique object to the ceremony and these pieces would come together and co-operate to form a cauldron. When the games ended, the cauldron would come apart again so that each country could take home their piece of it as a national memento of the event. Every one of the constituent pieces would be distinct from every other, their size and shape in no way reflecting the relative wealth, size or global status of any one country.

594

This idea was realized at the Olympic opening ceremony on 27 July 2012, when the 204 teams paraded into the stadium, each one led by an athlete carrying its national flag and a child carrying a polished copper object. As the competitors gradually assembled, each copper piece was unobtrusively attached to one of the slender rods that radiated from the exact centre of the stadium. Then the Olympic flame was borne into the arena and handed on to seven young athletes. As they ran into the centre of the stadium, spectators now saw the 204 copper elements arrayed on the ground and watched while the athletes ignited individual

flames within them. When the last ones were alight, the flames began to lift gently upwards on their metal stems. During the next forty seconds, the individual flames rose in waves and converged in the darkened stadium before surging together into a single great flame of unity, a symbol of the peaceful gathering of nations.

During the Olympic closing ceremony, the cauldron opened out once more, the blaze was extinguished and the cauldron was dismantled, each copper piece patinated with iridescent colour after its exposure to extreme heat. For the Paralympic Games, the cauldron was fitted with a new set of elements and ignited for a second time.

In bringing the idea to reality, we found that a height of 8.5 metres gave the object a scale that was appropriate to its position in the centre of the stadium. We gave each of its 204 pieces the approximate size and proportions of an A3 piece of paper, small enough for a young child to carry. With gold, silver and bronze already having their place in the Olympic tradition, we chose polished copper for the elements because of its distinctive warm colour and the extraordinary patination of its surface after heating. Each element was inscribed with 'XXX Olympiad London 2012' and the name of its country.

Since every element had its own gas supply, igniter and burner head, and was individually operated by pivots and levers, the cauldron was a sophisticated device with more than a thousand moving parts. The rods were set out in ten rings and attached to ten circular drive plates, enabling the cauldron to lift in ten waves of movement. In the tradition of British engineering, this mechanism was precision-machined and assembled in the north of England and the copper pieces were hammered by hand from sheets of flat metal using a craft technique that is usually used for restoring the body panels of historic cars.

Until the moment when the cauldron was lit, none of the 80,000 spectators in the stadium or the billion viewers worldwide watching on television knew where it was located, who would light it or what it would look like.

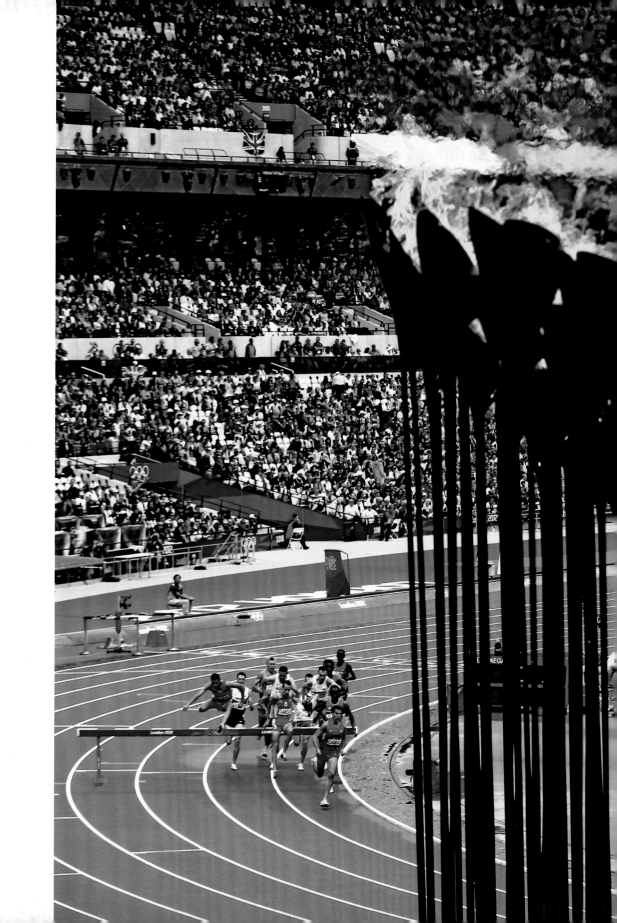

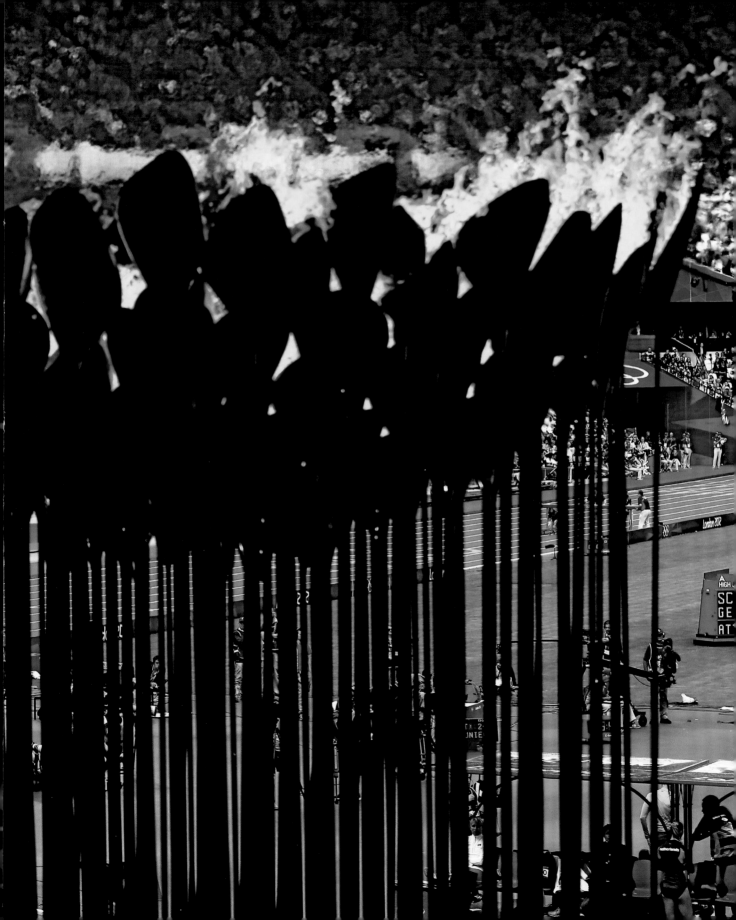

Project-Makers

Aberystwyth Artists' Studios
COMMISSIONERS: Aberystwyth Arts
Centre, Aberystwyth University.
SPONSORS: Aberystwyth University, The
Arts Council of Wales, Welsh Assembly
Government, Aberystwyth Arts Centre.
CONSULTANTS: Packman Lucas
(Structural Engineer), Max Fordham
Consulting Engineers (Mechanical and
Electrical Engineer), Adrian Tester
(Building Services Engineer), Davis
Langdon (Quantity Surveyor), B3 Safety
(CDM Coordinator). MAKERS:
Heatherwick Studio Construction (Main
Contractor), A. L. L. Hughes & Sons
(Subcontractor), Lowfields Timber
Frames (Prefabricated Timber Frames),
Renotherm (Spray Foam Insulation),
EOM Electrical Contractors (Electrics),
Edwards & Owen (Plumbing), AWS
Turner Fain (Glazing), NaturaLight
Systems (Glazing), Gareth Pugh Steel
Framed Buildings (Guttering).
HEATHERWICK STUDIO: Tom
Chapman-Andrews, Peter Ayres, Lucia
Fraser, Julian Saul, Ole Smith, Craig
Stephenson. *Page 354.*

Aberystwyth Meeting House
COMMISSIONERS: Aberystwyth Arts
Centre, University of Aberystwyth.
CONSULTANT: Packman Lucas
(Structural Engineer). MAKER: Tarmac
Topblock. HEATHERWICK STUDIO: Ole
Smith. *Page 366.*

Arts & Business Award
COMMISSIONERS: Arts & Business,
Arthur Andersen. MAKERS: Essex
Replica Castings, Opal Signs. *Page 48.*

Autumn Intrusion
COMMISSIONER: Harvey Nichols.
SPONSORS: London Docklands
Development Corporation, M-real
Corporation (formerly Metsa-Serla),
3M. COLLABORATORS: Ron Packman,
Jonathan Thomas. CONSULTANTS:
Packman Lucas (Structural Engineer),
Elektra (Lighting Designer). MAKERS:
Heatherwick Studio, Vertigo Rigging
(Installation), Tim Fishlock, Louise
Raven, Julian Saul, Joanna Scott, Miri
Heatherwick, Stewart McCafferty.
Page 98.

B of the Bang
COMMISSIONERS: New East
Manchester (Manchester City
Council, English Partnerships,
North-West Regional Development
Agency). SPONSORS: English
Partnerships, European Commission,
Northwest Regional Development
Agency's Public Art Programme,
Manchester City Council.
COLLABORATORS: Ron Packman,
Toby Maclean. CONSULTANTS:
Packman Lucas (Structural Engineer),
Manage (Project Manager), Professor
Michael Burdekin (Materials
Consultant), Flint & Neill (Wind
Consultant and Checking Engineer),
Professor C. Baker (Wind Consultant),
Invisible Cities (Visualizer). MAKERS:
Westbury Structures (Main
Contractor), William Hare (Main
Contractor), Aker Kvaerner Heavy
Industries (Fabrication), Abacus
(Spike Plate Bending), Thyssen
(Civils), Butterley (Civils), Butterley
Pierce (Civils), Alfred MacAlpine
(Civils), Alfa Construction (Installation),
Steelbenders (Plate Bending), Angle
Ring (Leg Plate Bending), CF Booth
(Solid Leg Machining), Stent
Foundations (Piling), Sheffield
Forgemasters (Leg Normalizing).
HEATHERWICK STUDIO: Rachel
Hain, Stuart Wood. *Page 232.*

Baku Monument
COMMISSIONER: Innova. SPONSOR:
Middle East Petroleum. CONSULTANT:
TALL Engineers (Structural Engineer).
HEATHERWICK STUDIO: Stuart Wood,
Zeinab El Mikatti, Jem Hanbury.
Page 402.

Baku Tea House
COMMISSIONER: Innova. SPONSOR:
Middle East Petroleum. CONSULTANT:
Adams Kara Taylor (Structural
Engineer). HEATHERWICK STUDIO:
Stuart Wood, Neil Hubbard, Tom Yu.
Page 526.

Ballpoint
COMMISSIONER: Pentagram.
HEATHERWICK STUDIO: Ingrid Hu,
Craig Stephenson. *Page 302.*

Barking Square
COMMISSIONER: London Borough
of Barking & Dagenham
COLLABORATORS: McAlister Architects,
McAlister Landscape Architects, Ron
Packman. HEATHERWICK STUDIO:
Kieran Gaffney. *Page 158.*

Barnards Farm Sitooterie
COMMISSIONER: Barnards Farm.
COLLABORATOR: Toby Maclean.
CONSULTANT: Packman Lucas
(Structural Engineer). MAKERS: Barry
Dorling, ASPL (Metal Machining).
HEATHERWICK STUDIO: Kieran Gaffney,
Polly Brotherwood. *Page 160.*

Belsay Sitooterie
COMMISSIONER: English Heritage.
COLLABORATOR: Ron Packman.
CONSULTANT: Judith King (Art
Consultant). MAKERS: Heatherwick
Studio, Michael Herbert. HEATHERWICK
STUDIO: Tom Chapman-Andrews, Alex
Knahn. *Page 150.*

Bench
COMMISSIONER: Cass Sculpture
Foundation. COLLABORATOR:
Gavin Pond. MAKER: Pallam Precast.
Page 56.

Blackburn Emergency Platform
COMMISSIONER: Railtrack.
HEATHERWICK STUDIO: Tom
Chapman-Andrews. *Page 128.*

Bleigiessen
COMMISSIONER: Wellcome Trust.
SPONSOR: 3M. COLLABORATOR: Flux
Glass. CONSULTANTS: Manage (Project
Manager), WSP Group (Structural
Engineer), Edwina Sassoon (Art
Consultant). MAKERS: Heatherwick
Studio, Torpak (Glass Bead
Manufacture), Ormiston Wire (Wire).
HEATHERWICK STUDIO: Rachel Hain,
Eleanor Bird, Christos Choraitis,
Marion Gillet, Ellen Hägerdal, Jem
Hanbury, Ingrid Hu, Toby Maclean,
Simon Macro, Tomomi Matsuba, Craig
Stephenson, Stuart Wood. *Page 250.*

BMW Pavilion
COMMISSIONERS: BMW UK, Contrasts

cal and Electrical Engineer), GSA (Civil and Structural Engineers), CBRE (Planning Consultant), Giles Quarme Associates (Heritage Consultant), SKM Enviros (Environmental Consultant), Royal Botanical Gardens of Kew (Horticultural Advisor), Alectia (Process Consultant). HEATHERWICK STUDIO: Katerina Dionysopoulou, Eliot Postma, Alma Wang, Ville Saarikoski. *Page* 566.

Doha Grand Hotel
COMMISSIONER: Al Ghariya for Real Estate Investment. COLLABORATORS: RHWL, JA Designs, Najib and Mazen Salha. CONSULTANTS: WSP (Structural Engineer and Environmental Consultant), Lerch Bates (Lift Engineer and Traffic Consultant), Marine Projects (Marina Consultant), Cracknell Ferns (Landscape Consultant), 3DW (Visualizer). HEATHERWICK STUDIO: Mathew Cash, Stuart Wood, Christian Dahl, Jeg Dudley, James Whitaker. *Page* 468.

Double Clothing
COLLABORATOR: Zoe Lee. *Page* 166.

East Beach Café
COMMISSIONER: Brownfield Catering. COLLABORATORS: Ron Packman, Fred Manson. CONSULTANTS: Adams Kara Taylor (Structural Engineer), Boxall Sayer (CDM Coordinator), AMA Consulting (Environmental Consultant), RBC (Approved Inspector), Alan Clayton Design (Kitchen Designer), Janet Turner (Lighting Consultant), Into Lighting (Lighting Designer), Wordsearch (Graphics). MAKERS: Langridge Developments (Main Contractor), Littlehampton Welding (Steelwork), D10 Engineering (Additional Steelwork), Chant Electrical (Electrics), Renotherm (Spray Foam Insulation), Uno Interiors (Interior), Advance Screeding (Floors), Rustington Windows (Glazing), Solarlux (Glazing). HEATHERWICK STUDIO: Peter Ayres, Virginia Lopez Frechilla. *Page* 344.

Eden Project Exhibition Buildings
COMMISSIONER: The Eden Project. COLLABORATOR: Land Use Consultants. CONSULTANT: SKM Anthony Hunts (Structural Engineer). HEATHERWICK STUDIO: Kieran Gaffney, Rachel Hain, Stuart Wood. *Page* 246.

Electric Cinema Façade
COMMISSIONER: Peter Simon.

COLLABORATORS: Gebler Tooth Architects, Jeff Bell (Glass Specialist). CONSULTANT: Packman Lucas (Structural Engineer). HEATHERWICK STUDIO: Tom Chapman-Andrews. *Page* 148.

Electricity Pylon
COMMISSIONER: Royal Institute of British Architects, Department for Energy and Climate Change, The National Grid. COLLABORATOR: Toby Maclean. CONSULTANT: TALL Engineers (Structural Engineer). HEATHERWICK STUDIO: Neil Hubbard. *Page* 582.

Expanding Furniture
COLLABORATOR: Haunch of Venison. MAKER: Marzorati Ronchetti. HEATHERWICK STUDIO: Stuart Wood, Zeinab El Mikatti, Ingrid Hu, Hana Reith. *Page* 330.

Extrusions
COMMISSIONER: Haunch of Venison (Aluminium Version), Cass Sculpture Foundation (Timber Test Piece). COLLABORATORS: Pearl Lam (Aluminium Version), Jonathan Thomas (Timber Test Piece). MAKERS (Aluminium Version): Longkou Conglin Industry Aluminium, CPP, Littlehampton Welding, High Grade Metal Finishing. HEATHERWICK STUDIO: Stuart Wood, Mark Burrows, Ingrid Hu. *Page* 504.

Film Festival Ticket Office
COMMISSIONER: London International Film Festival. COLLABORATORS: Ron Packman, Julian Saul. *Page* 74.

Garden Railings for a London House
COMMISSIONER: Undisclosed. *Page* 110.

Gazebo
STUDENT WORK. *Page* 58.

Glass Bridge
SPONSORS: Hewlett-Packard, St. Gobain. COLLABORATORS: Ron Packman, Argent, Imperial College London. CONSULTANTS: SKM Anthony Hunts (Structural Engineer), iGuzzini (Lighting Designer), Unit 22 (Model Maker). HEATHERWICK STUDIO: Stuart Wood, Kieran Gaffney, Andrew Taylor. *Page* 280.

Gradated Tower
COMMISSIONER: Concepts

Development Management. COLLABORATOR: Albert Taylor. HEATHERWICK STUDIO: Tom Chapman-Andrews, Simon Whittle. *Page* 466.

Grange-over-Sands Café and Bridge
COMMISSIONER: Grange Town Council. COLLABORATOR: Austin-Smith: Lord. CONSULTANT: Gifford (Structural Engineer). MAKER: University College London (Electron Microscope Scanning). HEATHERWICK STUDIO: Stuart Wood. *Page* 290.

Group of Towers
COMMISSIONER: KH Land. COLLABORATOR: Roger Ridsdill Smith. CONSULTANT: Arup (Structural Engineer). HEATHERWICK STUDIO: Peter Ayres, Tim Miller. *Page* 464.

Guastavino's
COMMISSIONER: Terence Conran. CONSULTANT: Packman Lucas (Structural Engineer). MAKER: Heatherwick Studio. HEATHERWICK STUDIO: Tom Chapman-Andrews, Catherine Kullberg Christophersen. *Page* 174.

Guy's Hospital
COMMISSIONER: Guy's and St Thomas' NHS Foundation Trust. SPONSORS: Guy's and St Thomas' NHS Foundation Trust, Pool of London Partnership, Guy's and St Thomas' Charity, Friends of Guy's Hospital. CONSULTANTS: Packman Lucas (Structural Engineer), Franklin + Andrews (Project Manager and Quantity Surveyor), Sinclair Knight Merz (Services Engineer), Landrock Associates (Planning Supervisor), Subtechnics (Surveyor). MAKERS: Crispin & Borst (Main Contractor), A1 Steel (Steelwork), iGuzzini (Lighting). HEATHERWICK STUDIO: Tom Chapman-Andrews, Rachel Hain, Claudia Hertrich, Ingrid Hu, Glenn Morley. *Page* 336.

Hairy Building
COMMISSIONER: Notting Hill Improvements Group. COLLABORATOR: Ron Packman. HEATHERWICK STUDIO: Tom Chapman-Andrews. *Page* 144.

Harewood Quarter
COMMISSIONER: Hammerson. CONSULTANTS: Adams Kara Taylor (Structural Engineer), Benoy (Retail Consultant), GROSS MAX (Landscape

(Expeditor). MAKERS: Shawmut Design & Construction (Main Contractor), Hillside Ironworks (Staircase Steelwork), Imperial Woodworking Enterprises (Woodwork), Talbot Designs (Glass Panels), Decca (Furniture). HEATHERWICK STUDIO: Tom Chapman-Andrews, Rachel Hain, Jem Hanbury. *Page 320.*

Masdar Mosque
COMMISSIONER: Foster + Partners. COLLABORATOR: Foster + Partners. CONSULTANT: WSP Group (Structural Engineer). HEATHERWICK STUDIO: Mark Marshall, Neil Hubbard, Andrew Taylor, Abigail Yeates. *Page 486.*

Masts
COMMISSIONERS: Milton Keynes City Council, Artpoint, Vodafone. COLLABORATOR: Toby Maclean. CONSULTANT: Packman Lucas (Structural Engineer). MAKER: Jonathan Wright (Model Maker). HEATHERWICK STUDIO: Tom Chapman-Andrews. *Page 192.*

Materials House
COMMISSIONER: The Science Museum. SPONSORS: Royal Society of Arts & Commerce, Arts Council of Great Britain, Arts Lottery, materials donated by more than 80 companies. COLLABORATOR: Jonathan Thomas. CONSULTANTS: Packman Lucas (Structural Engineer), Clare Cumberlidge (Art Consultant), Ben Eastop (Art Consultant). MAKERS: MAKE, Vertigo Rigging (Installation), GFM (Profile Cutting). HEATHERWICK STUDIO: Kieran Gaffney. *Page 116.*

Millennium Bridge
COMMISSIONERS: London Borough of Southwark, *The Financial Times.* COLLABORATOR: Ron Packman. *Page 96.*

Millennium Dome: National Identity Zone
COMMISSIONER: The New Millennium Experience Company. COLLABORATORS: Lorenzo Apicella, Tim Elliott, Ron Packman, Gerald Scarfe, Richard Sharp, David Zolkher. CONSULTANT: Spectrum (Zone Producer). HEATHERWICK STUDIO: Kieran Gaffney, Tom Chapman-Andrews, Jonathan Wright. *Page 132.*

Milton Keynes Information Centre
COMMISSIONERS: Milton Keynes City Council, English Partnerships. CONSULTANTS: Packman Lucas (Structural Engineer), Artpoint (Art Consultant). HEATHERWICK STUDIO: Stuart Wood, Veljko Buncic. *Page 276.*

Milton Keynes Public Art Strategy
COMMISSIONERS: Milton Keynes City Council, English Partnerships. COLLABORATOR: Maisie Rowe. CONSULTANT: Artpoint (Art Consultant). HEATHERWICK STUDIO: Kieran Gaffney. *Page 308.*

Montblanc Diary
COMMISSIONER: Montblanc. *Page 68.*

Motorway Bridge
COMMISSIONER: Essex County Council, Segro. CONSULTANTS: SKM Anthony Hunts (Structural Engineer), Van den Berk (Trees). HEATHERWICK STUDIO: Stuart Wood. *Page 316.*

Nottingham Eastside
COMMISSIONERS: Roxylight, Eastside and City Developments. CONSULTANTS: Mike Luszczak (Landscape Architect), Hopkins Architects (Master Planner), BWP (Engineer). MAKER: Laing O'Rourke (Contractor). HEATHERWICK STUDIO: Fergus Comer, Jem Hanbury, Abigail Yeates, Dandi Zhang. *Page 374.*

Notting Hill Residential Tower
COMMISSIONERS: Land Securities, Delancey. COLLABORATOR: Conran & Partners. CONSULTANTS: Ramboll UK (Structural Engineer), Hill International (Project Manager), King Sturge (Planning Consultant), Knight Frank (Property Advisor), Arup (Façade Consultant), Hoare Lea (Mechanical and Electrical Engineer), Colin Buchanan (Transport Consultant). HEATHERWICK STUDIO: Tom Chapman-Andrews, William Aitken, Jeg Dudley, Abigail Yeates. *Page 416.*

Office Interior
COMMISSIONER: System Simulation. COLLABORATORS: Ron Packman, Malin Palm. *Page 84.*

Old Airport Road Park
COMMISSIONER: Sheikha Salama Bint Hamdan Foundation. CONSULTANTS: Adams Kara Taylor (Structural Engineer), AECOM (Landscape Architect). HEATHERWICK STUDIO: Katerina Dionysopoulou, Robert Wilson. *Page 556.*

Olympic Cauldron
COMMISSIONER: LOCOG (London Organising Committee of the Olympic and Paralympic Games). COLLABORATORS: Martin Green, Catherine Ugwu, Bill Morris, Stephen Daldry, Mark Fisher, Hamish Hamilton; Piers Shepperd, Scott Buchanan and team; Patrick Woodroffe and team; Danny Boyle, Suttirat Larlarb, Mark Tildesley, Tracey Seaward and team; Kim Gavin, Es Devlin and team; Bradley Hemmings, Jenny Sealey and team; Rick Smith, Karl Hyde and team. CONSULTANTS: Stage One (Structural Engineer, Mechanical Engineer), FCT (Flame Engineer), London 2012 Ceremonies Technical Team, Robbie Williams Productions (Project Manager), Scott Buchanan (post-tender Project Manager). MAKERS: Stage One, FCT (Flame Engineer and Fabricator), Contour Autocraft (Copper Elements). HEATHERWICK STUDIO: Katerina Dionysopoulou, Andrew Taylor. *Page 590.*

Olympic Velodrome
COMMISSIONER: London Organising Committee of the Olympic Games. COLLABORATORS: Faulkner Browns Architects, Martha Schwartz Partners. CONSULTANTS: Adams Kara Taylor (Structural Engineer), Max Fordham Consulting Engineers (Mechanical and Electrical Engineer). HEATHERWICK STUDIO: Mathew Cash, Tom Chapman-Andrews, Stuart Wood, Christian Dahl, Jem Hanbury, Robert Wilson, Dandi Zhang. *Page 422.*

Pacific Place
COMMISSIONER: Swire Properties. COLLABORATORS: Ron Packman, Fred Manson. CONSULTANTS: Wong & Ouyang (Executive Architect and Structural Engineer), Hugh Dutton Associés (Concept Engineer), Isometrix (Lighting Designer), Mode (Graphic Designer), Andreas Hiersemenzel (Glass Consultant). MAKERS: Gammon (Main Contractor), Yearfull Contracting (Interior Contractor), BSC (Timber Benches), Whitton Casting (Lift Buttons). HEATHERWICK STUDIO: Mathew Cash, Fergus Comer, Claudia Hertrich, Alex Jones, William Aitken, Chloé Ballu, Tom Chapman-Andrews, Jennifer Chen, Christos Choraitis, Christian Dahl, Bim Daser, Jeg Dudley, Melissa Fukumoto, Rachel Glass, Jem Hanbury, Ingrid Hu, Neil Hubbard, Adelina Iliev, Alexander Jackson, Anna Jacobson, Ben Johnson,

Image Credits

All images © Heatherwick Studio unless otherwise indicated.

Adams Kara Taylor: 424 (top right), 425
Aglaé Bory: 377
Anthony Hunt Associates: 281
Courtesy of ArtLyst.com: 594 (bottom)
Arts & Business: 48, 49, 50, 51
Assembly Studios: 375, 404 (bottom left, bottom right), 405
Iwan Baan: 13 (third left), 16, 382, 384, 385 (bottom left, bottom right), 387, 388, 389 (bottom left, top right, bottom right), 390, 392 (bottom), 393 (bottom), 394, 442, 448 (top left, bottom), 450, 452 (bottom right), 454, 455 (bottom), 458, 537, 539 (top right), 540 (top right), 541, 542, 544
David Baluizen: 190
Roger Bamber: 348 (top)
Rob Barty: 11 (top left)
BBC Photo Library: 252, 283 (top left)
Benchmark Furniture: 54 (top left), 55
Fabrice Bourrelly, 3DW Ltd: 469, 470 (bottom left, bottom right), 471, 527, 528
Chris Brown: 496
John Burke, Age Fotostock: 490
Carnes: 316 (left)
Christina Chelmick: 412 (top right, bottom right)
China Central Television courtesy of the British General Consulate, Shanghai: 449
Ronald Codrai: 564 (top right)
Collection of the Samuel Dorsky Museum of Art: 574
Livia Cormandini: 310
Cristiano Corte, Marzorati Ronchetti: 4, 435 (top right)
ESO: 11 (third left)
Catherine Evans: 344, 350
Foreign & Commonwealth Office: 455 (top)
FreeFoto.com: 251 (top left)
From *Edwardian Inventions* by Dale & Gray, 1979: 9 (top left)
Getty Images: 591 (top), 594 (centre right), 596–97
Stephen Gibson: 8 (bottom right)
Isobel Goodacre: 433
Graham Carlow Photography: 452 (top right)
Len Grant: 233, 237, 238, 239, 242
Rick Guest: 164, 165
Eric Guy, Museum of English Rural Life, University of Reading: 10 (second right)
Hasbro Ltd: 144

Heatherwick Studio and Holly Wilson: 194
Hemis.fr, SuperStock: 532 (top left)
Homes and Communities Agency: 9 (bottom left)
Image credit unknown: 8 (third right), 54 (top right), 62, 63, 64 (bottom left), 114 (bottom left), 115, 154, 168 (bottom left), 196, 197, 211 (top left), 231, 234 (top right), 236 (top), 246 (top right), 393 (top right), 417, 418 (top left), 460 (top left), 494 (top right), 538 (top right), 546, 552 (top right), 567
Infinite 3D: 158 (bottom right)
John Hughes: 434 (bottom), 435 (bottom)
www.jonathangregson.co.uk: 346
Henryk Tomasz Kaiser: 40 (top right)
Tatiana Karapanagioti: 131
Nikolas Koenig: 320, 324 (second right)
Trevor Laidler: 214 (second left), 215
LakeRidge Photography: 198 (right)
Nic Lehoux: 324 (second left), 327
Whitney Loewen: 10 (third right)
Longchamp Paris: 169, 173
Lucas Digital: 453 (top left)
Magic Car Pics: 9 (third left)
Peter Mallet: 430, 504, 510, 511
Manchester Evening News: 241
Martha Schwartz Partners: 423
Daniele Mattioli: 447 (top left, top right, bottom right), 448 (top right), 456
William Murray: 348 (bottom left), 349 (bottom right)
Scott Nash: 13 (bottom left)
National Cycling Centre: 424 (bottom right)
National Geographic, Getty Images: 11 (second left)
Cristobal Palma: 244
Phil Captain 3D McNally: 507 (top)
Mark Pinder: 87, 89, 90, 95, 163 (bottom right), 236 (bottom)
Pollinger Ltd and the Estate of Mrs J. C. Robinson: 9 (second left)
Mike Powell, Getty Images: 11 (bottom left)
Press Association: 590, 592 (left)
Louie Psihoyos, Science Faction, Corbis: 262 (bottom)
Reuters/Pawel Kopczynski: 593
Salviati: 306, 307
Edwina Sassoon: 254, 255 (second left)
Norbert Schoerner: 257
Sinclair Knight Merz: 263 (top)
Susan Smart: 436
Charles Smith, Corbis: 464
SOM Architects: 414
Steve Speller: 52, 53, 56 (bottom), 57,

78, 81, 82, 83, 98, 103 (top left), 106, 108, 116, 121, 123, 124, 132 (bottom left, bottom right), 133, 134, 136, 137, 140 (second left, bottom), 142, 160, 177, 180, 182, 183, 185, 188, 208, 216, 219, 220, 229 (bottom), 250, 256, 258, 260, 264, 265, 370, 371, 372
Sophie Spencer-Wood: 58
SSPL via Getty Images: 8 (top right)
Andy Stagg: 351, 352
George Steinmetz, Corbis: 262 (top left)
Edmund Sumner: 336, 338, 339, 340, 356 (bottom), 357, 358, 360, 408, 412 (top left, middle, bottom left), 413
Swire Properties Ltd: 383 (top left)
TALL Engineers: 245
Andrea Tani: 530 (bottom right)
Wilfred Patrick Thesiger © Pitt Rivers Museum, University of Oxford: 530 (top left)
James Towill: 522 (top)
Uniform Communications Ltd: 547, 548, 550
University College London Science Lab: 291
Kikuko Usuyama: 324 (top left)
Tom Vack, Magis: 300, 432 (top right, second right, bottom right)
Van den Berk Nurseries: 316 (right)
Victoria and Albert Museum, London: 595 (bottom)
Jasper White: 19, 39, 42 (bottom), 43, 46, 47, 64 (top right), 66, 68, 69, 72, 73, 88 (top left), 102, 113, 122, 126, 127, 129, 130, 170, 172, 179, 186 (top), 199, 206 (bottom right), 267, 268 (bottom left), 269, 274, 275, 289, 294, 295, 309, 318, 330, 331, 332 (bottom left), 333, 334, 335, 343, 396, 397, 403, 406 (bottom left), 407, 432 (top left), 453 (bottom left), 462, 472, 484, 493, 500, 518 (bottom left, bottom right), 556, 559 (top right), 580, 581, 594 (left), 595 (centre)
Adrian Wilson: 324 (top right, bottom right), 325, 328
Worthing Herald: 497
Wright Bus: 539 (top left)
WSP Group: 468

Considerable efforts have been made to trace the rights owners of the material reproduced in this book, but in some cases we have regrettably been unable to do so. We would be pleased to insert an appropriate acknowledgment in any subsequent reprint of this book.

Heatherwick Studio
1994–2012

Shantha Adivhalli
William Aitken
Sam Aitkenhead
Simone Altmann
George Amponsah
Julin Ang
Doris Asiamah
Sogol Atighehchi
Simona Auteri
David Aviram
Peter Ayres
Jeremy Backlar
Chloé Ballu
Elaine Baptiste
Sofia Bark
Melanie Bartle
Stefania Batoeva
Janice Baumann
Jan Baybars
Ramona Becker
Andreja Beric
Carolina Biegun Elgue
Eleanor Bird
Ben Bisek
Einar Blixhavn
Camille Booth
Sarah Borowiecka
Polly Brotherwood
Veljko Buncic
Mark Burrows
Jennifer Butler
Mathew Cash
Tom Chapman-Andrews
Michael Charbonnel
Lucy Charlton
Jennifer Chen
Yü Chen
Doris Cheong
Daryl Cheung
Leo Cheung
Chun Chiu
Christos Choraitis
Yao Jen Chuang
Ashley Clayton
Kate Close
Sally Cohen
David Cole
Natalie Cole
Louise-Anne Comeau
Fergus Comer
Rosie Connors
David Costa
Alex Cotton
Holly Cowan
Nerma Cridge

Jacob Crittenden
Megan Cumberland
Christian Dahl
James Darling
Bim Daser
Ken Day
Jacob de Berker
Alienor de Chambrier
Laurie Dickason
Katerina Dionysopoulou
Pinar Djemil
Jenny Draxlbauer
Laurence Dudeney
Jeg Dudley
Nina Due
Christina Dyrberg
Eyal Edelman
Julia Edwards
Zeinab El Mikatti
Bee Emmott
Sarah Entwistle
Danielle Eveleigh
Pam Fauchon
Amber Fenley
Chiara Ferrari
Lisa Finlay
Mark Finzel
Tim Fishlock
Ian Fitzpatrick
Catherine Flowers
Lucia Fraser
Eran Friedland
Melissa Fukumoto
Kieran Gaffney
Hattie Gallagher
Frank Gilks
Marion Gillet
Rachel Glass
Paloma Gormley
David Grant
Emer Grant
Adam Grice
George Guest
Ellen Hägerdal
Rachel Hain
Trond Halvorsen
Jem Hanbury
Ben Hanson
Tim Harris
Lucy Heale
Elena Heatherwick
Hugh Heatherwick
Marisa Heatherwick
Miri Heatherwick
Moss Heatherwick

Thomas Heatherwick
Vera Heatherwick
Max Heine-Geldern
Anna Heinrickson
Hayley Henry
Claudia Hertrich
Shannon Hewlko
Sabine Hielscher
Mathew Hill
Andy Hillman
George Hintzen
Lisa Hirst
Etain Ho
Le Ha Hoang
Christopher Hon Ming Lam
Ingrid Hu
Neil Hubbard
Jaroslav Hulin
Hao-Chun Hung
Jimmy Hung
William Hunter
Adelina Iliev
Marina Illum
Alice Ives
Alexander Jackson
Anna Jacobson
Catherine James
Dominique Jenkins
Roberta Jenkins
Holly Jerrom
Anya Johnson
Ben Johnson
Kara Johnson
Alex Jones
Jonathan Jones
Maria Kafel-Bentkowska
Sarah Kaye
Kevin Kelly
Abigail Kendler
Catherine Kenyon
Flora Kessler
Kate Kilalea
Alex Knahn
Makiko Konishi
Gergely Kovacs
Catherine Kullberg Christophersen
Johan Kure
Keely Lanigan
Margot Laudon
Changyeob Lee
Helen Lee
Viviane Lee
Zoe Lee
Elizabeth Leidy
Sacha Leong

Vivien Li
Mavis Lian
Chia Ling Chung
Pascoe Lintell
Virginia Lopez Frechilla
Clare Lowther
Pikyan Luk
Jakob Lund
Stuart McCafferty
Garvan McGrane
Toby Maclean
Andrew McMullan
Abigail McNeill
Simon Macro
Mike MacVean
Helen Maier
Clare Manassei
Sogi Mangalsuren
Fred Manson
Mark Marshall
Kirsten Martin
Stepan Martinovsky
Tomomi Matsuba
Gemma Matthias
Tom Meacock
Posy Metz
Dirk Meuleneers
Liz Middleton
Craig Miller
Tim Miller
Benjamin Mills
Siobhan Milne
Jody Milton
Holly Mitchell
Rosie Mitchell
Nader Mokhtari
Xavier Flores Moncunill
Bruce Morgan
Glenn Morley
Matthew Morris
Chloe Mostyn
Tony Mullins
James Mustill
Sayaka Namba
Erika Nokes
Michele Oke
Karol Olszewski
Satoko Onisi
Leonora Oppenheim
Cara O'Sullivan
Juan Ignacio Oyarbide
Ron Packman
Christopher Palmer
Hannah Parker
Warren Parker

Clara Pierantozzi
Ross Plaster
Naya Posotidou
Eliot Postma
Luis Potter
Raphaela Potter
Jeff Powers
Lucy Priest
Umesh Qarmar
Thomas Randall-Page
Ryan Ras
Miyong Rathe
Louise Raven
Chris Rea
Alex Reddicliffe
Hana Reith
Stefan Ritter
Sandra Robinson
Peter Romvári
Maisie Rowe
Urzsula Russek
Ryszard Rychlicki
Ville Saarikoski
Danai Sage
Siba Sahabi
Sarah Sandercock
Julian Saul
Heidi Schaefer
Hannah Schneebeli
Asako Sengoku
Dina Shahar
Richard Sharp
Eyal Shaviv
Jill Skulina
James Smith
Ole Smith
Thomas Smith
Tan Sohanpall
Rachel Song
Edward Steed
Craig Stephenson
Rosslyn Stewart
Sebastian Stoddart
Jonathan Sturgess
Daniel Swann
Lukasz Szczepanowicz
Ana Taborda
Lucy Tams
Andrew Taylor
Ying WenTeh
Chris Thomas
James Thomas
George Thomson
Emma Thorn
Sharon Toong

Leisa Tough
Jacqueline Townsend
Colleen Tracey
Sebastian Ute
Dominic Vadra-Edwards
Jasper Van Oosterhout
Paula Velasco Ureta
Guido Vericat
Bettina von Kameke
George Wainwright
Alma Wang
Daniel Wang
Dominik Watracz Yarocki
Peter Webb
Daniel Weidler
James Whitaker
Simon Whittle
James Wignall
Thomas Williams
Genevre Wilshire
Craig Wilson
Robert Wilson
Jerzy Wiltowski
Simon Winters
Stuart Wood
Helen Wren
Andrew Wright
Douglas Wright
Jonathan Wright
Abigail Yeates
Eda Yetis
Chris Yoo
Sophie Young
Tom Yu
Chen Zhan
Dandi Zhang

Written by Thomas Heatherwick and Maisie Rowe

Coordinated by Liz Middleton

Book team: Dominique Jenkins, Kara Johnson,
Clare Lowther

And also: Peter Ayres, Alienor de Chambrier, Arancha
Chia, Chun Chiu, Kate Close, Sally Cohen, Ken Day,
Pinar Djemil, Bee Emmott, David Grant, Neil Hubbard,
Kate Kilalea, Bernard Leon, Mavis Lian, Cathy Middleton,
Siobhan Milne, Matthew Morris, Rebecca Roke, Sarah
Simpkin, Alex Stetter, Andrew Taylor, Stefany Tomalin,
Jasper White, Robert Wilson, Stuart Wood

Designed by Here Design

On the cover: UK Pavilion. Copyright © 2012 Iwan Baan

First published in the United Kingdom in 2012 by Thames
& Hudson Ltd, 181A High Holborn, London WC1V 7QX

First paperback edition 2013

Copyright © 2012 and 2013 Heatherwick Studio

All Rights Reserved. No part of this publication may be
reproduced or transmitted in any form or by any means,
electronic or mechanical, including photocopy, recording
or any other information storage and retrieval system,
without prior permission in writing from the publisher.

British Library Cataloguing-in-Publication Data
A catalogue record for this book is available from the
British Library

ISBN 978-0-500-29093-4

Printed and bound in China by C & C Offset Printing Co. Ltd

To find out about all our publications, please visit
www.thamesandhudson.com.
There you can subscribe to our e-newsletter, browse or download
our current catalogue, and buy any titles that are in print.